D1031702

The Goodyear Tire & Rubber Company

Series on Ohio History and Culture

Kevin Kern, Editor

Joyce Dyer, *Gum-Dipped: A Daughter Remembers Rubber Town*

Melanie Payne, *Champions, Cheaters, and Childhood Dreams: Memories of the Soap Box Derby*

John Flower, *Downstairs, Upstairs: The Changed Spirit and Face of College Life in America*

Wayne Embry and Mary Schmitt Boyer, *The Inside Game: Race, Power, and Politics in the NBA*

Robin Yocum, *Dead Before Deadline: . . . And Other Tales from the Police Beat*

A. Martin Byers, *The Ohio Hopewell Episode: Paradigm Lost and Paradigm Gained*

Edward C. Arn, edited by Jerome Mushkat, *Arn's War: Memoirs of a World War II Infantryman, 1940–1946*

Brian Bruce, *Thomas Boyd: Lost Author of the "Lost Generation"*

Kathleen Endres, *Akron's "Better Half": Women's Clubs and the Humanization of a City, 1825–1925*

Russ Musarra and Chuck Ayers, *Walks Around Akron: Rediscovering a City in Transition*

Heinz Poll, edited by Barbara Schubert, *A Time to Dance: The Life of Heinz Poll*

Mark D. Bowles, *Chains of Opportunity: The University of Akron and the Emergence of the Polymer Age, 1909–2007*

Russ Vernon, *West Point Market Cookbook*

Stan Purdum, *Pedaling to Lunch: Bike Rides and Bites in Northeastern Ohio*

Joyce Dyer, *Goosetown: Reconstructing an Akron Neighborhood*

Robert J. Roman, *Ohio State Football: The Forgotten Dawn*

Timothy H. H. Thoresen, *River, Reaper, Rail: Agriculture and Identity in Ohio's Mad River Valley, 1795–1885*

Brian G. Redmond, Bret J. Ruby, and Jarrod Burks, eds., *Encountering Hopewell in the Twenty-first Century, Ohio and Beyond. Volume 1: Monuments and Ceremony*

Brian G. Redmond, Bret J. Ruby, and Jarrod Burks, eds., *Encountering Hopewell in the Twenty-first Century, Ohio and Beyond. Volume 2: Settlements, Foodways, and Interaction*

Jen Hirt, *Hear Me Ohio*

S. Victor Fleischer, *The Goodyear Tire & Rubber Company: A Photographic History, 1898–1951*

Titles published since 2003.
For a complete listing of titles published in the series, go to www.uakron.edu/uapress.

The Goodyear Tire & Rubber Company

A Photographic History, 1898–1951

S. Victor Fleischer

The University of Akron Press
Akron, Ohio

ISBN: 978-1-629220-46-8 (cloth)
ISBN: 978-1629221-96-0 (ePDF)
ISBN: 978-1-629221-97-7 (ePub)

A catalog record for this title is available from the Library of Congress.

∞ The paper used in this publication meets the minimum requirements of ANSI/NISO z39.48–1992 (Permanence of Paper).

Cover Photo: *Blimps Over Cleveland*, 1936 (Neg. No. 198-1-2546C). The Goodyear blimps *Reliance*, *Puritan*, and *Enterprise* fly over downtown Cleveland during the 1936 Great Lakes Exposition. Cover design by Amy Freels.

The Goodyear Tire & Rubber Company was designed and typeset in Minion by Amy Freels and printed on sixty-pound white and bound by Bookmasters of Ashland, Ohio.

All images from The Goodyear Tire & Rubber Company Records, The University of Akron, University Libraries, Archival Services.

For my wife Susan, daughter Elizabeth, and mother Jerilynn.
In memory of my father William L. Fleischer, and my friend and colleague Craig Holbert.

Contents

Acknowledgments

I would like to thank many people without whom this book would not be possible. First, to the thousands of Goodyear employees who built the products featured in this book, and to the photographers and darkroom staff who visually captured and preserved the rich and fascinating history of the company, especially Aaron Vandersommers. Their names are included in the credits to the photographs in this book where possible. I would also like to thank my predecessor, John V. Miller, for laying the groundwork to acquire the Goodyear Photograph Collection, and for collecting and preserving the rich history of the company in thousands of boxes and files, which provided the enormous background information for the text. I also greatly appreciate the generous support of the great folks from The Goodyear Tire & Rubber Company, past and present, who had the foresight to donate the photographs and other historical records to The University of Akron Archives, especially Faith Stewart, Scott Baughman, and Duane Hurd. And to my supervisors, current and former deans of University Libraries Dr. Aimée L. deChambeau and Phyllis O'Connor, respectively, who permitted me time off to work on this manuscript.

I especially want to acknowledge the National Endowment for the Humanities who awarded my department a $303,000 grant in 2009 to inventory, preserve, digitize, and make available online 23,515 photographic negatives from the Goodyear archives, some of which are featured in this book. This project would not have been possible without their generous support. I would also like to thank numerous people who worked on the grant and made it possible. The work they did in securing the grant and on digitizing, cataloging, and uploading the photographs online greatly helped in my endeavor to review, select, and add images to this book. This includes Cheryl Kern-Simirenko, Craig Holbert, Michelle Mascaro, John Vincler, Julie Gammon, Chuck Urbancic, Frank Bove, Trevor Burkholder, Susan Ashby, Mike Dowdell, and especially Emily Gainer who supervised the project, communicated with the vendor, and hired and trained the student assistants. These include Kevin Klesta, C. J. Dupre, Charlotte Palmer, Tammi Mackey, Greg Voorhees, Meagan Hawthorne, Devan Murphy, Sarah Highman, and Sarah Loeser. I apologize if I am leaving anyone out. I would also like to thank David Matthews and the Northeast Document Conservation Center who digitized most of the photographs featured in this book.

I would also like to acknowledge my current staff, especially John Ball and Mark Bloom, who assisted with locating and selecting images and information for this work. Bob Grippo and Bill Smith shared their knowledge and expertise on Goodyear-made figure balloons, and Eric Brothers, Eddie Ogden, and Neal Sausen assisted with the chapter on airships. Similarly, Greg Guderian at the Newark Public Library assisted with identifying Bamberger parade images, and John Beckham at Bierce Library helped track down several elusive resources. I would also be remiss if I did not mention the great folks at The University of Akron Press, past and present, who made this book possible, including Tom Bacher, Dr. Jon Miller, Amy Freels, Thea Ledendecker, Carol Slatter, Julie Gammon, and student assistants Emily Miller, Daniel Paparella, Sonia Potter, and Kaylie Yaceczko for their valuable input and countless hours spent designing this book and copyediting the text. Additionally, Eric Brothers, Bob Grippo, and Keith Buckley fact-checked many chapters for historical accuracy and saved me from making numerous errors.

Last but not least, to my wife, Susan, and daughter, Elizabeth, for being patient with me as I spent many hours away from home in the archives and at my laptop selecting and researching images and writing the text for this book. And to my mother, Jerilynn Fleischer, and in-laws, Marko and Mira Vranic, who took care of my daughter so I could have time to write this text. I would also like to thank many friends and family for their continued advice and support throughout the time I worked on this project, especially my brother Bill, Tom Paolucci, Art Swaton, Sam Giamo, and John Telek. The assistance of all those acknowledged here and those I left out is greatly appreciated.

Preface

Besides oil, steel, and cotton, perhaps no material has been more important to our lives than rubber. As The Goodyear Tire & Rubber Company wrote 100 years ago, "There is scarcely an article in the world today supplying human needs that is more nearly universally used than rubber. It is made to serve civilization in thousands of ways."[1] Similarly, rubber tycoon and competitor Harvey Firestone Jr. asserted in the 1930s that "rubber enters into almost every phase and activity of life."[2] Less than a decade later, during World War II, the Rubber Manufacturers Association (RMA) pointed out that "rubber has given the world mobility....On rubber depends modern world transport, communications, safety, and health. In war and peace."[3] And as the Firestone Tire & Rubber Company acknowledged more than 30 years later, "Rubber is one of the most essential of the world's raw materials" and "also one of the most versatile."[4] Surely, these statements hold true today. In fact, in recent times, economists Colin Barlow, Sisira Jayasuriya, and C. Suan Tan noted in *The World Rubber Industry* that "rubber is one of the world's major commodities" that figures prominently in "the evolving global economy."[5]

Indeed, since Charles Goodyear's discovery of vulcanization in 1839, rubber has transformed the lives of millions of Americans and people around the globe. Volumes have been written about this amorphous substance and its many functions, for, as rubber scholars Howard and Ralph Wolf pointed out in their seminal work on the subject, "On rubber there is, of course, an immense technical library."[6] It graces the wheels of our cars, trucks, motorcycles, bicycles, and farm equipment. Rubber wraps the wheels of buses, airplanes, and—at one point—even trains, safely moving people and products from point A to point B. It also permeates these vehicles with hundreds of rubber parts under the hood and inside the cabin, from belts and hoses to floor mats and engine mounts. Beyond this, though, rubber pervades almost every industry on the planet in the form of products known as mechanical goods. These drive belts, hoses, and conveyors forged American industry and helped build this nation and other countries across the globe.

It can be found, too, in the home and office—in the cushions of our furnishings and bedding, and in gaskets and fittings in our plumbing and appliances. This versatile substance even exists under our feet in the soles of our shoes and in tile flooring and padding. The list goes on and on. Harvey Firestone Jr. summed up the importance of this versatile material best when he wrote:

Without it, no factory could run, no modern building could operate, no fast railroad train could travel across the country, and no steamship could sail the high seas. No home could be conducted in the modern sense without the articles and implements of rubber that are made for our daily use. From the first cry of the newborn babe until the last slow march to the grave, things made of rubber are indispensable to our modern life.[7]

Rubber companies in Akron, Ohio—the former "Rubber Capital of the World"—manufactured these important rubber products. The Goodyear Tire & Rubber Company was among these industrial pioneers. From tires that won the first Indianapolis 500 races and broke land speed records on the Bonneville Salt Flats, to those that traversed the frozen landscape of Antarctica on Admiral Byrd's Snow Cruiser and explored the lunar surface on the Modular Equipment Transporter, Goodyear has made tires for almost every mode of transportation conceivable. In addition to tires, they also manufactured some of the most significant balloons and airships in the history of lighter-than-air flight. This includes observation and barrage balloons that helped win the world wars and stratosphere balloons that broke world altitude records and laid the foundation for the space race. They also brought smiles to the faces of generations of young and old alike through their work on figure balloons that, for decades, stood as the hallmark of the Macy's Thanksgiving Day Parade.

Goodyear's long line of products goes far beyond tires and blimps. From their "rubber railroads" that helped build important public works projects in this country, to a variety of nonrubber products that helped win the Second World War, the significance of Goodyear goes well beyond being just another rubber company. The history of the rubber industry, and The Goodyear Tire & Rubber Company in particular, is incredibly fascinating, especially in terms of the products they manufactured that helped advance transportation and industry and continue to impact our lives today. As the author of a pamphlet titled *The Rubber Giants* wrote about the industry, "Its story is a dramatic one."[8] Indeed, it deserves to be told and should continue to be recounted. The importance of the rubber industry and Goodyear's and Akron's role in it is captured in the hundreds of thousands of images in the company's corporate archives, known as The Goodyear Tire & Rubber Company Collection. This history needs to be relayed, for, as the company once noted, "Goodyear's history is really the history of an industry, and of our nation."[9]

In his book, *Growing American Rubber,* the late historian Mark Finlay notes, "Nowadays, rubber seems almost invisible despite its everyday importance."[10] Similarly, colleague Stephen Harp writes in *A History of World Rubber,* "The history of rubber is no longer well-known." "Rubber is now a commodity that is largely behind the scenes," he continues, "in contexts where we take it for granted."[11] Almost a century earlier, in 1917, the B. F. Goodrich Company similarly opined, "Rubber articles have become so common that we very rarely think of the part this commodity plays in our daily lives. Unless we deliberately count them, we never think of rubber."[12] It is my goal that this volume will help bring this important subject to light

through the presentation of a selection of some of the best images from The Goodyear Tire & Rubber Company Collection that help to tell this story. It is my intent to showcase some of the most interesting, historically significant, and visually appealing photographs from the collection. I will also attempt to put them into a broader historical context and to show them in a new light so they can be viewed and enjoyed by the public.

It is important to note that I tried, wherever possible, to select images that have rarely been seen and had not been previously published. Where possible, I listed the photographer of the photographs, if they are known, in the credits to the images. I wrote this volume to encourage others to research the vast historical resources housed in our repository and others, in order to learn more about Akron's and Goodyear's impact on industry and transportation, and to reflect on the rubber and polymer industry's past while considering its future. As the old adage goes, "don't forget where you came from" and "never lose sight of where you are going."

Notes

1. The Goodyear Tire & Rubber Company (hereafter Goodyear), *The Story of the Tire* (Akron, OH: Goodyear Tire & Rubber Company, 1919), 5–8.

2. Harvey Firestone Jr., *The Romance and Drama of the Rubber Industry* (Akron, OH: Firestone Tire & Rubber Company, 1936), 19.

3. The Rubber Manufacturers Association, *The Rubber Industry and the War* (New York: Rubber Manufacturers Association, ca. 1944), 3.

4. The Firestone Tire & Rubber Company, *Rubber* (Akron, OH: Firestone Tire & Rubber Company, 1977), 1.

5. Colin Barlow, Sisira Jayasuriya and C. Suan Tan, *The World Rubber Industry* (New York: Routledge, 1994), i.

6. Howard and Ralph Wolf, *Rubber: A Story of Glory and Greed* (New York: Covici Friede, 1936), ix.

7. Harvey Firestone Jr., 19.

8. The Standard Oil Company, "The Rubber Giants: Industry in the Ohio Heritage," Panel Guide (Album III, Number 5), 1961.

9. Goodyear, "Goodyear: 65 Years of Progress," ca. 1963, booklet, The Goodyear Tire & Rubber Company Records (hereafter GR), The University of Akron, University Libraries, Archival Services (hereafter UA Archives).

10. Mark R. Finlay, *Growing American Rubber* (New Brunswick, NJ: Rutgers University Press, 2009), 3.

11. Stephen Harp, *A World History of Rubber: Empire, Industry, and the Everyday* (Malden, MA: John Wiley & Sons, 2016), 137.

12. The B. F. Goodrich Company, *A Wonder Book of Rubber* (Akron, OH: B. F. Goodrich Company, 1917), 8.

Introduction

The University of Akron Archival Services was founded in 1965 as a division of University Libraries. Then known as University Archives, its mission was to collect, preserve, and provide access to primary and secondary source materials that documented the history of the University and its predecessors, dating back to the institution's founding in 1870. A few years later, thanks to the University's strong ties with the community, the department acquired archival collections on local history. Then, in 1970, the archives established the American History Research Center (now known as Special Collections) as a regional repository. The goal was to acquire archival materials that documented the history of the region—particularly Akron and Summit County—and its burgeoning tire and rubber industry, which has been so intimately linked with the University.[1] Under the leadership of former archivists John V. Miller and Dr. David Kyvig, the department acquired archival collections on Akron's rubber and polymer industry. This included the B. F. Goodrich Company Records, the General Tire & Rubber Company Records, and the United Rubber Workers Records, to name a few. Finally, in 1994, the archives acquired one of its flagship collections: The Goodyear Tire & Rubber Company Records, more informally known as the Goodyear Collection.

The Goodyear Tire & Rubber Company was founded in 1898 by bankrupt brothers F. A. and C. W. Seiberling. The early years of the company were plagued by a lack of capital, competition with well-established companies who vowed to put them out of business, patent blockades, and infringement lawsuits. Ever the fighters, the brothers and their young factory manager Paul Litchfield strove to make the company a success. In 1902, the company won their first major patent suit against Kelly-Springfield over the right to make carriage tires. This put the brothers on a path to success. As F. A. Seiberling later recalled, "We blew the whistle for an hour that day and let the Kelly people know that we were on earth and that we proposed to stay!"[2] But the company did more than just survive. Before long, Goodyear became the world's largest tire company. They soon expanded with plants in Canada and Mexico, cotton farms in Arizona, and rubber plantations in Asia and South America. By 1926, Goodyear was the largest rubber manufacturer in the world. In the second half of the twentieth century, Goodyear grew to become a multinational corporation with multi-billion-dollar earnings. Today, Goodyear measures sales of nearly $15 billion and employs over 60,000

people in its factories around the world. They have been one of the leaders in the business for over a century, accomplishing milestones and making major impacts on the industry.[3]

The Goodyear Tire & Rubber Company Records at The University of Akron Archival Services date from the company's founding in 1898 to the early 1990s and document the rich and fascinating history of the largest and most influential tire and rubber company in the world. At over 3,000 cubic feet, the collection is one of the department's largest, most significant, and most heavily utilized. A diverse group of patrons—students, educators, scholars, historians, genealogists, artists, architects, engineers, hobbyists, and enthusiasts—use this collection for important projects such as research papers, books and journal articles, historical exhibitions, documentary films, television broadcasts, educational programs, and marketing campaigns. It consists of historical records including annual reports, correspondence, publications, advertisements, newspaper clippings, news releases, artifacts, motion picture films, and, of course, photographs.

While the original donation from Goodyear contained hundreds, if not thousands, of photographic prints and negatives, the company continued to maintain its extensive photo archive at its corporate headquarters in East Akron. In the mid-2000s, University Libraries negotiated with the company to donate its photograph "morgue" to the University in order to properly manage and preserve this invaluable resource and make it more readily accessible to the public for research and discovery. After a thorough professional appraisal, which valued the collection at $1.1 million, the company gifted the photographs to the archives in 2008 to be maintained with the rest of its corporate records of enduring value.[4] In December of that year, 57 army surplus cabinets filled with cherished photographic prints and negatives were transferred to The University of Akron Archives, located in the Polsky Building in downtown Akron. Because of its immense historical value, the collection has had an immediate impact on the archives and its patrons.

The Goodyear Photograph Collection, more formally known as the Photographic Prints and Negatives Series of The Goodyear Tire & Rubber Company Records, has been called "one of the first corporate photograph collections ever established."[5] It consists of hundreds of thousands of images that visually document the history of the company, from 1898 to 1984. Although the exact number of the contents in this photograph collection is difficult to ascertain, it is estimated that the 154,000 files contain close to a million photographic images, if not more. These files feature pictures in many formats, including glass plate negatives, acetate and nitrate negatives, slides, and prints. The majority of the images are black and white; however, the collection also contains nearly 6,000 folders of color negatives—or roughly 60,000 color images—dating from 1960 to the mid-1980s. The images capture almost every aspect of the company's history, which seems to naturally split into three categories: people, places, and products. This volume focuses on Goodyear's vast array of products, with the hope of publishing additional volumes of historic images on Goodyear's diverse workforce and extensive physical plant. Many of the images in this book do depict Goodyear employees engaged in the manufacturing and use of the company's products, as well as the numerous factories where these materials were manufactured.

The significance of the collection lies in its multi-dimensional documentation of twentieth century history. The images document important themes in American history that provide

research and pedagogical value to students, educators, scholars, and the general public. This includes research interests such as the rubber industry, labor relations, factory conditions, women in the workforce, lighter-than-air flight, professional and amateur sports, transportation, advertising, aeronautics, and wartime production. Aaron Vandersommers, former Manager of Creative Services for Goodyear, captured the significance of the collection when he simply stated, "The country's history is in those files."[6]

The Goodyear photographs cover topics that are technical but also personal in scope. They document the evolution of rubber product technology through images of raw materials, finished products, and manufacturing techniques, as well as machinery and processes. Factory equipment—including Banbury mixers, buffing machines, crude rubber slicing machines, testing equipment, tire building machines, and more—is prominently featured in the negatives, some of which Goodyear manufactured itself. Moreover, many of the images depict human factors associated with the company's activities, which are of great interest to social and labor historians. These images offer insight into working conditions, gender dynamics, and company-sponsored programs for training both men and women in skills ranging from drafting to typing and stenography. They capture the diverse labor force in Akron, Ohio, the former "Rubber Capital of the World," in addition to the company's plants around the globe.

Immigrants from Germany, Italy, Austria, and Hungary—as well as African Americans from the South—flocked to Akron's rubber factories in the early twentieth century, when the city was one of the fastest growing in the nation. Even Deaf workers migrated to Akron during the first half of the twentieth century for the sake of working in the rubber industry, making the city the "Crossroads of the Deaf."[7] Images show this diverse workforce engaged in a variety of tasks during various stages of rubber production, including milling, curing, vulcanizing, and inspecting. The labor force in foreign countries, including plantations in the Far East, is also captured in the images. These photographs depict native workers clearing the land, planting and tapping rubber trees, and collecting and processing the latex. While the Goodyear Photograph Collection includes many images that document this diverse workforce, only a handful of images in this volume depict European immigrants and people of color due to the issues of race and class prevalent at the time. During the period of this study, most racial and ethnic groups were relegated to more menial tasks in the rubber factories and were not involved in skilled jobs like tube and tire building, at least until the start of World War II. Therefore, the images depicted in this volume are reflective of these socioeconomic conditions.

For industrial production, Goodyear is most recognized for tires. Thousands of images visually chronicle innovations in the tire industry that are of immense importance to business historians and rubber and polymer scientists, as well as those interested in America's industrial heritage. In addition to early bicycle, carriage, and motorcycle tires, the images include an abundance of automobile tires that had an impact on industry and society. This includes the straight side, a readily detachable tire invented in the early 1900s which came into universal use and was a milestone in the industry. A few years later, Goodyear released a nonskid, which it did not invent but improved upon with their unique tread design known as

the "All-Weather." It remained the industry standard for the next 40 years and became one of the most distinctive tire treads in the business. In the early 1920s, the Goodyear balloon tire swept the market. Nearly all cars in the nation were on balloons by the middle of that decade.

The company manufactured not only innovative tires for automobiles, but also trucks and buses, and it played a major role in garnering widespread acceptance for pneumatic tires in the trucking and busing industries. Goodyear also developed one of the first pneumatic airplane tires, which it later applied to tractors, thus revolutionizing the agricultural industry. In addition, the company manufactured colossal off-road tires for giant earthmoving equipment. It was these tires that helped to build the country's roads, bridges, and public works projects such as facilities for the Manhattan Project and the Alaska pipeline. Images in the collection document these significant engineering feats. The largest and most unusual tires Goodyear had made up to that time outfitted the Snow Cruiser used in Admiral Richard Byrd's expeditions to the Antarctic, but perhaps still more impressive are the photographs that show Goodyear tires for lunar equipment used on man's first and second landings on the moon via Apollos 11 and 12. Images portray moon vehicles, lunar tires and equipment, and astronauts exploring the moon's surface.[8]

Goodyear furthermore manufactured mechanical goods—among them air brakes, fire hoses, transmission belts, valves, gaskets, and, most importantly, rubber conveyor belts, which were used for ship-to-shore transfer of merchandise and carrying coal and ore out of mines deep under the earth's surface. Goodyear engineers travelled the world installing them in places as far and wide as Chile, South Africa, and Alaska. The conveyor belts made a number of major construction projects in the United States possible, including the Grand Coulee and Shasta dams, and fired American industry in places such as Cleveland, Pittsburgh, and New York. These products and the engineering marvels they helped build are featured in the collection.

Goodyear made innovations in other areas that advanced technology and helped the nation along its path to becoming a superpower. Even before World War II, Goodyear—led by Dr. Ray Dinsmore and his team in Akron—experimented with the production of synthetic rubber. In 1937, Goodyear produced a small batch of synthetic rubber and its first synthetic tire. Two years later, the company set up a pilot plant and produced its own brand of synthetic rubber named Chemigum. By the end of the war, Goodyear had a 30,000 ton plant in Akron and 60,000 ton plants in Los Angeles and Houston. Together, these factories produced approximately 325,000 tons of synthetic rubber for the Allied war effort. These important projects are captured in the collection as images of synthetic rubber plants, and the manufacturing of products from this artificial material abound.[9]

Perhaps some of the most interesting images document the company's involvement in the world wars. These photographs are multi-dimensional in viewing both the production and utilization of war products. During World War I, Goodyear made observation balloons for the US Army and rudimentary blimps for the US Navy. Military uses of Goodyear products were more prominent, though, in World War II—among them gas masks, tank tracks, rubber assault craft, pontoons for portable bridges, and blimps. Goodyear trained personnel and produced airships during World War II that were used in reconnaissance, air-sea rescue, antisubmarine defense, and as ship escorts. Goodyear also manufactured parts for

many of America's most famous war planes, such as the Boeing B-29 Superfortress, B-24 Liberator, Martin B-26 Marauder, and FG-1 Corsair. These components not only included wheels and brakes, but also wings, tail fins, and fuselages, and are pictured in the collection. Some images were top secret during the wars and were only made public when the negatives were transferred to Archival Services. An example includes depictions of inflatable rubber dummy tanks and airplanes the company made for Operation Fortitude, an Allied plan to deceive the Nazi high command into believing that the Normandy landings were a feint, and that the real attack was going to be delivered in July at Pas-de-Calais. Indeed, Goodyear products contributed to the success of the Normandy invasion and helped win World War II.[10]

Goodyear is well-known throughout the world for its contributions to lighter-than-air flight. The collection contains thousands of photographs of airships that seldom, if ever, have been seen before. The lighter-than-air images are an incredible resource that are of immense importance to aviation historians, educators, and enthusiasts throughout the world. The collection features images of some of the most important dirigibles in lighter-than-air history, such as the *Hindenburg* and the *Graf Zeppelin*. Photographs also show important airships from American history. This includes the USS *Shenandoah*, the first American-built rigid airship; the USS *Los Angeles*, the most successful and longest-serving United States Navy zeppelin; and the USS *Akron* and its sister ship, the USS *Macon*, which were the largest helium-filled airships in history. The christening of the *Akron* by First Lady Lou Henry Hoover was a national event and is captured in detail in the negatives. Other images depict Goodyear's first advertising blimps, the *Pilgrim* (now preserved at the Smithsonian Institution) and the *Puritan*, in addition to later airships such as the *Mayflower, Columbia, America*, and their sister ship in Europe, the *Europa*.

An international icon that has become an important symbol in American culture, the Goodyear blimp is one of the most recognizable images in the world and one of the most successful advertising campaigns in history. The blimp is known worldwide because of its appearance at most major sporting events for the last 75 years, from the Super Bowl to the Olympics. It has also appeared at political conventions, world fairs, and royal weddings, and it has been used to take aerial shots of other major events, many of which can be found in the negatives.[11]

The collection also captures the construction and utilization of airship facilities. Many photographs depict the Wingfoot Lake Airship Base in Suffield, Ohio, which is the oldest airship base in the United States and is often referred to as "The Kitty Hawk of Lighter-Than-Air Flight." All the navy's early airship pilots received their training at Wingfoot Lake. There are also images of the Goodyear Airdock in Akron, which was, at the time of its construction, the largest building in the world without interior supports. It was an engineering marvel. Other important airship bases including Moffett Field in California and Lakehurst Naval Air Station in New Jersey are also represented in the collection. These images are of use to students and professors of engineering and aviation, as well as lighter-than-air scholars and enthusiasts.

The last topic represented in the collection relating to lighter-than-air products is parade balloons. Many of the parade balloon images document the Macy's Thanksgiving Day Parade in New York City—one of country's most recognizable holiday traditions. It is, for many, the highlight of the Thanksgiving holiday, which officially ushers in the Christmas season.

Goodyear began making balloons for the Macy's parade in 1927, only three years after the parade began. Many of the character balloons that are part of America's cultural memory—Superman, Underdog, Popeye, Bullwinkle, Snoopy, Mickey Mouse, and the colossal turkey—appear in the photographs. Some of these balloons also appeared in other memorable parades throughout the country, including New Jersey's Bamberger's Thanksgiving Day Parade and the Gilmore Circus parades that traveled the West Coast in the 1930s. Many of the images in the collection document the balloons and the parades, as well as historic buildings and street scenes along the parade routes.[12]

Racing has been a part of Goodyear—and Goodyear a part of racing—practically from the time the company began. Through this particular sport, the company tested and demonstrated the quality of their products. The first automotive race to feature Goodyear tires occurred in 1901, and by 1919, every major race in the country was won on Goodyear tires. The company's motorcycle tires also won many races and broke records. Several of these early races, drivers, and their historic vehicles are represented in the photos. While the company took a hiatus from automotive and motorcycle racing for many years, the 1960s saw a resurgence in Goodyear racing tires. At that time, the company entered the Grand Prix-Formula One circuit—supplying tires, tire testing, and tire service for most of the major world driving champions. Also during this time, Goodyear became the dominant tire supplier on the big time American motocross circuits. They claimed Indianapolis 500 wins in the modern era, and they helped achieve many NASCAR victories. The company has been associated with American motor-racing greats including A. J. Foyt, Mario Andretti, Bobby Unser, Richard Petty, Darrell Waltrip, and others, many of whom are featured in the photographs. More importantly, perhaps, Goodyear also became involved in highly publicized attempts to set land-speed records during the 1960s. A series of images in the collection depicts land-speed record holders Mickey Thompson and Craig Breedlove alongside their "rocket cars" on the Bonneville Salt Flats in Utah. These photos are of tremendous use to sports and automotive historians, as well as students and scholars of American popular culture.[13]

Another great American tradition documented in the collection is the All-American Soap Box Derby, a youth soap box car race, which has been called "amateur racing's grand prix" and "the greatest amateur racing event in the world."[14] Although it started in Dayton, Ohio, in 1934, the race moved the following year to Akron, which still hosts the world championship finals. Over one million children have participated in the event in its 85-year history, making it what the late author and historian George Knepper called "a legend, a great American institution."[15] Since Goodyear was a major sponsor of the race, company photographers captured many aspects of this event, including celebrities such as the Bonanza Boys, who attended the derby. Politicians, soldiers, aviators, athletes, and artists were also captured in the historic images, either taking factory tours, christening or riding on Goodyear blimps, or promoting Goodyear products. Among these celebrities are Babe Ruth, Bob Feller, Frank Lloyd Wright, Marlene Dietrich, Eddie Rickenbacker, Winston Churchill, Richard Nixon, Harry Truman, Amelia Earhart, and Charles Lindbergh. Photographs of other important personalities have been captured by Goodyear photographers. These include founders F. A. and C. W. Seiberling and longtime CEOs Paul Litchfield and E. J. Thomas.

Sports historians will be interested in the images of company-sponsored recreational activities, which depict interactions between labor and management not often encountered. Goodyear's recreation program, a vital aspect in the Goodyear family philosophy, included hundreds of sports teams and social clubs. The most important was Goodyear's basketball team, known as the Wingfoots, one of the earliest in the United States and an important force in amateur basketball at home and abroad. In its 60 years of varsity basketball, Goodyear company teams won major championships, and five players captured Olympic gold medals. The most famous is Larry Brown, a player and former head coach in the National Basketball Association (NBA) and an NBA Hall of Famer. The Wingfoots became a part of the National Basketball League, predecessor to today's NBA. Images of games and players are featured in the collection, as are the company's other sports teams and recreational activities.[16]

In showing many aspects of industry, business, society, and popular culture, the Goodyear photographs represent one of the largest and most significant corporate photographic collections in the country. Seldom duplicated elsewhere, the images are unique resources of interest internationally, nationally, and locally. In addition, many of the images are rather artistic and possess aesthetic qualities, especially several stunning prints by noted American photographer Dorothea Lange. According to Dr. Kevin F. Kern, Associate Professor of History at The University of Akron, "The Goodyear photograph collection is a resource of undisputed historical value. Not only does it contain images available nowhere else that speak to twentieth-century US industrial history, it also has proven pedagogical value."[17]

As a result of the enormous historical value and research significance of the collection, Archival Services applied for and received a $303,000 Humanities Collections and Reference Resources Grant from the National Endowment for the Humanities in 2009, one of the largest grants in University Libraries history. The funding was used to preserve a portion of the negatives and prints by rehousing them into acid-free, archival-safe enclosures and placing the original nitrate and acetate negatives in cold storage. The grant also funded the digitization of over 23,000 images and the creation of metadata records for those items. Finally, the digital files were uploaded to the department's online digital repository so they could be made more readily accessible and discoverable by the public in a searchable online database. This database is available at www.uakron.edu/libraries/archives/digitalcollections.

The grant funded the digitization of all the negatives from 1898 to 1951, which were considered the most historically significant and the most at risk of degradation and loss. The end date was chosen because it also is when film companies stopped producing nitrate film. Nitrate film is incredibly hazardous, as it can spontaneously combust and cannot be extinguished. It was incredibly important to identify the images on nitrocellulose film base and separate them before digitizing them and placing them in cold storage. Other negatives from this early period were showing signs of deterioration, including cracked glass plate negatives and shrinking acetate negatives with vinegar syndrome. Thus, it was vital to identify these images, arrest any further degradation, and reformat them before they were completely lost, and to reduce handling of the originals.[18]

This book showcases a selection of images from 1898 to 1951 that were digitized and preserved as part of the grant project. Photographs from after this time period have not been digitized and are out of the scope of this book, but are available at the archives for research and study. Nearly two hundred of the 23,515 digitized images are highlighted in this book. These images are some of the most extraordinary, aesthetically pleasing, and historically significant photographs from the collection. They capture one of the most crucial and important times in the company's and the country's past. Covering the period from the end of the nineteenth century to the start of the Cold War, the images from this time period tell the story of labor, industry, and manufacturing in the US and beyond during the first half of the twentieth century. This volume will focus on Goodyear's products. While the company literally made countless rubber products—as well as some nonrubber goods—this study will mostly focus on those products that put the company on the map and had the greatest impact on both national and international industry, society, and culture. The succeeding pages tell the history of Goodyear's products through the lens of the camera, with historic images from the company's archives.

Notes

1. For more information on The University of Akron Archives see John V. Miller, "The Formation and Early Development of The University of Akron Archives, 1965–1973," (master's thesis, Kent State University, 1992). See also annual reports for University Archives, Archival Services, and the American History Research Center, UA Archives.
2. "Mr. F. A. Seiberling's speech to the SSS Club" (speech, Stan Hywet Hall & Gardens, Akron, OH), 1916, Willard P. Seiberling Papers (hereafter Seiberling Papers), UA Archives.
3. George Knepper, *Akron: City at the Summit* (Tulsa, OK: Continental Heritage Press, 1981), 204.
4. James I. W. Corcoran, "Mass Appraisal of an Archive of Folders of Photographs and Photographic Negatives for Charitable Donation," 2008, report in UA Archives.
5. Ibid, 13.
6. Aaron Vandersommers, "The Goodyear Photograph Collection" (lecture, The University of Akron, Akron, OH, May 20, 2009).
7. For information on the Deaf population in Akron see Clyde D. Wilson, *Akron History of the Deaf* (Akron, OH: C. Wilson, 1993); Philip J. Dietrich, *The Silent Men* (Akron, OH: Goodyear, 1983); and Marcus S. Miller, "The Deaf and Hard of Hearing in Akron Industry" (master's thesis, The University of Akron, 1943).
8. For information on Goodyear's tire production see Goodyear, *The Story of the Tire* (Akron, OH: Goodyear, 1968).
9. For information on Goodyear's synthetic rubber production see Hugh Allen, *The House of Goodyear* (Cleveland, OH: Corday & Gross), 436–438. See also Paul Litchfield, *Industrial Voyage: My Life as an Industrial Lieutenant* (New York, NY: Doubleday, 1954), 290–294. For general sources on synthetic rubber history see Charles F. Phil-

lips, *Competition in the Synthetic Rubber Industry* (Chapel Hill, NC: The University of North Carolina Press, 1963); and Peter J. T. Morris, *The American Synthetic Rubber Research Program* (Philadelphia: The University of Pennsylvania Press, 1989).
10. For information on Goodyear's contributions to World War II see Goodyear, "Goodyear's Contribution to the War Effort," n.d., MS, GR. See also Litchfield, 279–314.
11. For information on Goodyear's contributions to lighter-than-air flight see A. Dale Topping, *When Giants Roamed the Sky*, ed. Eric Brothers (Akron, OH: The University of Akron Press, 2001); James R. Shock, *The Goodyear Airships* (Bloomington, IL: Airship International Press, 2002); and Hugh Allen, *The Story of the Airship* (Akron, OH: Lakeside Press, 1943).
12. For information on Goodyear's parade balloons see Robert M. Grippo and Christopher Hoskins, *Macy's Thanksgiving Day Parade* (Charleston, SC: Arcadia Press, 2004).
13. For information on Goodyear racing see Jeffrey L. Rodengen, *The Legend of Goodyear: The First 100 Years* (Ft. Lauderdale, FL: Write Stuff Enterprises, 1997), 185–203.
14. Dawn Mitchell, "The All-American Soap Box Derby," *Indianapolis Star*, August 23, 2018.
15. Knepper, *Akron*, 141.
16. Murry R. Nelson, *The National Basketball League: A History, 1935–1949* (Jefferson, NC: McFarland & Co., 2009).
17. Kevin Kern to the National Endowment for the Humanities, July 6, 2011, UA Archives.
18. For information on nitrate, acetate, and color negatives see Debra Hess Norris and Jennifer Jae Gutierrez, eds., *Issues in the Conservation of Photographs* (Los Angeles, CA: Getty Conservation Institute, 2010).

Chapter 1
Where the Rubber Meets the Road
Carriage, Car, and Cycle Tires

"The rubber tire was the foundation of Goodyear's business career, the thing that made it a great company."[1]
—Hugh Allen, Goodyear publicist

In 1898, when the Seiberlings opened the doors to The Goodyear Tire & Rubber Company, they chose to manufacture only three products: carriage tires, bicycle tires, and automotive tires. The first products to roll off the production lines—on November 21, 1898—were solid tires for carriages and bicycles. Their first sale occurred on December 1, 1898, and came to a total of $251.80. Goodyear exclusively produced carriage and bicycle tires its inaugural year, but three years later, the company added automobile tires to their lineup, and the venture quickly expanded. Less than 20 years later, tire sales totaled $64 million, and Goodyear became "the No. 1 company in tires."[2] By the start of the Great Depression, the rubber company had an estimated capacity of 75,000 tires a day, or approximately 26 percent of the total field. By the end of World War II, Goodyear manufactured tires for numerous modes of transportation. In many of these lines, they invented new products and processes that helped transform the industry.[3]

Thousands of images in The Goodyear Tire & Rubber Company Collection document the corporation's contributions to the tire industry and showcase the variety of tires, tubes, and rims designed and manufactured by the company. The images illustrate almost every aspect of tire development, including studio shots of the tires, cross sections, drawings, advertisements, tire damage, and competitors' products. They also show tire testing, the stages of tire manufacturing, and tire builders—both male and female. The images capture Goodyear tires on different modes of transportation, such as carriages, automobiles, bicycles, and motorcycles. Some of the photographs show vehicles important to the history of transportation that are now considered antique or classic automobiles—including Duesenbergs, Packards, Hudsons, and rare vehicles such as Dymaxion cars. The photographs also capture vintage motorcycles manufactured by companies such as Indian, Excelsior, and Harley-Davidson. Some of these products appear in photographs of early automotive and motorcycle races, including some of the first Indy 500s and motorcycle board track competitions.

Helping the Horse

Carriage Tires for Business and Pleasure

Goodyear manufactured carriage tires for horse-drawn vehicles the year it opened. After F. A. Seiberling fought and eventually won a patent suit filed by Kelly-Springfield, Goodyear became one of the leaders in the carriage tire field. By 1912, thanks to the quality of their product, competitive pricing, and an extensive advertising campaign, the company had sold nearly four million carriage tires. They collaborated with carriage manufacturers to develop tires of superior materials and advanced construction. By the nineteen teens, Goodyear offered at least five distinctly different carriage tires and advertised "a type for every service." This included the famous Goodyear Wing, which featured distinct patented wings that prevented debris and moisture from damaging the tire, thereby increasing its life; the Goodyear Eccentric Cushion, which incorporated a wire hole below the center that eliminated internal wire troubles and the danger of the tire rolling off the channel; and the Goodyear Side Wire, which prevented the wires from slipping between the tire and channel and shredding it to pieces. Most models were available in multiple sizes, as well as on reels in continuous lengths.[4] However, the advent of the automobile brought about the decline of the passenger carriage and commercial wagon at the turn of the twentieth century. By the mid-1920s the industry was almost extinct. With its near demise went everything associated with these vehicles, including tires.[5]

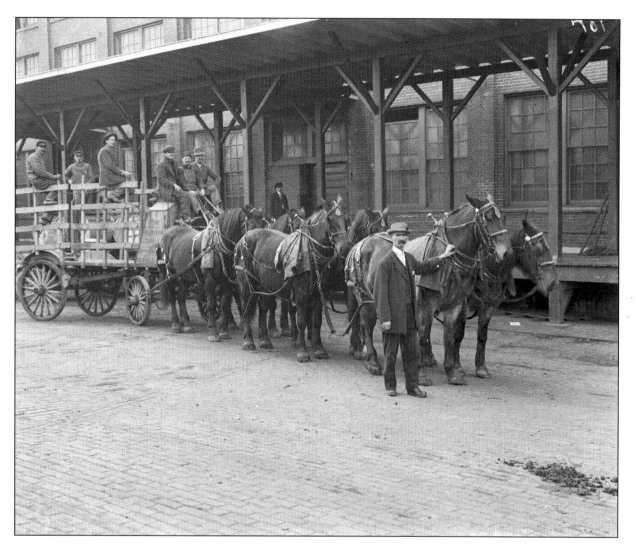

Six Goodyear Truck Teams with Wagon, 1913
Goodyear employees sit in one of the company's three horse-driven wagons shod with Good-
year carriage tires outside the shipping room platform at the Akron Plant. Farron G. Hills,
who presided over the horse teams, stands in the foreground. By the time this photograph
was taken, Goodyear had captured 75 percent of the carriage tire market and had sold nearly
four million carriage tires to roughly one million customers.[6]

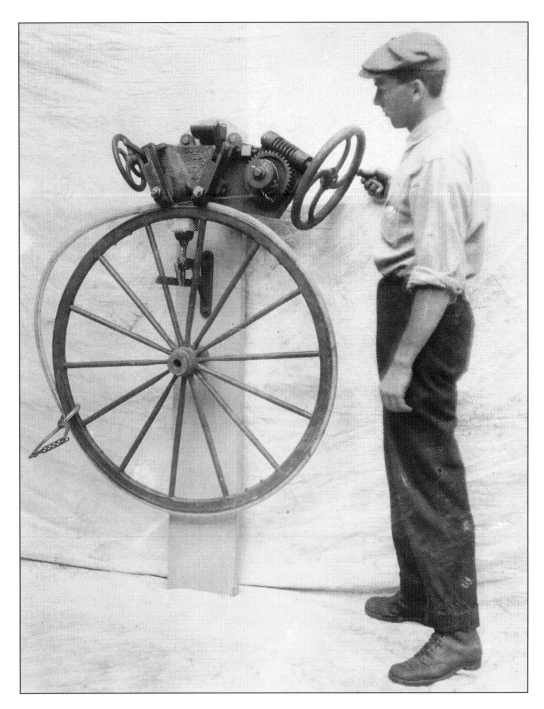

Putting on a Carriage Tire, 1914
A tire builder mounts a Goodyear carriage tire to the rim. Goodyear not only manufactured carriage tires, wires, and accessories, but also the equipment required to mount them to wheels, including this Style D Machine. Since Kelly-Springfield controlled the only practical device for this purpose, Goodyear's master mechanic Bill State developed this machine to break the Kelly monopoly and expand the use of carriage tires.[7]

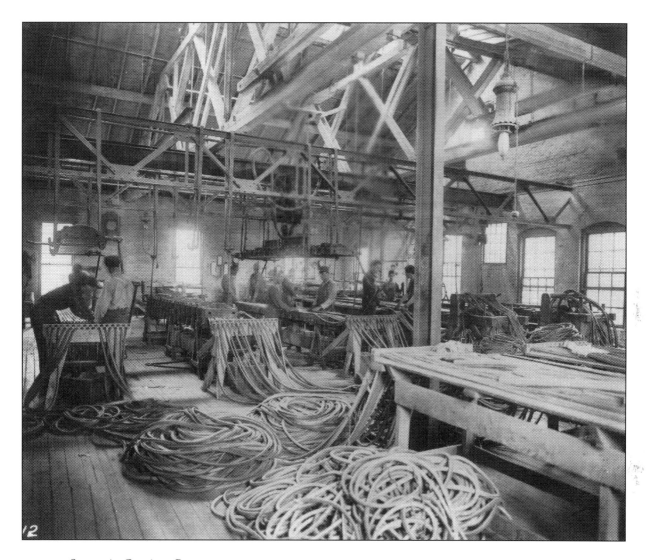

Scenes in Carriage Room, 1914

Tire builders construct carriage tires in the Akron Plant's Carriage Room by feeding stock into one end of a machine that mixes it together like a sausage grinder. Pressure forced the rubber stock through an aperture, and it emerged from the other end the exact size and shape of the style desired. Workers then cured the tires and placed wires through the holes, soldering the ends to hold them onto the rims.[8]

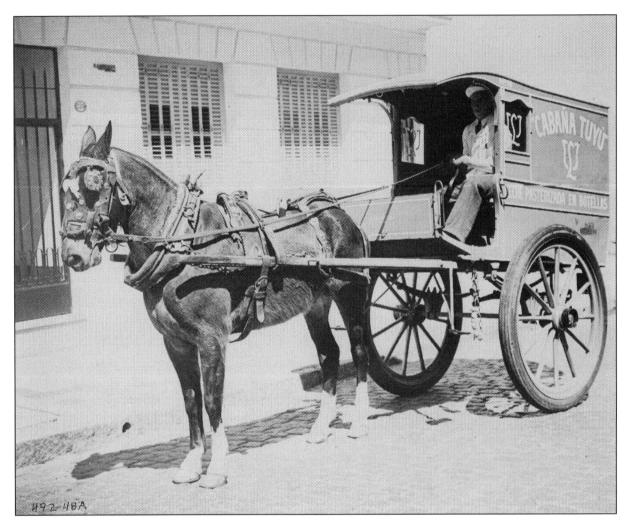

Spanish Milk Wagon, 1947
Although the automobile and motor truck supplanted the horse-drawn carriage early in
the 1900s, Goodyear continued to sell carriage tires well into the twentieth century. While
the tires continued to be used in America on a limited basis—especially in rural areas—the
company focused on exporting them where it found a ready market overseas, as evidenced
by this mid-century Spanish milk wagon.[9]

I Want to Ride My Bicycle

Bike Tires for Racing, War, and Recreation

The first bicycles—then known as velocipedes—had wooden wheels followed by iron rims and eventually solid rubber tires. In 1888, the Scottish-born veterinary surgeon and inventor John Boyd Dunlop fashioned pneumatic rubber tires to a bicycle, which helped generate a cycling boom.[10] Goodyear president and later chairman Paul W. Litchfield noted that "the bicycle was an old invention. With steel tires it made but slow progress. The adoption of a solid rubber tire gave it increased public usage, but it was the pneumatic tire which made it a big industry."[11]

The first Goodyear bicycle tires rolled off the line in 1898. By 1900, the company built 4,500 bicycle tires per day. By the following year, they produced 400,000. In the formative years Goodyear manufactured single- and double-tube bicycle tires with exotic sounding names such as the Monarch, Cactus Puncture Proof, Surety, Krackajack, Eureka, Tip-Top, Ajax, and the most popular, the Giant Heavy Roadster.[12] Hartford Rubber, the owners of the Tillinghast patent under which Goodyear produced most of its bicycle tires saw their success as a threat and revoked their license. Goodyear sidestepped this by making bicycle tires with two plies separated by muslin—and later tissue and then toilet paper—to reduce costs. This innovation allowed them to avoid patent infringement and royalty payments, which reduced costs and gave them an opportunity to expand their business.[13]

Despite their popularity, Goodyear manufactured what Litchfield called "poor quality" bicycle tires in the early years.[14] Later, the company took "the first step ever taken toward standardizing the bicycle tire business" by abandoning the manufacturing of all brands with the strategy of focusing on only one—the Goodyear Blue Streak—and making it well. By concentrating on a single brand, the company reduced manufacturing costs, eliminated waste, and added profits by selling directly to the dealer. Goodyear made 15,000 Blue Streaks a day by 1916, when it launched its One Million Bicycles for 1916 campaign. Inevitably, "automobiles crowded bicycles almost out of the picture," and Goodyear discontinued manufacturing bicycle tires to focus on automotive and truck tires. Later, when bicycles made a resurgence in the early 1930s, they resumed production. By 1935, the Goodyear Akron Plant manufactured over a million annually, putting it on top of the industry once more. At that time, the company made two types of bicycle tires: the standard single tube and the straight-side balloon tire, along with the bicycle inner tube. By the end of the decade Goodyear would also manufacture the Speedway and Pathfinder brands. When the Second World War erupted, Goodyear bicycle tires became "a potent weapon against the Axis." The company newsletter, the *Wingfoot Clan*, described how bicycles equipped with their tires "speed busy war-workers to their vital tasks all over the United Nations [and] save precious gasoline."[15] By the end of the war, Goodyear had sold 5.2 million bicycle tires per year on the domestic market alone.[16]

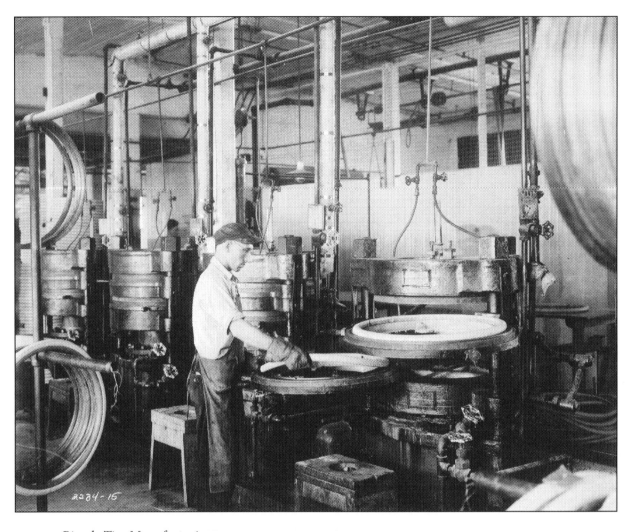

Bicycle Tire Manufacturing, 1915
A tire builder makes a Goodyear Blue Streak bicycle tire at the Akron Plant. By the time of this photograph, Goodyear had eliminated all other types of bicycle tires and produced only one to reduce manufacturing costs and streamline production. They made 15,000 Blue Streak bicycle tires a day through a unique construction process of two reinforcing fabric strips under tough, rugged treads that guarded against punctures. Soon, Goodyear discontinued manufacturing bicycle tires to focus on automotive and truck tires but resumed production in the 1930s.[17]

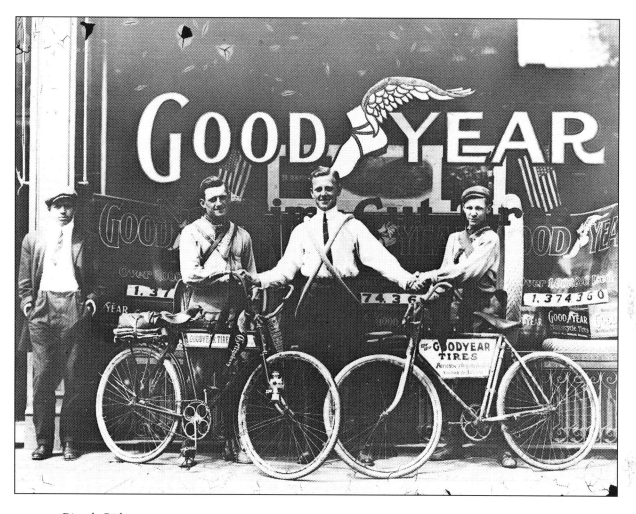

Bicycle Riders, ca. 1914

A Goodyear tire dealer shakes hands with two young men traveling from New York to Atlanta on bicycles outfitted with Goodyear bicycle tires. The window in the background contains Goodyear tire advertisements, including a sign stating that over one million Goodyear bicycle tires had been sold. By 1914 Goodyear dealers operated in over 72 cities across the country.

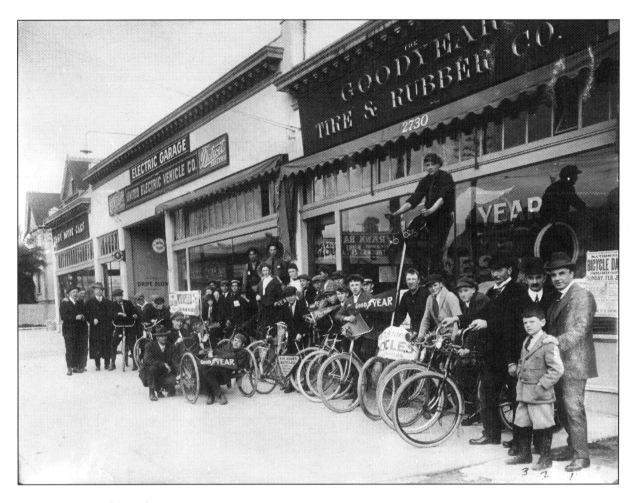

National Bicycle Race, 1916

On National Bicycle Day in February 1916, Goodyear helped organize bicycle races such as this one in Oakland, California, and in nearly every branch city across the country. The event was part of a sales campaign called One Million Bicycles for 1916, in which the company pledged to help sell one million bicycles that year and outfit them with Goodyear tires. The event proved a major success, for the races achieved their goal of arousing new interest in bicycling, as well as creating new business seized by the automobile and motorcycle.[18]

I Get Around

Automobile Tires for the Road and the Track

Shortly after Goodyear opened its doors, the Seiberlings felt that the automobile had a big future and wanted to get into the action. In 1900 they persuaded Paul Litchfield—who had experience in automobile tire manufacturing in New England—to join their firm as production manager. Before long, Litchfield and the Seiberlings went to work to remedy the shortcomings of the clincher tire and, in late 1901, developed the straight side, which ran straight down instead of curving inward. Goodyear not only broke the monopoly—as the association of license holders who divided up the market had no control over the straight side—but also built a better product. This led a number of car manufacturers to switch over to straight-side tires in 1907. In 1910, 54 of these manufacturers contracted with Goodyear to feature their tires, which translated to one-third of the automobiles made that year.

In 1904, Goodyear built cord tires for automobiles. Unlike other manufacturers, Goodyear built their cord tires featuring side-by-side layers, which was a technique employed in place of cross weaving them. This made the tires extremely resilient and able to resist ply separation, a common failure of early cords. The early models of this product came with a choice of studded, Blue Streak, or corrugated treads. Then, in 1908, Goodyear released their first nonskid tread, which helped cars travel safely on wet and snowy roads at higher speeds, as well as off-road. Distinguished by the familiar diamond blocks that resisted skidding and provided superior traction, the famous All-Weather tread design remained relatively unchanged for over four decades. Goodyear then spent over a decade improving their cords and introduced the multi-ply cord by 1915, which they offered in the no-hook and quick detachable clincher types for gasoline and electric cars with a choice of tread. This tire doubled the mileage of former fabric tires. Soon, other manufacturers adopted the Goodyear multi-ply cord principle for tire construction. By 1916, 60 leading motor car manufacturers specified Goodyear as regular equipment, totaling three-quarters of a million automobiles annually.[19]

Between 1908 and 1913 auto production increased nearly eightfold, and auto registrations sextupled. Over the next seven years, auto production quintupled, and registrations soared to over eight million. Since "all of these new cars required multiple sets of tires,"[20] Goodyear increased their sales force in 1915 and embarked on a comprehensive sales campaign, with the goal of "placing Goodyear tires in every city, town, and hamlet in the land."[21] They advertised in major magazines including *The Saturday Evening Post* and the best trade journals and newspapers of their branch cities, telling the story that "Goodyear Means Good Wear."[22] By 1917, after introducing mass-production principles, Goodyear sales hit the $100 million mark, and two years later, the company manufactured its 250 millionth tire. In the early 1920s, Goodyear expanded their cord automobile tire line by offering many options, including the Goodyear clincher fabric tire. They also added the economical Wingfoot cord and heavy-duty cord, "the 'work shoe' among tires," designed to be stronger than necessary for people like doctors, salesmen, and tourists who "drive fast and hard" on rough roads.[23]

By this time, the company estimated that a thousand tires an hour rolled off their production lines. In 1927, Goodyear produced its 100 millionth passenger car tire.[24]

The company eliminated dangerous shoulder breaks common to cord tires by developing a highly elastic and resilient cord fabric called Supertwist, "the backbone of the world's greatest tire."[25] Around 1924, Goodyear incorporated this new fabric into their balloon tires, which were fatter than other tires and thus had a larger surface area in contact with the road. This was a design that provided greater air cushioning and riding comfort. Some of their other advantages over regular tires included increasing the life of the car, eliminating vibration, reducing fuel and repair bills, increasing speed, adding traction, enhancing safety, and improving the appearance of the car. Balloon tires caught on immediately and quickly drove clinchers out of the field, resulting in Goodyear selling a million balloon tires in fewer than three months. Goodyear later scientifically redesigned the balloon tire and released the still newer All-Weather balloon. The Pathfinder balloon soon followed in addition to the more economical Pathfinder straight side cord.[26]

On its thirtieth anniversary, to "keep pace with motordom's demands," Goodyear introduced the Double Eagle, which had a higher profile, thicker rubber side walls, double-thick tread, and a heavier carcass made with more plies and rubber.[27] In 1931, Goodyear adapted the Airwheel to passenger cars, which carried still further the principles of greater air volume and low air pressure that began with the balloon tire. The advantages of the Airwheel, embodied in the company's G-3 tire, included increased mileage, easier riding, and less skidding. The tires were also less susceptible to punctures.

Seven years later, the company unveiled its first rayon tire cord, followed by its first nylon tire cord a decade later. Then, in the late 1930s, Goodyear released the LifeGuard tire and tube, noted as "the greatest of recent contributions to motoring safety."[28] Developed and built exclusively by Goodyear and described as "a tire within a tube," the design eliminated the hazards of blowouts, particularly at high speeds, which made faster travel possible. In 1941, Goodyear released the DeLuxe tire and tube, a nonskid automobile tire distinguished by its departure from the rib tread that better gripped the road and provided even tread wear. By this time, Goodyear made a number of its tires with synthetic rubber, which they helped develop and pioneer during World War II, when the Japanese cut off the vast supply of natural rubber from East Asia.

Throughout the war, Goodyear produced all types of tires for military vehicles, in addition to passenger car tires made of reclaimed rubber—"war tires"—that could be recapped when worn. Soon, the company would produce over 25 million tires a year, or 2.5 million a month.[29]

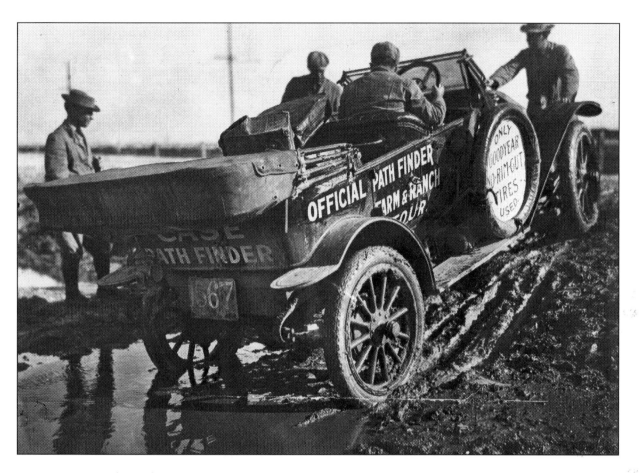

Farm and Ranch Tour Car, 1912

Goodyear marketed their automobile tires to farmers and ranchers from an early date. This Case Touring automobile with Goodyear Pathfinder No-Rim-Cut tires went on a tour of agricultural communities throughout the country to demonstrate these tires' superior performance in the mud. They were easier to mount to the rim and did not bruise or rim-cut like standard clincher tires, thus extending the life of the tire.

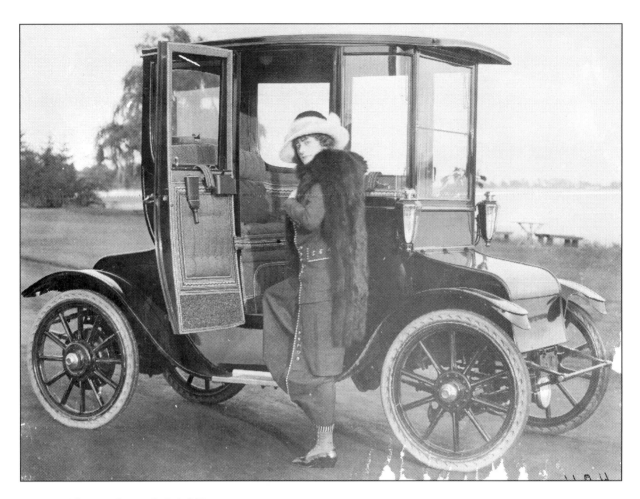

Electric Car with Solid Tires, 1914

In the early twentieth century, Goodyear purchased and sold tires from the Motz Tire & Rubber Company, especially Goodyear-Motz Truck Tires and Goodyear-Motz Cushion Electric Tires. The latter were marketed to women for electric cars, such as the one seen in this photograph, with the slogan "She Shall Decide." The Motz company was located on E. Market Street in Akron directly across the street from the Goodyear Plant. It was in operation from 1905 until approximately 1919, when Goodyear purchased the company.[30]

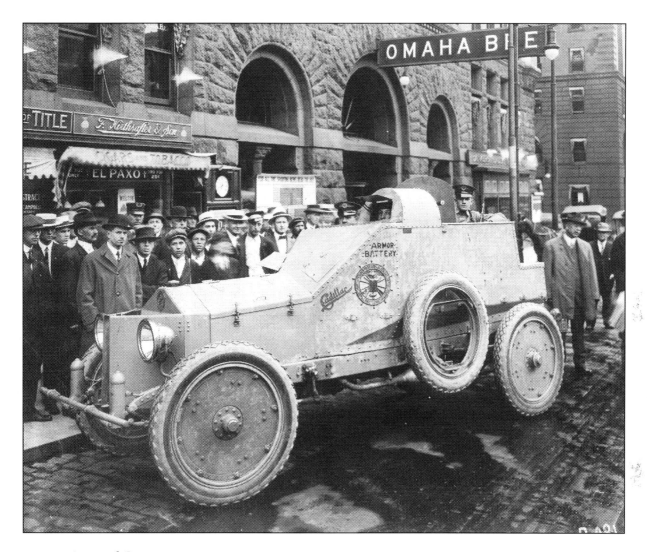

Armored Car, 1915

America's first fully armored military vehicle, the Davidson-Cadillac armored car, stops in Omaha, Nebraska, on its performance tour from Chicago to the Panama Pacific Exposition in San Francisco. American military educator and inventor Royal Page Davidson and his cadets at the Northwestern Military and Naval Academy developed the car to convince the government of the merits of a mechanized army. Goodyear had the honor of supplying the tires. This was one of several military vehicles in the early 1900s that sported Goodyear's All-Weather treads.[31]

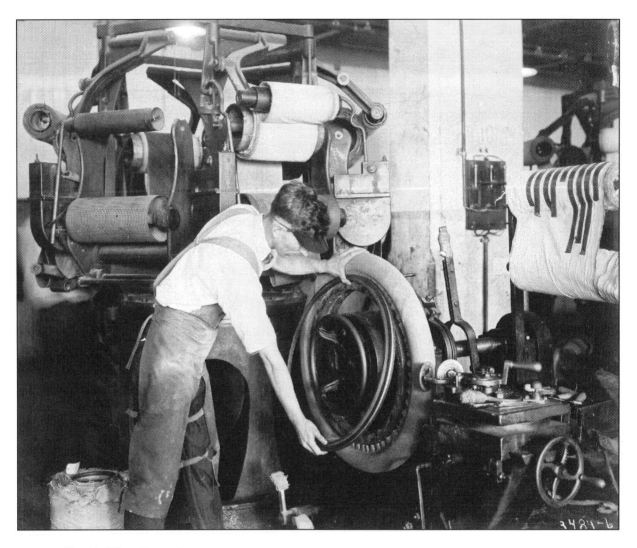

Tire Building Operations, 1917
A tire builder constructs a passenger car tire on a tire-building machine designed in 1909 by Goodyear's master mechanic, William State. The machine had eliminated hand building at the company and initiated mass production, improving tire quality as it eliminated human error. By the time this picture was taken, Goodyear's innovations included the multi-ply cord—also known as the fortified tire; a No-Rim-Cut feature; an On-Air cure that protected against blowouts; multiple braided piano wires that provided greater tire security; and a double-thick tread that prevented skidding.[32]

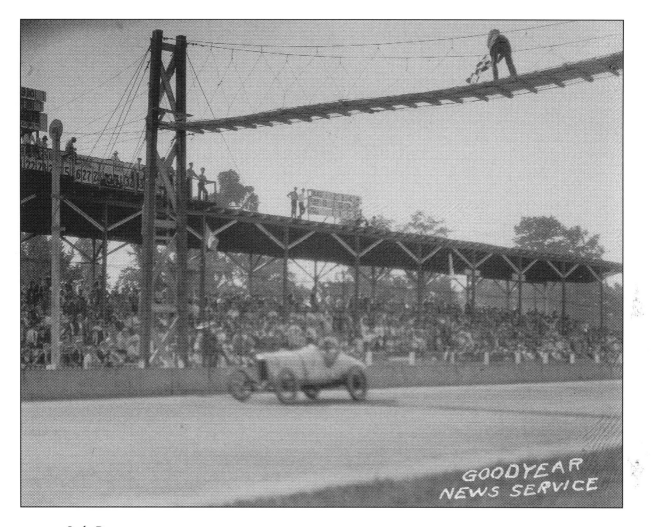

Indy Race, 1922

An early race car shod with Goodyear tires crosses the finish line at the 1922 Indianapolis 500. Goodyear entered auto racing in 1902 to test their straight-side tires and by 1916 cars running on Goodyears won races at speeds of nearly 100 miles per hour. 1919 then proved to be the golden year of racing for the company as 90 percent of the cars at the Indy 500 ran on Goodyear tires and tubes. After winning many races and breaking records, Goodyear withdrew from automotive racing and took a 37-year hiatus from the sport to cut costs.[33]

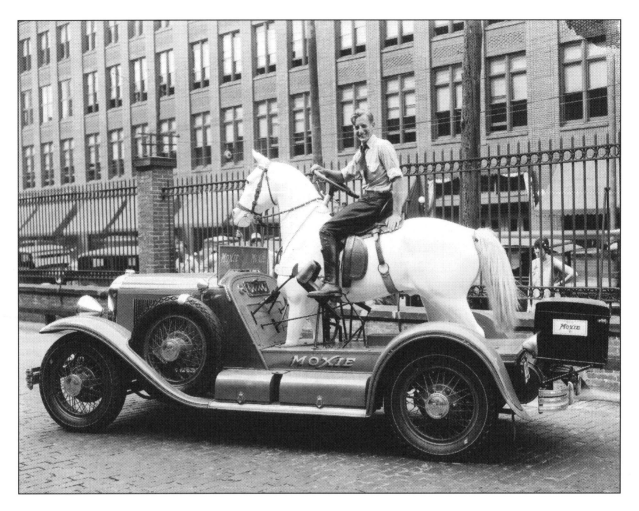

Moxie Horsemobile, 1931

The company's automobile tires not only shod cars that broke distance and speed records, but also unique creations that advertised products, such as this Moxie Horsemobile, a modified Rolls-Royce with Goodyear tires. Moxie used the car in parades and public events to promote their soda, while Goodyear utilized it to market their tires. The first one appeared in 1918 and continued through the 1930s. The year this photo was taken, Goodyear adapted the Airwheel to passenger cars, building off the success of their balloon tires.

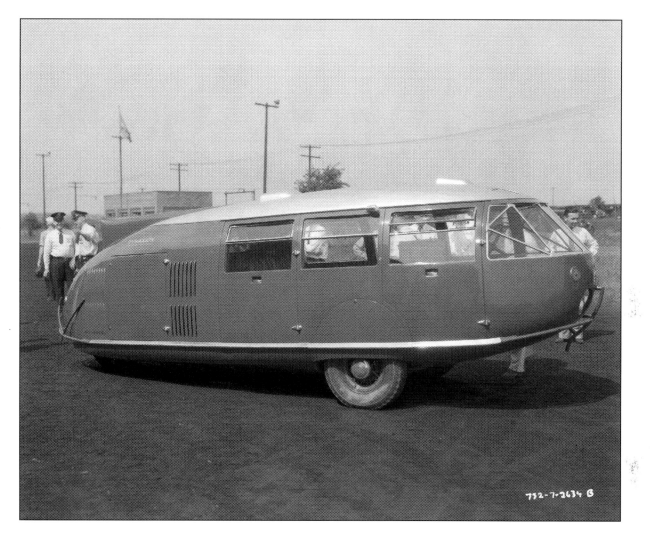

Streamline Car, 1934

A crowd forms around one of three prototypes of the odd-looking 20-foot long Dymaxion car designed during the Great Depression by the American designer, inventor, and futurist Buckminster Fuller. The car was known for its light weight and unusual teardrop aerodynamic design that was streamlined for fuel efficiency, which helped it reach a top speed of 120 miles an hour. It was also known for its three-wheel design—one in the back that steered and two motorized drive wheels at the front—which made it incredibly maneuverable. Goodyear outfitted this strange contraption with their balloon tires. Although the design caught media attention and was featured at an exhibit at the 1934 Chicago World's Fair, a fatal crash of the first prototype resulted in negative publicity. While this scared away investors and ended the project, the streamline design influenced later designers.[34]

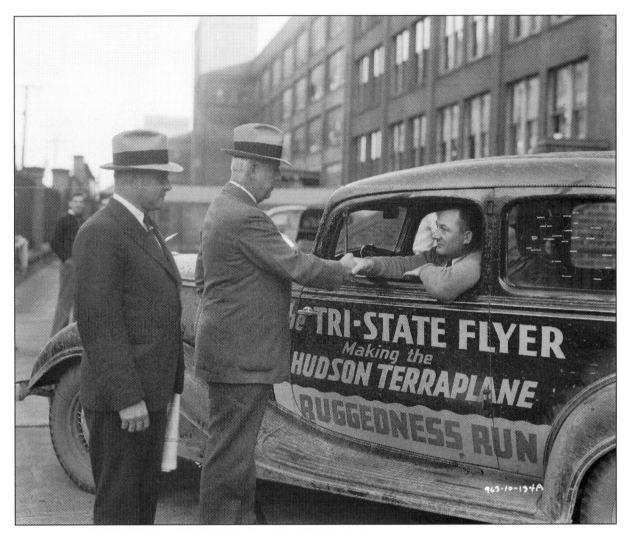

Hudson Terraplane Contest, 1934

Paul Litchfield shakes hands with the driver of the Tri-State Flyer, a Hudson Terraplane out-fitted with Goodyear tires that went on a two-week publicity stunt called the Ruggedness Run in 1934 with 20 other Hudson Terraplane owners from across the country. The event put the car and its tires through its paces to show their superior durability. Goodyear also tested their tires on their own fleet and the cars of their salesmen who traversed the countryside. In addition, daredevils such as Erwin G. "Cannon Ball" Baker pushed their tires to the limits on record-breaking cross-country endurance jaunts.[35]

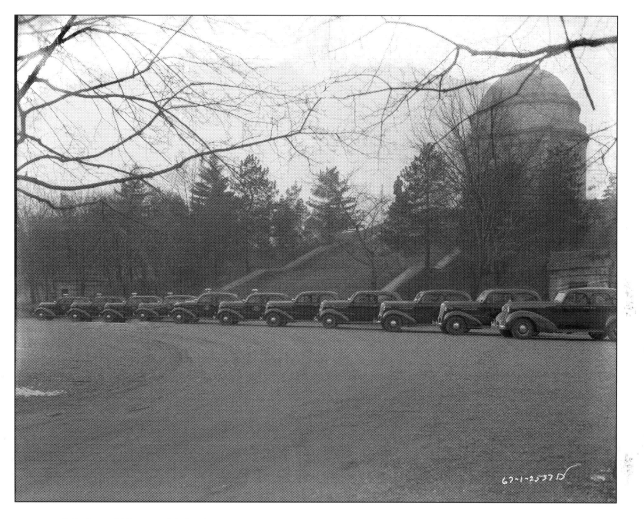

LifeGuard Tires at McKinley Monument, 1937
A fleet of police cars shod with Goodyear LifeGuard tires sits in front of the William McKinley Monument in Canton, Ohio. The LifeGuard tire and tube, which the company called "the greatest of recent contributions to motoring safety" and described as "a tire within a tube," purportedly eliminated the hazard of blowouts and made faster travel possible.[36]

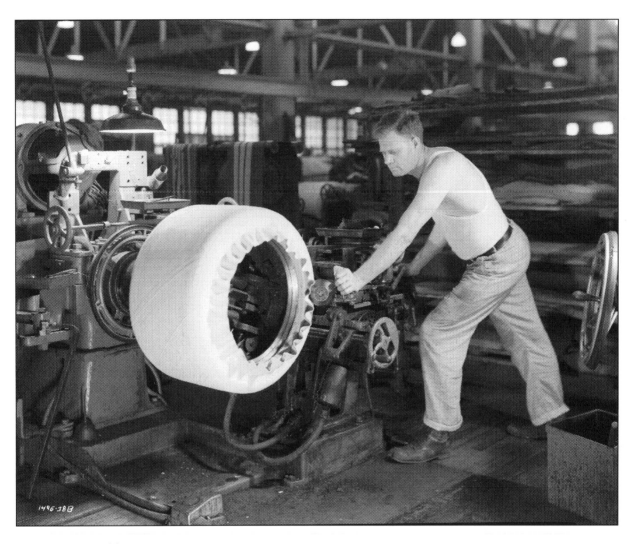

Tire Building, 1938
Tire builders constructed passenger car tires by stretching plies over a mold and attaching the bead and tread. They sent the mold to the curing department where workers loaded them into massive steam-heated containers in recessed areas called pits for vulcanization. Next, pit workers removed the tires from the molds and sent them to the finishing department for cleaning, wrapping, and shipping.[37]

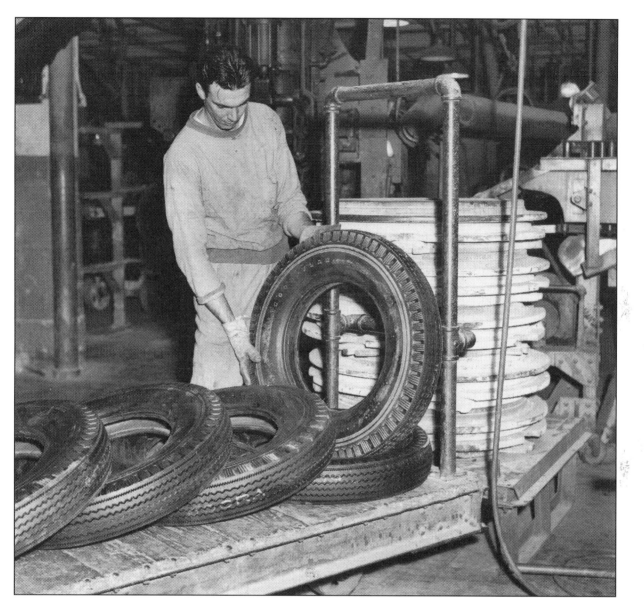

War Tires, 1942

A worker loads Goodyear "war tires" on a hand cart at Akron's Plant 2 during World War II. Throughout the war, Goodyear manufactured hundreds of thousands of tires for jeeps and military vehicles. On the home front they also made tires for passenger cars from reclaimed rubber that could be recapped when worn. Goodyear utilized its own brand of synthetic rubber to manufacture tires for civilian and military use.[38]

Living to Ride, Riding to Live

Motorcycle Tires for Work and Play

Goodyear's vast experience with bicycle and automobile tires led to another success story. When the Hendee Manufacturing Company introduced the Indian motorcycle in 1901 and Harley-Davidson followed with their creation two years later, the company actively pursued the market.[39] The rubber company began manufacturing motorcycle tires in 1909, and the following year the first Goodyear motorcycle tire reached the public. In the early days, the firm produced two types of motorcycle tires offering a combined six different treads to give motorcyclists "a tire for every road they travel." This included Goodyear stock tires with a corrugated tread, a nonskid tread, and a studded tread; Blue Streak tires with treads for "all sorts of weather and all kinds of roads"; and the Black Tread Blue Streak for heavier motorcycles, side cars, and commercial use. By 1912 Goodyear produced 1,000 motorcycle tires daily, and two-thirds of motorcycles produced came from the factory Goodyear-equipped.[40]

Goodyear won the acceptance of motorcyclists and manufacturers alike by testing their tires in the popular new sport of the day: motorcycle racing. Author David Schonauer noted how, "a century ago, Americans fell in love with speed," and "the new sport of motorcycle racing began drawing large crowds bent on celebrating a piston-powered future." Motorcycle manufactures held the events on horse-racing ovals and bicycle velodromes before wooden board tracks called motordromes existed.[41] Jake DeRosier, the first motorcyclist to race on Goodyear motorcycle tires, broke all professional records in 1911 at the Los Angeles Motordrome and would go on to win the world's championship in Brooklands, England. Two months later, Don Johns broke all amateur records on Goodyear tires, and in October 1912, the company equipped the first motorcycles to finish in the Brighton Beach 24-hour endurance race. By 1913, Goodyear could claim that all professional and amateur world records for motorcycles had been set by bikes equipped with their tires.[42]

The period following World War I became known as "the Dark Ages for motorcycling," and motorcycle racing "died a slow death."[43] In the early 1920s, American motorcycling entered what author Phil Schilling called "its deep winter of despair" because, in only two short years, the number of motorcycles manufactured decreased by over half, and the number of motorcycle manufacturing companies declined from 20 to 13 in the same period as automobile sales proliferated. The stock market crash of 1929 caused many more motorcycle manufacturers to close their doors. It became an expensive form of entertainment, with motorcyclists becoming a minority group of motorists. By the end of the 1920s, the sport lost its appeal either due to the novelty wearing off or to the appalling injuries and deaths caused by the "murderdromes."[44] However, Goodyear continued to hire a number of experimental motorcycle riders to test their tires in endurance and hill-climbing contests. When riding for sport and entertainment waned, Goodyear rebranded Blue Streaks "the speedometers of business" and sold them to retail merchants for commercial cycles and sidecar delivery vehicles. They also sold a new product called the All-Weather tread balloon motorcycle tire to civilian riders for street use. The company later introduced DeLuxe All-Weather motorcycle tires, the Grasshopper, and the Eagle Rib, which saw extensive use in the 1940s, particularly speeding soldiers across the battlefields during World War II.[45]

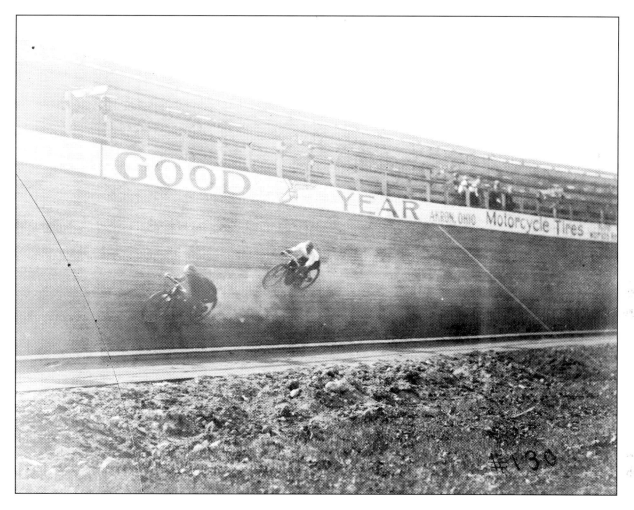

Racers at Columbus, 1912

Motorcycles featuring Goodyear tires compete in one of the earliest motorcycle races on a board plank track, also known as a motordrome. The company began manufacturing motorcycle tires in 1909 and the following year introduced the first Goodyear motorcycle tire to the public. At this race, known as the Federation of American Motorcyclists (FAM) meet in Columbus, Ohio, 22 of 23 racers rode on Goodyears.[46]

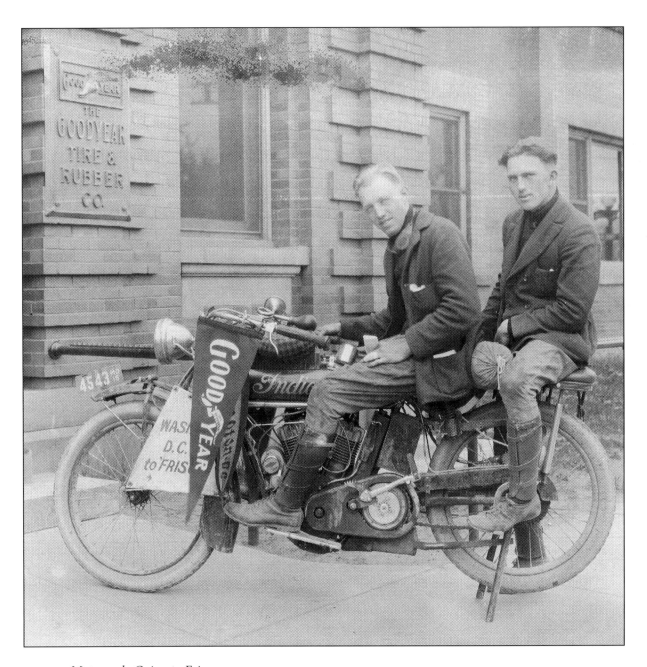

Motorcycle Going to Frisco, ca. 1915

Two motorcycle riders pose on their Indian motorcycle featuring Goodyear tires before embarking on a cross-country journey from Washington, DC, to San Francisco. In the nineteen teens and early '20s, as motorcycle racing and manufacturing declined, daredevils raced across the continent to break the trans-American record and promote riding, and Goodyear capitalized on these opportunities to promote their motorcycle tires.

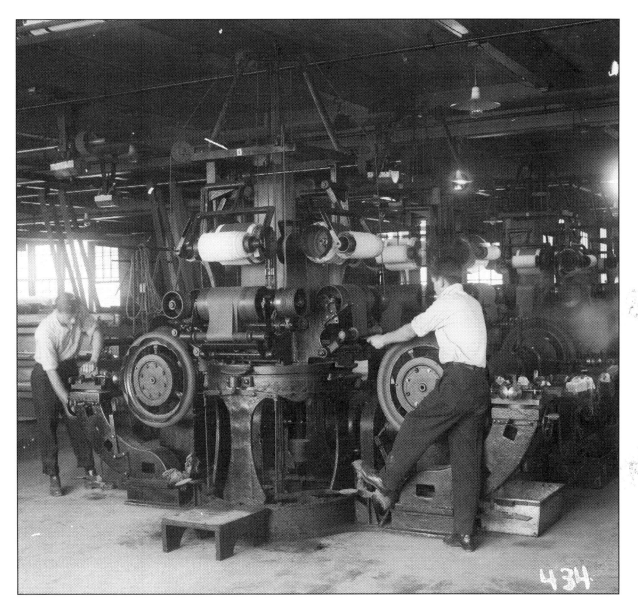

Motorcycle Tire Building Machine, 1914
Tire builders at the Akron Plant construct Blue Streak motorcycle tires on tire-building machines. These machines eliminated human error and produced the "perfect tire," unlike many of Goodyear's competitors, who built their tires by hand. By the time of this photograph, Goodyear produced over 1,000 motorcycle tires a day to keep up with demand.[47]

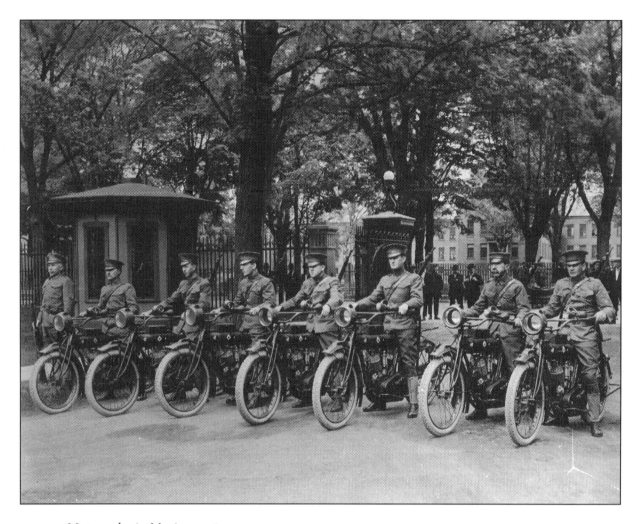

Motorcycles in Mexico, 1916
US Army soldiers in Mexico ride motorcycles shod with Goodyear motorcycle tires. Before Goodyear motorcycle tires saw action in World War I, the company tested their military readiness on the Mexican border during the fight against revolutionary Francisco "Pancho" Villa. Later, during the First World War, 85 percent or 35,000 Goodyear motorcycle tires contributed to the war effort on the Western Front.[48]

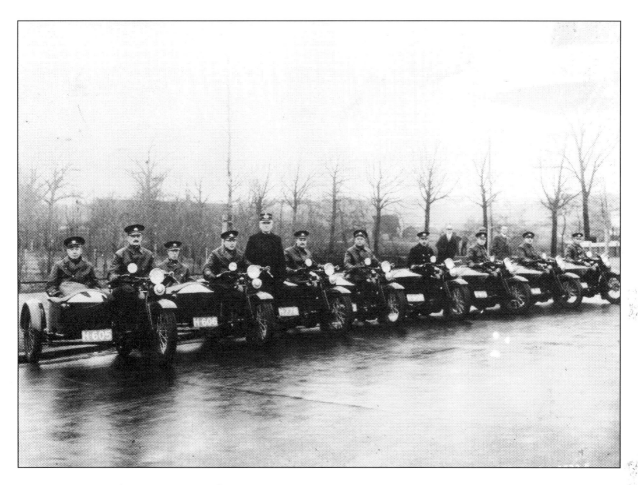

Hague Police Force on Goodyears, 1924
Goodyear motorcycle tires outfitted police bikes all over the world—from Akron, Ohio, to this security detail at The Hague in the Netherlands. A reporter once called the automobile "the greatest accessory to crime the world has ever invented" and claimed that "the best method yet invented for catching them is the motorcycle."[49]

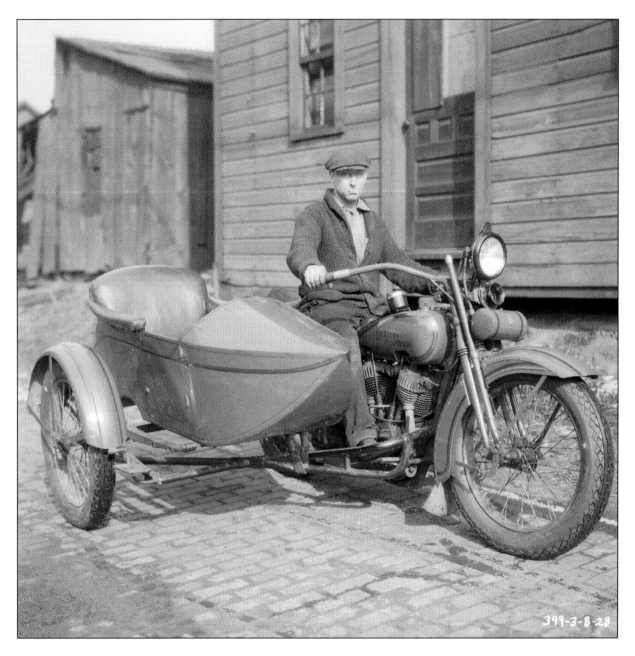

Harley-Davidson Motorcycle with Sidecar, 1928
By the end of the 1920s, when motorcycle racing and motorcycle production declined, Goodyear marketed their motorcycle tires to civilian riders for street use. They also sold them to retail merchants for commercial cycles and sidecar delivery vehicles, such as this Harley-Davidson Model J with a sidecar.

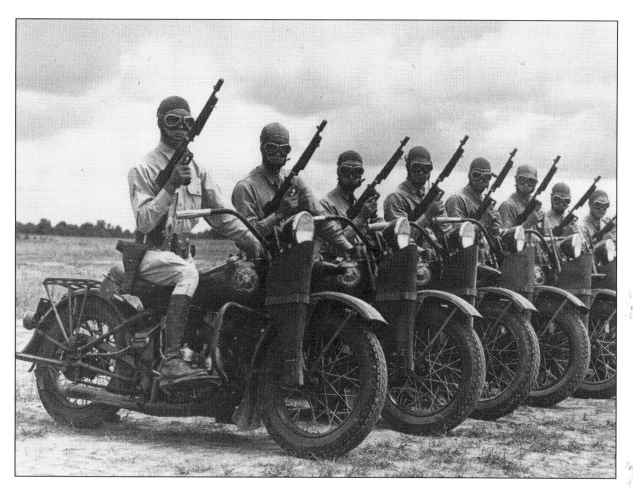

Motorcycle Tires in World War II, ca. 1943

In addition to outfitting military cycles used during the Mexican Border War and during
the First World War, Goodyear motorcycle tires sped the military across the battlefields of
Europe during World War II. In this photograph, US Army soldiers ride Harley-Davidson
WLA scouting bikes outfitted with Goodyear All-Weather tread balloon motorcycle tires.

Totally Tubular

Inner Tubes for Every Kind of Vehicle that Rolls or Flies

Goodyear once noted that "it takes a casing and a tube to make a tire."[50] They started making rubber inner tubes shortly after Paul Litchfield came to the company in 1900 to manufacture automobile tires. At this time they were making a single-tube tire, which included the tube, fabric, and tread, vulcanized as one piece. However, these tubes "had proved to be a failure in automobile work" according to Litchfield because they punctured easily and frequently.[51] By the end of the Roaring Twenties, after years of testing and development, the company produced puncture sealing tubes, which were claimed to automatically seal once an object was pulled from the tube. At this time, they were also making tubes for clincher, cord, and straight-side tires in various sizes, in both regular and Heavy Duty Tourist, made thicker with extra rubber layers. By the early 1930s, Goodyear produced tubes for balloon tires in different sizes and types—including Zeppelin, heavy duty, Standard, Pathfinder, and Speedway—for cars, trucks, and buses. They advertised them in the *Saturday Evening Post* and other publications as "good insurance for your new tires" and "a Goodyear Tube for every tire on every kind of vehicle that rolls or flies."[52] Then, in 1934, the company produced the famous LifeGuard tube consisting of two tubes or air chambers, one inside the other, which prevented blowouts and accidents to improve safety. By the following year, over 1.5 million LifeGuard tubes had been sold.[53]

Throughout World War II, production of LifeGuard and puncture sealing tubes was severely curtailed except for high-priority military purposes. During the conflict, the company also designed and manufactured run-flat tires that ran for approximately 60 miles without injury after they had been deflated, as well as bullet-sealing inner tubes, which, as their name indicates, prevented the escape of air from pneumatic tires when punctured by gunfire or other objects. The military used them on motorcycles, scout cars, and other vehicles of the Allied mechanized army. Goodyear also manufactured airplane tubes from an early date and, by World War II, were even making dual seal airplane tubes as original equipment on thousands of civilian and commercial planes. The US Navy and Army Air Corps used many of these tubes on their fighters and bombers. By the start of World War II, the company also produced heavy-gauge, resilient motorcycle tubes to protect against rim chafing, bead chafing, pinching, and corrosion for rugged all-around motorcycle service. At this time, the company was marketing their tubes for ambulances, fire trucks, police cars, taxis, service cars and trucks, house trailers, and off-road vehicles. After the conflict, the company improved their puncture sealing tubes by building upon their experience in manufacturing bullet seal tubes during the war.[54] In the early 1950s, Goodyear also improved their LifeGuard tubes and marketed their synthetic rubber tubes with the slogan, "Synthetic rubber tubes are tops!"[55]

Taking Tube off Mandrel, 1920

Goodyear tube builders remove an inner tube from the mandrel in the Tube Room at the Akron Plant. By the mid-1920s, Goodyear manufactured a number of tubes to accompany their long and growing line of tires. Goodyear produced tubes of pure vulcanized rubber by hand by rolling tube stock into thin sheets on a calendering machine and then building them, layer upon layer, to the desired thickness. Tube builders then cut the stock to the proper length and rolled it around a mandrel before placing in a heater for curing. Unlike other companies, Goodyear vulcanized the valve patch into the tube instead of cementing it on so that it became an integral part of the tube, making it leakproof, waterproof, oilproof, and heat resistant.[56]

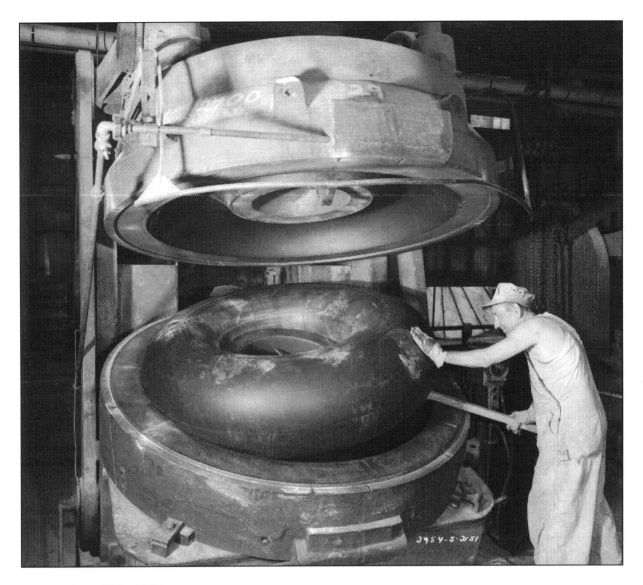

Large Tube Mold, 1951
A Goodyear employee pries a large tube from its mold at the Akron Plant. During World
War II, the company produced bullet-sealing inner tubes for the Allied mechanized army.
Shortly after the war, Goodyear manufactured giant tubes like these for large airplanes and
off-road equipment by feeding compounded and milled tube stock into a tubing machine
known as a "duplex." After being soapstoned, the tube stock was cut by knife to desired
lengths, then continued on a conveyor to a splicing machine where the tubes were spliced
and prepared for inflation and curing. After curing, the tube was removed from the mold
and placed on the conveyor to pass through the final steps of finishing, inspecting, and test-
ing.[57] Photo by Don Klotz.

Steel Wheels

Rims for Every Tire

As The Goodyear Tire & Rubber Company once noted, "There is more to being a good tire dealer than meets the eye. Today, a tire dealer cannot limit his business to selling tires. Every major tire dealer who sets his sights on doing a top-flight job, finds it essential to offer expert rim and wheel service."[58] Goodyear manufactured rims shortly after they started making automobile tires. Some of their first rims included detachable, detachable demountable, and Ideal rim. The latter was a simple four-piece rim with an endless base that did not have splits and prevented dirt and water from causing damage to the tube and tire. These rims also did not require special fastenings and tools like those of other manufacturers, which meant that the tire could be changed without taking the rim off the vehicle. Other major advancements came during World War I, when the company set out to prove that heavy trucks could run on pneumatic tires. At the time, large rims were unavailable, so Goodyear entered the rim business to produce its own truck rims. Soon, the rim industry adopted the new large style of rim. By 1918, the company made detachable rims in wood and cast steel in different sizes for solid and pneumatic tires that fit most makes of motor cars and trucks on the market.[59]

In 1925, Goodyear set up a small department to manufacture rims, and the following year built its Rim Plant in Akron, which expanded further after World War II. Later, during the 1930s, Goodyear made wheels for low-pressure balloon tires. By the end of the decade, Goodyear had a complete line of rims including Types K, L, M, and R for pneumatic tires on trucks, trailers, buses, tractors, farm implements, and contractors' equipment. Then, in 1939, the company launched its earthmover rims to the world, which outfitted many off-road and construction vehicles such as dump trucks, road graders, and front-end loaders. By this time, the tire manufacturer was also one of the country's leading producers of steel rims. During World War II, the company made rims for military vehicles and spacer bands for run-flat tires, which kept them from pulling off the rim when deflated by bullets. In fact, the Goodyear bead spacer band, which later became an industry standard, was used as an early form of bead lock, a set of steel rings placed between the beads that held the bead in place after the tire was hit. After the war, the principal design features of all Goodyear rims included the complete interlocking of the gutter and side flanges, and all their rims at this time met Tire and Rim Association standards in order to carry the Association stamp.[60]

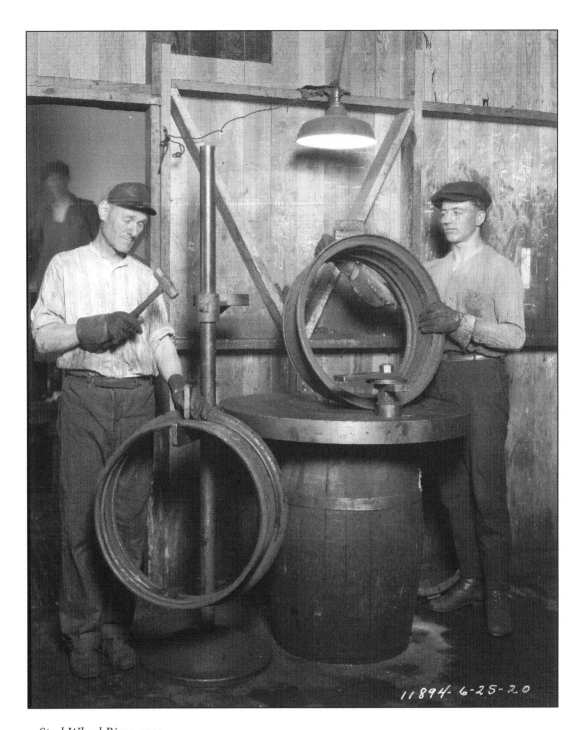

Steel Wheel Rims, 1920
Builders finish metal rims by hand at the Akron Plant. Goodyear experimented with rim development as early as 1900, when employee Nip Scott improved the straight-side tire. The company soon developed their own rims, and before long, Goodyear became one of the largest manufacturers of heavy truck rims in the world.[61]

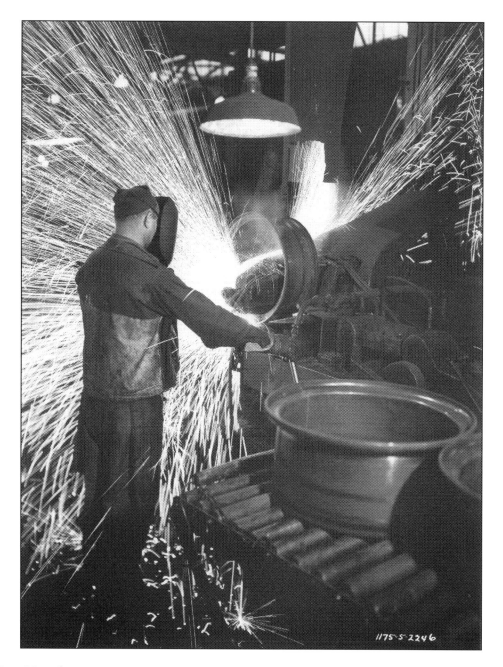

Rim Manufacturing, ca. 1946

Sparks fly as an employee grinds a rim in Akron's Rim Plant. By the time of this photograph, the company made rims by pickling the steel and feeding it into circling machines before coin stamping and shearing. Then, the rims were bumped to close the ends before welding them into a complete circle. Chippers were used to remove excess welds, and the rim was ground smooth, followed by punching in valve slots and driving lug holes, which were then galvanized or painted. By the Second World War Goodyear made split, endless, detachable, and demountable base rims weighing as much as 650 pounds each.[62]

Notes

1. Hugh Allen, *The House of Goodyear*, Cleveland, OH: Corday & Gross, 1949, 202.
2. Paul W. Litchfield, *Industrial Voyage: My Life as an Industrial Lieutenant*. Garden City, NY: Doubleday, 1954, 115.
3. Litchfield, 255; and Harold S. Roberts, *The Rubber Workers: Labor Organization and Collective Bargaining in the Rubber Industry* (New York: Harper & Brothers, 1944), 15.
4. For information on Goodyear's carriage tires see *Carriage Tire Section*, 1911, pamphlet, Goodyear Records (hereafter GR); *Goodyear Carriage Tires*, 1915, pamphlet, GR; and Goodyear, *Goodyear Carriage Tires*, Catalog No. C-45 (Akron, OH: Goodyear, 1912).
5. For information on the history of carriages see Jack D. Rittenhouse, *American Horse-Drawn Vehicles* (New York: Bonanza Books, 1948), 1.
6. Litchfield, *Industrial Voyage*, 84.
7. See Goodyear, *Goodyear Carriage Tires*, Catalog No. C-45 (Akron, OH: Goodyear, n.d.); and "Retiree Brunswick Remembers the Goodyear of 62 Years Ago," *Wingfoot Clan (Akron Edition)* (hereafter WC; all references to the *Wingfoot Clan* are the Akron edition unless otherwise noted), September 23, 1965.
8. "How Are Holes Placed in Carriage Tires," *WC*, July 14, 1926.
9. "A Good Name Is Rather to Be Chosen Than Great Riches," *WC*, March 14, 1928.
10. For information on the history of the bicycle see Tom Ambrose, *The History of Cycling in Fifty Bikes* (New York: Quid Publishing, 2013); David V. Herlihy, *Bicycle: The History* (New Haven, CT: Yale University Press, 2004); and Joe Lindsey, *"History" in The Noblest Invention: An Illustrated History of the Bicycle* (New York: Rodale, 2003), 122–142.
11. Paul W. Litchfield, *History Lessons from the Motor Truck* (Akron, OH: Goodyear, n.d.), 10.
12. Goodyear, *Catalog No. 156: Goodyear-Akron Bicycle Tires* (Akron, OH: Goodyear, 1905). See also Catalog 155.
13. See "Goodyear Began Producing 60 Years Ago This Week," *WC*, November 19, 1958; and Maurice O'Reilly, *The Goodyear Story* (Elmsford, NY: Benjamin Company, 1983), 14, 16.
14. Litchfield, *Industrial Voyage*, 84–85.
15. "The Real Miss Americas," *WC*, February 2, 1944.
16. For information on Goodyear's bicycle tires see the following articles in *WC*: "Second Class Bicycle Tires," March 30, 1932; "Bicycle Tires," May 10, 1933; and "Bicycle Tires," May 23, 1935. See also "Kids Are 'Big Wheels' in Bike Tire Testing Program," *Goodyear Triangle*, December 5, 1961; Goodyear, "Goodyear Bicycle Tires," n.d., news release, GR; "Bicycle and Toy Tires," 1936, MS, GR; and "Blue Streaks," sales brochure, n.d., GR.
17. See Goodyear, "Goodyear Bicycle Tires," n.d., news release, GR; and "Second Class Bicycle Tires," WC, March 30, 1932.
18. "1,000,000. It's Up to You," 1916, brochure, GR; and "A Ring of Truth," 1916, brochure, GR.
19. For information on early Goodyear passenger car tires see the following sales brochures in GR: "Every 3rd New Car a Goodyear Car," n.d.; "Goodyear Detachable Tread Automobile Tire," n.d.; "Cord Tires," 1915, "Goodyear Tires," 1916; "Goodyear Fortified Tires," 1915; "Goodyear Cord Tires for Gasoline Cars," 1915. See also "Goodyear Pneumatic Automobile Tires Consumers Net Cash Price List," 1913; "Goodyear Cyclecar and Light Car Tires Dealers Price List," 1914; Allen, 204; and Litchfield, *Industrial Voyage*, 102.
20. Daniel Nelson, *American Rubber Workers & Organized Labor* (Princeton, NJ: Princeton University Press, 1988), 44–45.
21. "1915 Campaign, Automobile Tire Department," 1915, MS, GR.
22. See "Goodyear Intention and Goodyear Ability," n.d., sales brochure, GR; and "Seventy-One Cities Show Goodyear Leads All Others," n.d., sales brochure, GR.
23. See "The 4 in. Goodyear Heavy Duty Cord," 1924, sales brochure, GR.
24. "Newspaper Advertisements That Will Sell Tires—Now," 1923, MS, GR.
25. "Facts on the World's Greatest Tire," sales brochure, 1927, GR.
26. For information on Goodyear balloon tires see the following resources in GR: "Facts about Balloon Tires," 1924, sales brochure; "Goodyear Balloon Tires," n.d., advertisement; "Don't Listen to Rumors," 1924, sales brochure; and "The New All-Weather Balloon," advertisement, 1927. See also "Here Is the Millionth New Design Balloon Tire," *WC*, March 30, 1927; and Allen, 206–207.
27. "The Goodyear Double Eagle," 1928, sales brochure, GR.
28. See "LifeGuards Take Country by Storm," *WC*, April 13, 1938; and "Know Your Products," *WC*, March 22, 1950.
29. See the following MSS from GR: "Minutes Well Spent in the Selection of a Tire," 1933, sales brochure; "Goodyear Tires," October 17, 1941, news release; and "The Elliptic Tire," 1977, sales brochure. See also the following *WC* articles: "Two New Lines of Passenger Car Tires Just Introduced This Week by Goodyear," April 7, 1948; "Sets Production Record with New Double Eagle," October 7, 1948; and "New War Tire Ready for Quantity Production," September 30, 1942.
30. See Goodyear advertisement in *Akron City Directory*, 1913, 27. For information on the Motz Tire & Rubber Company, particularly its founding, see *Akron City Directory*, 1908, 25.
31. "This Armored Motor Car Is Now Touring Across the Continent," *New York Times* (hereafter *NYT*), July 18, 1915.
32. See "Goodyear Tires," March 25, 1916, advertisement in *The Saturday Evening Post*; and "Goodyear Fortified Tires," 1915, advertisement, GR.
33. Goodyear, "Goodyear Historical Background: Indianapolis 500," n.d., news release, GR.
34. For information on the Dymaxion car see John Rennie, "13 Vehicles That Went Nowhere," *Scientific American*

277, no. 4 (October 1997): 64–67; Allera Fuller Snyder and Victoria Vesna, "Education Automation on Spaceship Earth: Buckminster Fuller's Vision," *Leonardo* 31, no. 4 (1998): 289–292; and Donald J. Bush, "Streamlining and American Industrial Design," *Leonardo* 7, no. 4 (Autumn 1974): 309–317.

35. See Jack Miller, "Terraplane Performance," *The Hudson Triangle* 17, no. 4 (Fall 2015): 6; and "Cannonball Baker Is Helped by Goodyears," *Los Angeles Times* (hereafter *LAT*), March 9, 1924.

36. See endnote 28.

37. Snowden B. Refield, "The Making of Automobile Tires," *American Machinist* 32 (July 29, 1909): 191–197.

38. "1,500,000th Synthetic Rubber Passenger Tire," *WC*, June 7, 1944.

39. For information on the early history of the motorcycle see Michael Partridge, *Motorcycle Pioneers: The Men, the Machines, the Events* (New York: Arco Publishing, 1977); and Bob Holliday, *Motorcycle Panorama: A Pictorial Review of Design and Development* (New York: Arco Publishing, 1975).

40. "Black Tread Blue Streak Motorcycle Tires," n.d., sales brochure, GR.

41. David Schonauer, "Spokes and Splinters," *Smithsonian* 42, no. 1 (April 2011): 12–14.

42. See "Motorcycle Tires," n.d., sales brochure, GR; and "Every Corner on Two Wheels: Goodyear Motorcycle Racing Tires," *Go: The Goodyear Tire Dealer Magazine* (April 1969): 2.

43. Schonauer, "Spokes," 12–13.

44. Phil Schilling, *The Motorcycle World* (New York: Random House, 1974), 102–103.

45. See the following MSS in GR: "Blue Streaks, The Business of Pleasure," 1918, sales booklet; "Goodyear Balloon Motorcycle Tires," n.d., sales brochure; and "Goodyear Motorcycle Tires: For Safety and Comfort," n.d., advertisement.

46. See "Motorcycle Tires Once Important Part of Our Business," *WC*, October 1, 1930; and "Black Tread Blue Streak Motorcycle Tires," n.d., sales brochure, GR.

47. "Goodyear Motorcycle Tires," 1912, sales brochure, GR.

48. "Goodyear Blue Streak Motorcycle Tires, Confidential Dealers' Prices," 1918, sales brochure, GR.

49. Schilling, *Motorcycle World*, 55.

50. "Goodyear Laminated Tubes," ca. 1915, sales brochure, GR.

51. Litchfield, *Industrial Voyage*, 93–95.

52. "Save Money on Tires," n.d., sales brochure, GR.

53. For information on Goodyear tubes see the following MSS in GR: "Goodyear Automobile Casings, Tubes and Tire Savers," 1922, sales brochure; "Goodyear Puncture Seal Tube," 1929, sales brochure; and "Mr. Litchfield's Speech: LifeGuard Conference," ca. 1937.

54. See the following MSS in GR: *Goodyear Airplane Manual*, n.d.; C. F. Libby to Bruce Chapman, July 27, 1950; "Data on Butyl Puncture Seal LifeGuard," 1951, report; and P. W. Litchfield to H. Grady Zellner, February 1, 1940. See also "P. W. Litchfield Talk to Organization" (speech, Goodyear Hall, Akron, OH), November 25, 1940, Frank B. Baldwin Papers (hereafter Baldwin Papers), UA Archives.

55. "Goodyear Synthetic Rubber Tubes Are Tops!," n.d., sales brochure, GR.

56. See Goodyear, "How Tubes Are Made," in *The Story of Goodyear* (Akron, OH: Goodyear, 1925), 16; "Goodyear Tubes," ca. 1916, sales brochure, GR; and "The Importance of Good Tubes," ca. 1919, sales brochure, GR.

57. "P. W. Litchfield Talk to Organization."

58. Goodyear, *Goodyear Rim Manual* (Akron, OH: Goodyear, 1945).

59. See "Goodyear Rims," 1918, sales brochure, GR; and "Goodyear First Company to Make 65 Million Rims," *WC*, January 7, 1965.

60. See the following sales catalogs in GR: "The New Goodyear Type 'K,'" ca. 1926; "Goodyear Rims for Tractors and Implements," 1933; "Goodyear Rims for Pneumatic Tires," 1936; and "Wheels for the New Low Pressure Balloon Tires," ca. 1938. See also "The Search for the Perfect Circle," n.d., publication, GR; "More Floor Space Is Added at Rim Plant," *WC*, September 26, 1951; and Allen, *House of Goodyear*, 424.

61. See Litchfield, *Industrial Voyage*, 93–95; and "Goodyear Played Vital Role in World War I Hostilities," *WC*, October 11, 1962.

62. See *Goodyear Tire Handbook*, 32; "Goodyear: Truck Rim Cuts Wear," *Akron Beacon Journal* (hereafter *ABJ*), May 4, 1961; "Goodyear Rims," 1916, sales booklet, GR. See also the series "Know Your Products" in *WC*, March 29, 1950 and April 5, 12, and 19, 1950.

Chapter 2
Off the Beaten Path
Truck, Tractor, Train, and Plane Tires

"Goodyear's major task has been not only to keep up with the changes in passenger car tire requirements, but also to furnish specialized tires for numerous other services."[1]
—*The Goodyear Tire & Rubber Company*

As the trucking industry grew in the early 1900s and matured during the First World War, Goodyear manufactured tires intended to travel off the beaten path. The company's work in this area began with truck and bus tires, which then led to experimentation and development of tires for tractors and for farm implements. These tires were built upon Goodyear's experience in wheels for airplanes, which they developed early in the century, paralleling the development of the truck tire. These tires could travel the uneven terrain of early undeveloped airfields, allowing pilots to bring their passengers to a safe landing. With airplanes, tractors, and farm implements on rubber, the company began developing off-road or earthmover tires. This innovation contributed to building some of the most significant engineering projects in this country and allowed people to explore the far reaches of the planet. As the company noted after World War II, Goodyear tires "greatly aided in the development of many of the nation's indispensable highways, dams and other ventures too numerous to mention."[2]

In addition to the thousands of images in the Goodyear Collection that document the company's contributions to the automotive tire industry, the collection also visually chronicles numerous tires the company designed and developed for trucks, buses, tractors, trains, and planes. Hundreds of photographs show solid and pneumatic tires on vintage motor trucks manufactured by companies such as Mack, Nash, Packard, and International, hauling every type of product imaginable—from beer to furniture to ice cream. Other photographs show vintage tractors and farm equipment by manufacturers such as John Deere, Case, Farmall, and McCormick-Deering engaged in agricultural and commercial ventures. Many images show historic airplanes during the infancy of heavier-than-air flight, including World War I-era biplanes and bombers used in the Second World War. Some of the most interesting photos, however, capture off-road tires used on colossal construction equipment that built

major engineering projects in this country, and strange vehicles seldom seen or heard of, including the Swamp Buggy, Snow Cruiser, and Budd-Michelin railcar.

Keep On Truckin'

Truck Tires for On- and Off-the-Road Hauling

Shortly after the beginning of the twentieth century, motor trucks replaced the horse and wagon for hauling commercial goods. By 1910, there were 6,000 trucks on American highways and one million within a decade. Before long, Goodyear began manufacturing truck tires to meet the demand.[3] Recognizing that they could not build one tire to meet the countless uses of motor trucks and the wide variation in road conditions, they developed specialized tires so that motor truck owners could choose from three main areas—solid, cushion, and pneumatic tires. Goodyear developed their tires through a long period of experimentation in the laboratory followed by practical tests on the road. The firm never put their tires on the market until they proved practicable and economical under actual trial. Goodyear continued to keep pace with the growing size, weight, capacity, and power of trucks by developing improved tires for service on and off the highway.[4]

Mack Truck, ca. 1910
In the early twentieth century, commercial motor trucks across the country equipped with Goodyear solid truck tires moved almost every type of product conceivable, from ice cream to beer, as seen in this photograph of an early Mack truck in New York City used by the Pabst Brewing Company. Goodyear's early solid truck tires included the S-V Press-On, S-J Hand Attachable, solid side flange, solid No-Rim-Cut, and solid clincher. The individual block truck tire was an innovation with independent tread blocks that the driver could quickly change in the field if damaged, an exclusive feature that saved time and money.[5]

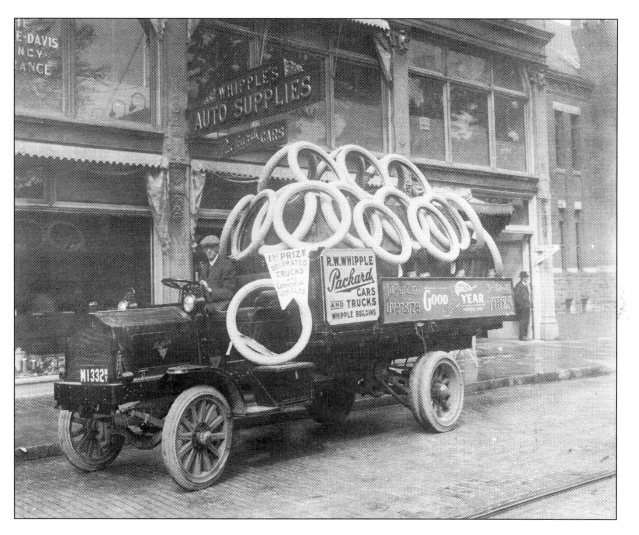

R. W. Whipple and Packard Truck, 1912

Goodyear transported and promoted their early tires on their own delivery trucks and on this Packard operated by R. W. Whipple Company of New York. When neither pneumatic nor solid tires proved the most economical or yielded the most productive results, the firm recommended cushion tires, including the Motz commercial cushion and hollow-center cushion with a Goodyear-patented egg-shape slot design that flexed under load to absorb shock and protect the truck and its cargo. Known as "the intermediate truck tire," the company marketed it for light- and medium-weight urban delivery trucks to haul fragile loads at high speeds on city streets. Hundreds of businesses across the country chose them for their fleets of delivery trucks.[6]

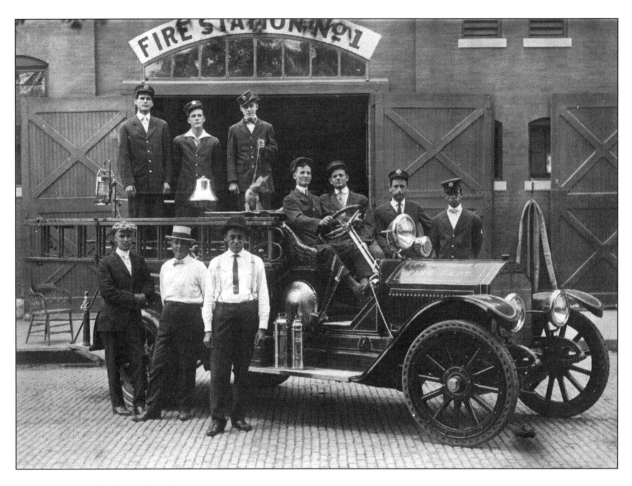

Pine Bluff Fire Truck, 1916
In the early twentieth century, Goodyear fire truck tires reportedly equipped over 60 percent of the nation's new motor driven fire engines, including this vehicle displayed in front of the station in Pine Bluff, Arkansas. Goodyear tires outfitted fire trucks in over 700 towns and cities across the country such as Boston; Kansas City; Oklahoma City; Newport, Kentucky; and Lima, Ohio.[7]

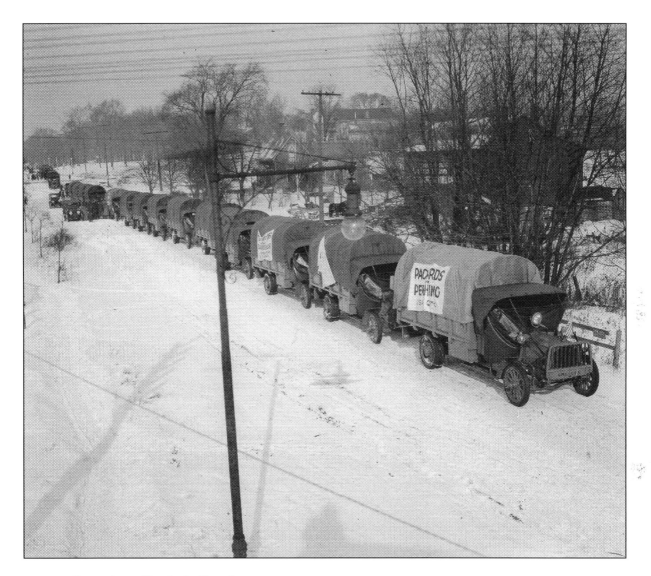

Government Trucks in Transit, 1917

Packard motor trucks featuring Goodyear truck tires traverse the snowy roads during World War I in a campaign known as "Packards for Pershing." US General John J. "Black Jack" Pershing championed the use of trucks for military purposes, and Goodyear outfitted many of those used by his American Expeditionary Forces in France. Later, during World War II, Goodyear met the great demand for tires by the government again and shod military trucks in record numbers. By 1945, the company produced five million truck tires annually for the war.[8]

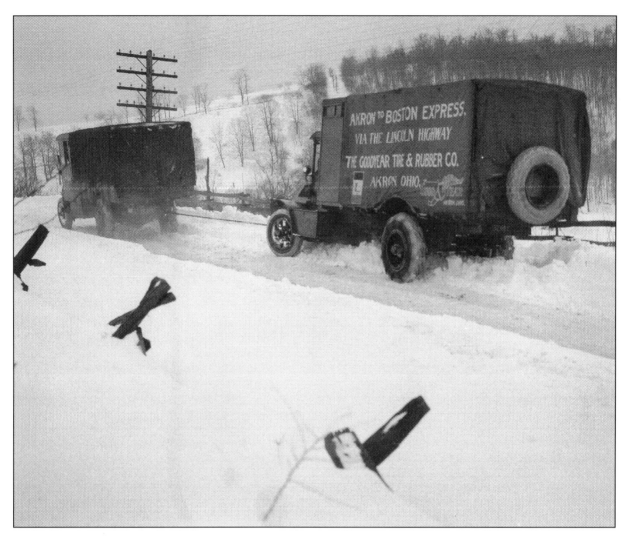

Akron-to-Boston Express Trip, 1918
A truck pulls Goodyear's Akron-to-Boston Express freight truck out of the snow on its peril-
ous journey to deliver tires to "Beantown." Established in 1917 and known as The Wingfoot
Express, the operation had the two-fold purpose of developing a satisfactory pneumatic
truck tire and demonstrating its value in long-distance transportation. Even though these
tires allowed trucks to travel farther and faster and accomplish more work than solid truck
tires did, the industry did not immediately adopt pneumatics, and the company fought a
long battle to win their acceptance.[9]

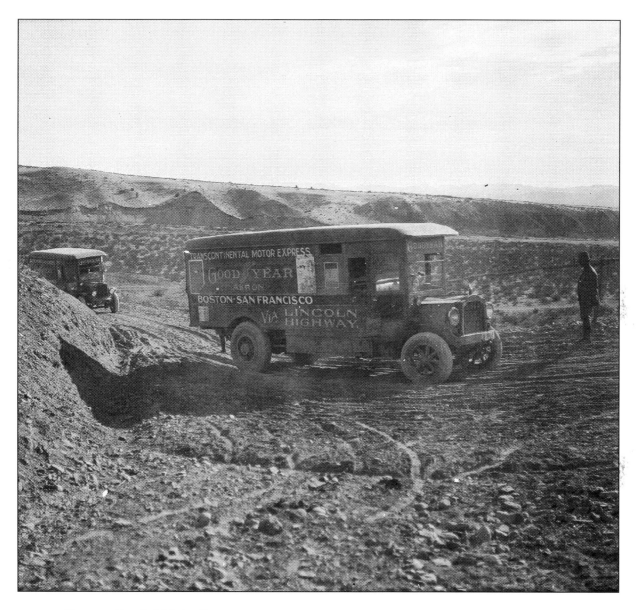

Transcontinental Motor Express, 1919
Goodyear's Transcontinental Motor Express, the first cross-county truck line, negotiates the desert roads on its way from Boston to San Francisco via the Lincoln Highway. The trucks demonstrated the full capabilities of Goodyear pneumatic cord truck tires in heavy hauling over all kinds of roads and conditions and set a speed record for coast-to-coast travel by commercial vehicles. However, pneumatic truck tires did not pass solids in sales until 1926, and solids faded quickly thereafter.[10]

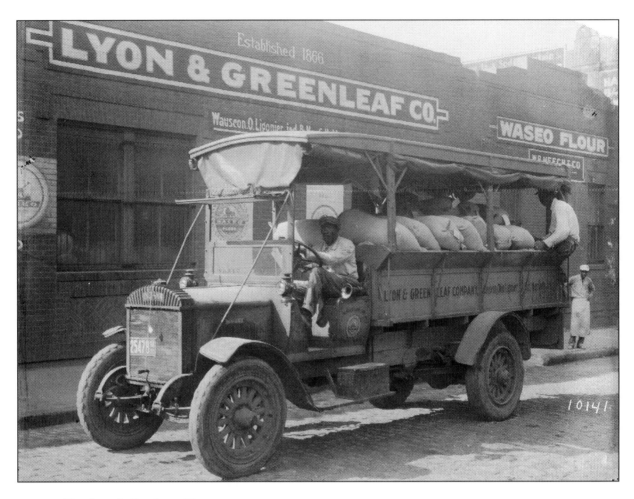

Truck with Goodyear Tires, 1919

African American employees at the Lyon & Greenleaf Company haul sacks of Waseo Flour
in Norfolk, Virginia, on an Indiana truck shod with Goodyear cord truck tires. By the time
of this photograph, Goodyear truck tires also equipped tandem trucks that traveled city
streets and rolled across the countryside on transcontinental journeys to demonstrate their
advantages to truckers. The massive six-wheel trucks solved the problem of heavier loads
being hauled on larger tires that raised the truck bed higher than most loading platforms.[11]

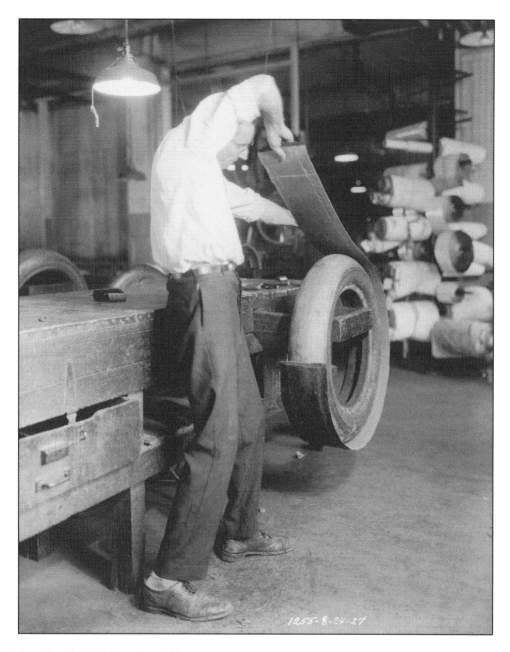

Plying "Ready Build" to Truck Tire, 1927

A Goodyear tire builder applies "ready build" to a truck tire in Goodyear's Akron Plant. By the mid-1920s, the Goodyear truck tire lineup consisted of nearly a dozen types of tires for different hauling, including the heavy duty cushion, grooved pneumatic truck tire, high profile solid, demountable cushion, and industrial solid. In 1923, Goodyear introduced the Wingfoot cord truck tire with cross-rib tread to supplement the All-Weather tread. Two years later, they launched the balloon tire for trucks and buses, which made faster, heavier hauls possible. By the end of the decade, Goodyear sold more pneumatics than solids.[12]

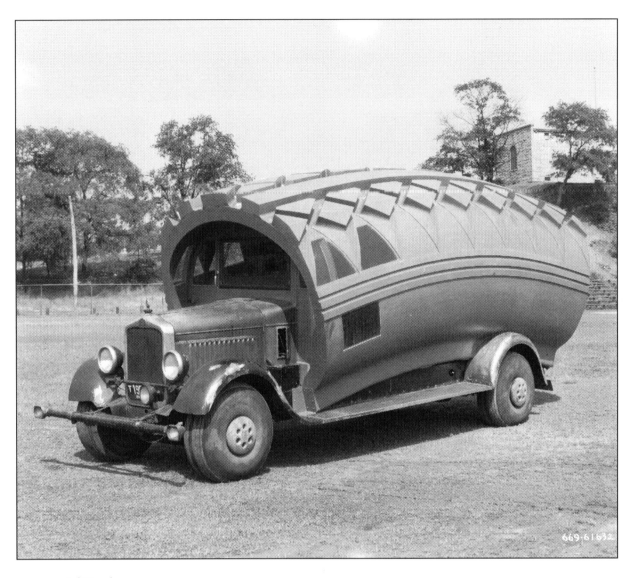

Ad Truck, 1932
Goodyear built this odd-looking truck to carry repairmen and tools to service their outdoor advertising signs across the country. The wooden tire section advertised Goodyear's All-Weather tread design with abrasion-resistant, diamond-shaped tread blocks that provided outstanding traction.[13] By the time of this photo, Goodyear had premiered three new specialized truck tires, which it called "the giants of heavy hauling": the dump truck pneumatic, the super cushion, and a new super heavy duty cushion.[14]

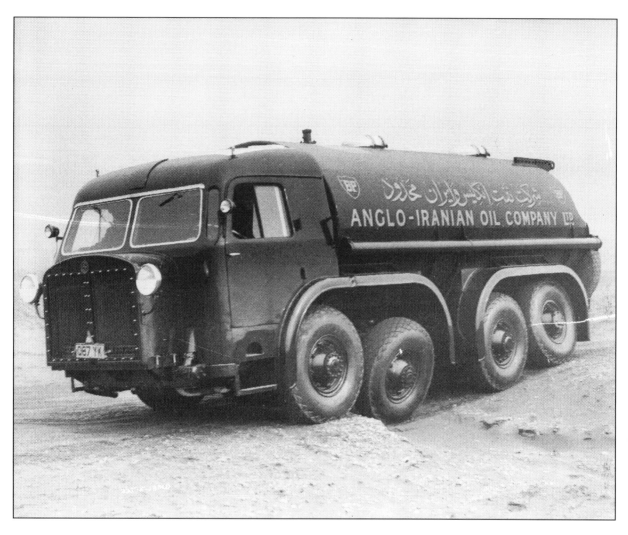

Oil Truck, 1932

By the 1930s, Goodyear truck tires were all over the world, including on this oil truck from the Anglo-Iranian Oil Company, predecessor of British Petroleum (BP). These special wheels compensated for the uneven terrain of the Iranian oil fields while the All-Weather tread propelled the truck through the loose desert sands. Shortly after this photo was taken, Goodyear introduced the rayon cord truck tire, made from a special rayon perfected by Goodyear engineers that could withstand the extreme conditions required by faster and longer hauling.[15]

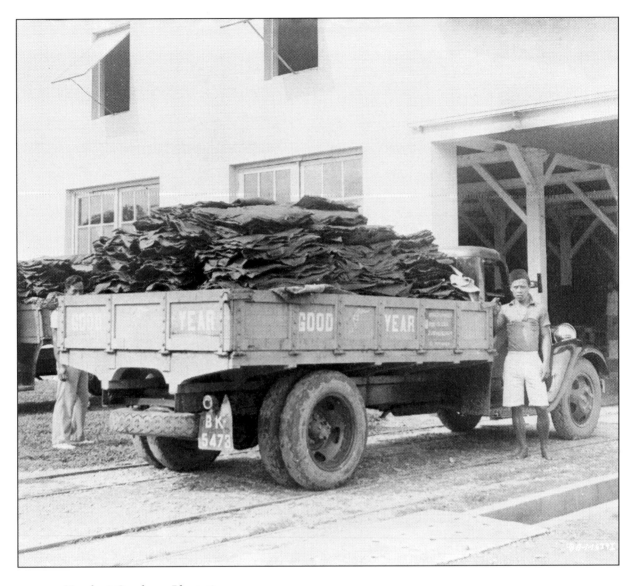

Truck at Goodyear Plantation, 1939
A plantation worker stands next to a Goodyear truck hauling sheets of crude rubber and shod with Goodyear balloon tires at one of Goodyear's plantations in the Far East. By the early 1940s, Goodyear truck tires included the Studded Sure Grip, 8-Ply heavy duty Airwheel, Marathon Airwheels, Stop Start, and Hi-Miler, many of which shod Allied military trucks during World War II.[16]

The Wheels on the Bus

Goodyear Tires for Public Transportation

Building on its success in the truck tire business, Goodyear entered the field of bus tires in the early twentieth century. In the 1910s in Akron, they tested their pneumatic truck tires on buses that traversed the city's steep grades. As with their truck tires, Goodyear offered three lines of bus tires: solid, cushion, and pneumatic. By the mid-1920s, busing was a growing industry with an estimated 53,000 buses in use as common carriers, school transportation, electric railway lines, sightseeing buses, hotel transports, and industrial and real estate development work.[17] As a result, Goodyear tires equipped buses in most major cities in the country by the start of the Great Depression. Around this time, the company also released the balloon bus tire, which provided better cushioning on rough roads, increased passenger comfort and reduced maintenance costs. Greyhound bus lines had balloon tires on their vast network of passenger coach operations that crisscrossed the country. A decade later, Goodyear sold a complete line of bus tires including the S-V Solid, All-Weather Wingfoot cord, smooth tread, and All-Weather cushion and solid. By the 1930s, Goodyear tires also shod buses that crossed the deserts of North Africa and the Middle East. Production of civilian buses almost ceased entirely during World War II as the Office of Defense Transportation controlled the industry, but after the war, bus production resumed, allowing Goodyear to reach its twentieth-century sales peak shortly thereafter.[18]

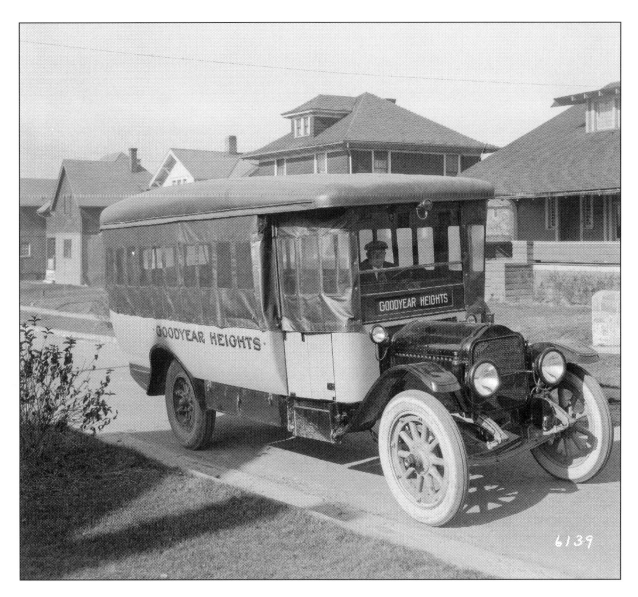

Goodyear Heights Bus, 1918
Goodyear tested their pneumatic truck tires on the Goodyear Heights bus line, which transported workers from company housing to the factory, proving that passengers could be carried on their pneumatic tires on the steep hills of Akron.[19]

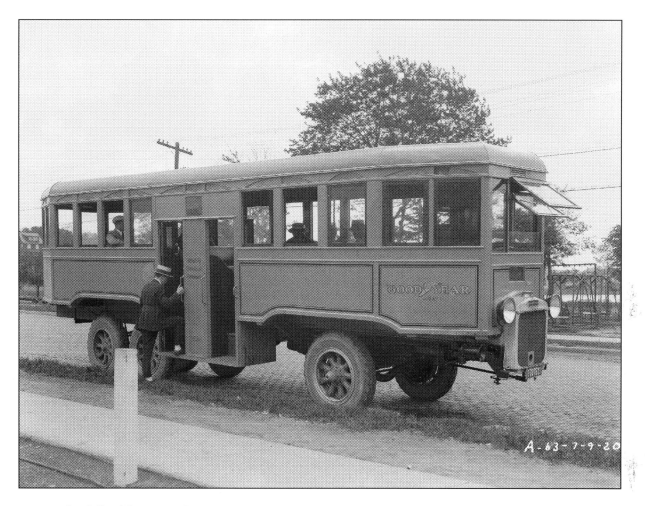

Six-Wheel Passenger Bus, 1920
Goodyear made its entrance into the bus market with the first-ever six-wheel, three-axle bus chassis, originally developed as a method for handling heavier loads in the trucking industry. Their design of an experimental eight-wheel, four-axle bus was later adopted by bus manufacturers and became an industry standard.[20]

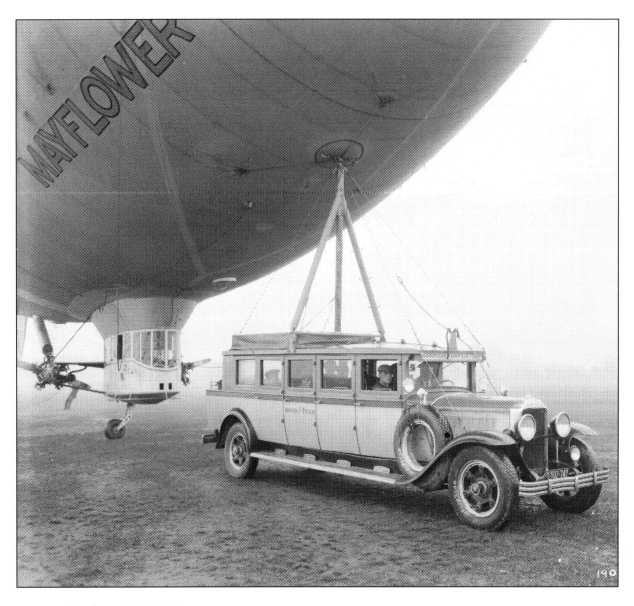

Mayflower Mast to Bus, 1930
A bus manufactured by the Flxible Company of Loudonville, Ohio, features Goodyear balloon bus tires. The bus served as a portable mooring mast and movable base to operate the company's famous blimps and demonstrated the versatility of Goodyear tires.[21]

Old Bus, 1939

By the 1930s, Goodyear balloon bus tires outfitted bus lines that crisscrossed the country, including Greyhounds. They also shod sightseeing buses that traversed the nation's natural wonders, such as this Fageol bus that winds its way past massive redwood trees in California en route from San Francisco to Santa Cruz. The Fageol Motors Company of Oakland, California was credited with inventing this style of wide, low transport for carrying heavy passenger loads on curvy roads, known as the Safety Coach. Two of the Fageol brothers left the Oakland plant in 1927 to form Fageol Twin Coach Company in Kent, Ohio, which continued to make light-weight Unibody buses with dual engines from 1927 to 1955.[22]

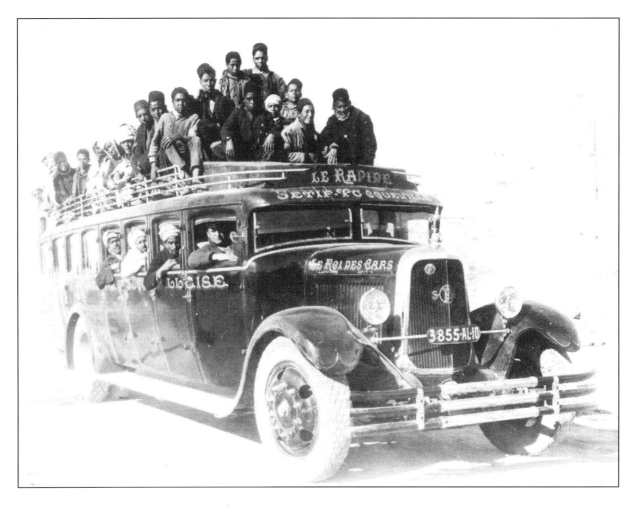

Goodyear Tires on a Bus in Algiers, 1932
This French Panhard and Levassor SS bus, dubbed "Le Rapide," which offered service from
Setif to Tocqueville, carried passengers across the harsh sands of North Africa on Goodyear's
diamond-treaded cord bus tires. Goodyear tires also reportedly outfitted the first bus line
across the Arabian Desert, which ran from Beirut to Baghdad and supplanted the camel.[23]

All Aboard!

Goodyear Train Tires for Rail and Road

In the early 1930s, Goodyear tested and developed rail tires for trains, following up on those introduced by Michelin in France early in the decade. The idea started when Paul Litchfield visited the old country and saw rubber-tired trains on European railroads. Litchfield's goal was to gain an edge over the competition—as the Europeans had done—by developing rubber-tired rail cars that could carry passengers and freight at a lower price than buses or motor trucks. The first train tire Goodyear developed included a solid rubber resilient wheel that included a ring of rubber placed between the steel tire and the steel hub. The second type of wheel included a pneumatic resilient wheel in which the company replaced the solid rubber ring with a pneumatic tire. This provided additional cushion and performed better under higher temperatures. To guard against blowouts, the company incorporated a simple, ingenious device into this tire—an aluminum safety ring that picked up the steel outer ring and, in a few revolutions, re-centered it with the axle—making the unit a conventional steel wheel. Goodyear also developed a third type of rail tire during this period, which outfitted the Twin Coach Company's rail-highway bus, a hybrid vehicle made in Kent, Ohio, that ran on either roads or rails because of a retractable wheel apparatus. However, usage of rubber-tired rail cars waned during World War II due to the shortage of rubber and the expense of producing them for a limited market.[24]

Bus with Rail Tires, 1932
Goodyear executives at an Akron train station examine pneumatic rail tires manufactured for the Budd-Michelin railcar, also known as the Reading 66, the first specially designed pneumatic-tired rail car in America. Goodyear also tested and sold a number of rail tires for other companies—including the Pittsburgh Railways Company and a similar outfit in Newark for street cars. The Pullman Company also used sets of these experimental tires for street cars on the Chicago Surface Line. Photo by Tru Williamson.[25]

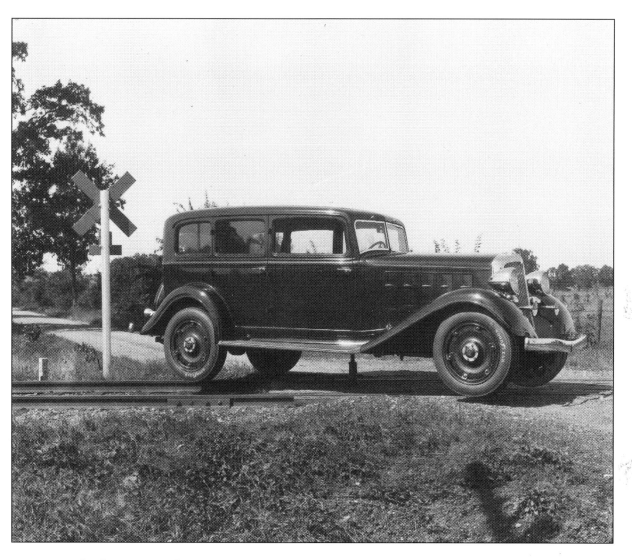

Fairbanks-Morse Railcar, 1933

Goodyear worked with Fairbanks, Morse and Company in the 1930s to provide pneumatic rail tires for a number of their creations, known as Railmobiles. These contraptions resembled standard rail cars, buses, and even automobiles that could run on or off the rails. Goodyear collaborated with the Chrysler Corporation and Fairbanks-Morse to develop this Model CT rail car, which could change directions by simply being jacked up and rotated, as demonstrated in this photograph.

Aim High

Goodyear Airplane Tires for War and Peace

Goodyear's work making airplane tires began in 1909, six years after the Wright brothers made their historic flight at Kitty Hawk. That year, Paul Litchfield developed a pneumatic tire for airplanes, resulting in the Wing airplane tire that replaced the skid or sled-runner type of landing gear and bicycle tires that had been featured on the earliest planes. Later that year, Goodyear also experimented with the No-Rim-Cut airplane tire, which combined cushion, resiliency, toughness, blowout resistance, and application ease. The year 1910 also stands as a milestone in the company's history with the introduction of the straight side cord tire for airplanes, the manufacture of rubberized airplane fabric, and the establishment of Goodyear's Aeronautical Department. Goodyear engineers built an airplane tire-testing machine to help develop a sturdier, more resilient cord-type construction that later became standard on most airplane tires. The budding aircraft industry quickly adopted Goodyear airplane tires, and notable aviators including the Wright brothers, Glenn Martin, and Glenn H. Curtiss utilized their tires and equipment.[26]

A further test of the rubber giant's airplane tires occurred during World War I, when Goodyear furnished a large portion of the wheels for the war effort. Later, in 1929, Goodyear purchased an airplane exclusively for tire testing, development, and experimental work, which soon became a "flying laboratory" fleet of test planes at the Akron Municipal Airport. They also analyzed them on their own aircraft, which transported company executives to the firm's many factories and rubber plantations around the globe, as well as in the National Air Races. With the advent of World War II and the creation of the Goodyear Aircraft Corporation, the company greatly expanded and produced airplane tires, rims, and brakes in mass quantities for military aircraft. Their improvements on tires and aircraft components permitted military planes to land and stop safely on shorter runways, a necessity during the war. In order to keep pace with the demands for airplane tires and tubes that could absorb the punishing impacts and grinding wear of landing heavier and faster aircraft, Goodyear used rayon and then nylon in airplane tires. Goodyear tires and other rubber components graced Allied bombers, fighters, and transport planes in the theaters of the war.[27]

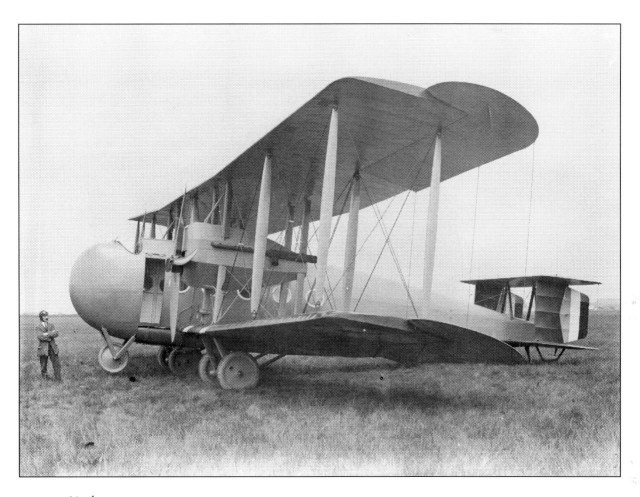

Airplane, 1920

An early airplane pilot stands in a field examining his Vickers Vimy biplane equipped with Goodyear clincher airplane tires. Goodyear tested these tires on planes such as this British heavy bomber during World War I and furnished a large portion of the wheels for the war effort.[28]

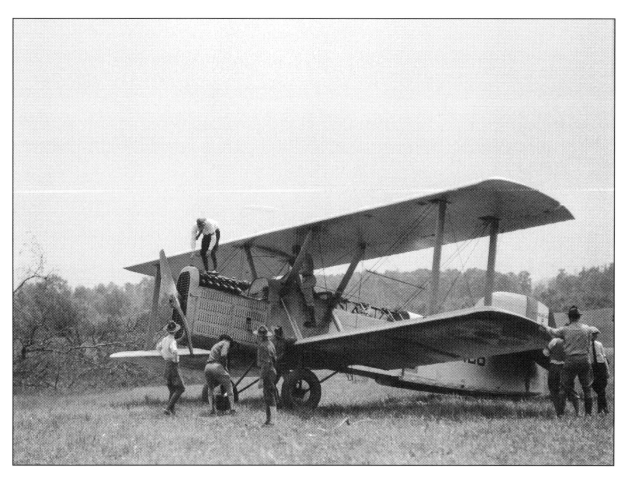

Douglas DT, 1925
Goodyear continued to make airplane tires after World War I, including those that outfitted this Douglas DT torpedo bomber for the US Navy. Pilots and ground crew ready the biplane for takeoff as the faint image of the dirigible USS *Los Angeles* soars in the background.

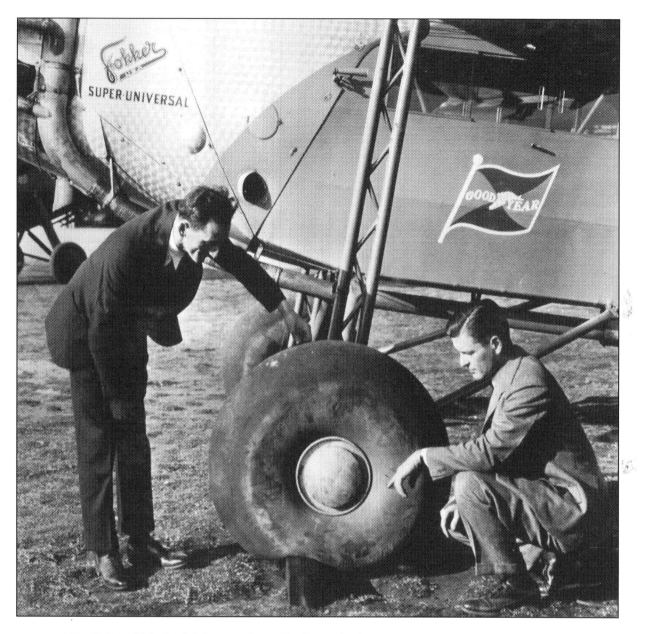

Pilot Bell and Mr. Ludok Inspect the Fokker's Airwheels, 1929
When the speed and expanding popularity of the airplane brought a challenge to the tire-manufacturing industry, Goodyear built the Airwheel, a low-pressure pneumatic aircraft tire that facilitated safe landing on rough runways and undeveloped airfields of the day. By the 1930s, the Airwheel became standard in aeronautics, and major airlines utilized them on their fleets of mail and passenger planes. Around this time, the firm also developed the puncture-sealing aircraft tire tube, the dual seal nose wheel, and tricycle landing gear.[29]

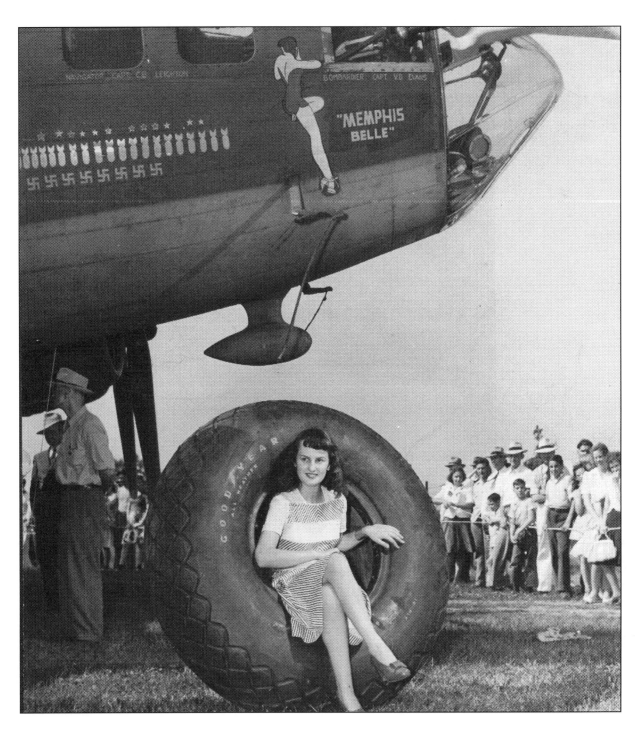

Memphis Belle in Akron, 1943
Goodyear Aircraft employee Dorothy Jean Humphrey sits inside one of the huge tires of the famous *Memphis Belle* B-17 Flying Fortress during its visit to Akron. The company produced airplane tires, rims, and brakes in mass quantities for aircraft during World War II.[30]

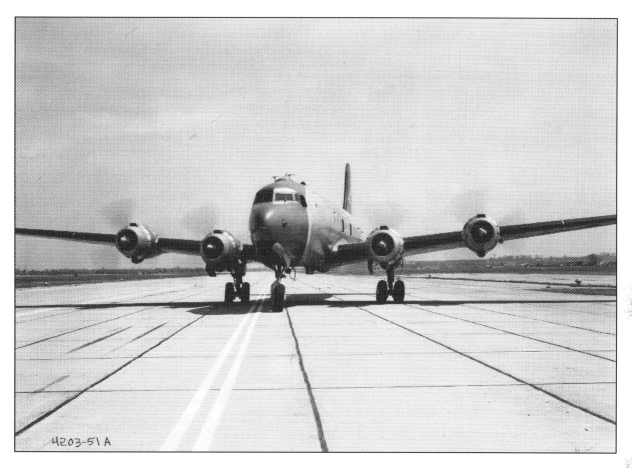

4203-51 A

Crosswind Landing Gear, 1951
Goodyear introduced crosswind landing gear in 1947, which became an important contribution to aviation. This Goodyear invention allowed larger commercial aircraft like DC-3 transport planes to take off and land without regard to wind direction. The United States Air Force soon adopted crosswind landing gear for their larger military aircraft, like this Douglas C-54 Skymaster. Photo by Bill Klotz.[31]

Down on the Farm

Goodyear Tractor Tires in the Field and on the Road

Until the 1930s, farmers outfitted gasoline tractors and other agricultural equipment almost exclusively with steel-cleated rims, which bogged down in muddy and sandy soils and destroyed tree roots, crops, and road surfaces. One of the earliest uses of rubber tires on farm tractors dates back to 1919.[32] A decade later, Goodyear engineers applied the first set of Airwheels on a tractor in Florida that provided grip on the loose dry sands. While Airwheels did not damage lawns, roads, or runways, they lacked the traction necessary for operation on harder ground and muddy soil. Goodyear conducted exhaustive tests of new tractor tires on the company's farms in Arizona, which they called "a vast agriculture research laboratory and proving ground for new agriculture equipment."[33] Development of the tractor tire progressed rapidly during the 1930s and resulted in the company's release of nonskid tractor tires with self-cleaning lugs and tires for varying soil conditions.[34]

Farmers overwhelmingly preferred rubber tires over steel wheels because they increased profits, shortened the work day, and improved working conditions. Rubber farm tires also required less fuel, traveled faster, made equipment easier to steer, pulled heavier loads, reduced vibration and repairs, and did not damage lawns, fields, crops, or tree roots. Before long, farmers bought pneumatic tires for their farm implements for the same reasons they purchased them for their tractors. Consequently, Goodyear went to work and developed rubber tires for all kinds of farm implements. In addition, the company manufactured tractor tires for industrial hauling for small tractors, graders, industrial tractors, and highway mixers, marketing them with the slogan "Goodyear Means Good Wear." In the early 1940s, the company also experimented with tubeless tractor tires, but when Japanese forces bombed Pearl Harbor and cut off supplies of natural rubber from Asia, the United States government ordered farm implement makers to return to steel wheels, which automatically cut production of tractors and tractor tires.[35]

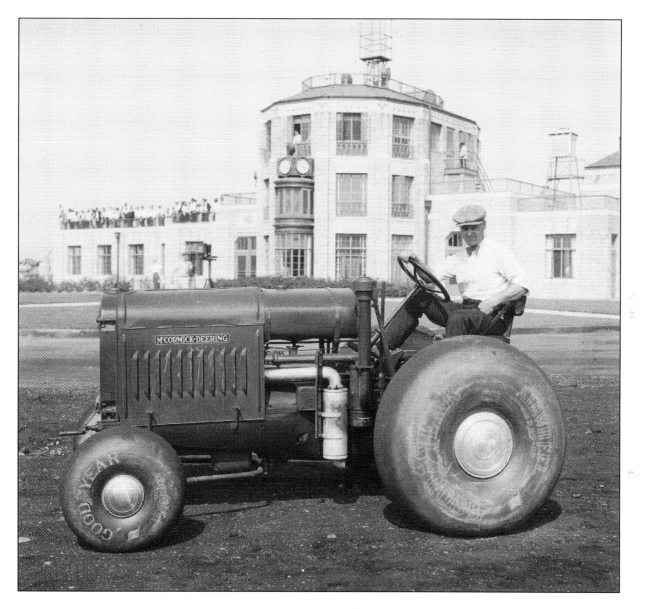

McCormick-Deering Tractor at Akron Municipal Airport, ca. 1931
A McCormick-Deering Tractor at the Akron Municipal Airport features Goodyear's donut-shaped Airwheel tractor balloon tires. Originally developed for farmers operating in sandy soils, these tires were later adopted for lawns, golf courses, airports, and roads where regular tractor lugs would have been too destructive.[36]

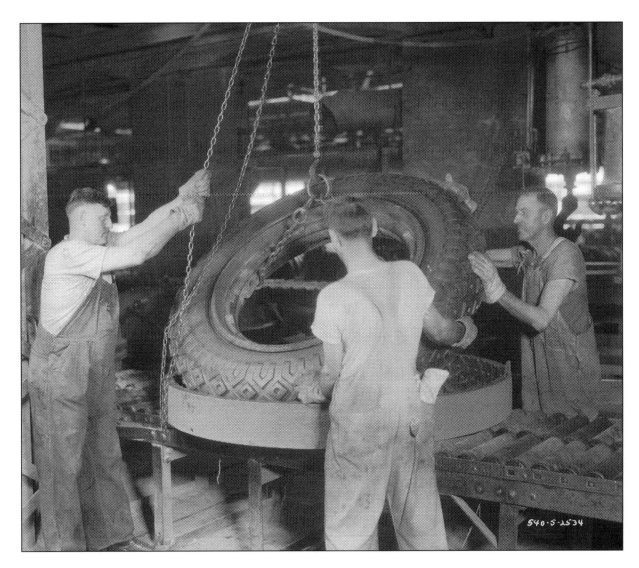

Tractor Tire in Pit, 1934
Tire builders remove a Goodyear nonskid tractor tire from its mold. Designed for maximum traction, these tractor tires had deeper treads to meet traction problems encountered in different types of soil. This photograph clearly shows the distinctive hollow-center diamond button design with bars on the edge of the tread.[40]

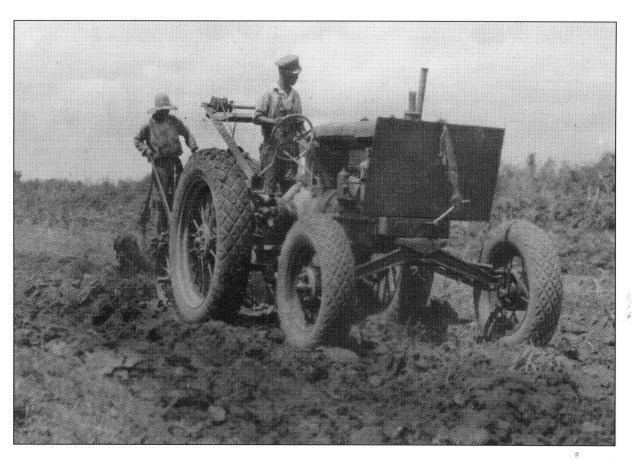

Tractor on Goodyear Tires, 1934
Two African American sharecroppers plow a muddy field with a tractor outfitted with Good-year nonskid tires. By the time of this photo, Canadian lumber companies also utilized Goodyear lug tractor tires and puncture seal tubes to haul logs out of forests in treacherous winter conditions. At this time, the company also perfected a liquid that filled tractor tires. This helped increase traction and decrease wear, slippage, and fuel consumption.[37]

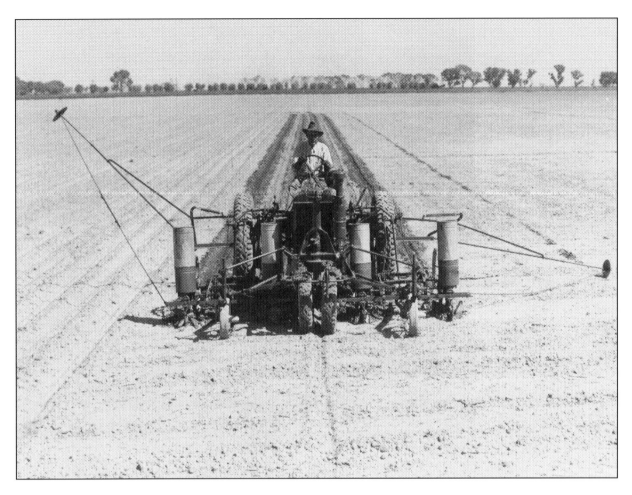

Cotton Planting at Litchfield Park, 1937
This F-20 Farmall tractor demonstrates Goodyear's nonskid tractor and farm implement tires on the company's farms in Arizona. By the early 1930s, farmers bought pneumatic tires for their farm implements, and Goodyear sold a complete line of farm implement tires, rims, and felloes to meet the demand. This included the Plow Tail wheel tire, special Rib tire, tractor implement tire, and Hillside Combine Special.[39]

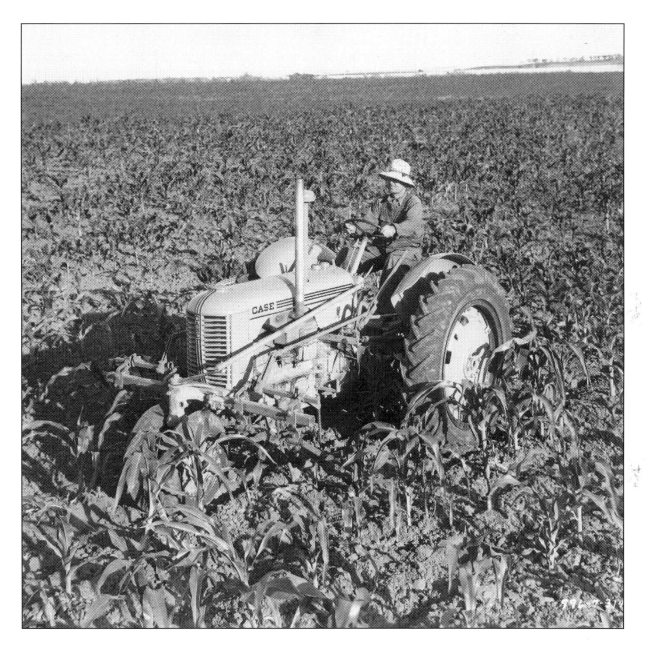

Case Tractor on Sure Grip Tires, 1941
A Case Model DC Tractor demonstrates the pulling power of the Goodyear Sure Grip tire. This tire, a successor to the nonskid tractor tire with hollow-center diamond button, had self-cleaning lugs that provided greater traction and an open center design that expelled mud from the tread. Around this time, Goodyear also released the Type X Sure Grip tractor tire, a lower priced tire designed for "all-around farm work" with positive traction in all soil conditions. It also manufactured farm tires for various soils, including the Rice and Cane Field Special.[38]

Blazing the Trail

Goodyear Off-the-Road Tires for Construction and Exploration

Goodyear's Off-the-Road—or earthmover tires—for giant construction machinery sprung from their work with truck, tractor, and airplane tires. In 1928, Goodyear introduced special pneumatic truck tires called Dump Truck Specials for vehicles engaged in off-road service. Three years later, they released the pneumatic lug tractor tire for power graders, and the Airwheel began to be used on graders and dump trucks. The company also contributed to public works projects initiated during the Great Depression by building earthmover tires for steam shovels, dump trucks, and road-building machines. From this base, Goodyear's earthmover line expanded to include a special tire for nearly every construction machinery job. [41]

Before long, the company's off-the-highway rubber tires carried the gigantic loads involved in earthmoving, mining, logging, and construction. In 1938, Goodyear added a new 32-ply, 1,300 pound earthmover tire to its line of excavating equipment. A few years later, the firm made four major product changes in its line of Off-the-Road tires for the rugged service of construction and earthmoving jobs in preparation for the increased demand for big equipment in all phases of anticipated national defense projects. By this time, Goodyear also made special road grader tires with nonskid and rib tread designed with patented low-stretch Supertwist cord to give maximum traction, long life, and satisfactory service in low speed operation on motor graders, tractors, and other heavy equipment. They also introduced earthmover rims in 1929 and developed the tapered rim in the 1940s, which eliminated rim pull and tire slippage. These wheels assisted in construction projects around the globe including dams, dikes, canals, tunnels, and power houses. Soon thereafter, Goodyear Off-the-Road tires, ranging in sizes from six to nearly ten feet in diameter and weighing over a ton, appeared on giant construction equipment including bulldozers, front-end loaders, scrapers, power shovels, dump trucks, ore trucks, mining scoops, cotton pickers, and cranes. Manufacturers such as Lorain, John Deere, and Caterpillar chose these tires to build dams, waterways, railways, and highways during peacetime, and training fields during World War II. [42]

Road Grader Outfitted with Goodyear Tractor Tires, 1932
An Adams No. 10 Motor Grader featuring Goodyear Off-the-Road tires grades a road in Kent County, Michigan. Goodyear promoted their truck, tractor, and off-road tires to municipal, county, state, and federal governments throughout the country, especially for road work. Public works projects—including Boulder Dam, Grand Coulee Dam, and Tennessee Valley—utilized Goodyear earthmover tires during the Great Depression, leading Goodyear to rename their dump truck tire the "TVA Special."[44]

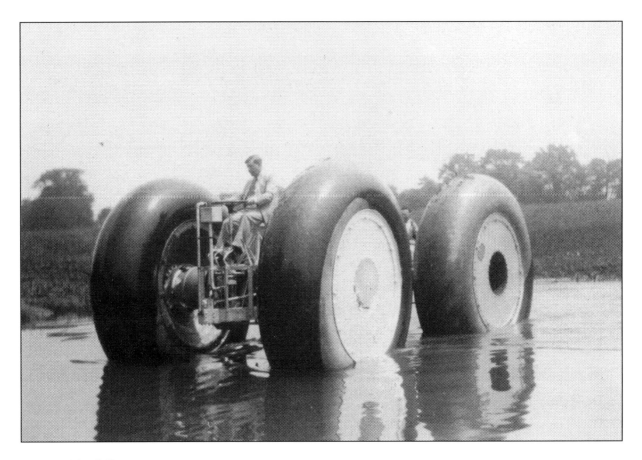

Marsh Buggy, ca. 1937
The Marsh Buggy, Gulf Oil Company's huge amphibian car—reportedly the first pneumatic-tired vehicle to operate successfully over land and water—traverses a swamp. Designed for exploring areas impossible to reach by truck or boat, such as the marshlands in Louisiana and the Florida Everglades, the vehicle rode on land and floated on water with Goodyear's innovative Off-the-Road tires and rims.[46]

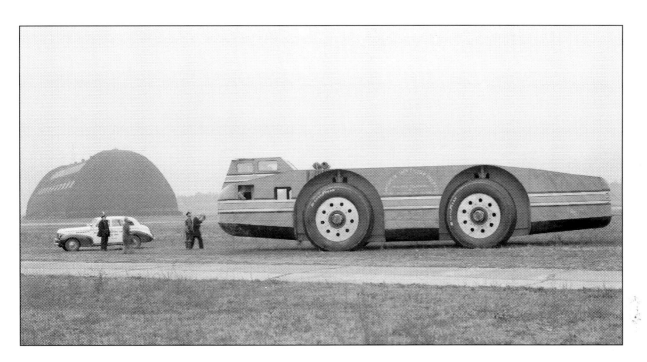

Snow Cruiser at Akron, 1939
The Snow Cruiser, driven by Admiral Richard E. Byrd and his team during his third expedition of Antarctica, stops in Akron on its way to Boston for departure to the South Pole. The mammoth 55-foot-long, 75,000-pound vehicle rolled across vast unchartered ice fields, climbed polar mountains, and crossed 15-foot crevasses on its four 10-foot-high, 750-pound Goodyear tires. Photo by Tru Williamson.[47]

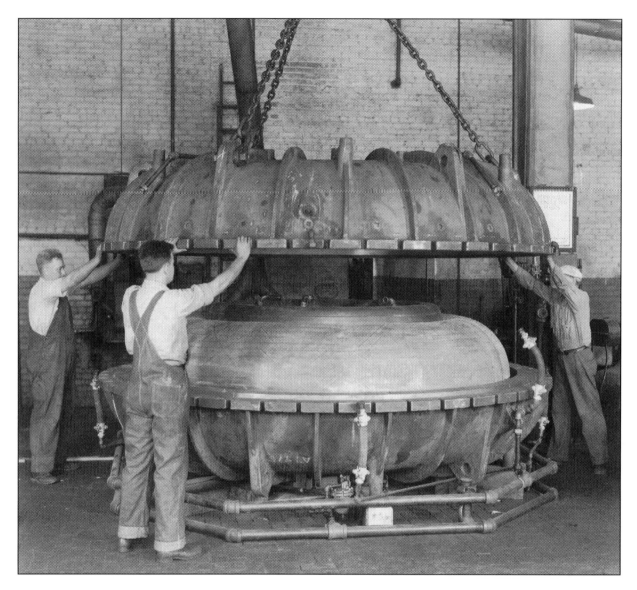

300,000,000th Tire, 1939
Pitmen take Goodyear's 300 millionth tire out of its massive mold by removing the 10-ton lid with chain hoists. This event received much fanfare, mostly because of the size of the huge Off-the-Road tire and the novelty of the project. As the *Wingfoot Clan* reported, "Of all the tires built by Goodyear, none attracted as wide attention as the 300 millionth."[48]

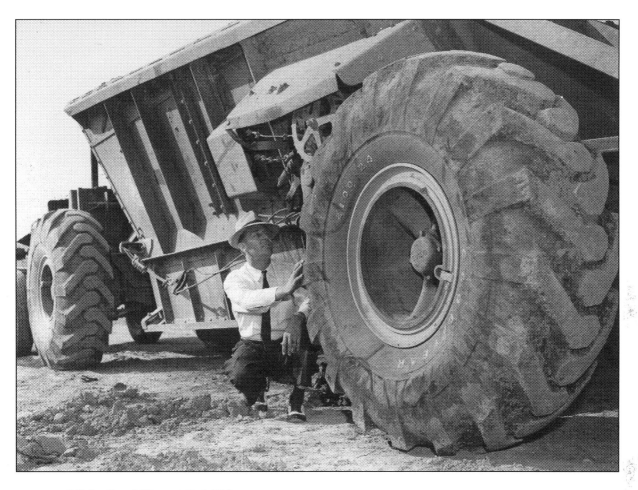

Off-the-Road Tires at Oak Ridge, 1942
An executive examines a large Goodyear Off-the-Road tire on a construction vehicle involved in building Oak Ridge, Tennessee—a production site for the Manhattan Project during World War II. The company made major product changes to its line of off-road tires in preparation for the increased demand for big equipment in national defense projects. This included earthmover, heavy duty, low-pressure, and ML Logger tires, available in various treads including the All-Weather, Studded Sure Grip, and Hard Rock Lug.[45]

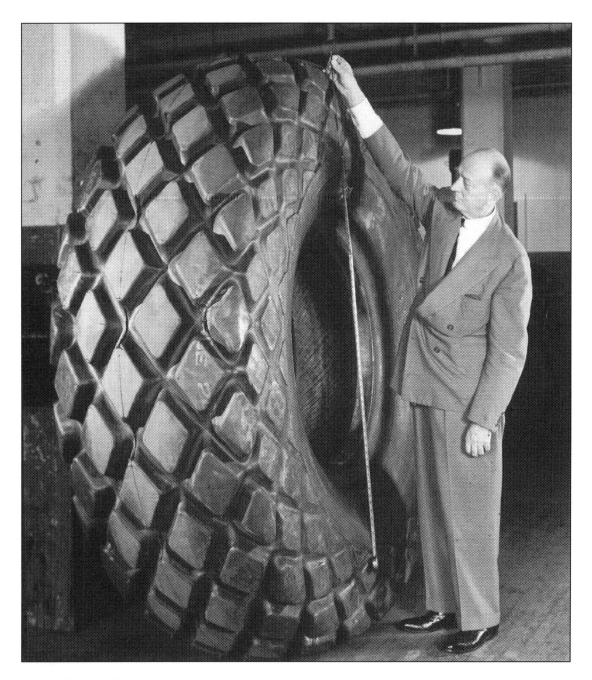

Earthmover Tire, 1946
A Goodyear executive measures a giant earthmover tire, the largest the company had built to that date. Goodyear introduced the large-section flotation and low-pressure tire for off-the-highway vehicles in the early 1930s. From this base, Goodyear's earthmover line expanded to include a special tire for almost every job, ranging in sizes from six to ten feet and weighing over a ton. Around this time, they also introduced the tapered rim, which eliminated rim pull and tire slippage.[43]

Notes

1. Goodyear, *The Story of the Tire*. Akron, OH: The Goodyear Tire & Rubber Company, 1968, 37.

2. Ibid.

3. For information on the history of trucking see F. Van Z. Lane, *Motor Truck Transportation* (New York: D. Van Nostrand, 1921); and Robert F. Karolevitz, *This Was Trucking* (Seattle, WA: Superior Publishing, 1966).

4. "Truck Tires and Their Relation to Truck Investment," n.d., advertising brochure, Goodyear Records (hereafter GR).

5. See the following MSS in the GR: "The Wingfoot Cord Truck Tire," 1923, sales brochure; "Goodyear Truck Tire Direct Mail," 1926, "Goodyear Individual Block Truck Tire," n.d., sales brochure; and *Goodyear Motor Truck Tires*, 1912.

6. "Motz Cushion Tires," n.d., sales brochure, GR.

7. See "3 Out of 5 on Goodyear Fire Truck Tires," n.d., sales brochure, GR; and "About the Wonderful New Goodyear Cushion Truck Tire," n.d., advertising booklet, GR.

8. See the following WC articles: "Goodyear Played Vital Role in World War I Hostilities," October 11, 1962; "War Takes Terrific Toll on Tires," July 12, 1944; "'More Tires' Plea of Military Men," July 19, 1944; and "Largest Truck Tire Room in World at Goodyear," February 26, 1947. See also "They Are Always a Good Bargain," October 7, 1932, advertisement in *The Saturday Evening Post* and Goodyear, *Goodyear Motor Truck Tires* (Akron, OH: Goodyear, 1912).

9. Litchfield, *Industrial Voyage*, Garden City, NY: Doubleday, 1954, 141–142.

10. See "A New Chapter in the History of Transportation," n.d., advertising booklet, GR; and "Goodyear Cord Tires for Motor Trucks," n.d., sales brochure, GR.

11. See "Goodyear Built the First Six-Wheel Truck in US," *WC*, May 16, 1963; and "The Company Once Built Its Own Trucks to Improve Efficiency," *WC*, March 3, 1966.

12. See "Goodyear Truck and Bus Tires: A Guide to Selection of Proper Tire Equipment," 1930, booklet, GR; "Goodyear All-Weather Truck Balloons," February 22, 1932, advertisement in *Time Magazine*; and "The Goodyear Super Cushion Tire," 1929, advertisement, GR.

13. See Allen, *The House of Goodyear*, Cleveland, OH: Corday & Gross, 1949, 204; Litchfield, *Industrial Voyage*, 102; and "Truck Used in the 1930s," *WC*, October 5, 1967.

14. "6 Distinct Types of Goodyear Tires for Commercial Cars," 1929, advertisement, GR.

15. See Allen, *House of Goodyear*, 220; and "Put Your Truck on Goodyear Pathfinders," July 7, 1931, advertisement in *The Country Gentleman*.

16. "Data Book of Goodyear Truck, Bus, Trailer, and Industrial Tires," n.d., GR.

17. For information on the history of busing see Susan M. Mandell, Stephen P. Andrew, and Bernard Ross, *A Historical Survey of Transit Buses in the United States* (Warrendale, PA: Society of Automotive Engineers, 1990), 8–10.

18. For information on Goodyear bus tires see "Is Bus Tire Business Worth Going After?," *The Goodyear News* 14, no.

6 (June 1925): 10; "Prominent Users of Goodyear Cord Truck Tires," 1923, sales brochure, GR; and "On All Fifth Avenue Coaches," n.d., advertisement, GR.

19. Lee P. Hart, "Goodyear's Role in the Trucking Industry," 1955, MS, GR.

20. See Mandell, *Historical Survey*, 8–10.

21. See the following *Wingfoot Clan* (hereafter *WC*) articles: "Bus Attracts Attention," October 10, 1928; "New Coaches for Use in Goodyear's Blimp Fleet," March 12, 1947; and "Business Relationship 'Just Keeps Rolling,'" November 25, 1942.

22. See "Goodyear Tire Goes over 100,000 Miles," *WC*, January 16, 1929; Richard W. Meade, "The Double-Deck Motor Omnibus, *SAE Transactions* 19 (1924): 531–559; Mike McNessor, "Decadent Deliveries," *Hemmings Classic Car* (March 2012); and "Greyhound Buses Travel 400 Million Miles Yearly on Goodyear Tires," *WC*, August 27, 1930.

23. See "Blazes Trail across Arabian Desert on Buses Shod with Goodyear Tires," *WC*, August 11, 1926.

24. For information on Goodyear's rail tires see Charles A Stillman to E. E. Adams, July 16, 1934, GR; "Finds Rail Hints Abroad: Litchfield Tells of New Trains to Meet Bus Competition," *NYT*, August 10, 1932; "Rail-Highway Bus Foreseen as Serious Threat to Locomotive if Legal Bars Can Be Overcome," *ABJ*, August 23, 1932; "Railroad Tires Open New Line," *Akron Times-Press* (hereafter *ATP*), May 17, 1932; and "New Bus Plan Disapproved," *NYT*, March 10, 1942.

25. See "Budd Delivers First Rail Car," *Automobile Topics*, November 12, 1932; and "Pneumatic 'Rail Tire' May Revolutionize Railway Travel," *The Tulsa Tribune*, May 5, 1932.

26. For information on Goodyear's early work in airplane tires see the following MSS in the GR: "Goodyear's Contributions to Aeronautics Since 1909," n.d.; Goodyear, *Aviation Products by Goodyear* (Akron, OH: Goodyear, n.d.); "Heavier-Than-Air Activity—Goodyear," n.d.; "After Two Years: The Unusual Records of the Stay-Tight Aeroplane Fabric," 1912, sales brochure. See also Goodyear airplane tire blueprints in Willard P. Seiberling Papers, (hereafter Seiberling Papers), UA Archives. And see Gill Robb Wilson, "Genealogy of American Aircraft," in *Flying* (January 1954), 1; "Goodyear's Role Large in Birth of Aviation: 67th Anniversary of Orville Wright's First Flight Is Being Celebrated Today," *WC* (*Aerospace Edition*), December 17, 1970; "The Development of the Aeroplane Tire," *Aerial Age Weekly* (November 22, 1915); T. A. Knowles, *The Goodyear Aircraft Story* (Akron, OH: The Goodyear Aircraft Corporation, n.d.), 1; and Shafto Dene, *Trail Blazing in the Skies* (Akron, OH: Goodyear, 1943).

27. For information on Goodyear's later work in airplane tire development see "American Airways Uses Airwheels," 1932, advertisement in *Aviation*; "To Land Bigger Planes on Smaller Fields," ca. 1944, advertisement, GR; and "Aviation Products Division," n.d., GR. See also the following WC articles: "Goodyear Is Big Factor in Japan

Bombing," June 21, 1944; "On the Go in the Air: Company Has Helped Aviation Progress," December 9, 1965; and "Goodyear Makes Tires for This Big Combat Glider," January 3, 1945. Also see "Flew Goodyear-Equipped Planes on Historic 'Round World Flights," *Goodyear Triangle* 39, no. 17 (April 23, 1957).

28. See Goodyear, *Everything in Rubber for the Airplane* (Akron, OH: Goodyear, 1920); "Marines Insisted, Yesterday's Tire Is Alive Again," *WC*, May 2, 1966, and "Fact sheet: US Navy Curtiss A-1 Planes," n.d., news release, GR. For information on the Vickers "Vimy-Commercial" Biplane see "'Milestones' The Vickers Machines," reprinted from *Flight* (June 12 and July 17, 1919): 11–12; and "The Vickers-Vimy Commercial Aeroplane," reprinted from *Engineering* (June 6, 1919), Seiberling Papers.

29. See J. P. Banks to W. Ross Richardson, July 2, 1962, GR; "Former Goodyear Waco Is High-Flying Rarity," *ABJ*, January 10, 1980; and Goodyear, *Goodyear Aviation Products: Volume One* (Akron, OH: Goodyear, n.d.).

30. See "American Airways Uses Airwheels," 1932, advertisement in *Aviation*. See also the following *WC* articles: "On the Go in the Air," December 9, 1965; "Goodyear Makes Tires for This Big Combat Glider," January 3, 1945; and "Huge Plane Tires for *Memphis Belle*" (Aircraft Edition), July 21, 1943.

31. For information on Goodyear's crosswind landing wheels see the following *WC* articles: "World's Major Airlines Men See Demonstration of Goodyear's Cross-Wind Landing Wheels," June 14, 1950; "Cross-Wind Wheels for T-6 'Texan' Trainers Soon to Be Installed," June 14, 1950; and "On the Go in the Air." See also Goodyear, *Cross-Wind Landing Wheels* (Akron, OH: Goodyear, 1948).

32. For information on the history of tractors see Robert C. Williams, *Fordson, Farmall, and Poppin' Johnny: A History of the Farm Tractor and Its Impact on America* (Chicago, IL: University of Illinois Press, 1987); and Marvin McKinley, *Wheels of Farm Progress* (St. Joseph, MI: American Society of Agricultural Engineers, 1980).

33. "35 Years of Agriculture Progress: Desert Farm Laboratory," n.d., MS, GR.

34. For information on Goodyear's tractor tires see "The Tractor that was Part Airplane," February 14, 1949, advertisement in *Newsweek*; and Goodyear, *Goodyear Tire Handbook*, 18.

35. See Goodyear, *Goodyear Farm Tire Handbook for Tractor and Implement Tire Dealers* (Akron, OH: Goodyear,

1940?); and "Goodyear Cushion Tires for Fordson Tractors on Whitehead and Kales Wheels for Industrial Hauling," n.d., sales brochure, GR. See also the following *WC* articles: "Pneumatic Tire Plays Key Role Today on Farm," May 29, 1946; and "Future Farmers Ride on Rubber," August 31, 1938.

36. W. H. deBruin, "Farm Tire Applications in Agriculture" (lecture, American Society of Agricultural Engineers, Michigan State College, East Lansing, MI, May 1950), GR.

37. "Three Wheels Make Hauling Easy," *WC*, February 13, 1935.

38. "35 Years of Agriculture Progress: Desert Farm Laboratory," n.d., MS, GR.

39. See Goodyear, *Goodyear Farm Tire Handbook*; and "Ralph W. Sohl Is Named Farm Tire Development Head," *WC*, February 6, 1946.

40. "Farm Tires Vital Factor in Life of Every Individual," *WC*, August 28, 1946.

41. "Goodyear Tires Used on Gigantic Engineering Jobs," *WC*, October 26, 1938.

42. For information on Goodyear's Off-the-Road tires see "Controlling Earth Mover Tire Costs by Careful Tire Selection and Good Operating Practice," pamphlet, GR; Goodyear, "Off-the-Road Tires," n.d., news release, GR; and "It Takes Big Trucks for the Big Tire Jobs," *Goodyear Triangle* (June 19, 1942).

43. See "No One Dreamed of Tires Weighing Half a Ton Twenty-Five Years Ago," *WC*, May 25, 1938; and "Earthmover Tire Weighs Nearly a Ton," *WC*, May 26, 1947.

44. "Government Sales Department: The How, Why and Where of Government Sales," 1923, sales manual, GR.

45. "Goodyear Tires Used on Gigantic Engineering Jobs," *WC*, October 26, 1938.

46. "Blimp Goes to Rescue of 'Marsh Buggy," *WC*, November 24, 1937; and "Marsh Buggy Propelled by Goodyears," *WC*, January 27, 1937.

47. See the following *WC* articles: "Gigantic Snow Cruiser Soon to Visit Here," October 4, 1939; "World's Largest Automobile to be in Akron," October 18, 1939; and "Millions See Snow Cruiser's Goodyear Tires," November 15, 1939.

48. "Pitmen Calm as Klieg Lights Blaze Away," *WC*, August 23, 1939.

Chapter 3

Gentle Giants

Goodyear Airships in War and Peace

"The history of lighter-than-aircraft is the story of admirable perseverance of men of great vision and unfaltering devotion to an idea fighting the faint-heartedness of human nature which is only too willing to give up."[1]
—*Dr. Karl Arnstein, Vice President, Goodyear-Zeppelin Corporation*

Dirigibles, also known as steerable or directable airships, first appeared in Europe in the nineteenth century. According to author Lennart Ege, the first serious attempt to build a dirigible was made in England in 1816 by two Swiss inventors—Jean Pauly and Durs Egg—but it was never completed. In 1850 Frenchman Pierre Jullien demonstrated what Ege called "a really outstanding airship model," powered by a clockwork engine with two propellers, at an exhibition in Paris, but a larger machine of this type that could carry a person never materialized. Two years later, French engineer Henri Giffard flew from Paris to Trappes, France, in a steam-engine-powered airship of his own design, achieving the first sustained power controlled flight in history, which "truly inaugurated the airship era."[2] In 1863, physician and inventor Dr. Solomon Andrews flew his unpowered dirigible called the *Aereon* in New Jersey and later around New York City. Then, in 1884, Frenchman Charles Renard and Arthur Constantin Krebs made the first fully controllable free flight in their airship, *La France.* As author C. J. Hylander wrote, "For the first time a true dirigible balloon followed a fixed course and returned to earth at the point from which it had departed."[3]

These primitive airships were not practical since they were fragile, nonrigid, and too small to carry a commercial load. Count Ferdinand von Zeppelin experimented with rigid outer frames that would allow much larger airships and made successful flights at the turn of the century, thereby establishing the airship as the first practicable form of air travel. Long interested in flight, and airships in particular, Goodyear cofounder F. A. Seiberling envisioned a Goodyear-built airship soaring across the Atlantic and worked with others to make his dream a reality. Thus began a long and varied career in the manufacturing and development of various types of airships, which continues to this day. Many of these airships revolutionized the industry, created indelible icons, carried the Goodyear name across the globe, and were used extensively during both world wars.[4]

The Goodyear Photograph Collection contains thousands of historic photographs that document the history of the company's airships and airship operations. These visually stunning images capture Goodyear airships during every aspect of operation, including construction, christening, maiden flights, test and operational flights, and even crashes. The photographs also show the famous passengers and christening ceremonies, as well as blimp crews and Goodyear employees who designed and operated the airships. Other images show the airships over famous landmarks, including the US Capitol, the Pacific Coast, the Cleveland lakeshore, and the Goodyear Airdock. Some photographs in the collection capture airships that were not manufactured by Goodyear and were not part of their airship operations, but were important in the history of lighter-than-air flight. A small selection of these fascinating and historic images, most of which have never been published, are featured in this chapter.

More than a Bunch of Gas Bags

Goodyear Blimps for Marketing and the Military

Goodyear began manufacturing blimps, also known as pressure airships or nonrigid airships, at a very early date.[5] The company constructed the gas bag for its first airship, known as Vaniman's Airship *Akron*, in 1912 for a transatlantic flight. According to one newspaper account, "It marked the beginning of the dirigible industry in Akron, and the nation."[6] Unfortunately, the airship exploded on a test flight, the first of several Goodyear airships that ended in disaster. Goodyear then took a break from airship design until World War I when they manufactured numerous blimps for military service.[7]

Goodyear began operating their own airships in June 1919, when they constructed the *Wingfoot Air Express*, which exploded and crashed in Chicago during a demonstration flight. The depression of 1920–1921 temporarily stalled Goodyear's blimp operations; however, they resumed in 1925 with a new fleet of airships, including the *Pilgrim* and the *Puritan* (most were named after the winners of the America's Cup races). The company primarily used the blimps for publicity, research, training, search and rescue missions, passenger and cargo service, mail delivery, promotional purposes, and sightseeing tours—especially in major cities such as New York, Boston, Miami, and Washington, DC. Other Goodyear blimps operated on the West Coast, frequently appearing over Los Angeles and San Francisco.[8]

From an early date the blimps made appearances at national events, including world's fairs and the Olympics. Many of Goodyear's blimps set records and achieved many firsts, such as cross-country flights. Famous people—including Amelia Earhart, Babe Ruth, and Walt Disney—christened Goodyear's blimps or rode as passengers. The company built blimps for the US Army as well as US Navy in the 1920s and 1930s. During World War II several of Goodyear's blimps were requisitioned and used by the US Navy for anti-submarine patrol, search and rescue missions, and delivering supplies to remote areas. The navy continued to employ blimps until 1961. Some of Goodyear's blimps are so significant that portions of them are part of museums and archives throughout the nation, including the Smithsonian Institution.

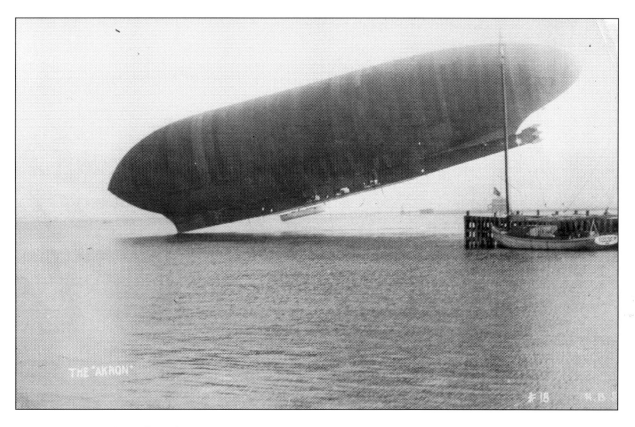

Vaniman's Airship Akron, *1912*

Vaniman's Airship *Akron* with a gas bag supplied by Goodyear takes a trial flight in Atlantic City, New Jersey, in mid-June 1912. Goodyear President F. A. Seiberling, who financed the project, called it the *Akron* because he "wanted the name to be carried across the ocean" as the goal of the project was to be the first to cross the Atlantic. Sadly, on July 2, 1912, due to internal pressure that split the bag, the airship exploded shortly after liftoff in front of a crowd off the Jersey shore. The explosion killed all its passengers, including the airship's designer and pilot, American businessman and adventurer Melvin Vaniman. The disaster put Goodyear's involvement in airship development on hold because, as Seiberling noted, "I did not have much heart for dirigible experiments for a long time." Photo by H. B. Smith.[9]

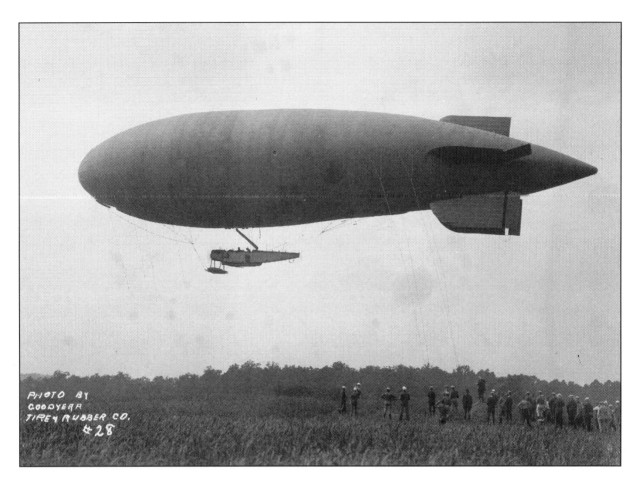

B-Class Airship, 1917
Naval personnel and ground crew observe the testing of an early US Navy airship at Wingfoot Lake in Suffield, Ohio, during World War I. Goodyear manufactured envelopes for B-class (shown here) and C-class blimps for the navy during the war. They never saw foreign service, but were utilized for coastal defense and convoy and patrol duties in the Atlantic.[10]

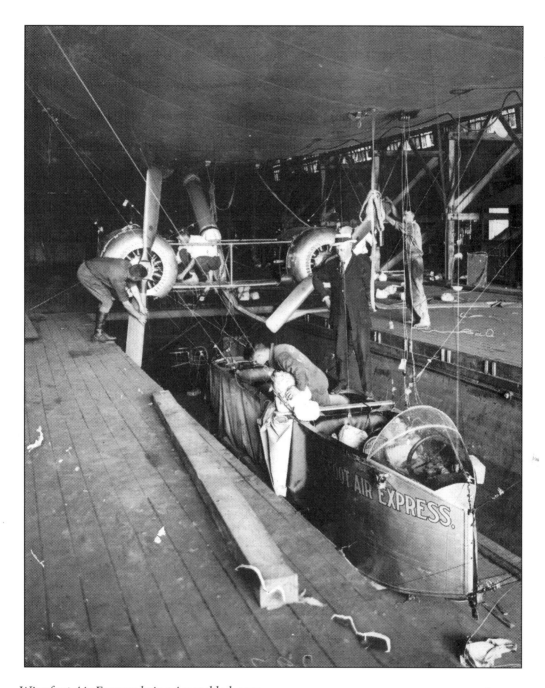

Wingfoot Air Express being Assembled, 1919

The *Wingfoot Air Express*, manufactured by Goodyear in Akron, Ohio, is being assembled in the wooden hanger at the White City Amusement Park in Chicago. On July 12, 1919, the hydrogen-filled blimp exploded while on its third flight over the "Windy City," killing 13 people, including three crew members. Miraculously, the two pilots parachuted to safety. The accident prompted Goodyear to switch to helium as a lifting gas in future blimps.[11]

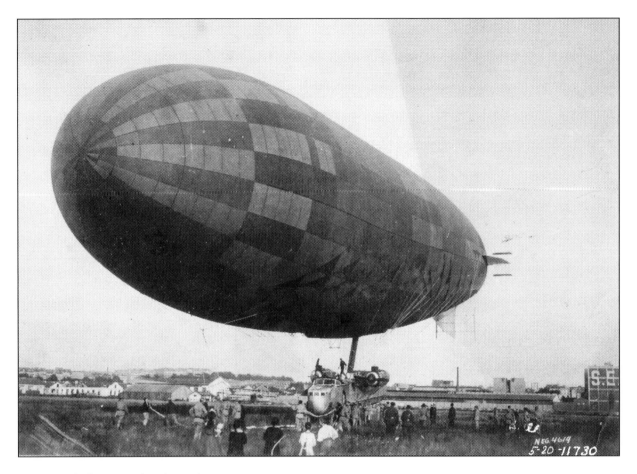

Chalais-Meudon (CM-5), 1920

In 1920, Goodyear acquired the *Chalais-Meudon* (CM-5)—a French-built World War I non-rigid airship—for the purpose of starting an express and mail-carrying airship service. They purchased it from the US Navy, which used it during the First World War for European coastal patrol. Goodyear quickly abandoned this project due to the depression of 1920–1921 and deterioration of the envelope.[12]

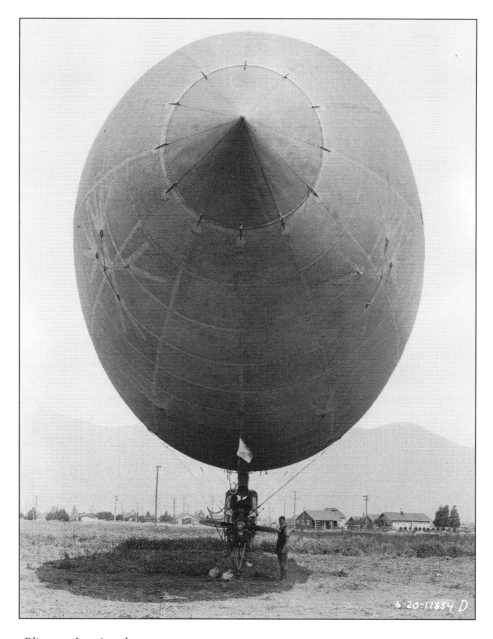

Pony Blimp at Los Angeles, 1920

A blimp pilot stands next to the gondola, or control car, of Goodyear's first Pony Blimp (also known as the D-57), which the company operated out of a small wooden hangar at its Los Angeles plant from 1919 to 1923. In 1920, the 95-foot-long Pony Blimp became the first passenger-carrying airship line in the Western Hemisphere when it offered regularly scheduled service between LA and Catalina Island. Goodyear marketed the Pony Blimps as "every man's airship" for commercial, sporting, and military purposes, but the idea never caught on. The company later sold the blimp to Hollywood producer Marshall Neilan who used it to film movies, including *Custer's Last Fight*.[13]

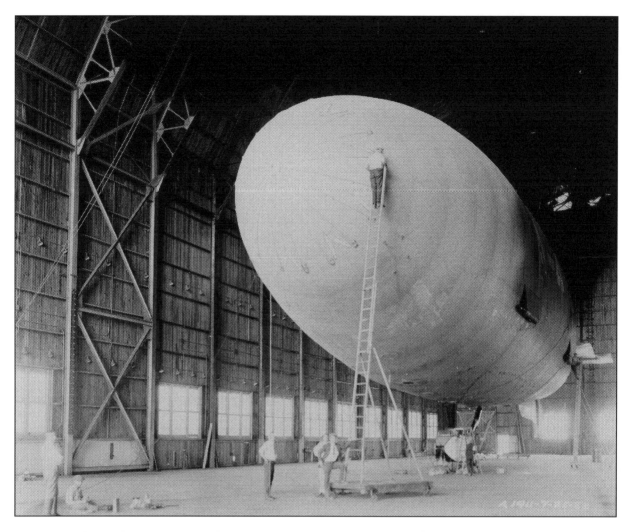

Airship A-4 in Hangar, 1922
The A-4, a 95,000-cubic-foot, 162-foot-long blimp Goodyear built for the US Army in 1919 nears completion in the company's hanger at Wingfoot Lake. This early experimental airship was operated out of Langley Field, Virginia and later Scott Field, Illinois as a training and demonstration ship. During its five-year career it performed several publicity stunts, including landing on top of the Statler Hotel in Cleveland.[14]

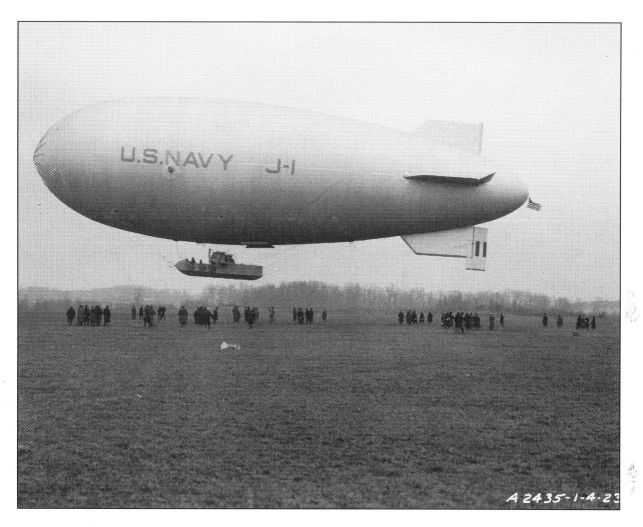

Airship J-1, 1923

Goodyear produced a number of early blimps for the United States Navy during the interwar period, including the J-1, the first of the J-class blimps. Designed in 1919 by Goodyear and the Navy Bureau of Aeronautics, it had a boat-style control car capable of water landings and a single ballonet to reduce weight. Operated out of Hampton Roads, Virginia, and later Lakehurst, New Jersey, it was at that time the navy's only active blimp.[15]

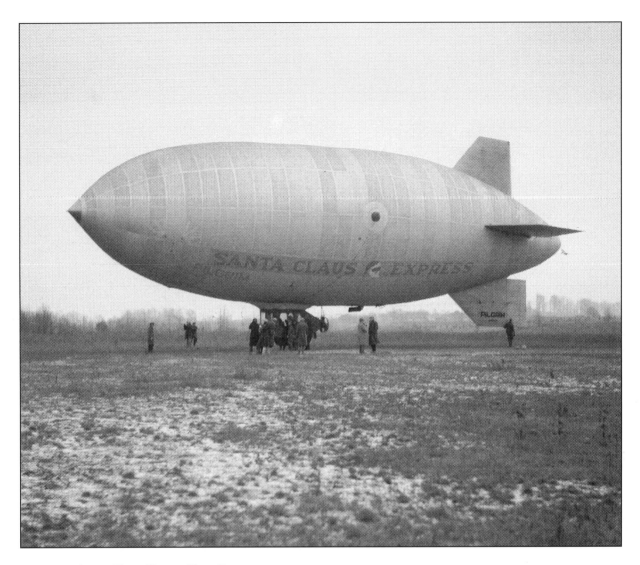

Pilgrim Blimp/Santa Claus Express, 1925
Passengers board Goodyear's *Pilgrim* blimp on Christmas Eve 1925, when the company attached a large "Santa Claus Express" banner to the sides of the airship and used it to help St. Nicholas deliver toys to local children. The 110-foot-long airship was the first in the world to be inflated with helium, the first nonrigid airship with an enclosed gondola attached directly to the envelope, and the first to feature a landing wheel. However, the *Pilgrim* might be most famous for demonstrating the ability of blimps to land on roofs of buildings when it docked on top of the M. O'Neil Building in Akron in 1928. Goodyear replaced the envelope with a larger capacity one in the late 1920s and in 1932 donated its control car to the Smithsonian Institution.[16]

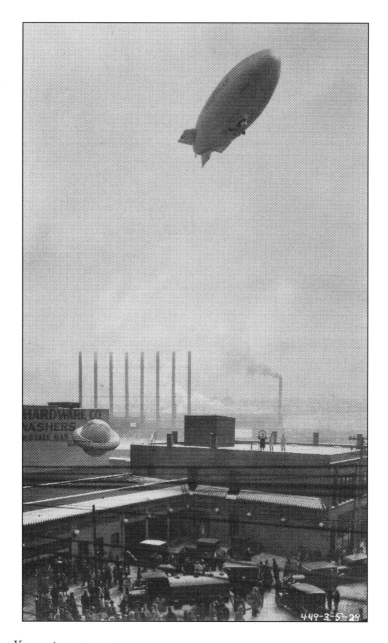

Puritan over Youngstown, 1929

The *Puritan* soars over Youngstown, Ohio on one of its many promotional tours, as a crowd of observers outside a Goodyear service station takes to the streets to catch a glimpse of the nation's first commercially licensed blimp. Goodyear's fleet of blimps started in 1928 with this twin-engine airship, the first of the TZ-type. The company used the blimp for promotional purposes and sightseeing flights over New York City, the 1933 Chicago World's Fair, and Miami, Florida. A number of accidents, including crashing into a mountain in Kentucky, caused the *Puritan* to earn the name "hard luck ship" of the Goodyear fleet. The company retired the blimp after it suffered severe damage from a hurricane in 1938.[17]

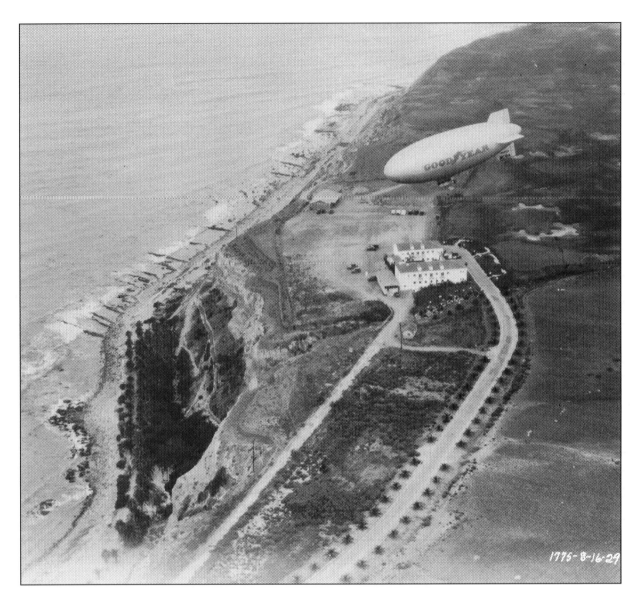

Volunteer over California Coast, 1929
The 86,000-cubic-foot *Volunteer* floats over the California coast on a test flight shortly after
its maiden voyage. Goodyear built the ship for promotional work on the West Coast. It
was known for achieving many firsts, including the first blimp at an international sporting
event—the 1932 Olympic Games in Los Angeles—and purportedly the first aerial coverage
provided by an airship. The *Volunteer* made the first successful cross-county round trip in
1932 and established a record for a blimp operating independently of a hangar at the 1939
Golden Gate International Exposition in San Francisco. Its most publicized event involved
picking up mail from an ocean liner at sea and delivering it to the post office. The company
deflated the *Volunteer* and retired it in 1939.[18]

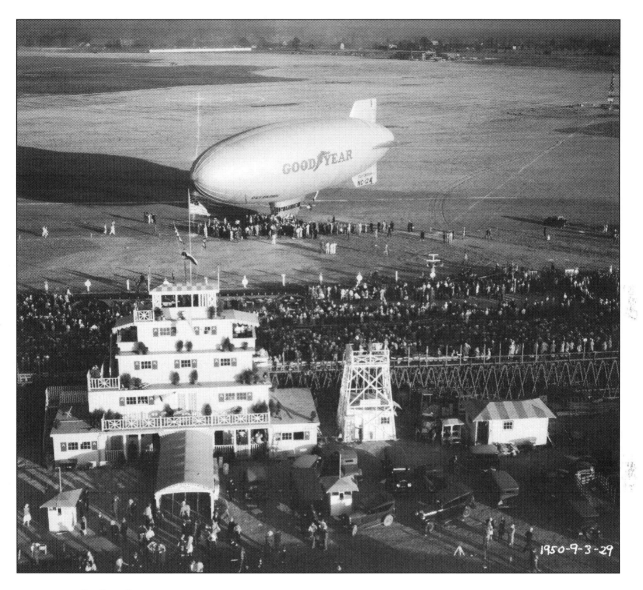

Defender Christening, 1929

A crowd gathers at the Cleveland Municipal Airport to watch Amelia Earhart christen the *Defender*. Known as the flagship of the fleet, the *Defender* served as the largest blimp in the company's flotilla. It participated in several experiments, including making the first successful launching of a glider from a blimp and being the first airship to receive an oil refueling while airborne. In 1931, Goodyear attached pontoons to the cabin and landed it in Biscayne Bay. Goodyear retired the blimp in 1934; however, the US Navy purchased it for training and utility purposes during World War II and designated it G-1, the first of the G-class navy airships. Unfortunately, the G-1 collided midair with the L-2 (former *Ranger*) in 1942, killing 12 people and destroying the ship.[19]

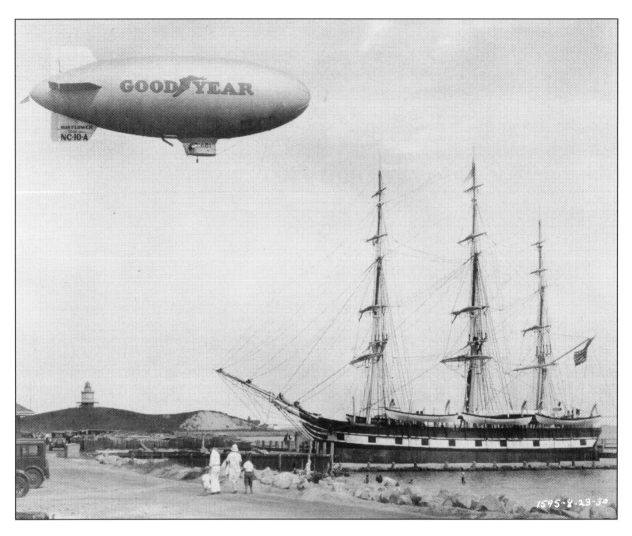

Mayflower with USS Constitution, 1930

The *Mayflower* floats majestically over the USS *Constitution* in Boston Harbor. The blimp made frequent appearances around New England in the 1930s, as it was based out of Boston. During a publicity stunt in 1929, the *Mayflower* became the first blimp to tow a surfboard. The blimp's most spectacular feat, though, occurred in 1930, when it picked up Paul Litchfield and others from an ocean liner, thus completing the first ship-to-shore transfer of passengers by air. During a storm in Kansas City in 1931, the *Mayflower* crashed into high tension wires, destroying the ship and killing its pilot. However, Goodyear often recycled the names of its blimps and used the name on several ships in its fleet after World War II.[20]

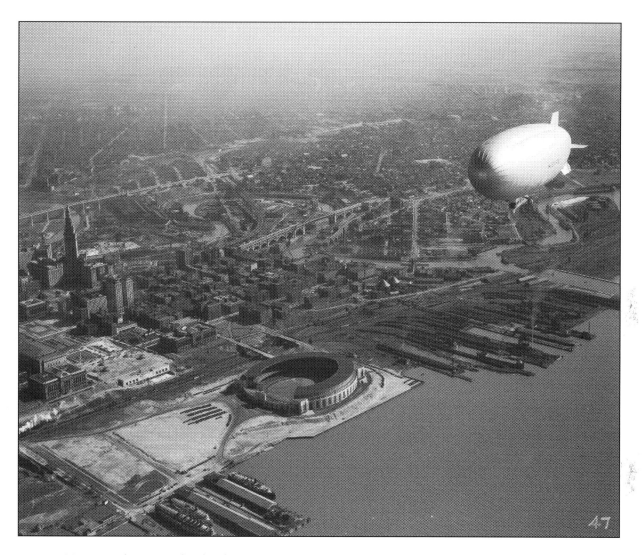

TC-13 Airship over Cleveland, 1933

The Goodyear-built TC-13 hovers over the Cleveland lakeshore on one of its many test flights. The Goodyear-Zeppelin Corporation made TC-type blimps for the US Army in the 1920s and early 1930s for defense of the nation's coasts and harbors. At 233 feet long and a capacity of 360,000 cubic feet, the later TC-class airships were the largest nonrigid airships ever constructed in the United States at the time. In 1937, the army terminated airship operations and conveyed the two remaining TC blimps to the navy. Photo by Tru Williamson.[21]

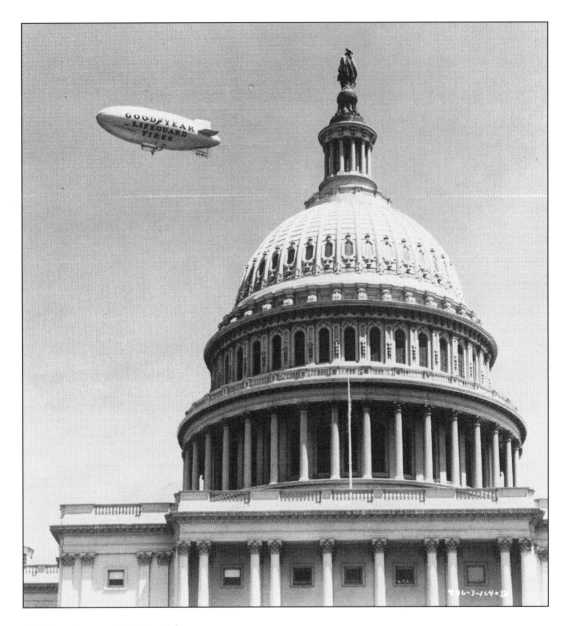

Enterprise over US Capitol, 1940

The second blimp named *Enterprise* circles the dome of the Capitol Building in Washington, DC, where it was stationed much of the year. At 123,000 cubic feet, the *Enterprise* was the largest blimp in the company's fleet and set the standard for Goodyear blimps from that time forward. Like many blimps, it also conducted search and rescue missions and delivered supplies to remote areas. During World War II, the *Enterprise* became the L-5 and flew patrol duty on the Pacific coast before relocating to Lakehurst for training purposes. Goodyear reacquired the airship's gondola after World War II and later used it on one of the *Columbia* blimps. The control car now resides in the Smithsonian Institution.[22]

Night Sign on Resolute, 1940

Workers affix components of an electric sign designed by H. Webster Crum and known as the Neon-O-Gram to the port side of the *Resolute*, the third Goodyear blimp to bear the name. The signs, which consisted of ten removable aluminum panels measuring four feet by six feet, were featured on a number of the blimps for marketing and informational purposes starting in the early 1930s. The first successful blimp sign appeared over the Century of Progress Exposition in Chicago in 1933. By 1935, Goodyear added the signs to the *Volunteer*, *Reliance*, and *Enterprise*. The company used the *Resolute* for sightseeing tours of New York City and, later Washington, DC, as well as for search and rescue missions, such as the Mississippi flood of 1937. During World War II, the *Resolute III* became part of the navy, which designated it the L-4 and utilized it to search for Japanese submarines off the California coast.[23]

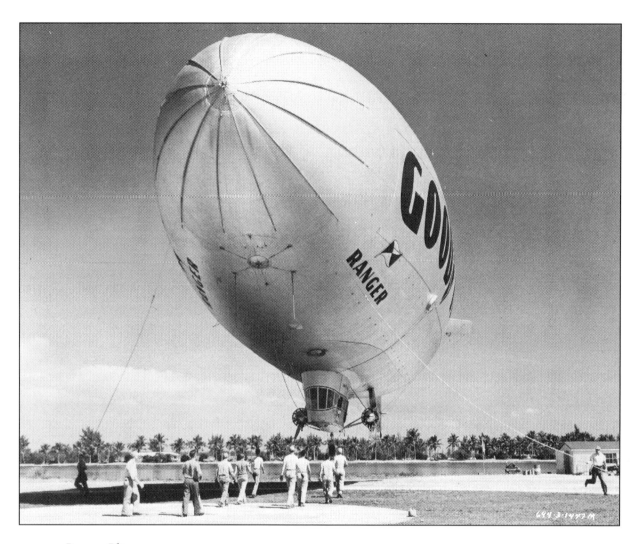

Ranger Blimp, 1947
The fourth of seven Goodyear blimps named *Ranger* comes in for a landing at its airbase in Miami, Florida. During World War II, *Ranger I*, built in 1940, became the Navy blimp L-2, which collided with G-1 in 1942. Its replacement, the proposed *Ranger II*, served in the Navy as the L-8. It helped defend the West Coast and became famous when it rendezvoused with the aircraft carrier *Hornet* at sea and delivered equipment used in Doolittles's raid. The blimp attracted national attention as "the Ghost Blimp" or "Flying Dutchman" when during a routine patrol over the Pacific Ocean in 1942, it crashed in Daly City, California, without its crew, who mysteriously vanished. Five other blimps carrying the name were built by Goodyear after the war, including the *Ranger IV* which was used for publicity and sightseeing tours in Miami.[24]

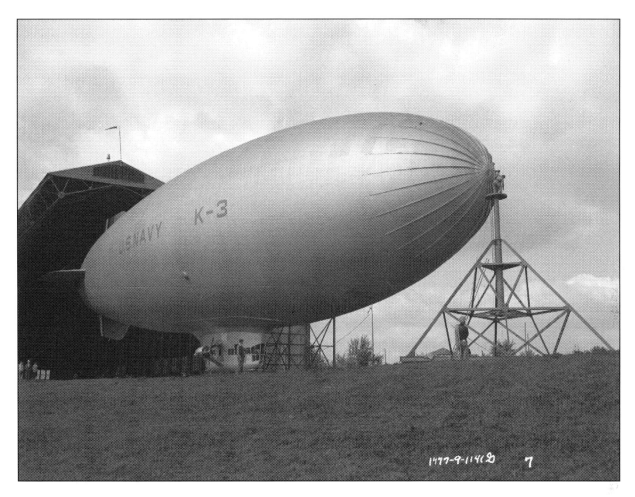

K-3 Blimp, 1941

The K-3, a US Navy K-class blimp built by Goodyear, sits moored to its mast outside the hanger at Wingfoot Lake. During the war, Goodyear produced 135 of the 251-foot, 425,000-cubic-foot capacity K-class blimps for the navy for patrol and anti-submarine warfare in the Atlantic and Pacific oceans and the Mediterranean Sea. The navy equipped them with radar, sonobuoys, magnetic anomaly detection equipment, depth bombs, and machine guns. The K-class blimps had a maximum speed of 78 miles per hour and a range of 2,200 miles. They demonstrated their long range in 1944, when two blimps completed the first transatlantic crossing by nonrigid airship.[25]

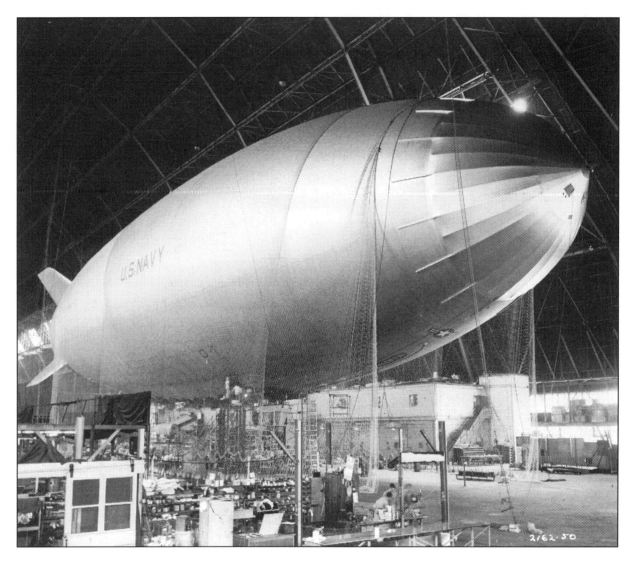

N-Type Airship, 1950
The first version of the N-class airship, designated ZPN-1, nears completion in the former Goodyear-Zeppelin Airdock at the Akron Municipal Airport, after World War II. This blimp launched a long line of navy N-type airships, the last Goodyear blimps utilized by the United States military. Photo by Tru Williamson.

Oh, the Humanity!

The Triumph and Tragedy of Goodyear Zeppelins

In addition to blimps, Goodyear earned fame by manufacturing rigid airships, commonly referred to as zeppelins.[26] After F. A. Seiberling left the company following its reorganization in 1921, Paul Litchfield championed the development of rigid airships in this country. In his treatise—*Why? Why Has America No Rigid Airships?*—Litchfield argued that "America is the only nation which can use airships" because "America is the only nation which has the safe, noninflammable helium gas." He concluded that "America must lead the world in air transportation. America should use rigid airships."[27] It is not surprising that, under Litchfield's leadership, The Goodyear Tire & Rubber Company gained distinction for their involvement in practically every early rigid airship venture in this country. They also have the honor of manufacturing the first and only American-built semi-rigid airship, the US Army's RS-1.[28] In the early 1920s, the company got started by assisting with the construction of the USS *Shenandoah* (ZR-1), the first rigid airship built in the United States and the first filled with helium as its lifting gas. The *Shenandoah* ended in disaster when it crashed in southern Ohio in 1925. However, this did not deter the navy's efforts to use rigid airships nor Goodyear's ability to build them.[29]

In the fall of 1923, the United States government arranged a partnership between The Goodyear Tire & Rubber Company and Luftschiffbau Zeppelin, which created the subsidiary Goodyear-Zeppelin Corporation. Through the Treaty of Versailles, the German-American agreement transferred the North American rights to the Zeppelin patents to Goodyear-Zeppelin along with the Luftschiffbau's key engineering personnel, headed by Dr. Karl Arnstein. The arrangement went into effect upon Luftschiffbau's delivery to the navy of its LZ-126 airship, later redesignated the USS *Los Angeles* (ZR-3).[30] Subsequently, Goodyear won a contract to manufacture two rigid airships for the US Navy, the USS *Akron* (ZR-4) and USS *Macon* (ZRS-5). The Goodyear-Zeppelin Corporation constructed them in the late 1920s and early 1930s in the Goodyear Airdock, which was built specifically for constructing and housing these giant airships. Considered the world's largest airships at that time, the navy used these dirigibles for endurance and training flights, search and rescue exercises, and tests of the spy basket and trapeze installation for in-flight handling of aircraft. Plagued by a number of problems, the *Akron* suffered three accidents before it crashed off the Atlantic coast in the spring of 1933. Its sister ship, the USS *Macon*, suffered a similar fate, crashing into the Pacific Ocean in the winter of 1935. The dramatic loss of the *Akron* and *Macon* contributed to the cancellation of the navy's rigid airship program, bringing to a close what author H. H. Harriman called "one of the most important chapters in the history of air navigation."[31]

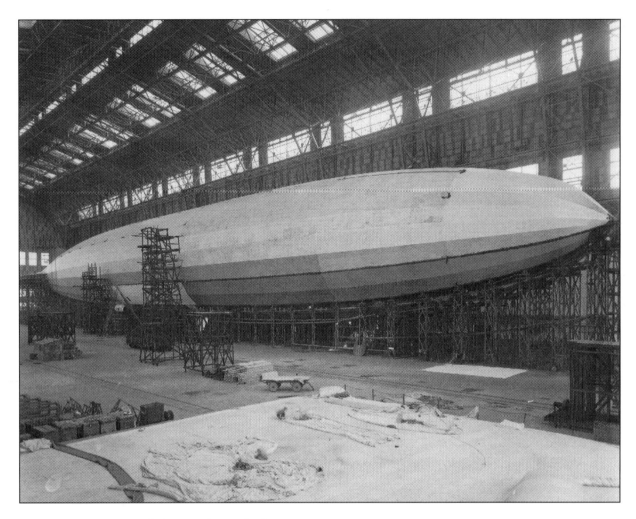

Construction of the USS Shenandoah, *ca. 1923*

The USS *Shenandoah* (ZR-1), the first rigid airship built in the United States, nears completion inside the massive airdock of the Naval Air Station in Lakehurst, New Jersey. Workers at the Naval Aircraft Factory in Philadelphia fabricated most of the parts of the enormous airship, while workers at Goodyear's Akron Plant made the airships 20 gas cells by cementing goldbeaters' skin (stomach linings of oxen) to BB grade cotton. The navy christened the airship the *Shenandoah*—a Native American word meaning "Daughter of the Stars"—in September 1923 and utilized it for fleet reconnaissance work.

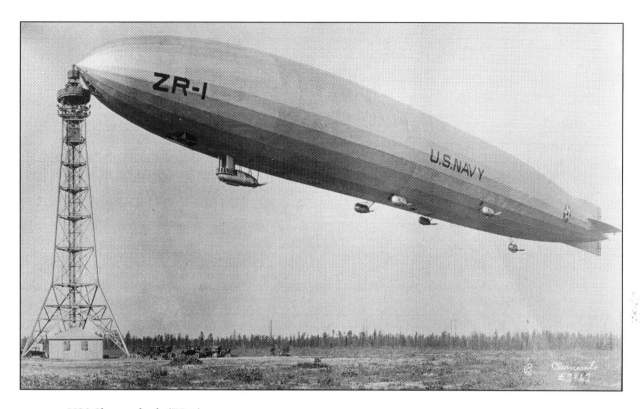

USS Shenandoah (ZR-1), 1924
The USS *Shenandoah* (ZR-1), the first rigid airship filled with helium as its lifting gas, floats majestically moored to its mast at the Naval Air Station in Lakehurst, New Jersey. The massive dirigible measured 680 feet long, 78 feet wide, and 90 feet high. In 1924, the airship made a lengthy transcontinental flight that covered more than 9,000 miles, the first flight of a rigid airship across North America. Photo by R. S. Clements.[32]

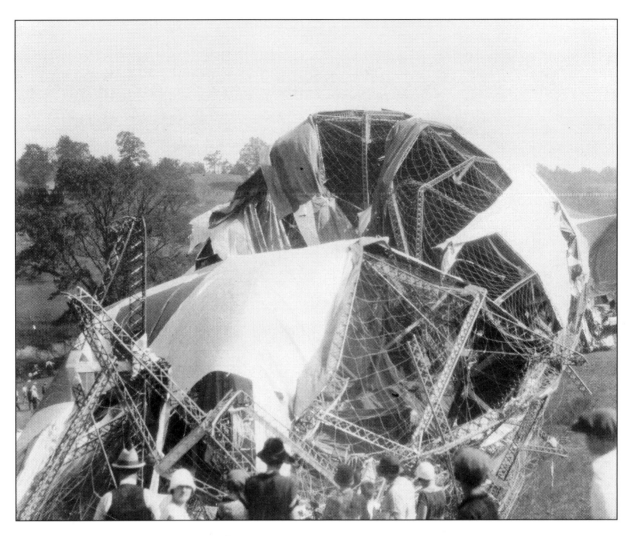

Wreck of the USS Shenandoah, *1925*
Throngs of onlookers observe the twisted, tangled mess of framing and fabric of the USS *Shenandoah*. After encountering thunderstorms and breaking apart in midair on a promotional tour of the Midwest, the once-mighty airship crashed in this valley in Noble County, Ohio, on September 3, 1925, killing 14 of its 43 crew members. The navy convened a court of inquiry into the crash and concluded that it was not due to human error or any lack of care or inspection in its manufacture and fabrication, but rather to "external aerodynamic forces arising from high velocity air currents." The *Shenandoah* catastrophe led to several changes in the design and construction of rigid airships to improve their safety.[33]

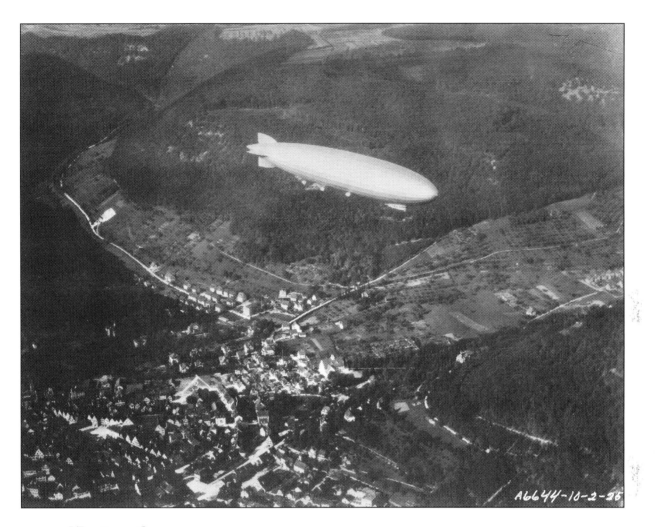

LZ-126 over Germany, 1924

The LZ-126, later renamed the USS *Los Angeles* (ZR-3), soars over Germany on a trial flight before crossing the Atlantic and being delivered to the US Navy for war reparations. The Luftschiffbau Zeppelin Company built the dirigible in Friedrichshafen, Germany, from 1923 to 1924. At 658 feet long and 104 feet tall, with a gas volume of 2,470,000 cubic feet, it was the world's largest aircraft when first flown. A dozen Luftschiffbau engineers under the leadership of Dr. Karl Arnstein emigrated to Akron, Ohio to form the nucleus of the newly created Goodyear-Zeppelin Corporation.[34]

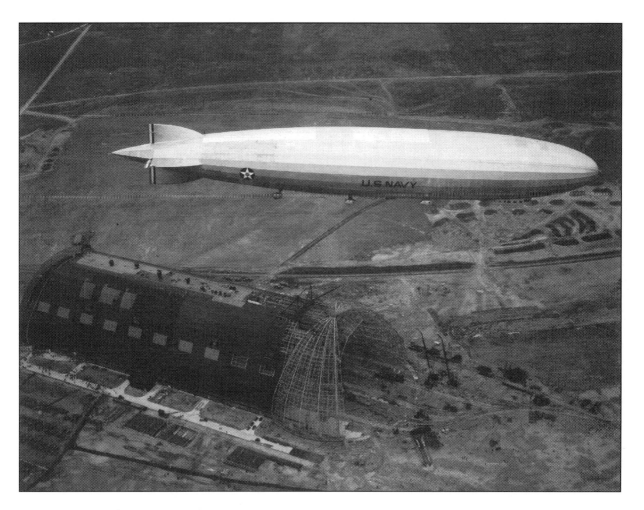

Los Angeles over Airdock, 1929
The USS *Los Angeles* with its navy insignia flies over the nearly completed Goodyear Air-dock in Akron during the ring-laying ceremonies for the USS *Akron*. The navy used the *Los Angeles*, which had a range of 5,400 miles, as an experimental and training ship. After logging 4,398 flight hours, covering a distance of 172,400 nautical miles, and making the first nonstop flight from New York to Panama, the navy decommissioned and dismantled it in 1939, thus ending the career of the navy's longest serving airship and the only American rigid airship that did not end in disaster.[35]

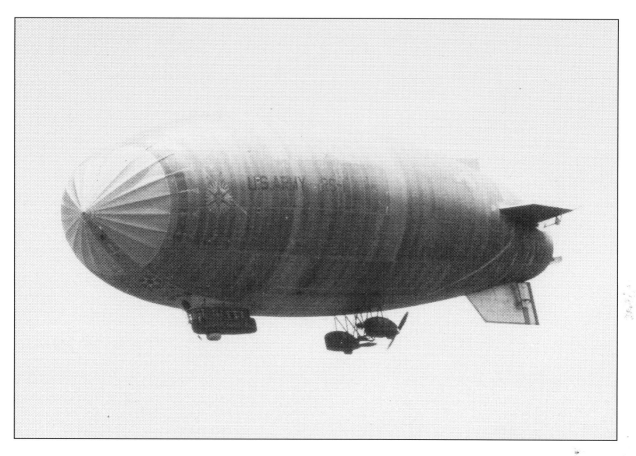

RS-1, 1926

The US Army's RS-1, manufactured by Goodyear in Akron in 1925, sails through the sky. It existed as the first and only American-built semi-rigid airship at that time. The army operated the 720,000-foot airship during the late 1920s until the requirement for a new envelope grounded the ship and resulted in it being scrapped. Semi-rigid airships quickly lost popularity as critics lambasted them, so Goodyear did not construct any other airships of this type. Photo by Carsten H. Barnstorff.

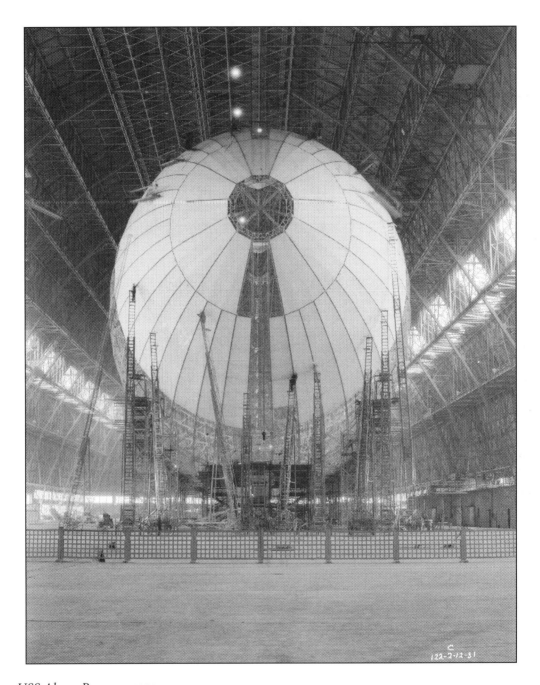

USS Akron Progress, 1931
Goodyear-Zeppelin workers atop 85-foot-high, multi-extension, rolling Magirus ladders apply the cotton fabric skin over the duralumin frame of the giant USS *Akron* (ZRS-4) in the Goodyear Airdock. The second rigid airship built in the United States, this helium-filled dirigible measured 785 feet long by 146 feet high, and had a gas volume of 6,500,000 cubic feet (about two and a half times larger than the *Los Angeles* and twice the gas capacity of the *Graf Zeppelin*).[36]

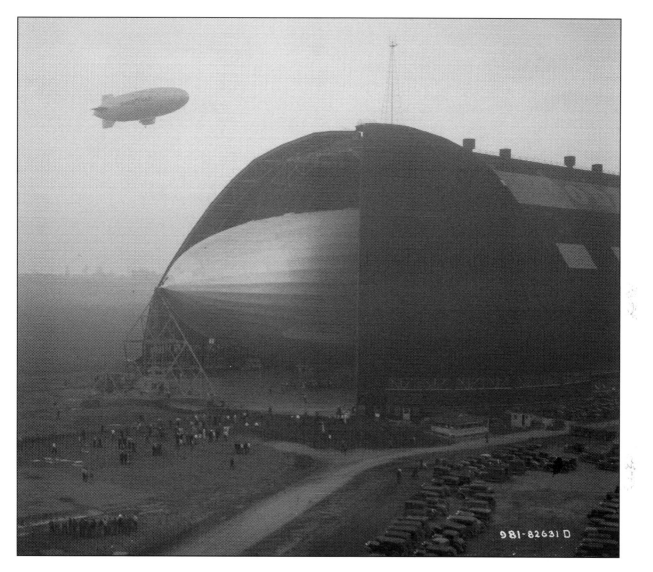

USS Akron in Airdock, 1931

The USS *Akron* emerges from its "cocoon" for the first time in the late summer of 1931, after its christening by First Lady Lou Henry Hoover. Crowds of onlookers came out to witness the event as a Goodyear blimp flew overhead. A team of experienced German airship engineers, led by Dr. Karl Arnstein, constructed the airship over an 18-month period. The *Akron* included features never before incorporated in airships, including a fleet of planes carried in its belly.[37]

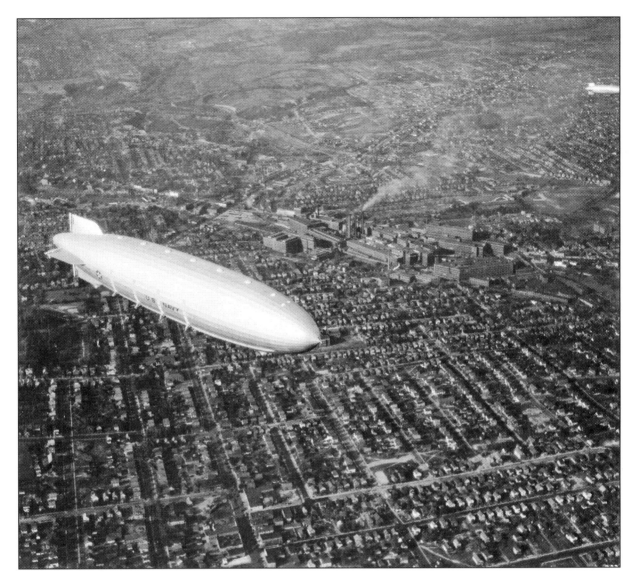

USS Akron over Factories, 1931

The USS *Akron* takes part in one of many trial flights in the late summer of 1931 as it soars over the sprawling Goodyear factories in Akron. During her accident-prone 18-month term of service, the *Akron* logged a series of endurance, training, and test flights. After encountering severe weather off the coast of New England, the mighty airship crashed in the Atlantic Ocean on April 3, 1933, killing 73 of its 76 crew members. This signaled the beginning of the end for the rigid airship in the US Navy.[38]

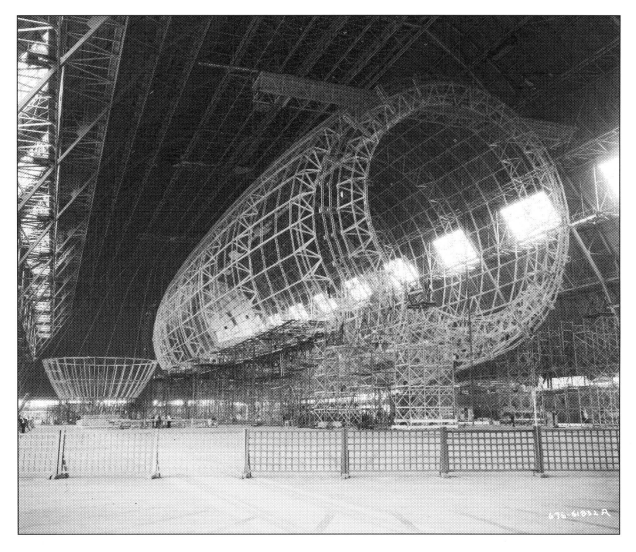

ZRS-5 Progress, 1932

Workers at Goodyear-Zeppelin construct the duralumin hull of the USS *Macon* (ZRS-5) at the Goodyear Airdock. While very similar to its sister ship, the *Macon* (named after the city of Macon, Georgia, the largest city in the congressional district of Carl Vinson, then chairman of the House of Representatives Naval Affairs Committee) had several changes, mostly to improve efficiency and reduce weight. The *Macon* and her sister ship were among the largest flying objects in the world in terms of length and volume.[39]

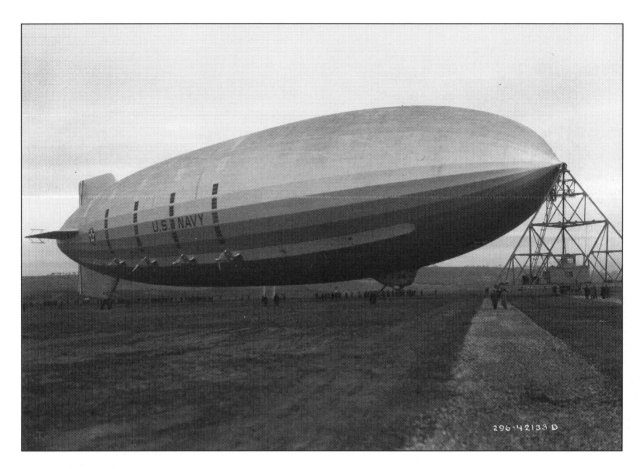

First Macon Trial Flight, 1933
The USS *Macon* moored to its mobile mast on the airfield in Akron, Ohio, right before its first trial flight in the spring of 1933. After six weeks of trials, the US Navy commissioned the *Macon* on June 23, 1933. The next day, the colossal dirigible left for the Naval Air Station in Lakehurst, New Jersey, where the navy based it for the summer while undergoing a series of training flights. On October 12, 1933, the *Macon* departed on a transcontinental flight to its permanent home at Sunnyvale, California. The navy used it for scouting and as a flying aircraft carrier, as Curtiss F9C Sparrowhawk biplane fighters could be launched from its belly. Photo by Tru Williamson.[40]

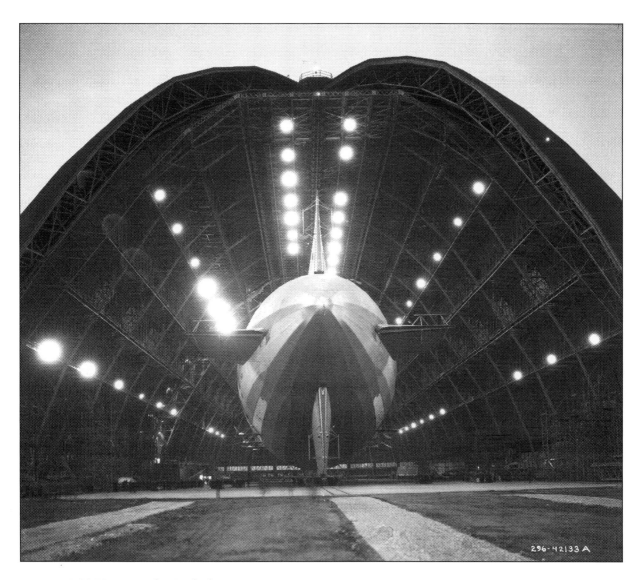

USS Macon in the Airdock, 1933
A view of the tail of the USS *Macon* (ZRS-5) as it sits in the Goodyear Airdock. Although the *Macon* had a far more productive career than its sister ship (it completed 50 flights), disaster struck on its return from Sunnyvale from fleet maneuvers. The mighty airship encountered a storm off Point Sur, California, and crashed and sunk in Monterey Bay on February 12, 1935, killing two of its 76 crew members. The dramatic loss of the *Macon* and its sister ship, *Akron,* within two years of each other contributed to the cancellation of the navy's rigid airship program. Photo by Tru Williamson.[41]

Rail Cars and Sky Cars

Goodyear-Zeppelin's Other Products

After the terrible losses of the Goodyear-Zeppelin dirigibles *Akron* and *Macon*, The Goodyear Tire & Rubber Company found no further customers for its rigid airships. Uncertain of the future of the subsidiary, the parent company explored other ways to make the Goodyear-Zeppelin Corporation viable and profitable. The company's engineers and designers worked together to develop several projects that built on their previous work in light metal alloys, structural engineering, and experimental transportation. This included the design and manufacturing of a ride for the Chicago World's Fair and a lightweight, high-speed, streamlined articulated train for passenger service in urban areas.[42]

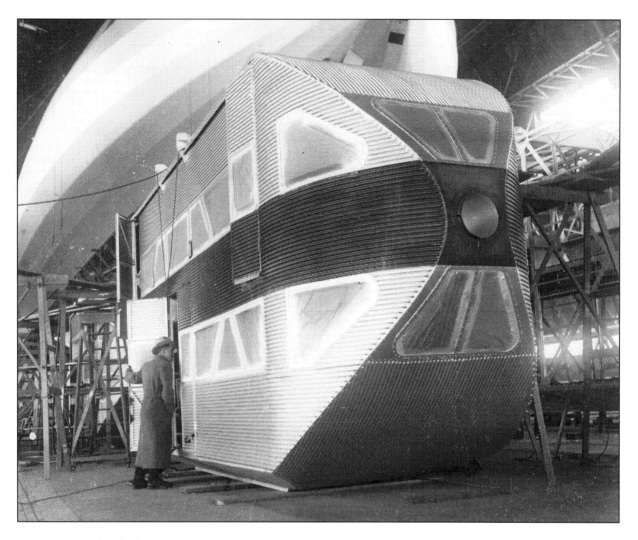

Completed Sky Car, 1933
A Goodyear-Zeppelin employee inspects one of the 12 double-decker "sky cars," or "rocket cars," the subsidiary built in the Akron Airdock for the Sky Ride at the Century of Progress Exposition in Chicago. The nearly completed USS *Macon* can be seen in the background. The Sky Ride, a transporter bridge or aerial tramway, carried fairgoers from one end of the exposition to the other. With a 1,950-foot span between two 628-foot-high towers—higher than any skyscraper in the "Windy City" at that time—the ride was called one of the fair's "most popular and prominent features."[43]

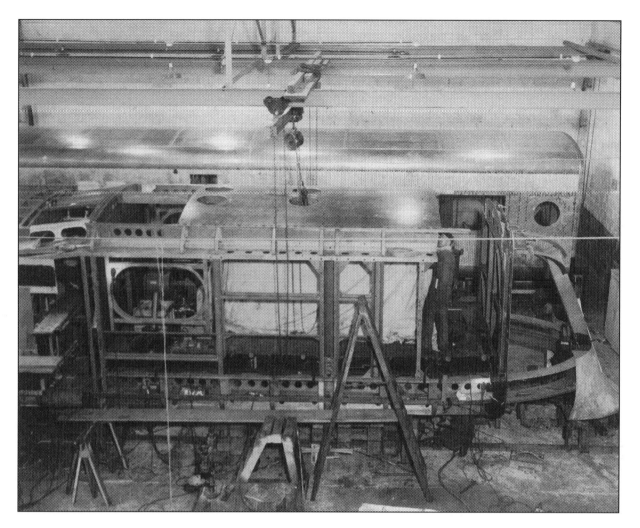

Construction of Rail-Zeppelin, 1935

Goodyear-Zeppelin employees in Akron's Plant III construct cars for the Rail-Zeppelin, a lightweight, high-speed, streamlined, articulated train that incorporated the design features of rigid airships. While it competed with other high-speed trains at the time, such as the Budd Company's "Pioneer Zephyr" and "Flying Yankee" and the German "Flying Hamburger," the Rail-Zeppelin had many distinct advantages. This included an aluminum alloy frame that provided strength while reducing weight and the incorporation of rubber insulation, pads, and hydraulic shock-absorbing equipment.[44]

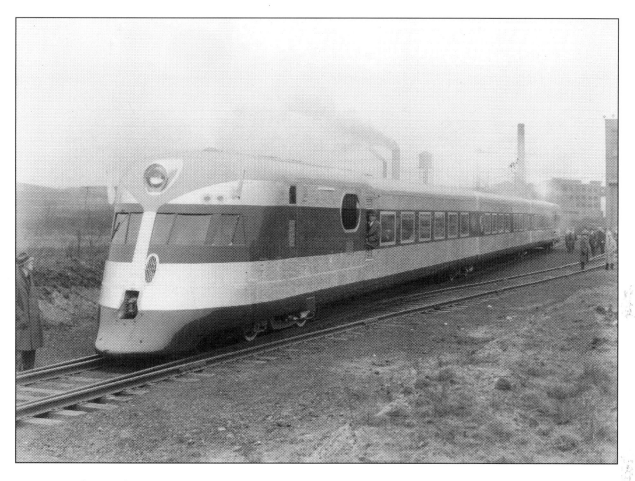

Rail-Zeppelin Test Run, 1935

Goodyear executives view the Rail-Zeppelin during a test run behind the Goodyear Airdock in Akron. Later dubbed "the Comet," the 207-foot-long train incorporated innovations such as engines at each end, which allowed the train to be operated from either side and prevented turnarounds. The New York, New Haven & Hartford Railroad put the first Comet into service in 1935 for rapid transportation between New England cities. While railroad executives were pleased with its performance and other railroads were interested in acquiring them, no additional orders were received—most likely due to its exorbitant price—leading the subsidiary to discontinue the project.[45]

Notes

1. Karl Arnstein, "A History of the Airship," n.d., *Karl Arnstein Papers* (hereafter Arnstein Papers), UA Archives.

2. Lennart Ege, *Balloons and Airships* (New York: Macmillan, 1974), 12.

3. C. J. Hylander, *Cruisers of the Air* (New York: Macmillan, 1931), 112.

4. For information on the early history of airships see Hylander, *Cruisers*, 87–119; Ege, *Balloons*, 129–144; and Basil Collier, *The Airship: A History* (New York: G. P. Putnam's Sons, 1974), 28–51.

5. According to A. D. Topping, "pressure airships is a term used to describe those airships whose shape is dependent on having a higher pressure inside the gas envelope than is found in the atmosphere outside." See A. Dale Topping, *When Giants Roamed the Sky: Karl Arnstein and the Rise of Airships from Zeppelin to Goodyear*, ed. Eric Brothers (Akron, OH: The University of Akron Press, 2001), 268.

6. "Details of the Airship 'Akron,'" n.d., MS, GR.

7. "Our Airship; Akron Makes Trial Flight at Atlantic City," *WC*, June 15, 1912.

8. For a history of Goodyear's blimps see Zenon Hansen, *The Goodyear Airships* (Bloomington, IL: Airship International Press, 1977); and Hugh Allen, *The Story of the Airship*, Chicago: R. R. Donnelley & Sons, 1943.

9. "F. A. Seiberling Tells of First Akron Airship," n.d., MS, GR.

10. James R. Shock, *US Navy Airships, 1915–1962* (Edgewater, FL: Atlantis Productions, 2001), 13–18.

11. See "The Crash of the Wingfoot Air Express," *Chicago Tribune Magazine*, n.d.; "Akron Aviation Leaders Figure in New Series," *ABJ*, June 10, 1979; "Akron Men Are First on Caterpillar Roll!," *ABJ*, June 3, 1930; and Zenon Hansen, 1. For information on the Chicago hanger see James R. Shock, *American Airship Bases & Facilities* (New Smyrna Beach, FL: M & T Printers, 1996), 106.

12. "Macon's Grandpa Never Flew Here," *ATP*, November 17, 1933.

13. See "A Fleet of Miniature Airships," *The Meccano Magazine* (n.d.): 781–782; Art Ronnie to Clyde Schetter, March 26, 1964, GR; "A Pony Blimp for Commercial Use," *Scientific American* (April 24, 1920): 459; and Zenon Hansen, "The History and Development of Goodyear Commercial Nonrigid Airships," *Wingfoot Lighter-Than-Air Society Bulletin* (September 1969).

14. See James R. Shock, *US Army Airships, 1908–1942*, 35; and *Air Service News Letter*, March 5 and April 14, 1923.

15. See Shock, *US Navy Airships*, 35; and Roy A. Grossnick, ed., *Kite Balloons to Airships: The Navy's Lighter-Than-Air Experience* (Washington, DC: Naval Air Systems Command, 1987), 18–23.

16. See "Data on Airship *Pilgrim*," 1935, MS, GR; "Dirigible Lands on O'Neil Store Roof," *ABJ*, June 20, 1928; W. F. Knight, "Trip Report: *Pilgrim* Airship Exhibit, Smithsonian Institute," 1954, MS, GR; "Goodyear Blimp *Pilgrim* Discarded," *ABJ*, July 8, 1932; and Hansen, *Goodyear Airships*, 10–11.

17. See "Blimp Makes Start for Kentucky Derby," *ABJ*, May 17, 1929; "Blimp Trip Scheduled," *Akron Sunday Times* (hereafter *ST*), June 26, 1932; H. Webster Crum, "Report Covering Loss of Nonrigid Airship *Puritan*," May 3, 1935, MS, GR; "Storm Batters Blimp *Puritan*," *ABJ*, September 22, 1938.

18. See "Newest Blimp to Perform on Pacific Coast," *ATP*, May 7, 1929; "Prevailing Winds from West Hooey, Says *Volunteer* Pilot," *ST*, May 1, 1932; "*Volunteer* to Be Dismantled," *ST*, October 29, 1939; "Sea-to-Land Mail Delivery; Blimp Beats Ship to Shore," *Los Angeles Examiner*, June 13, 1931; and K. L. Lange to Karl L. Fickes, February 4, 1930, GR.

19. See the following *ST* articles: "Miss Earhart Drops Pen to Christen Blimp," August 31, 1929; "Plan to Increase Capacity of Blimp," September 30, 1929; "6th Goodyear Blimp to Take Air This Week," August 18, 1929; and "Size of Blimp Appeals to Navy," September 1, 1935. See also "Defender 1931 Summary," n.d., MS, GR.

20. See "Christening Rites Planned for Blimp," *ABJ*, May 20, 1929; "Flight Handbook Goodyear GZ-19 Airship," n.d., MS, GR; "'Mayflower' Blimp Off for Lakehurst," *ABJ*, June 22, 1929; "Loans Akron Zep for Radio and Air Study," *Cleveland Plain Dealer*, June 25, 1929; "Both Nantucket Island Families Greet Dirigible," *ABJ*, October 19, 1929; "Storm-Tossed Blimp Burns, Two Injured," *ATP*, July 13, 1931; "'Mayflower' Leaves Navy Saturday," *ABJ*, April 23, 1947; and "Background Data, Airship Mayflower," n.d., MS, GR.

21. See the following *ABJ* articles: "TC-13 for Army," December 28, 1932; "Army Blimp Embodies Latest in Construction and Equipment," March 31, 1933; "Army Blimp Flies on Second Tests," May 4, 1933; and "Akron-Built Non-Rigid Airship Cruising Up and Down Atlantic Coast Relegates Fort to Secondary Defense," June 22, 1933. See also "Largest Blimp Ever Constructed in US to Be Tested over Akron," *ATP*, September 5, 1932.

22. See the following *ABJ* articles: "'Enterprise,' New Goodyear Blimp, Makes Trial Flights," August 25, 1934; "Blimp 'Enterprise' Put Into Navy Service," September 10, 1941; "Blimp's Errand of Mercy," February 12, 1936; "'Enterprise' Back in Capital," May 23, 1935; and "Blimp Primps for Miami's Skies," March 30, 1958. See also "Blimp 'Enterprise' Gets Navy Discharge Today," *ATP*, May 14, 1947; and "Enterprise," n.d., MS, GR.

23. See C. T. Hutchins to J. Boettner, September 9, 1929, GR; H. Webster Crum to Frank Petrie, October 25, 1939, GR; "Tiny Blimps Carry Flying Electric Signs," *Popular Science* (November 1939): 130–133; and "Blimp Arrives Here to Begin Daily Flights," *Washington Herald*, November 16, 1938. See also the following *ABJ* articles: "Sixth Blimp Is Christened," April 29, 1932; "Familiar Akron Ships 'Enlist' for Sub Patrol," March 3, 1942; "Goodyear Blimp Ordered to Flood Area," January 29, 1937; and "Goodyear Resolute Now in New York," May 21, 1934.

24. See "Goodyear Blimp Soon Will Rise," *ABJ*, March 10, 1940; and James R. Shock and David R. Smith, *The Goodyear Airships* (Bloomington, IL: Airship International Press, 2002), 108–109. For information on the Navy Type L airships see Goodyear Aircraft Corporation (hereafter GAC), "Final Specifications for Navy L-2 and L-3 Airships," September 3, 1941, Lockheed Martin Tactical Defense Systems Records (hereafter Lockheed Records); and GAC, "United States Navy L-Type Airships: Descriptive Specifications," July 1943, Lockheed Records. See also Larry Engelmann, "The Ghost Blimp," *Life Magazine* (July 1982), 81–90; "Akron Blimp Visits 96 Cities in US" *ABJ*, February 16, 1947; and "Blimp Primps for Miami's Skies," *ABJ*, March 30, 1958.

25. Allen, *Story of the Airship*, 69. For information on the Navy K-Type airships see GAC, "United States Navy Type-K Airships: Descriptive Specifications," September 1942, Lockheed Records, UA Archives.

26. Topping defines rigid airships as an "airship whose shape is maintained by an internal framework and whose lifting gas is contained by a separate gas cell or cells within that structure." This is in contrast to the nonrigid airships or blimps, also known as pressure ships, which have a single layer of specially treated fabric that holds the bag to shape only if sufficient pressure exists inside. Topping, *Giants,* 268.

27. Paul Litchfield, *Why? Why Has America No Rigid Airships?* (Cleveland, OH: Corday & Gross, 1945), 28, 142.

28. Topping defines a semi-rigid airship as "an airship with a rigid keel but whose envelope is maintained by gas pressure." Topping, *Giants,* 268

29. See "Recalls Crash of *Shenandoah*," *ATP*, March 4, 1933; and "Findings by the Court of Inquiry on the Loss of the *Shenandoah*," n.d., MS, GR.

30. "Proposal: 'Los Angeles' Commercial Operations; Training, Experiments and Demonstrations," n.d., report, Arnstein Papers.

31. For more information on the *Akron* and *Macon* see H. H. Harriman, ed., USS *Akron* and USS *Macon: World's Largest Airships* (Akron, OH: Akron Typesetting Company, 1931).

32. See "Navy Pins Faith on ZR-1 Even for Flight to Pole," *The New York Herald*, August 19, 1923; and "*Shenandoah* Festival Rekindles Airship Memories," *ABJ*, June 28, 1975.

33. See note 29 above.

34. Richard K. Smith, *The Airships Akron & Macon: Flying Aircraft Carriers of the United States Navy* (Annapolis, MD: Naval Institute Press, 1965), 7.

35. See "Los Angeles," n.d., MS, GR; and "Navy Airship Made History 28 Years Ago," *Navy Times*, March 4, 1959.

36. See "USS *Akron* Gives Our Citizens Thrill," *Akronian* (September 1931): 2; and "Zepp Moors, Takes Berth at Lakehurst," *ABJ*, October 28, 1931.

37. See Karl Arnstein, interview by Hugh Allen, n.d., Arnstein Papers; and "Fleet of Planes Will Nest in 'Akron' to Meet Attack," *ABJ*, September 21, 1931. For information on the USS *Akron* see Goodyear, "USS *Akron*," n.d., MS, Maynard L. Flickinger Papers (hereafter Flickinger

Papers), UA Archives; and "Airships (USS *Akron* and *Macon*)," n.d., MS, Floyd Hamilton Fish Papers, UA Archives.

38. See "The *Akron* and the *Macon* and an Era Died," *ABJ*, February 13, 1966; and Lynwood Mark Rhodes, "The Night the *Akron* Crashed," *American Legion Magazine* (August 1966): 16.

39. See the following *ABJ* articles: "$1,450,000 Asked For ZRS-5 Work," December 10, 1931; "*Macon* to Differ From Sister Ship," July 11, 1932; "USS *Macon* Gets Its First Engine," November 13, 1931; "'Macon' Defending Fleet in 'Battle," March 11, 1934; "To Land About 6 P.M.," April 21, 1933. See also "*Macon*, New Air Queen, Is Harbinger of Peace," *ST*, February 21, 1932.

40. See the following *ABJ* articles: "15,000 Brave Snowstorm to See *Macon* Christening," March 12, 1933; "Crowd Tense As Ship Flies," April 21, 1933; "*Macon* Locked in the Cup," April 22, 1933; "Officers Praise *Macon* Voyage," April 22, 1933; "Ship Leaves City Tonight," June 23, 1933; and "USS *Macon* Roars Way to California," October 13, 1933.

41. See the following *ABJ* articles: "Fin Loosened Says Officer," February 15, 1935; "Wiley Relates Vivid Story of *Macon* Crash," February 13, 1935; "Ola Bishop Sees Thrilling Rescue of Macon's Airmen," February 14, 1935; and "Naval Board Meets on West Coast While Congressional Probes Get Under Way," February 14, 1935. See also "Silence Greets *Macon* Findings," *ATP*, February 22, 1935; "Failure to Repair *Macon* Responsible for Crash Rosendahl Tells Probe," *ST*, August 1, 1937; R. G. Mayer, "USS *Macon*" (speech, Los Angeles Chamber of Commerce, Los Angeles, CA, January 23, 1934), GR; Special Committee on Airships, "Report No. 3: Technical Aspects of the Loss of the *Macon*," January 30, 1937, report, Flickinger Papers; "Hearings Before a Joint Committee to Investigate Dirigible Disasters," May 22–June 6, 1933," report, Flickinger Papers.

42. See Kristan Hanson and Mary Woolever, "Greater, Better, More Glorious: Documenting the Century of Progress Exposition," *Art Institute of Chicago Museum Studies* 34, no. 2 (2008): 81–83; and "A First in Railroad Industry," *WC*, August 20, 1964.

43. For information on the exposition see Lowell Tozer, "A Century of Progress, 1833–1933: Technology's Triumph over Man," *American Quarterly* 4, no. 1 (Spring 1952): 78–81.

44. Karl Arnstein to C. A. Stillman, January 8, 1935, GR.

45. See "Goodyear Builds Streamlined 'Rail-Zeppelin," 1935, MS, GR; The Goodyear-Zeppelin Corporation, "Prospectus: The Goodyear Rail Zeppelin," ca. 1934, MS, GR; "Abstract from article entitled 'Operating Experience with the New Haven Comet' by P. H. Hatch," n.d., MS, GR; H. D. Hoskins, "New York, New Haven & Hartford Railroad Train Estimated Out-of-Pocket Loss," March, 19 1935, MS, GR; Harry Vissering to Paul Litchfield, June 26, 1935, GR; Paul Kutta, "The New Haven's 'Comet," *Railroad Enthusiasts Bulletin* (January 1964): 3; and P. W. Litchfield to E. J. Thomas, March 15, 1935, GR.

Chapter 4

Up, Up, and Away

Goodyear Balloons for War, Recreation, and Exploration

"Scientific testing, more than advertising, was the main thrust of everything the Goodyear Corporation did in the...balloon contests. What we learned, sometimes painfully, was directly applied to the construction of the great airships."[1]
—*Ward T. Van Orman, Goodyear Balloon Pilot*

Stories of flight date back to the ancient Greeks with the myth of Icarus and Daedalus, who attempted to escape from the labyrinth by flying with wings made of feathers and wax. In the third century BC, China experimented with small hot air balloons known as sky lanterns and claimed the first successful flight. In 1250, Englishman Roger Bacon wrote about flying contraptions such as the ornithopter in his book, *Secrets of Art and Nature*. Soon thereafter, Leonardo da Vinci created sketches depicting flying machines such as fixed-wing gliders and rotorcraft; however, these machines—while imaginative—were impractical.[2] It was not until 1709 that Brazilian priest Bartolomeu de Gusmão made the first documented balloon flight in Europe, followed by the Montgolfier brothers in France during the mid-eighteenth century. But 1783 is the year that aviation historians consider "a watershed year for ballooning"[3] because of its many firsts, such as the first public hot air balloon demonstration and the first manned hot air balloon flight. The French and English subsequently experimented with different lifting gases such as hydrogen, as well as various balloon materials, including goldbeaters' skin. The first reported military implementation of balloons was by the French during the Battle of Fleurus and the Siege of Mainz, in 1794 and 1795, respectively, while the first American usage was during the Civil War. By the early 1900s, ballooning had become a popular sport.[4] Throughout the company's history, Goodyear produced thousands of balloons of differing types, including free, observation, barrage, stratosphere, advertising, and figure balloons.

The Goodyear Photograph Collection captures feats of design and engineering—from character balloons that put smiles on the faces of the young and the old around the world to stratosphere balloons that explored the far reaches of the atmosphere. Throughout the collection are images of free balloons and the national and international balloon races they competed in, as well as the brave pilots who flew them. The parade balloon images show

parades and celebrations that occurred throughout the country in the twentieth century and depict city streets and historic architecture in places such as New York City, Newark, and Pasadena. They also show some of the famous popular culture characters, as well as balloons made for the military, in stunning black and white. This includes the kite and barrage balloons that helped the Allies during both world wars.

Going Where the Wind Blows

Goodyear Free Balloons for War and Recreation

Throughout its history, The Goodyear Tire & Rubber Company produced hundreds of free balloons, meaning they were untethered to the ground. The company tested them in national and international balloon races in the early twentieth century. Generally spherical in shape, these balloons were made from rubberized fabric, varnished linen, or cotton. The balloons had a net that led down to a suspension ring which had ropes to support a basket underneath.[5] The military and sportsmen alike employed the balloons for free ballooning, which US Navy Commander Walter W. Boyd defined as "the technique of flying a motorless lighter-than-air craft using only the wind for power."[6] Direction and distance of the flight of a free balloon depended upon wind currents and atmospheric conditions, as well as the pilot's experience and knowledge of meteorology. Although C. H. Roth, chief instructor of free ballooning at the Goodyear Balloon School, called free ballooning "the most thrilling of all aeronautic sports,"[7] it was also one of the most dangerous.

Free ballooning dates back to 1306 when a Chinese balloon took off from Peking. The French later perfected the art of free ballooning in the late 1700s, led by the Montgolfier brothers. According to author and ballooning authority Jack Finger, free ballooning experienced its heyday from the early 1900s until the 1930s. In 1910, Goodyear sent two technical men to Europe to gather as much information as possible on the design and construction of balloons. When they returned, the company developed a balloon fabric that demonstrated a lighter and more gastight quality than the European versions. Shortly thereafter, Goodyear took orders for balloons, and in 1913, the company entered their own team in the international balloon race for the first time, later going on to win national and international races.[8] While participating in the competitions, the company trained blimp pilots and acquired knowledge that it applied to dirigibles, for as Hugh Allen states, "Ballooning has long been the indispensable primary training for airship pilots."[9]

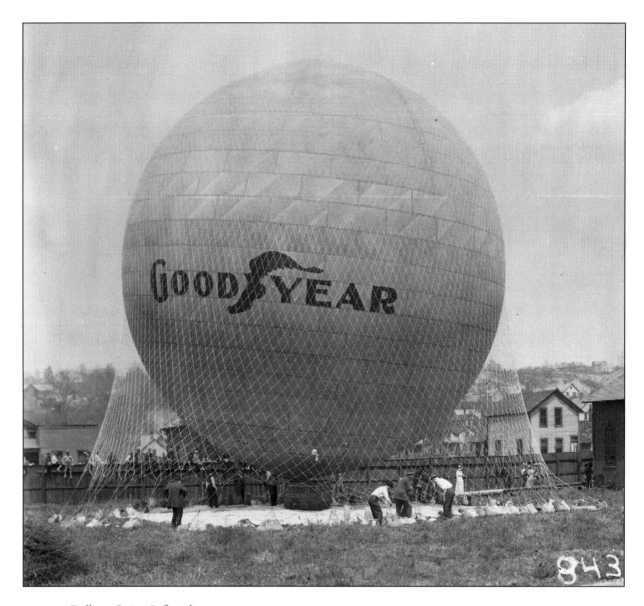

Balloon Being Inflated, 1912

Goodyear employees inflate the 80,000-cubic-foot spherical balloon simply known as *Goodyear* outside the factory in Akron. In 1913, the company entered their own team in the international balloon race, also known as the Gordon Bennett Cup, named after the millionaire American newspaper publisher who sponsored the event. Recognized as the world's oldest and most famous balloon race, the goal of the contest was to fly the furthest distance from the launch site. That year, Ralph H. Upson and Ralph Albion Drury (R. A. D.) Preston piloted the *Goodyear* to victory with a distance of 384 miles. The contest ran from 1906 to 1938—except for 1914 to 1919, during the First World War, and in 1931 due to inclement weather. The committee suspended the race in 1939 when Nazi Germany invaded the host country, Poland, starting World War II.[10]

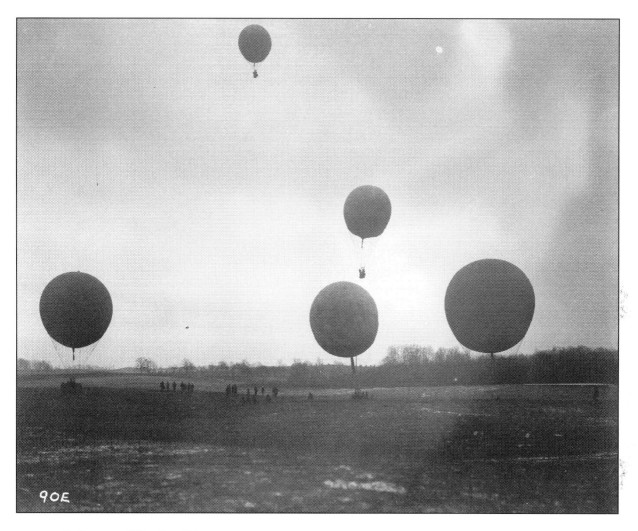

Balloons at Wingfoot Hangar, 1917

Several balloons take flight at Wingfoot Lake in Suffield, Ohio. During World War I, cadet officers of the army and navy flocked to Wingfoot Lake to receive flight instruction from Goodyear instructors. Eventually, Wingfoot Lake became known as the "Kitty Hawk of lighter-than-air" because of its significance in training pilots and establishing a lighter-than-air presence for the country.[11]

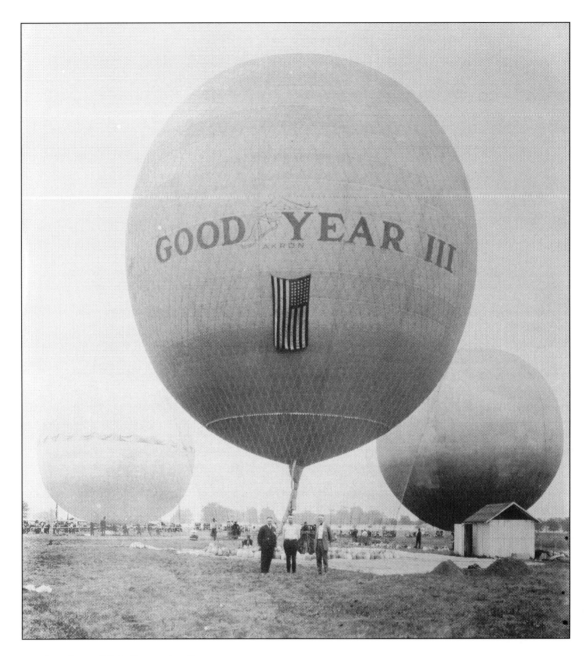

Goodyear III Balloon, April 23, 1924
Goodyear's renowned team of balloon pilots Ward T. Van Orman and Carl K. Wollam pose in front of the *Goodyear III* before the 1924 National Balloon Race in San Antonio, Texas. Van Orman, an American engineer, inventor, balloonist, and lifelong Goodyear employee, amassed an unprecedented record by winning five national balloon races and three international Gordon Bennett races, earning him the titles of "the best known name in ballooning" and "the world's greatest balloonist."[12] A year after this race, Paul Litchfield created the Litchfield Cup trophy to "stimulate interest in American ballooning."[13]

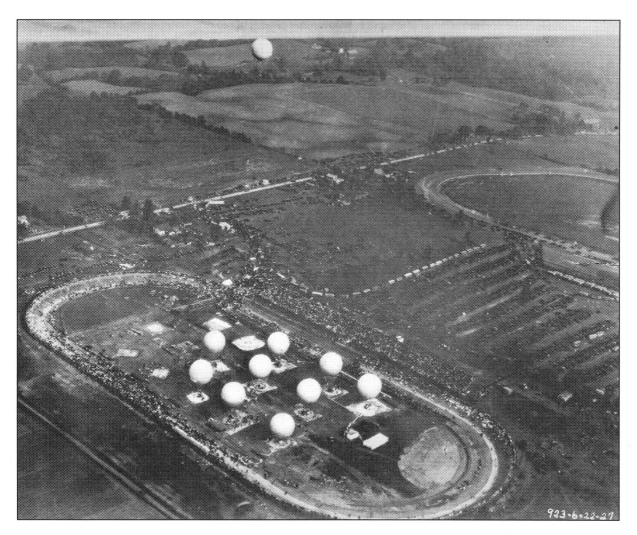

National Balloon Race, Akron, Ohio, 1927

Balloons ready for ascent from a racetrack north of Akron, Ohio at the National Balloon Race. Van Orman won the race with Walter W. Morton, traveling 718 miles in the *Goodyear IV* from Akron to Hancock, Maine. With this victory, Van Orman became the first and only person to win four years in a row. An unprecedented event, the Akron race had 15 entrants, making it the largest event of its kind in the United States to date. Goodyear manufactured 11 of the 15 balloons that appeared in the race. The National Balloon Races took place between 1909 and 1936, with no race held from 1917 to 1918 due to World War I, nor in 1933 or 1935 due to the Great Depression.[14]

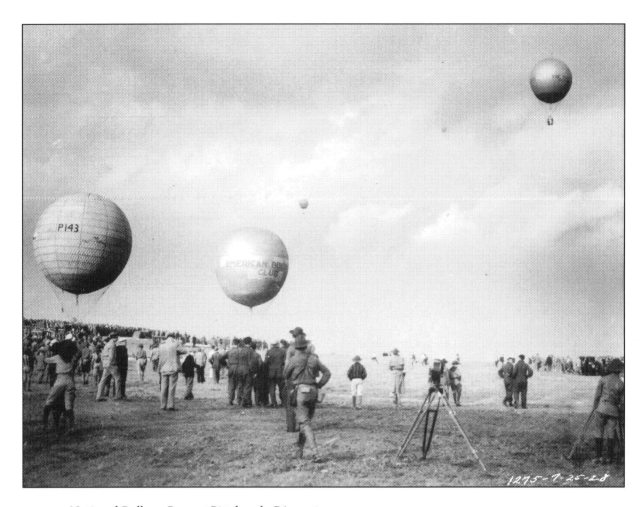

National Balloon Race at Pittsburgh, PA, 1928

The National Balloon Race in Pittsburgh, Pennsylvania, on May 30, 1928, was one that sur-
viving pilot Ward T. Van Orman would consider "the most disastrous day in ballooning his-
tory."[15] A thunderstorm began shortly after the competition started, and lighting struck two
balloons, including the *Goodyear V*, piloted by Van Orman and Walter W. Morton. Although
the direct hit killed Morton instantly, the unconscious Van Orman rode the balloon to the
ground, surviving with only a fractured leg. The accident led to a number of proposed rule
changes for national and international races to improve safety for pilots.

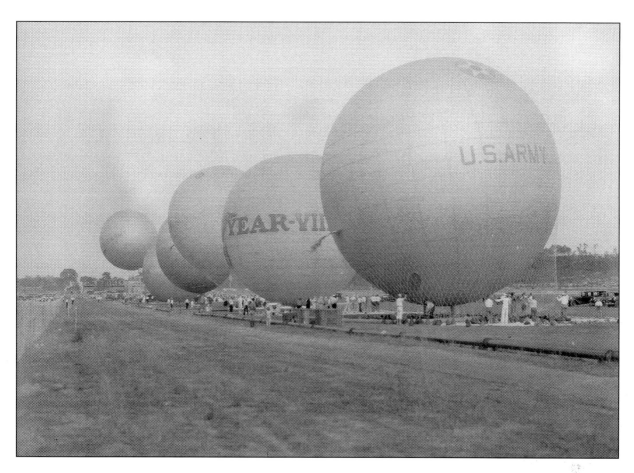

National Balloon Race, 1931

The competitors in the 1931 National Balloon Race ready their balloons for launch from the Akron Municipal Airport in Akron, Ohio. This included the 53-foot diameter, 80,000-cubic-foot *Goodyear VIII*—one of the most victorious racing balloons in history and the first to use a lightning arrester of Van Orman's design. There were only six entrants in the competition, as participation dwindled during the race's later years. The final national race took place on Independence Day 1936 in Denver, Colorado, where the Goodyear team of Frank A. Trotter and Verner L. Smith won in the *Goodyear X*.[16]

Behind Enemy Lines

Goodyear Observation Balloons in the World Wars

Many nations employed observation balloons during the world wars as aerial platforms on land and at sea, which were used for gathering intelligence and spotting artillery. This began during the French Revolutionary Wars, but the high point came during World War I, when both the Allies and Germany utilized them in great numbers behind the lines. The United States government turned to Goodyear, who, starting in 1916, built a thousand observation balloons for the Allied war effort. Both the army and navy purchased these balloons, which helped the military observe enemy troop movement and direct artillery fire. The military usually tethered each balloon to the ground with a 2,000 to 3,000-foot steel cable and reeled it in using a large winch. The navy also periodically towed them behind warships. In addition to manufacturing observation balloons, the government looked to Goodyear's expertise to train balloon pilots at Wingfoot Lake in Suffield, Ohio, a 720-acre tract of land the company purchased during the war to house and test the balloons.[17] According to Hugh Allen, this work was the company's "greatest contribution to the war"[18]

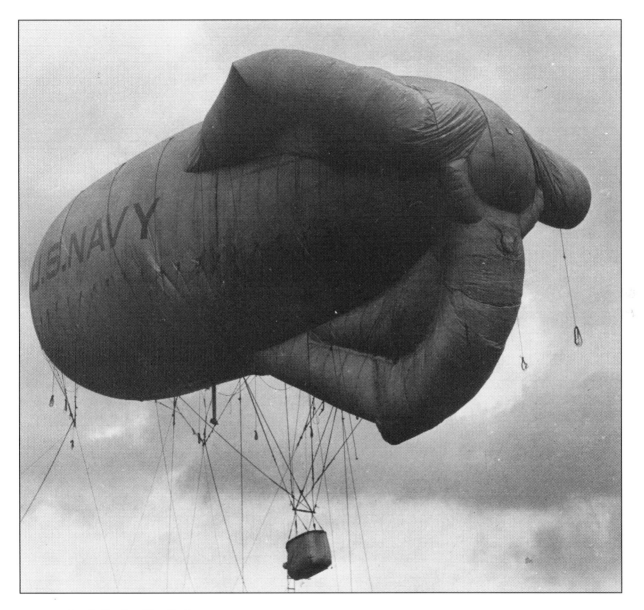

Single Basket Kite Balloon, ca. 1917
The US military employed this Goodyear-made kite balloon during World War I for gathering intelligence and spotting artillery. This model only had one basket, which reduced weight and allowed it to reach higher altitudes. The military most commonly used the kite balloon type, so called because they combined both balloon and kite principles. The Allies nicknamed them "sausage" balloons because the Germans had many of them.[21]

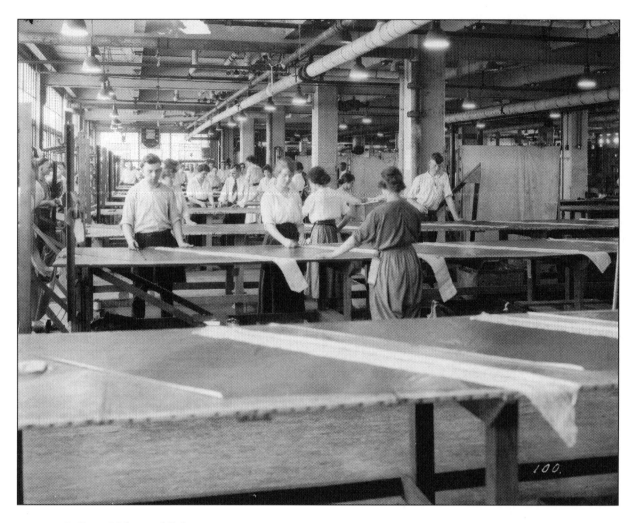

Balloon Valve and Fabric, 1917
Employees at Goodyear's Akron Plant cut two-ply cotton fabric for the envelopes of kite balloons during World War I. To meet the demand for these products, Goodyear increased the number of employees on balloon work from a few dozen to over 2,800—mostly women, known as "bloomer girls." Workers spread rubberized fabric onto tables and marked patterns, which they cut, cemented, and sewed together. They then assembled the parts including valve cords, rip cords, and suspension rigging, making five per day. The completed cigar-shaped envelopes, which cost upwards of $10,000, usually measured 92 feet long and had a maximum diameter of 27 feet when inflated.[20]

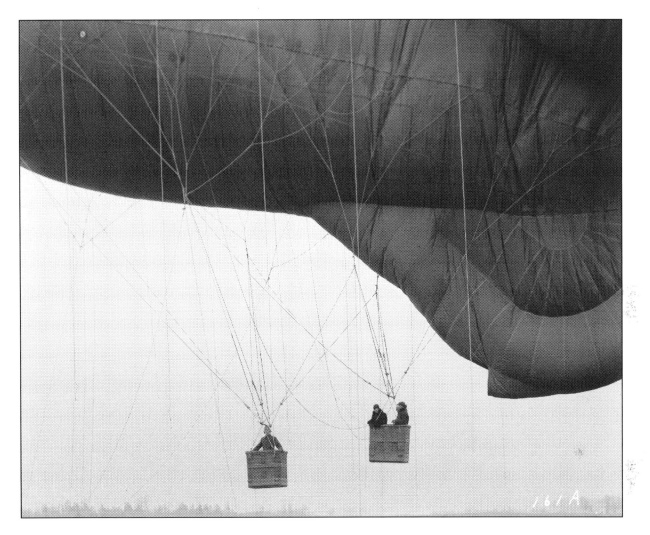

Twin-Basket Type "R" Kite Balloon, 1917

Goodyear manufactured this twin-basket Type "R" kite balloon in its Balloon Room in Akron. The balloon had two ballasts and two baskets, which increased the accuracy of artillery fire. Goodyear also made other experimental kite balloons, including the Type "C," "J," and "M." The result of these experiments led to the adoption of the Type "R" Caquot balloon, patterned after the French balloon of this type, designed by Albert Caquot. This type had the ballonet positioned at the front, which gave it a tendency to tilt downward, allowing for quicker descent in case of enemy attack.[19]

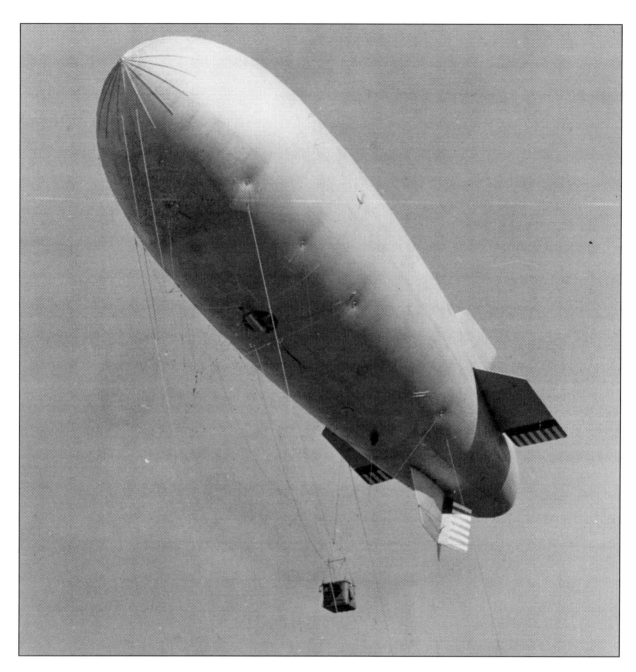

Modern Observation Balloon, 1939
A motorized observation balloon built by Goodyear floats over Wingfoot Lake during a test
run. Although observation balloons were practically obsolete by World War II—as planes
could do the job better—Goodyear experimented with motorized observation balloons early
in the war. These balloons eliminated the need to haul down, deflate, and move the balloons
by truck, as a power car could be attached to move it along the front under its own power.

Taking 'Em Down

Goodyear Barrage Balloons for the Military and the Movies

According to Hugh Allen, barrage balloons were the first product Goodyear manufactured in Akron for the Second World War, well before the US declared war. The US military utilized low-altitude barrage balloons to prevent attacks by low-flying enemy aircraft, and high-altitude balloons to force attacking aircraft to fly at greater altitudes, making their bombing less accurate. The military launched barrage balloons roughly a mile apart in an irregular pattern to form a spiderweb of steel wires that caused enemy planes to crash or get entangled as they flew into them. The navy also towed the balloons astern of a destroyer or flew them over harbors or docks to interfere with dive bomber attacks. The company designed even smaller balloons, resembling a blimp in appearance, to move with columns of troops, to prevent enemy strafing, and to protect vital defense sites against dive bombers. Goodyear and the military tested a variety of balloons made of rubberized cotton fabric at Wingfoot Lake in the summer of 1940. After the company worked out a few problems, they mass-produced barrage balloons for the war effort in both Akron and New Bedford, Massachusetts, turning out approximately 3,000 during the war. The company's barrage balloons were also used in peacetime, mostly by Hollywood movie studios to warn airplanes away from the vicinity of movie company sound stages.[22]

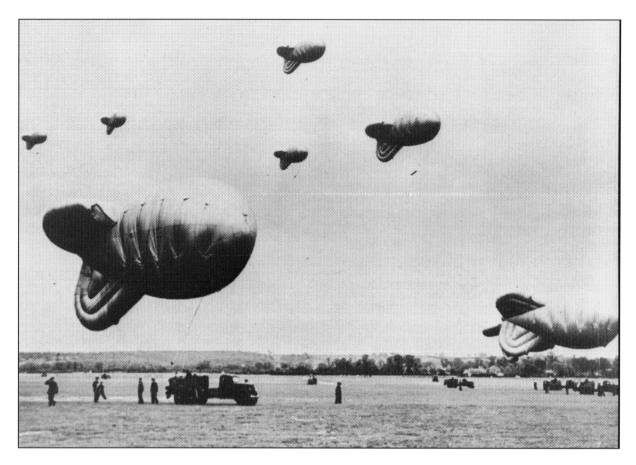

Barrage Balloons, 1939
D-7 barrage balloons float above the field at Wingfoot Lake like a swarm of bees. Goodyear built these 5,500-cubic-foot balloons expressly for the navy, which towed them astern of a destroyer or flew them over harbors or docks to interfere with dive bomber attacks. A crew of 12 men moved these balloons around on low trucks and raised them to 1,500 feet in under two minutes to protect vital defense sites. The Allies launched hydrogen-filled balloons similar to these during the invasion of Europe on D-Day.[23]

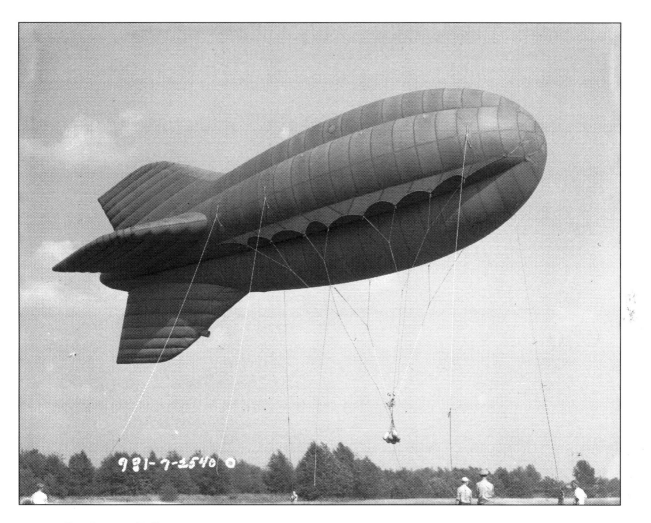

D-5 Barrage Balloon, 1940
Goodyear and the US military tested barrage balloons at Wingfoot Lake in the summer of 1940, including this D-5 model. The company built approximately 400 of these smaller type of four-lobed, four-finned barrage balloons, each of which had a 30,000-cubic-foot capacity and a 7,000-foot ceiling. Balloon workers constructed them out of a synthetic rubber cloth of cotton combined with black gum, which gave them their dark appearance.[24]

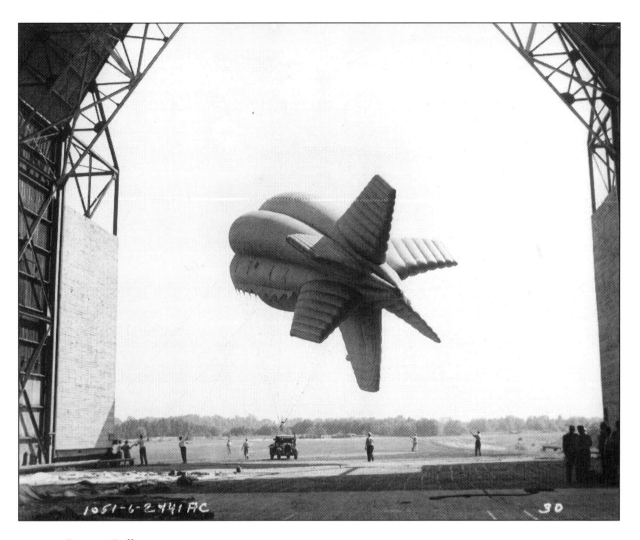

Barrage Balloon, 1941
A Strato Sentinel, the highest-altitude barrage balloon ever built, leaves the hangar at Wingfoot Lake. Based on the barrage balloons from World War I, the Strato Sentinel could ascend 15,000 feet, twice as high as earlier models. These helium-filled barrage balloons had a shorter, stubbier appearance and six fin-like stabilizers protruding from their tails that made them look like starfish when viewed from the rear. Made of rubberized cotton fabric and silvery in color, the balloons had a 68,000-cubic-foot capacity and weighed 1,000 pounds. Most served in Europe, but the US Army and Marine Corps utilized six squadrons of these barrage balloons to protect naval bases and depots on the home front.[25]

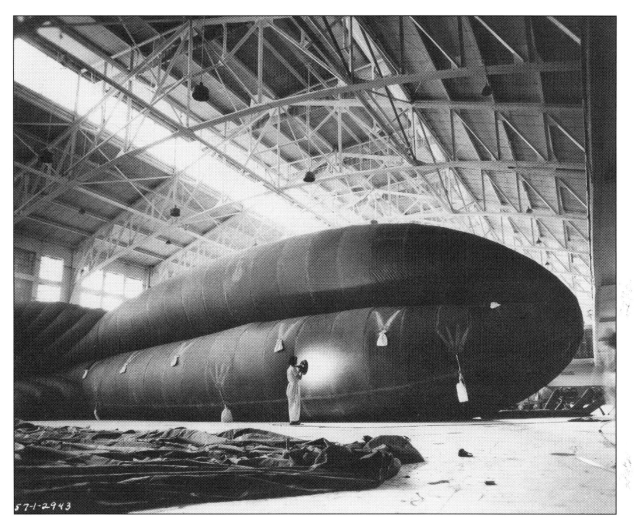

Barrage Balloon Building, 1943
Female workers build Model D-5 barrage balloons in the Goodyear Hall Gymnasium in
Akron. Due to lack of space at the Akron Plant, most of the balloons were built at Goodyear's
textile mill in New Bedford, Massachusetts. The US government acquired a British model
to study, which served as the inspiration for the ZK balloons mass-produced by Goodyear.[26]

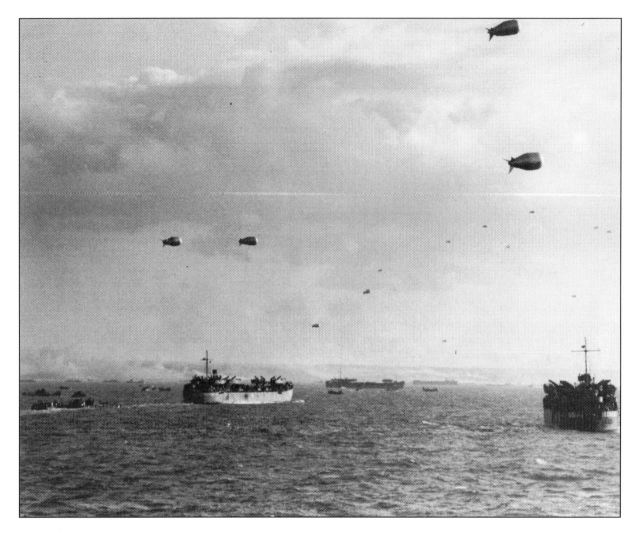

Barrage Balloons, 1944
Goodyear barrage balloons being towed by Allied warships crossing the English Channel towards France during the invasion of German-occupied Europe on D-Day, June 6, 1944. These Goodyear products played a small but vital role in the largest seaborne invasion in history.

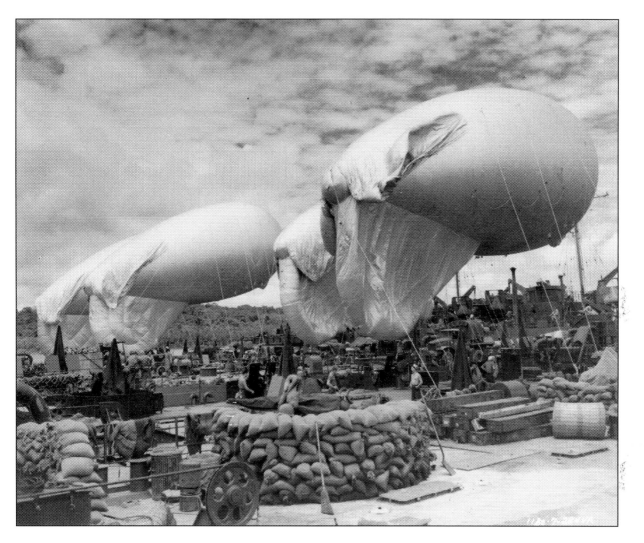

Barrage Balloons, 1944
D-7 barrage balloons being inflated at a military installation site in the European Theater of
Operations during World War II. Although the government kept their production secretive
at the time, sources estimate that Goodyear manufactured approximately 3,000 barrage bal-
loons during the Second World War.[27]

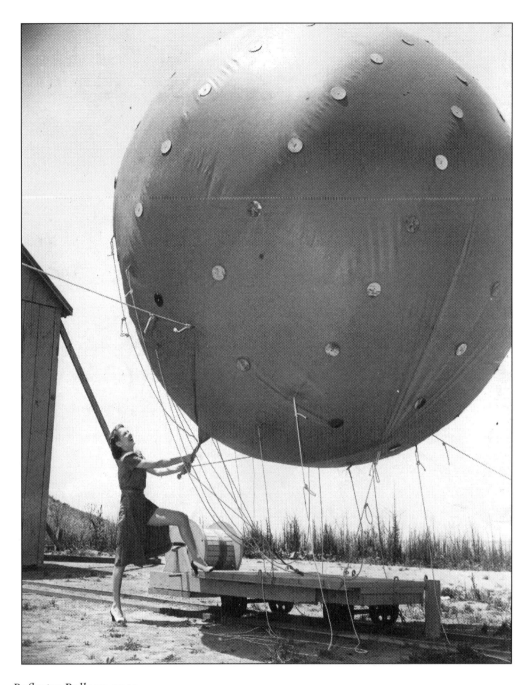

Reflector Balloon, 1940
Actress Anne Nagel holds a reflector balloon at Universal Studios in Hollywood. These 12-foot diameter, helium-filled balloons were used in peace time to warn airplanes away from the vicinity of movie sound stages. Goodyear manufactured the balloons in Akron for five Hollywood movie studios, including MGM and 20th Century Fox. Goodyear painted the spherical balloons bright orange and attached metal reflectors to the surface, which gave them the name "reflector balloons."[28]

Out of This World

Goodyear Stratosphere Balloons for Science and Exploration

Perhaps the most spectacular balloons manufactured by Goodyear were those that studied the stratosphere. Stratosphere balloons were manned, high-altitude, free balloons—filled with either hydrogen or helium—which carried a crew of up to three people in an airtight capsule to the stratosphere. In 1932, the organizers of the Chicago World's Fair arranged an American flight to the stratosphere and hired the Goodyear-Zeppelin Corporation to build the balloon, which launched Goodyear's venture into the design and construction of these huge contraptions. Later, the Goodyear subsidiary developed two balloons for the US Army Air Corps and the National Geographic Society to study the stratosphere and collect scientific data, which inadvertently broke altitude records. The press highly celebrated these missions and proclaimed the pilots national heroes. According to David DeVorkin, Senior Curator at the National Air and Space Museum, "certain characteristics of the Explorer series made it a significant event: it grappled with the technical obstacles that had to be overcome in order to address the scientific problems that access to the high atmosphere made possible."[29]

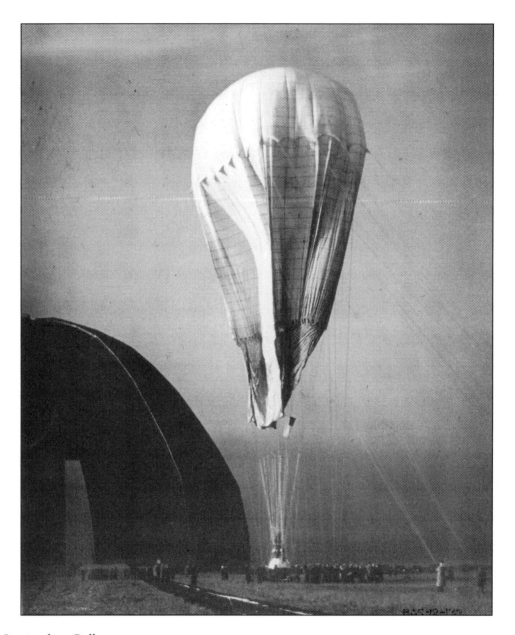

Stratosphere Balloon, 1933

The 165-foot-high, 105-foot-in-diameter *Century of Progress* balloon, built by the Goodyear-Zeppelin Corporation, rises outside the Goodyear Airdock shortly before its historic flight from Akron to New Jersey on November 20, 1933. The endeavor involved other companies and individuals, including Dow Chemical, which built the gondola; Thomas G. W. "Tex" Settle as pilot; Chester Fordney as copilot; and famed explorers Auguste and Jean Piccard as collaborators. The enterprise achieved the first successful flight from US soil to the stratosphere, and it reached a new American altitude record of 61,237 feet. The 600,000-cubic-foot capacity balloon took roughly 4,800 square yards of rubberized fabric to build—the largest balloon in the world at that time.[30]

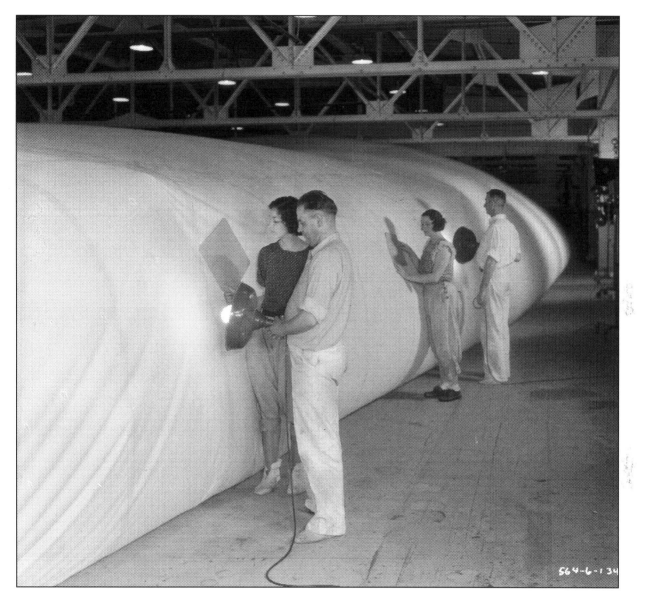

Explorer I Stratosphere Balloon, 1934

Workers in Goodyear's Balloon Room inspect the partially inflated *Explorer I* months before its launch from the Stratobowl in South Dakota's Black Hills. This balloon, sponsored by the US Army Air Corps and the National Geographic Society, had a hydrogen gas capacity of three million cubic feet and stood as tall as a 27-story building—five times the size of the *Century of Progress*. It took approximately two acres of rubberized fabric and over seven miles of cloth to make the massive balloon. On July 28, 1934, 30,000 people watched it reach a near-record altitude of 60,613 feet before the balloon ruptured and ignited. Fortunately, the crew managed to parachute to safety.[31]

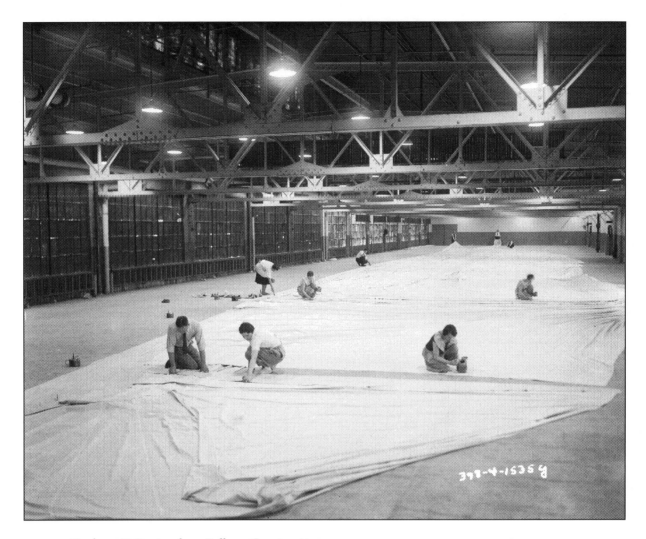

Explorer II Stratosphere Balloon Construction, 1935
Employees in the Goodyear Balloon Room construct the 3,700,000 cubic foot rubber envelope for the *Explorer II*. Twenty-three percent larger than the *Explorer I*—it required a larger balloon as a result of the nonflammable helium as its lifting gas—the new "super balloon" measured 192 feet in diameter and 315 feet tall. It had a total area of nearly 116,000 square feet and was made from more than three acres of rubberized fabric. It was the largest free balloon ever built to that time. On November 11, 1935, the *Explorer II* soared from the Stratobowl to 72,395 feet and claimed a new world altitude record until 1956. The flight also accumulated scientific data and captured the first photograph of the curvature of the Earth.[32]

Putting the Happy in the Holidays

Goodyear Figure Balloons for Parades and Public Events

In 1927, when the R. H. Macy Company in New York added larger-than-life figure balloons to their Thanksgiving Day Parade, they called upon Goodyear to manufacture them, and a beloved American tradition was born. The designs by Tony Sarg, a German-American puppeteer and illustrator, were carried out by James F. Cooper and his team in Goodyear's Balloon Room in Akron. The company made two types of parade balloons: spherical balloons that performers usually wore on their heads and full-size figure balloons—also known as parade or character balloons—which usually depicted licensed popular culture characters. Goodyear generally made at least one new balloon character every year. Early popular balloons included Felix the Cat, Mickey Mouse, and Superman. From 1927 to 1951, Goodyear produced over 70 figure balloons and approximately a dozen head and spherical balloons for the Macy's Thanksgiving Day Parade.[33] However, novelty head and full-size figure balloons also appeared in other events throughout the country and beyond, including the L. Bamberger & Company's Thanksgiving Day Parade in New Jersey, and the Gilmore Oil Company's parades that traveled the West Coast, from California to Washington. Building on the popularity of the balloons, Ernest Briggs, a longtime partner of Tony Sarg, took many of the inflatables on a world tour as part of the company known as Broadway Balloons. In the late 1930s, the balloons appeared in small towns and remote sections of the country before traveling on to South America and Canada.[34] According to one newspaper account, by 1940, the balloons appeared "from Boston to Cuba and Mexico, from the Rose Festival in Portland to the Provincial Fair in Nova Scotia [and] big fairs like the New York State Fair and the Canadian National Exhibition."[35]

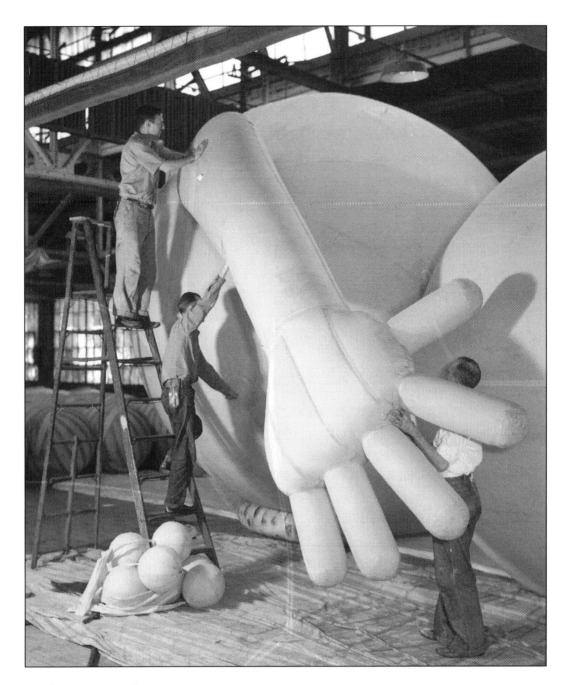

Making Figure Balloons, 1937
Three men in Goodyear's Balloon Room in Akron assemble sections of a parade balloon for the Macy's Thanksgiving Day Parade. Tony Sarg's protégé, Bil Baird, stands on the ladder. Each balloon took Goodyear nearly eight months and over 1,000 man-hours to design and build. Balloon workers constructed the balloons in sections as separate balloons and joined them together during final assembly. Goodyear built the balloons out of a strong, lightweight, rubber fabric similar to the skin of its famous blimps. Each balloon cost between $1,000 to $2,000 at the time, not including the helium.[36]

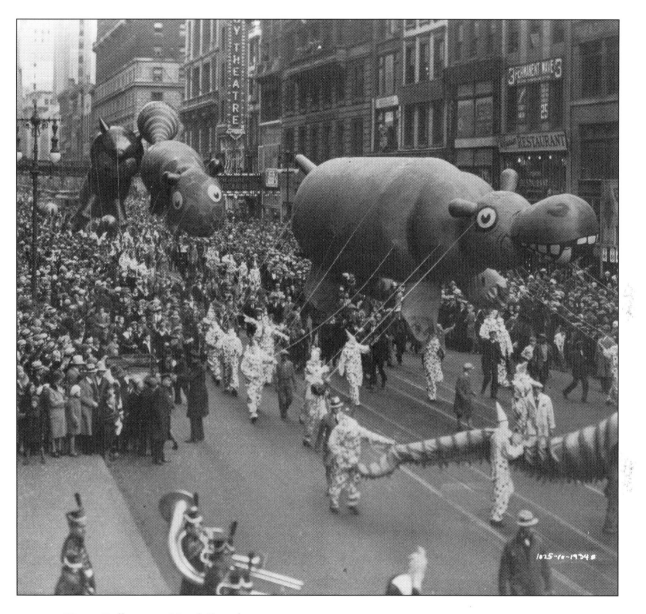

Figure Balloons at Macy's Parade, 1931
Several of the most popular Goodyear-made parade balloons of the day float down 34th
Street in New York City as part of the Macy's Thanksgiving Day Parade. Baird described the
creations as "simply upside-down marionettes manipulated from strings underneath rather
than above."[38] Over the years, the parade became a cherished American tradition viewed
by 65 million people annually and, according to Goodyear, "The balloons have become its
hallmark."[39]

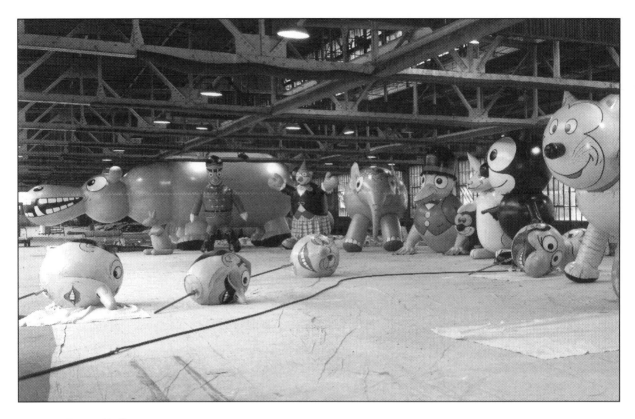

Figure Balloons, ca. 1933
This rare image shows a throng of early figure balloons in Goodyear's Balloon Room as several novelty head balloons are strewn across the floor. From left to right are the hippopotamus, kangaroo, drum major, clown, elephant, duck, rabbit, Felix the Cat, and Tom-Cat. James F. Cooper, called "one of the world's greatest balloon builders," designed the figures himself using Tony Sarg's drawings instead of blueprints. His crew made the balloons by cutting intricate patterns in rubber, cementing them together, and assembling them to form the figures.[41]

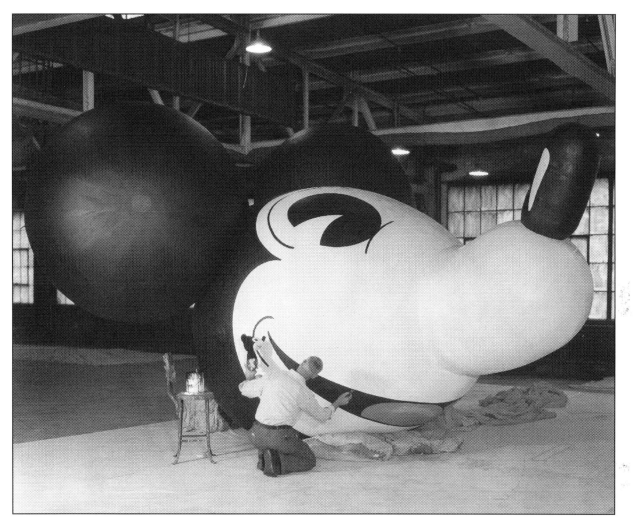

Mickey Mouse Balloon Being Painted, 1934
An artist paints the smile on the head of the Mickey Mouse balloon in the Goodyear Balloon Room one month before its debut in the 1934 Macy's Parade. That year, Walt Disney Productions, Ltd. (now the Walt Disney Company) partnered with Macy's to include figure balloons of some of its most beloved characters, a partnership that continues today. Called "a perennial favorite," the 35-foot-tall Mickey Mouse balloon disappeared from the scene in the late 1930s or early 1940s, but Goodyear later replaced it with a new Mickey balloon twice its size.[40]

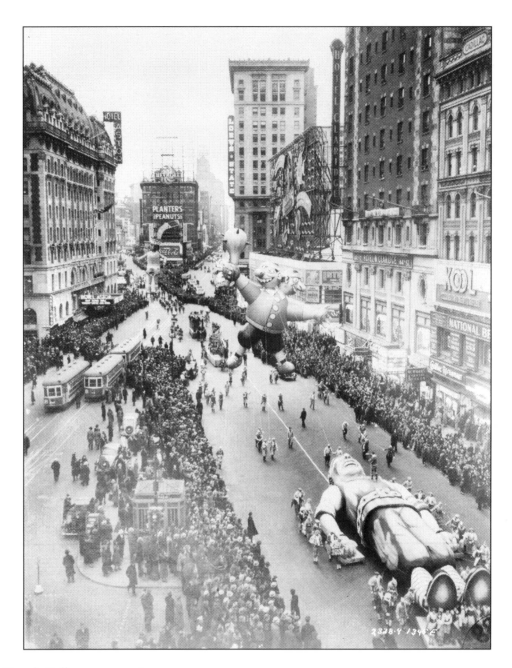

Parade Balloons, ca. 1936
Goodyear figure balloons including Gulliver and the two-headed giant make their way through Times Square during the 1936 Macy's Parade. Other famous character balloons at that time included the dragon, elephant, toy soldier, turkey, crying baby, alligator, pig, fish, and dachshund. Test flights took place in Akron several weeks before Thanksgiving and then Goodyear employees crated and shipped them to New York several days before the parade. Although the balloons had giant proportions—some towering to five or six stories—they only weighed about 250 pounds when deflated and fit into a crate the size of a telephone booth.[42]

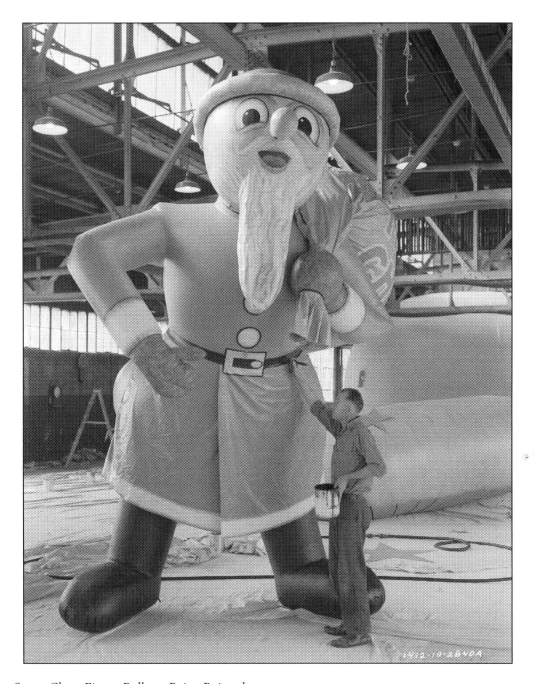

Santa Claus Figure Balloon Being Painted, 1940
A Goodyear balloon painter touches up the giant Santa Claus balloon in preparation for the 1940 Macy's Thanksgiving Day Parade. The following year, crowds expressed disappointment when it deflated in the middle of the parade. Goodyear workers readied the balloons each year by replacing rip panels, touching up paint, and inflating each balloon to test for leaks. The whole project was a major undertaking requiring dozens of people including engineers, draftsmen, fabric cutters, seamers, gluers, and riggers.[37]

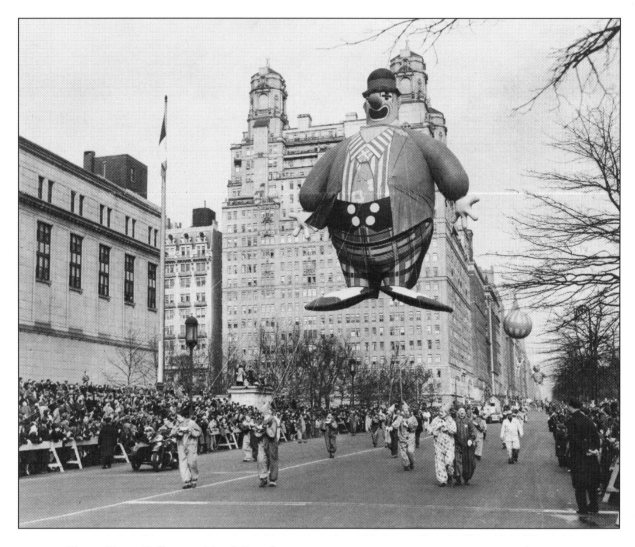

Clown Figure Balloon at Macy's Parade, 1945
The clown balloon (also known as Bobo the Hobo) travels down Central Park West during the 1945 Macy's Thanksgiving Day Parade after the event took a hiatus from 1941 to 1944 to funnel more helium and rubber into the war effort. The man on the flying trapeze and the teddy bear balloons can be seen in the background. Goodyear often recycled balloons such as the clown, Superman, and the bear to make new characters. For instance, the clown balloon transformed into a baseball player, a police officer, and a firefighter in successive years.[43]

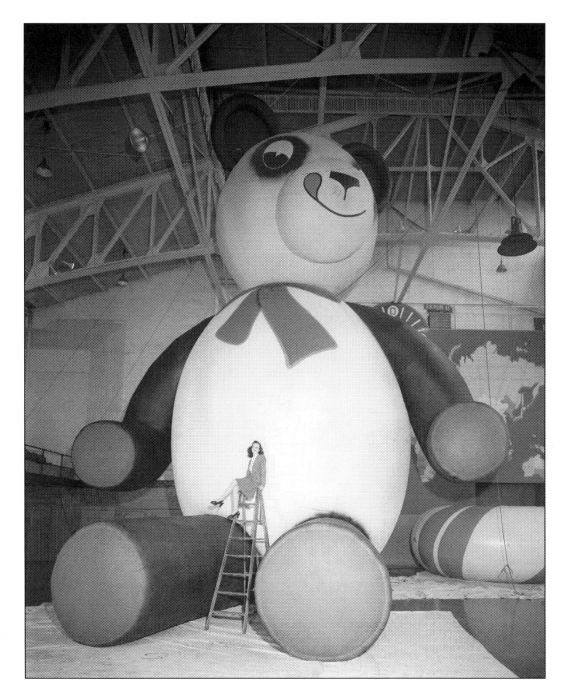

Panda Balloon, 1946

An employee poses atop a ladder in front of the panda figure balloon in the Goodyear Gymnasium to demonstrate the balloon's massive size. The balloon soars above the gymnasium floor as its head reaches into the rafters. A portion of the candy cane balloon is visible on the floor in the background. Goodyear often displayed the balloons in the Goodyear Gymnasium for their employees' enjoyment, especially during the holiday season. The panda balloon was prominently featured in the 1947 movie *Miracle on 34th Street*.

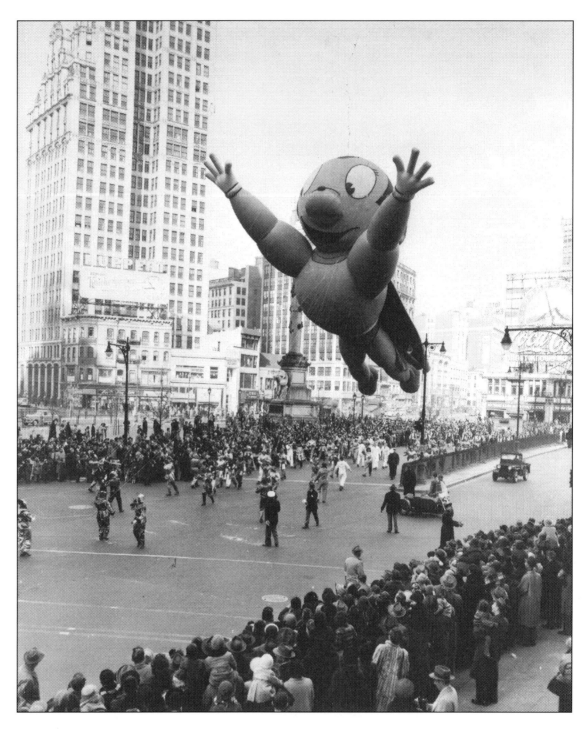

Mighty Mouse Figure Balloon at Macy's Parade, 1951
The Mighty Mouse figure balloon, manufactured by Goodyear, makes its debut in the 1951
Macy's Thanksgiving Day Parade. It soars through Columbus Circle above the crowd of
onlookers who marvel at its 42-foot armspan.[44]

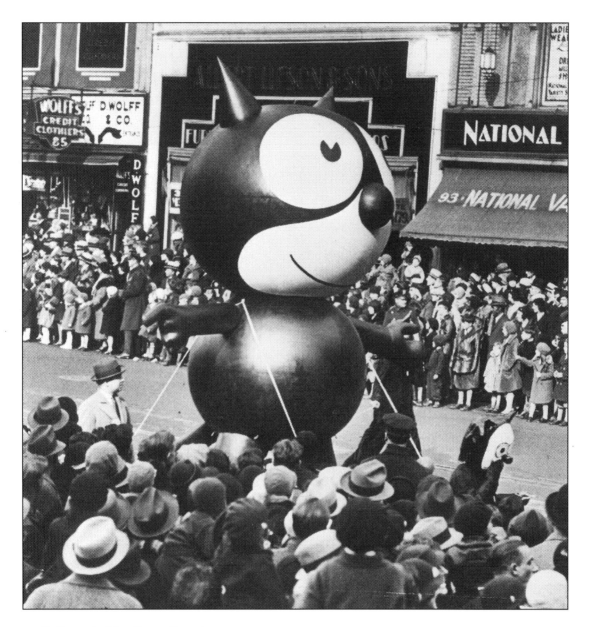

Balloons in New Jersey Parade, 1933
Goodyear's figure balloons also appeared in the L. Bamberger & Company's annual Thanks-giving Day Parade in New Jersey starting in 1931. This image shows one of the most popular balloon characters of the day, Felix the Cat, being carted down Market Street in downtown Newark on its way to Bamberger's. Called "the world's largest feline," this balloon was one of several versions of the lovable comic character Goodyear made for parades. While the parade balloons disappeared from the Bamberger's parade in the mid-1930s, replaced by simply designed floats and characters from nursery rhymes made of papier-mâché, they re-emerged for a time by 1940 with favorites such as Pinocchio and Donald Duck, among others.[45]

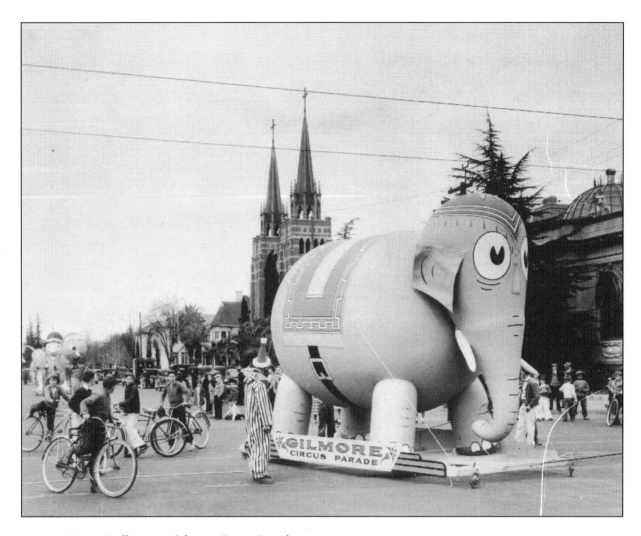

Figure Balloons at Gilmore Circus Parade, 1935
The Gilmore Circus Parade traveled the Pacific Coast in the mid-1930s and showcased Good-year's figure balloons, which costumed volunteers pulled on floats. The elephant can be seen in the foreground, while Goo-Goo the Duck and the popular Doodlebug are featured in the distance with several comic head balloons. In 1935, a selection of Goodyear's balloons made their first trip to the coast and left a lasting impression on the people of the American West. As the *Oakland Tribune* noted that year "their unique character as fun makers has won them instant popularity and brought them into wide demand for civic spectacles, conventions, fairs, benefits and public festivals of all kinds."[46]

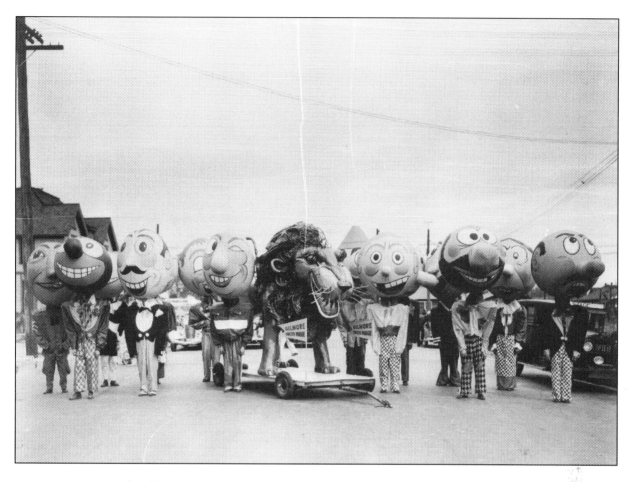

Comic Head Balloons at Gilmore Circus Parade, 1935
Goodyear created novelty comic head balloons for parades, including the Gilmore Circus Parade seen here, sponsored by the Los Angeles–based oil company. In addition to the Gilmore Lion, a Felix the Cat head can be seen, along with characters from the popular comic strip, the *Katzenjammer Kids*. An estimated half a million spectators saw the balloons in the Gilmore Circus Parade that kicked off the holiday season in Hollywood, California, and over 100,000 spectators crowded into Oakland's downtown business district to view the spectacle at the inaugural Downtown Day Festival.[47] When 13 of the figure balloons and 15 head balloons appeared at Gilmore's Desert Circus Parade in Palm Springs in 1936, one journalist remarked that the "strange laugh-provoking creatures, all built on a gigantic scale [added a] Mardi Gras atmosphere to the local event."[48]

You Know the Name

Goodyear Advertising Balloons for Marketing and Promotion

Shortly after Goodyear balloons debuted in the Macy's Thanksgiving Day Parade, the rubber company started manufacturing advertising balloons for companies and organizations to market their products. James F. Cooper and his team in Akron's famous Balloon Room made these products from the same materials used to produce the company's parade balloons. While Goodyear made some as simple as spheres with company logos painted on them, others consisted of elaborate figures and shapes similar to the company's comic figure balloons, as well as their famous blimps and kite balloons. They made the majority of the advertising balloons in the 1930s—probably to elicit business during the economic slump created by the Great Depression. However, the company seriously curtailed the production of advertising balloons during World War II as the government desperately needed balloon fabric and precious helium for the war effort.[49]

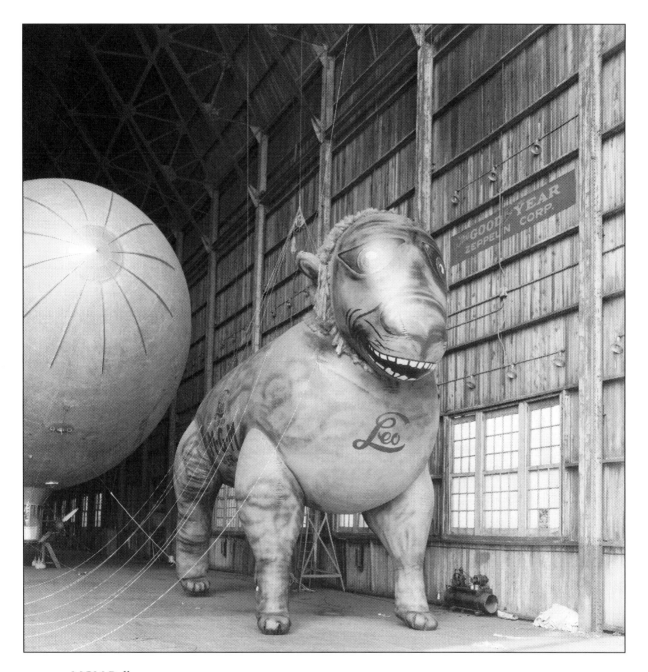

MGM Balloon, 1930
The Leo the Lion balloon sits in the airdock at Wingfoot Lake with the *Neponset* blimp in the background to show its size. Goodyear applied its experience in making figure balloons to create this advertising balloon for Metro-Goldwyn-Mayer (MGM) in Hollywood, California, to promote the studio and their films. The Leo mascot was created by American publicist Howard Dietz in 1916 for Goldwyn Pictures but was updated in 1924 for MGM's usage.[50]

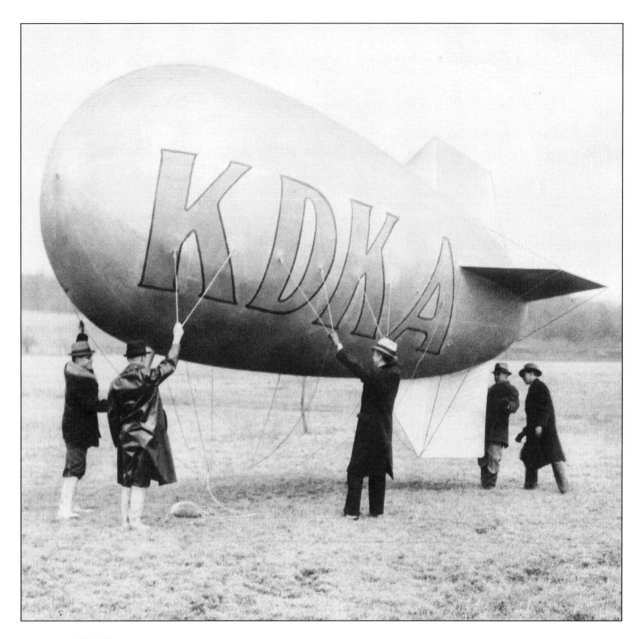

Ad Balloon, 1933
Five executives hold a Goodyear-made advertising balloon for the KDKA radio station in Pittsburgh, Pennsylvania. Although most ad balloons were spherical in shape, this creation resembles one of Goodyear's famous blimps. Goodyear manufactured ad balloons in almost any shape and size to attract the attention of potential customers, or, in this case, radio listeners.[51]

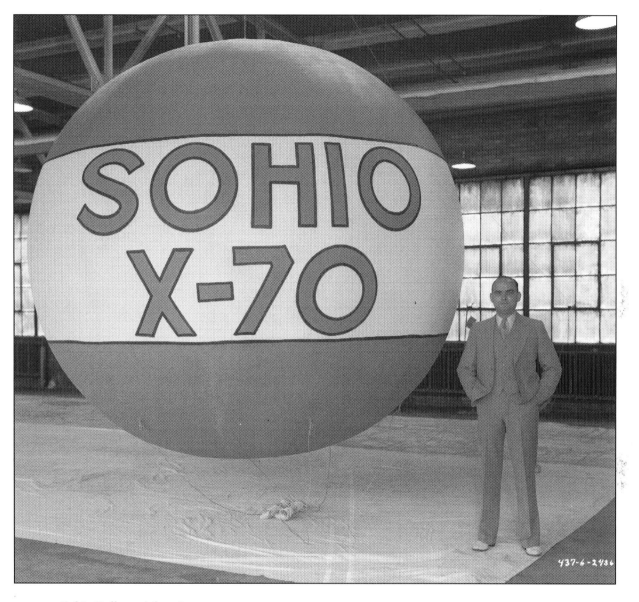

Sohio Balloon Advertisement, 1936

An executive stands next to a Goodyear-made advertising balloon that promotes Standard Oil Company's (Sohio) X-70 gasoline, which the company advertised as "so vastly different and better that you'd hardly call that 1921 stuff 'gasoline.'" These ad balloons, tethered to the roofs with ropes and weights, floated above buildings to promote various products.[52]

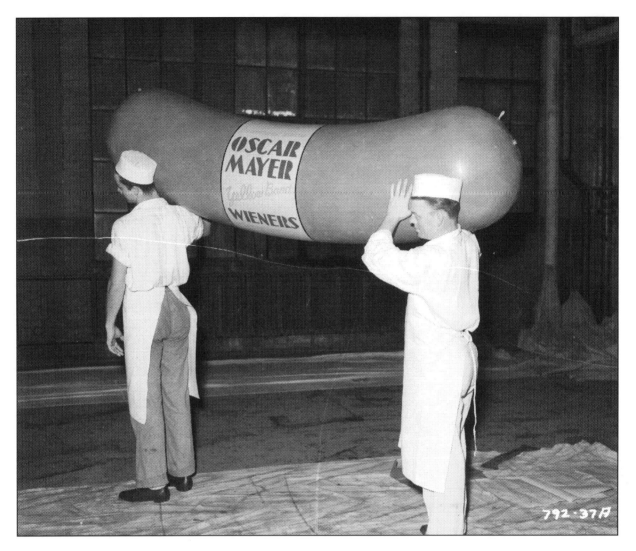

Hot Dog Balloon, 1937
Two delivery men from the Oscar Mayer Company carry a hot dog, or wiener, balloon on their shoulders at Goodyear's Balloon Room in Akron. Drawing on their experience in figure balloon manufacturing, Goodyear created assorted balloons in all shapes and sizes for advertising purposes by many companies during the Great Depression.[53]

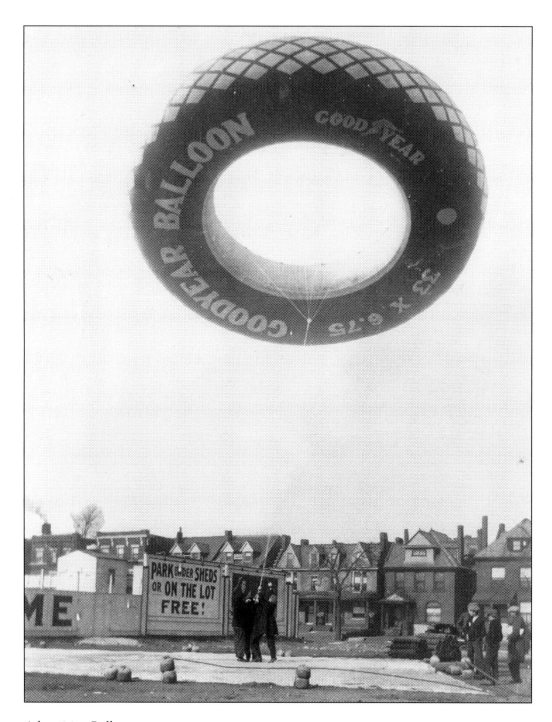

Advertising Balloon, 1937
An obvious tie-in, a Goodyear balloon advertising the company's balloon tires floats over a residential area in Akron. Goodyear not only made advertising balloons for other companies, but also to sell its own products.

Notes

1. Ward T. Van Orman, *The Wizard of the Winds* (St. Cloud, MN: North Star Press, 1978), xii.

2. For information on stories and early experiments in flight see D. A. Ray, *The History of Man-Powered Flight* (Elmsford, NY: Pergamon Press, 1977), 2–5.

3. See C. J. Hylander, *Cruisers of the Air: The Story of Lighter-than-Air-Craft* (New York: Macmillan, 1931), 10–24.

4. For a brief history of the development of early lighter-than-air flight see Lennart Ege, *Balloons and Airships*, 3–14; and Douglas H. Robinson, *Giants in the Sky: A History of the Rigid Airship* (Seattle, WA: University of Washington Press, 1973), 1–4.

5. "General Description of a Free Balloon," in Naval Aeronautical School, *Outline of Practical and Theoretical Course of Instruction in Free and Kite Ballooning* (Pensacola, FL: Naval Aeronautical School, n.d.), 3–8.

6. Walter W. Boyd, "Flight in a Basket," *Skyways*, n.d.

7. C. H. Roth, "Above the Clouds," n.d., MS, GR.

8. See "The Invention and Early History of the Free Balloons," in *Free Ballooning*, n.d., MS, GR; Jack Finger, "The Great Balloon Race of 1924," *Broadcaster* (April 1964): 10; and "A History of the James Gordon Bennett International Balloon Race," n.d., MS, GR.

9. Hugh Allen, *The House of Goodyear*, Cleveland, OH: Corday & Gross, 1949, 274.

10. See "The Romance of an Airship Factory" and "How the Coupe Internationale Was Won," *The New York Herald*, October 19, 1913; "'Round the World Flight," *NYT*, May 13, 1919; and "Ralph Upson, 80, Balloonist, Dies," *NYT*, August 15, 1968.

11. Allen, *House of Goodyear*, 48.

12. See "Winners of the James Gordon Bennett Cup," n.d., MS, GR; and "Was King of Goodyear Skies," *WC*, March 16, 1978.

13. Paul Litchfield to Hugh Allen, May 26, 1926, GR.

14. See "1925 National," n.d., MS, GR; National Aeronautic Association, "Van Orman Wins National Elimination Balloon Race and Litchfield Trophy," news release, May 6, 1926, GR; "US National Balloon Race Winners," n.d., MS, GR; and "Goodyear Wins National Balloon Race," *Goodyear News* (June 1927).

15. Ward T. Van Orman, "Balloon Racing," *Modern Mechanix and Inventions* (September 1932): 57.

16. See "Pittsburgh, PA Balloonists Killed in Storm," *Wisconsin Rapids Daily Tribune*, May 31, 1928; T. G. W. Settle to Chief of the Bureau of Aeronautics, n.d., GR; "Goodyear Pilots Will Fly New Balloon in National Event," *WC*, June 30, 1936; and Allen, *House of Goodyear*, 274–280.

17. See the following MSS from the GR: Goodyear, "Rubber Coated Fabrics for Aeroplanes and Balloons," n.d.; "The Goodyear Company and Aeronautics," n.d.; and "Goodyear Estimate for Type 'R' Kite Balloons," March 4, 1918.

18. Allen, *House of Goodyear*, 48.

19. Goodyear, "Modern Observation Balloon (Motorized)," n.d., news release, GR.

20. Goodyear, *The Construction, Operation and Repair of the "Type R" Kite Balloon* (Akron, OH: Goodyear, 1918), 11–17.

21. See "WWII Observation Balloon to Be Dedicated," *WC*, October 25, 1979; "Goodyear Kite Balloon Outline of Standard Procedure," n.d., MS, GR; and Naval Aeronautical School, 60–62.

22. See "Barrage Balloons," n.d., MS, GR; Goodyear-Zeppelin Corporation, "Prospectus for Barrage Balloons," June 22, 1939, MS, GR; and Allen, *House of Goodyear*, 465–466.

23. "Army Interested in Balloon Tests," *ABJ*, May 21, 1940.

24. Ege, *Balloons and Airships*, 214; and Allen, *House of Goodyear*, 466.

25. "Anti-Air Raid Balloons Made by Local Plant," *The Standard-Times*, August 14, 1941.

26. See "Harter Urges Balloon Tests," *ABJ*, May 17, 1940; and "Goodyear Blimp Soon Will Rise," *ABJ*, March 10, 1940.

27. Ibid.

28. See H. A. Haenny to John Shea, April 17, 1940, GR; Goodyear, "Reflector Balloons," n.d., news release, GR; and *Goodyear News* (August 1940).

29. David H. DeVorkin, *Race to the Stratosphere: Manned Scientific Ballooning in America* (New York, NY: Springer-Verlag, 1989), 219. See also Goodyear, "Stratosphere Flight," May 6, 1933, news release, GR; National Geographic Society (hereafter NGS), "National Geographic Society and Army Air Corps to Cooperate in Two Stratosphere Flights in Largest Balloon Ever Constructed," January 17, 1934, news release, GR; Allen, *House of Goodyear*, 280–283; and Ege, 202–203

30. See Ward T. Van Orman, "Navigation of the World's Largest Balloon," June 20, 1933, MS, GR; Goodyear, "Century of Progress Balloon," n.d., news release, GR; Dow Chemical Company and Union Carbide and Carbon Corporation, "Souvenir Program of the Piccard-Compton Stratosphere Ascension from Soldier Field," 1933, GR; Goodyear, "Stratosphere Flight," May 6, 1933, news release, GR; and "Piccard Happy as Flight Ends," *ATP*, October 24, 1934.

31. See NGS, *The National Geographic Society-US Army Air Corps Stratosphere Flight of 1934 in the Balloon "Explorer"* (Washington, DC: NGS, 1935). See also "Soviet Balloonists Claim World Mark," *ABJ*, September 21, 1934; Goodyear-Zeppelin Corporation, "Stevens Stratosphere Balloon," January 13, 1934, MS, GR; T. W. McDren, "Litchfield Award Presentation to J. F. Cooper," April 6, 1938, speech, GR; NGS, "World's Largest Free Balloon Nearing Completion in Akron, Ohio," May 8, 1933, news release, GR; "Army Gas Bag Is in Danger, Report Says," July 28, 1933, news release, GR; and V. R. Jacobs to Herb Wilson, January 19, 1934, GR.

32. See A. W. Stevens to Paul Litchfield, July 27, 1935, GR; and NGS, "Helium to Be Given First Major Peace Task in National Geographic-Army Stratosphere Flight," *Geographic News Bulletin* (May 16, 1935); Albert W. Stevens, "Exploring the Stratosphere," *National Geographic Magazine* (October 1934): 397–434; NGS, "If You Don't Believe World Is Round Stratosphere Photos May Convince You," *Geographic News Bulletin* (June 7, 1935); H. Latane Lewis, "Explorers of the Deeper Blue," *US Air Services* (Decem-

ber 1935); and "Explorer II Flight Site Dedication," *ABJ*, November 11, 1945.

33. For information on the Macy's Parade see Robert M. Grippo and Christopher Hoskins, *Macy's Thanksgiving Day Parade* (Chicago: Arcadia Publishing, 2004); R. H. Macy & Company, "Figure Balloons," n.d., news release, GR; and Robert Sullivan, ed., *America's Parade: A Celebration of Macy's Thanksgiving Day Parade* (New York: Time Magazine, 2001), 61.

34. See "Huge Animals Will Parade on Downtown Day," *Oakland Tribune*, June 14, 1935; James Bartlett, "The Bizarre Antics of Gilmore," *LA Weekly*, February 4, 2015; "Awe and Amazement Will Give Way to Laughter," *Santa Ana Register*, November 19, 1935; "Strange Cargo of Grotesque Beasts Here," *Santa Ana Register*, December 2, 1935; "Gilmore Circus 'Freaks' and Great Bargain Day Draw Crowds into City," *Bakersfield Californian*, March 19, 1935; "Giant Doodle Bug, Other 'Pets' Coming," *Bakersfield Californian*, March 14, 1935; "Celebration Opens Yule Season Here," *Kingsport Times*, December 5, 1940; "New Set-Up Varies Festival," *Ogden Standard-Examiner*, July 17, 1938; "Santa Claus Greeted Here Thursday with Big Balloon Parade," *Lock Haven Express*, November 26, 1938; "First Annual Yule Parade Opens Local Holiday Season," *Frederick Post*, December 2, 1938; "Balloon Figures of Funny Paper Characters Will Go on Parade for Butte Rodeo," *Butte Montana Standard*, August 4, 1938; and "Floating Fun; Huge Balloons Due for Safety Parade," *Winnipeg Free Press*, May 26, 1938.

35. "Festivities Will Open on Nov. 28," *Kingsport Times*, November 21, 1940.

36. See "Fact sheet: Macy's Thanksgiving Day Parade balloons," n.d., MS, GR; "NY parade enters 55th year," *Norfolk, Virginia Ledger-Star*, November 26, 1981; and Bil Baird, "William R. Ludwick," October 28, 1968, MS, GR.

37. Ibid.

38. Joseph Gustaitis, "A Thanksgiving Tradition," *American History* 30, no. 5 (Nov/Dec 1995): 32.

39. Goodyear, "Macy's Balloons: A Story of Art and Showmanship," n.d., news release, GR.

40. See Goodyear Aerospace Corporation, "Suggested Script for 1971 Macy's Thanksgiving Day Parade," n.d., MS, GR; Goodyear, "The Reappearance of Mickey Mouse," November 20, 1971, press release, GR; and Goodyear, "Macy's Parade Balloon Briefs," n.d., news release, GR.

41. "Largest Builder of Comic Balloons," *WC*, December 2, 1931.

42. See R. H. Macy & Company, "The Balloons: How They Are Made and General Background," and "Macy's Thanksgiving Day Parade Balloons," n.d., MS, GR; and Goodyear, "Making a Figure Balloon," n.d., news release, GR.

43. See Sullivan, 61; Goodyear, "How Figure Balloons Fly," n.d., news release, GR; Goodyear, "Macy's Parade Balloon Briefs;" and R. H. Macy & Company, "Figure Balloons."

44. Ibid.

45. See the following *NYT* articles: "Santa Arrives in Newark," November 27, 1931; "Plans for Balloon Parade," November 1, 1931; "200,000 See Newark Parade," November 25, 1932; "Parade in Newark Today," November 30, 1933; "Throngs See Newark March," December 1, 1933; "Carols End Newark Fete," November 20, 1934; "New Jersey Parade Viewed by 500,000," November 27, 1936; "Story Book Folk Parade in Jersey," November 25, 1938; "Thanksgiving Day Parade in New Jersey," November 22, 1940; and "Santa Still No. 1 to Small Fry among Throng at Toyland Parade," November 21, 1941. See also "Purrs Like a Zepp," *WC*, November 23, 1931.

46. "Huge Animals Will Parade on Downtown Day," *Oakland Tribune*, June 14, 1935.

47. "Strange Cargo of Grotesque Beasts Here," *Santa Ana Register*, December 2, 1935.

48. Renee Brown, "Explore Palm Springs: Desert Circus Parade," *Palms Springs Life*, February 5, 2016.

49. For information on Goodyear's advertising balloons see "Old-Time Balloons Create Interest; One Goes AWOL," *WC (Arizona Edition)*, August 12, 1960.

50. See Peter Hay, *MGM: When the Lion Roars* (Atlanta, GA: Turner Publishing, 1991).

51. See Lynn Boyd Hinds, *Broadcasting the Local News: The Early Years of Pittsburgh's KDKA-TV* (University Park, PA: Pennsylvania State University, 1995); and Lawrence Jankowski, *How Radio Got Started: Frank Conrad and KDKA* (Lakewood, CO: Instructional Video, 2008).

52. "Sohio Advertisement," *The Portsmouth Times*, July 20, 1949.

53. See Oscar Mayer, *Oscar Mayer & Company: From Corner Store to National Processor* (New York: Newcomen Society, 1970).

Chapter 5
The Right Tool for the Job
Goodyear Mechanical Goods for Home, Office, and Industry

"Goodyear Mechanical Goods go throughout industry—to the factory, to the mill, to the mine, to the farm; its products are put to work in a thousand uses of which the general public knows little."[1]
—C. C. Slusser, *Goodyear Factory Manager*

While Goodyear's founders originally concentrated on tires, they soon supplemented their production with other products. Shortly after the Seiberlings founded the company, they set up a small room in the old strawboard factory to house the molded goods department, where they manufactured a few miscellaneous articles, such as bicycle plugs and pedals, cigar mats, step pads, and rubber heels. In 1903, the department expanded to the second floor of the building, adding new products including diaphragms, interlocking tile, and rubber horseshoes. The unit gradually expanded during the next few years forming a lucrative part of the business. The firm decided to manufacture mechanical goods on a larger scale and organized the Mechanical Goods Division in 1913, when Akron's Diamond Rubber Company merged with B. F. Goodrich and numerous Diamond employees joined Goodyear to start the department. Also known as Industrial Products, the division manufactured merchandise such as hoses, transmission belting, conveyor belts, and molded goods that the company generally sold to industry rather than individuals. At first the division struggled to compete with a number of long-established competitors, but within 20 years it became a leader in the industry.[2]

In 1916, thirty Goodyear branches sold mechanical goods in twenty-two states and ten countries. By the company's twentieth anniversary, mechanical goods had broadened its lines to include belts, packing, mats, hoses, heels and soles, railroad materials, molded and lathe-cut goods, and other rubber products for mills, mines, farms, and factories. By the mid-1930s, the company sold mechanical goods to over a hundred major corporations and produced roughly 10,000 different sizes, combinations, and styles of products. However, the division did not attempt to manufacture everything possible, for that would have proved imprudent as a number of older and more established companies had already cornered the market in various lines. Instead, the unit specialized in items it could improve and make profitable, particularly belting, hoses, and molded goods.

Thousands of images of mechanical goods appear in the Goodyear Photograph Collection, from massive rubber belts that powered industry, mechanized the farm, and conveyed materials that built important engineering projects around this country, to rubber soles and heels that carried our soldiers across the battlefield in the world wars. Also included are images of early prefabricated homes built to combat the nation's housing shortage by providing accommodations for a growing population of war workers and others during and after World War II.[3] The photographs show practical goods in use throughout this country and others, including different types of hoses involved in fighting fires, mining for gold, and building numerous engineering projects. The images also capture the people and machinery that manufactured these products, as well as the products in their stages of production, many of which are featured in this chapter.

Powering the Planet

Goodyear Transmission Belts for Farm and Factory

"The belt drive is one of the oldest known means of transmitting mechanical power," a Goodyear publication once noted, and "belting is one of the most universal products that are known to the trade as Mechanical Rubber Goods."[4] Goodyear started manufacturing flat transmission belts in the early twentieth century. At first, rubber transmission belts had to compete with other types—including leather, stitched canvas, solid cotton woven, hair, and balata—but eventually consumers recognized the superiority of the Goodyear belt.[5] By 1913, the company made at least half a dozen brands for bucket elevators, main drives, and motor drives for manufacturing plants. Soon, the company produced 25 different belt drives for industrial applications and continued to improve their transmission belts throughout the 1920s and '30s. Before long, Goodyear manufactured belts for industries such as brick and clay, mining, baking, flour and feed mills, laundry, oil wells, paper mills, printing, and saw mills. Improvements in both belting and equipment made possible much longer single units, larger capacities, longer service, lower unit power requirements, and lower unit costs. The company tested these belts in actual service conditions on their own testing machines, allowing them to collect data and make adjustments, especially regarding speed, slip, tension, and power.

In addition to flat transmission belts, Goodyear produced V-Belts for countless industries. These products came in assorted sizes in light, normal, heavy, and extra heavy duty for a variety of single-belt machinery such as home appliances, power tools, automobiles, and farm equipment. In 1927, the company pioneered a method of making V-Belts called cutting and flipping that became a standard in the business. Two years later, they pioneered large cord construction to make V-Belts of a single layer of large cord that became the touchstone in the field. In 1933, the firm developed equipment and processes that removed most of the stretch from the cord and released low stretch V-Belts. When America entered the Second World War, the United States military required more resilient, high-performance belting, so Goodyear designers went to the drawing board. They solved the problem by inventing a new type of V-Belt bodied with steel cables instead of fiber cord. Soon, these superior belts replaced cotton belts for practically all drives on combat vehicles that saw extensive use in the war.[6]

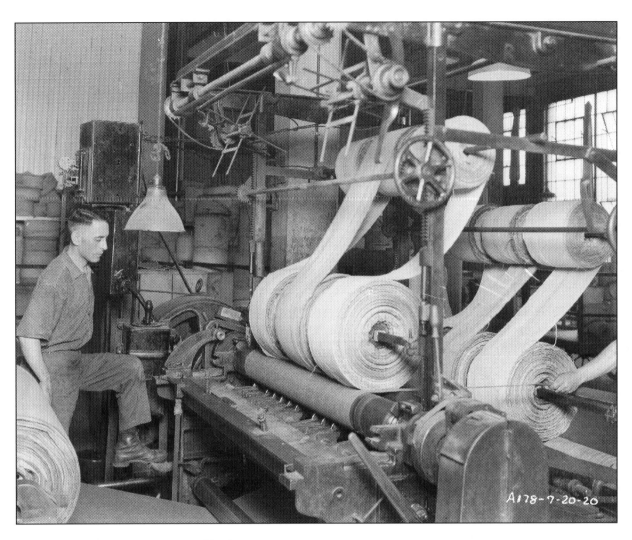

Belt Fabric Slitting Machine, 1920
A rubber worker at the Akron Plant slits rolls of Goodyear transmission belt into cut lengths. By the time of this photograph, Goodyear manufactured at least half a dozen brands of transmission belts, proving their claim that "there's a Goodyear belt for every conceivable purpose." This included Wingfoot for general purposes, Thor for heavy-duty main drives, Monterey for smaller machines, and Wyoga for lighter-use auxiliary drives. By the end of the 1920s, the company introduced Pumpwell and Drillwell brand belts with special oil-resistant rubber covers for oil fields.[7]

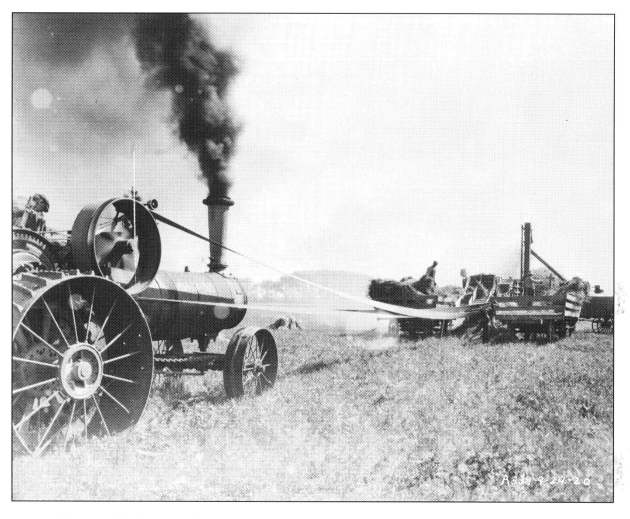

Klingtite Belt (Farm Application), 1920
Farmers use Goodyear Klingtite Endless Farm and Tractor Belts to transmit power from a tractor engine to a hay baler. Specifically designed for the agricultural industry, these weatherproof belts were an integral part of farm mechanization. The belts could be useful to saw and plane wood, crush stone, mix concrete, and convey ice. Unlike canvas-stitched belts, Klingtite did not require breaking in. It also reduced slippage and transmitted more power at lower tension. Shortly after this photo was taken, the company developed a longer life belt known as Goodyear Flex and one that resisted twisting called Two-Twist Cord.[8]

V-Belts in Operation, 1950
V-Belts operate a set of large circular saw blades at a sawmill. These belts were used extensively in industrial motors, power tools, home appliances, automobiles, and farm equipment. During World War II, Goodyear produced V-Belts for Allied tanks and other military vehicles. Photo by Bill Klotz.[9]

Moving Mountains and Building Bridges

Goodyear's "Rubber Railroads"

Conveyor belts date back to the time of the American Revolution, when warehouses employed leather or canvas belts to carry grain. These crude belts easily stretched and abraded, reducing their life and utilization. Rubber conveyor belts appeared after the Civil War, and while flexible and stronger, they could not be manufactured in large widths or handle abrasive materials. Goodyear manufactured its first conveyor belt in 1913. Then, as conveyor belts replaced mine cars and tracks in mining operations, Goodyear made improvements that helped advance the industry. In the second quarter of the twentieth century, Goodyear manufactured some of the largest and longest conveyor systems ever made to that time. These "rubber railroads" fueled American industry, carrying essential materials such as coal and ore from the bowels of the earth. They also conveyed gravel and crushed stone miles from quarries to help build some of the most important dams and construction projects in this country, which brought electricity, water, and flood control to thousands.[10]

11902·6-25-20

Goodyear Coal Conveyor Belt, Duluth, Minnesota, 1920
Goodyear's first steel cable conveyor belt gets tested at the Oliver Iron Mining Company in Duluth, Minnesota. These belts replaced the conventional cord fabric belts and sped the flow of iron ore to the nation's blast furnaces in places such as Pittsburgh and Cleveland. The company used this 1,100-foot conveyor to lift ore 240 feet from the working face to shipping barges on Lake Superior at the tipple. This required over 1.3 million feet—or 253 miles—of cables and was made "endless" on the job with special onsite vulcanizing equipment developed by Goodyear.[11]

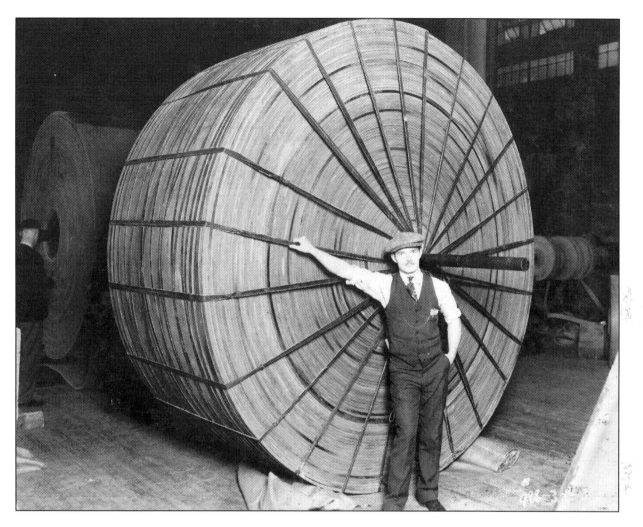

Largest Role of Conveyor Belt Ever Made, 1930
A roll of Goodyear conveyor belt is readied for shipment to Heyl & Patterson of Pittsburgh, a coal machinery supplier. The roll weighed 11 tons and was considered the largest conveyor belt ever made at the time. By the time of this photograph, Goodyear turned out close to 100,000 feet daily and had manufactured 65 million feet or over 12,000 miles of belting. They also developed several belts by this time that helped improve the industry, including the cushioned center, low stretch, Metzler cushion edge, and Hy-Temp.[12]

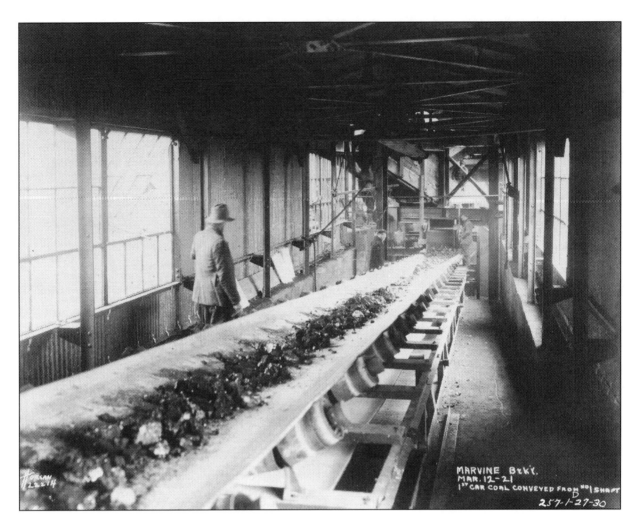

Coal Conveyor Belt, 1930

A Goodyear long-center conveyor belt brings coal out of the No. 1 Shaft at Marvine Colliery in Scranton, Pennsylvania, then known as "the Anthracite Capital of the World." This belt hauled 600 tons of coal per hour, 4,200 tons per day, and one million tons per year traveling at a rate of 350 feet per minute. This belt was similar to the 2,345-foot center conveyor system Goodyear built in 1924 for the H. C. Frick Coal & Coke Company's Colonial Mine on the banks of the Monongahela River south of Pittsburgh, which provided the coke that fired the blasts furnaces in the "Steel City."[13]

Conveyor Belt Construction, ca. 1932
Workers measure and cut conveyor belt fabric in the Conveyor Belt Room at the Akron
Plant. Goodyear made conveyor belts of fabric plies with a rubber skim coat in between to
increase flexibility, then applied a thick, tough cover of specially compounded rubber with
a calendering machine before curing them in huge curing presses. Shortly after this photo
was taken, Goodyear installed their first 100-percent-conveyorized mine and soon had a long
list of these installations with Penn Anthracite, Sahara, and Consolidated coal companies.[14]

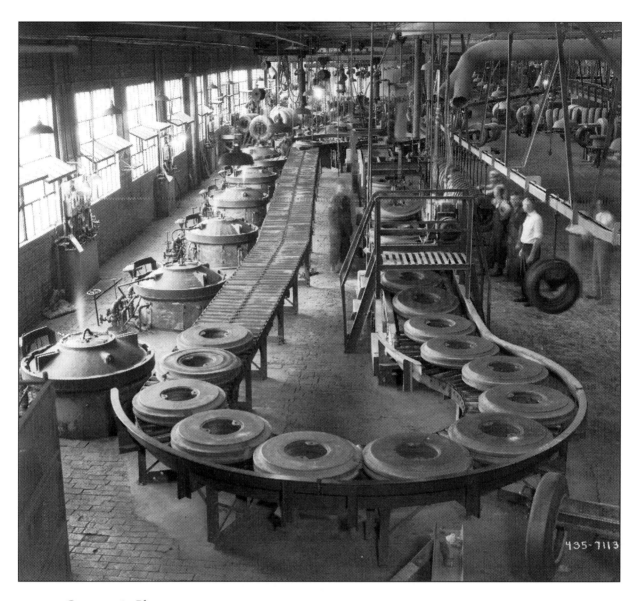

Conveyor in Plant 1, 1933

By the 1930s, many manufacturing plants featured Goodyear conveyor belts on production lines to move products. Goodyear tested these belts in their own factories, including this belt that moved tire molds from the vulcanizers at Plant 1 in Akron. By the end of World War II, Goodyear conveyor belts had been adopted for canning factories, meat packinghouses, grain elevators, post offices, and mail-order stores.[15] Around this time, Goodyear also produced an electrostatic belt for a particle accelerator, or "atom smasher," at the Westinghouse Research Laboratories in Forest Hills, Pennsylvania.[16]

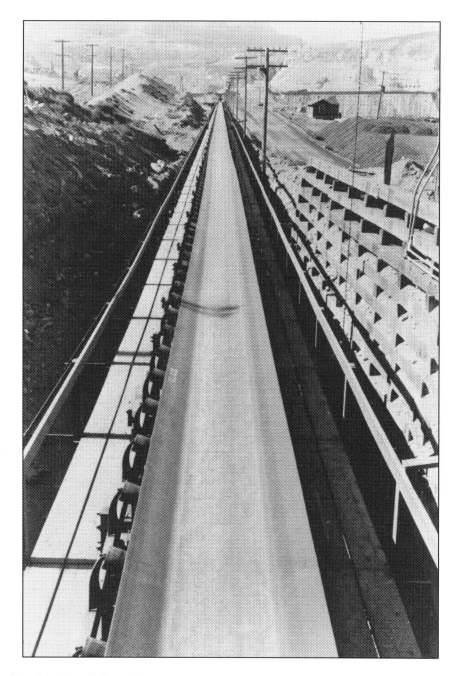

Grand Coulee Dam Belt, 1938
In 1938, Goodyear manufactured and installed the world's largest single-flight conveyor belt at the Grand Coulee Dam on the Columbia River in Washington State. The 10,000-foot, 80-ton belt required 120 bales of cotton and 50 tons of rubber. It carried 2,000 tons of concrete aggregate per hour, one and a half miles from the gravel quarry to the dam site. The belt carried over 11 million tons of material to help build the dam that produced hydroelectric power, provided irrigation water to thousands of farms, and created Franklin D. Roosevelt Lake.[17]

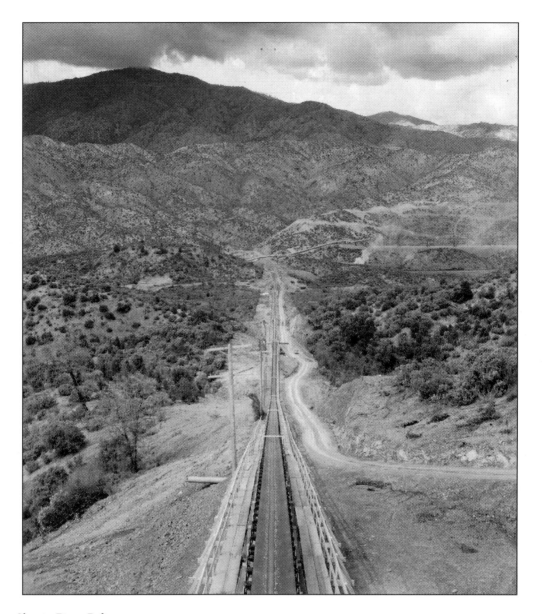

Shasta Dam Belt, 1940

In 1940, Goodyear created the longest rubber conveyor belt system in the world for the Shasta Dam in Northern California. Built at Akron's Plant 2, it was twice as long as any other conveyor belt previously built. Made of one million pounds of rubber and a half a million pounds of cotton, the 26-flight system weighed 11.5 million pounds and carried 1,200 tons of gravel an hour from Redding, California to the dam site 9.6 miles away at Coram. The 20-mile belt operated for four years carrying over 12 million tons of material to help build the second tallest dam in the country at that time that provided flood control, irrigation water, and hydroelectric power to California's Central Valley. After dismantling, the belt was shipped to the gold fields of South Africa.[18]

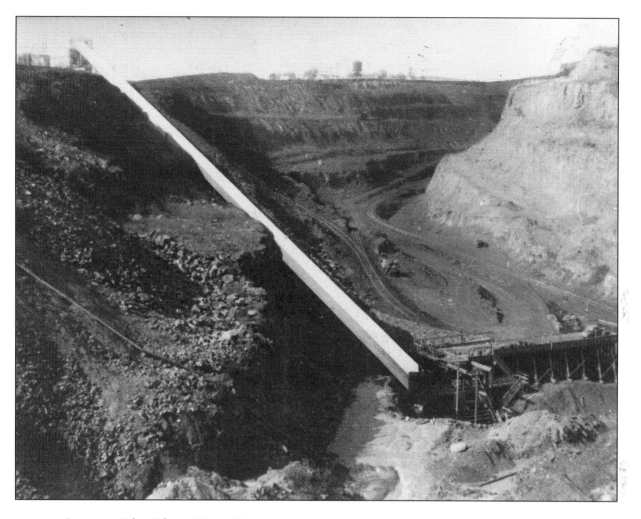

Conveyor Belt—Oliver Mining Co., 1942
This system of nine Goodyear conveyor belts helped the Oliver Iron Mining Company remove overburden at a rate of 2,200 tons per hour to strip mine iron ore at the famous Mesabi Range in Minnesota. Dubbed "the neatest strip act in history," this Goodyear belt moved an estimated 5.5 million yards of overburden up and out of the open pit to a spoil pile a mile and a half away. By the time of this photo, Goodyear had developed cord and compass steel cable conveyor belts, which soon saw use in mines around the country and South America.[19]

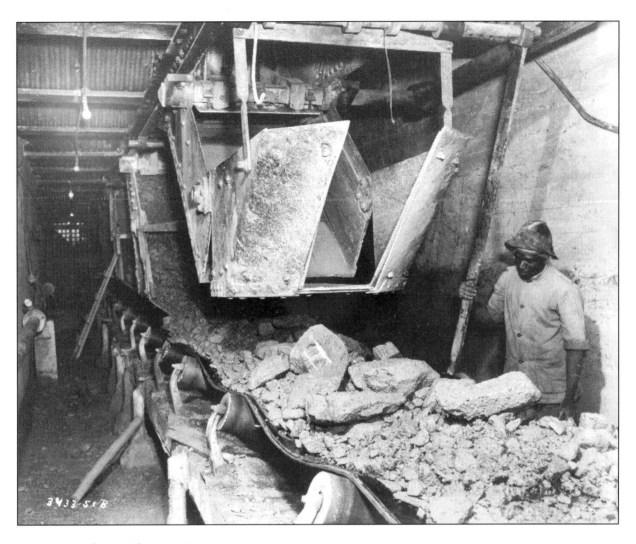

Langlaagte Chute in Operation, 1951
A mine worker operates the chute at the Langlaagte gold mine near Johannesburg, South Africa, which used a Goodyear conveyor belt to carry rock and debris out of the mine shaft. The same year as this photograph, Goodyear installed a massive seven-mile belt system at Bull Shoals Dam, a concrete gravity dam built by the Army Corps of Engineers on the White River in Arkansas that formed Bull Shoals Lake and provided hydroelectricity and flood control.[20] As the company noted, "from short hauls to installations miles in length, Goodyear 'rubber railroads' have carried millions of tons of materials over hills and valleys, crossing rivers, roads, and rail lines."[21]

Solids, Liquids, and Gases

Goodyear Hose for Every Purpose

While rubber hose may not sound significant, Goodyear hose played a role in a number of industries at home and abroad. According to Goodyear's Manager of Hose Sales Robert Mercer, "the hose industry is one of America's oldest" and Goodyear started manufacturing this product in 1913 with the motto "Make the Hose to Meet the Service" and "Goodyear Hose for every purpose."[22] Goodyear studied the conditions to which consumers subjected hose and determined how to build products that met those demands. Before long Goodyear manufactured hose for almost every type of material and application conceivable including water, fire, steam, air, gasoline, radiator, chemical, spray, sanitary, pneumatic tool, welding, and sand blasting. The company manufactured the majority of their hose for industry, as most manufacturing and processing businesses used some type of hose somewhere in their operations. Goodyear made improvements in rubber hose manufacturing that aided nearly 60 industries including aeronautics, agriculture, automotive, brewing, canning, dredging, electric, gas, mining, and textiles. By the mid-1930s Goodyear made nearly 70 styles and four general classes of hose—braided, wrapped fabric, woven jacket, and all rubber. By this time the firm had contracts with major companies making garden hose for Sears Roebuck and Macy's, fuel tank vent tube hose for Chrysler, oil suction and discharge hose for Gulf Oil Company, and paint hose for Ford and Studebaker.[23]

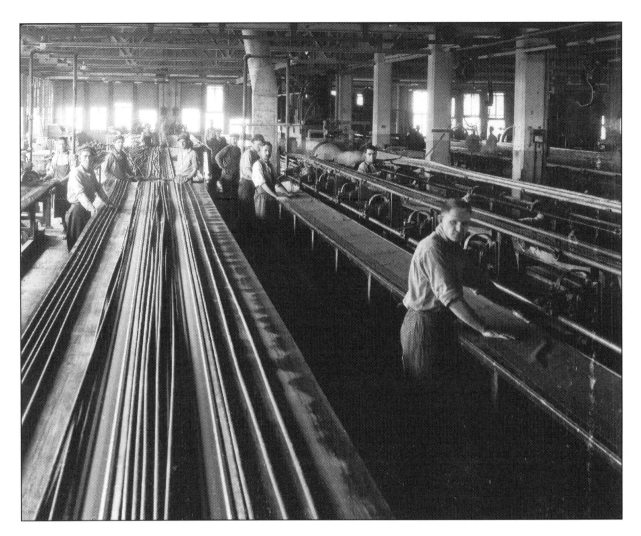

Making Hose in 3a, 1915
Goodyear started making various types of rubber hose in 1913 and by the time of this photo-
graph made ten brands and had a hose capacity of 6,000 feet per day, which reached 90,000
feet in ten years. At this time, Goodyear hoses came in various lengths, diameters, and lines
including Akron, Elm, Emerald, Glide, Monterey, Wingfoot, and Wyoga. However, one of
the company's most prominent early hoses included the Goodyear patented Kantkink Flex-
ible Metallic Hose that prevented kinks, tangles, fraying, crushing, and breakage, making it
ideal for the automotive, railroad, and mining industries.[24]

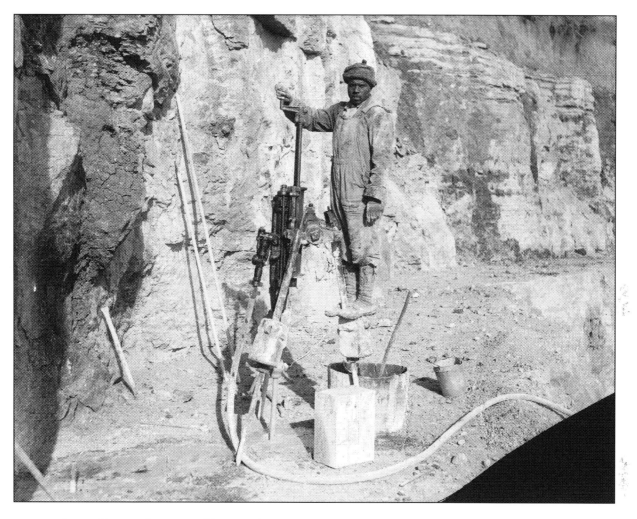

Steam Hose in Operation (Open Pit), 1920

A laborer poses with his tripod mounted rock drill outfitted with Goodyear air drill hose in an open pit mining operation. The mining industry was one of the largest consumers of Goodyear hoses for many different types of service, especially air hoses used on pneumatic tools to remove rock and ore and grease hoses to lubricate mine cars. Goodyear hoses are said to have been utilized in the gold mines of Alaska, the copper mines in Montana, and even on the construction of the Panama Canal.[25]

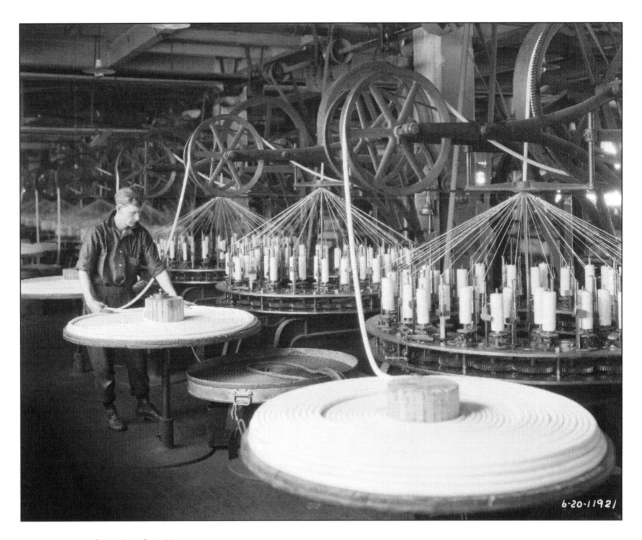

Braiding Garden Hose, 1920
A worker braids Goodyear Garden Hose in the Hose Braiding Room at the Akron Plant. While Goodyear manufactured most of their hose for industry, one of the company's most successful lines included garden hose, called "perhaps the best known of Goodyear's Mechanical Goods line."[26] They constructed the hose from five distinct layers that provided "years of service" in thousands of American homes. By the time of this photograph, the company claimed to have sold six million feet of this product.[27]

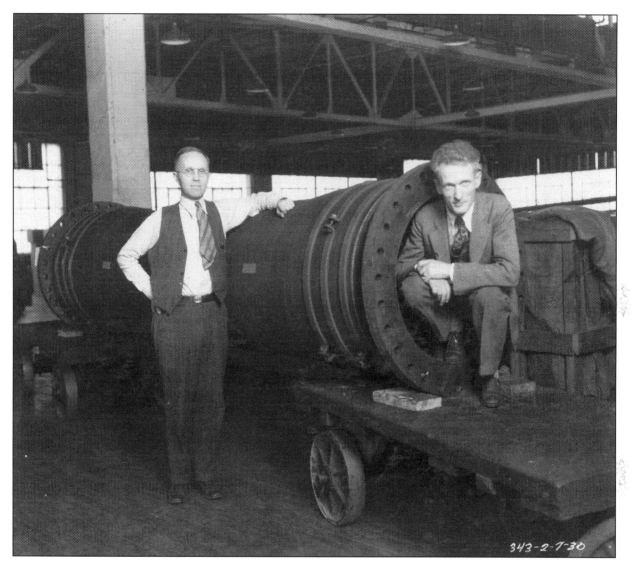

World's Largest Sand Suction Hose, 1930
Two executives pose with the world's largest sand suction hose, which was designed and manufactured by Goodyear and became standard on many large dredges in use at that time. Developers employed Goodyear suction hoses to dredge out channels, bring in sand to fill up tide lands or low lying areas, and build artificial islands. The Army Corps of Engineers even utilized Goodyear dredge hose during the Florida land boom of the 1920s to create islands off the coast of Miami.[28]

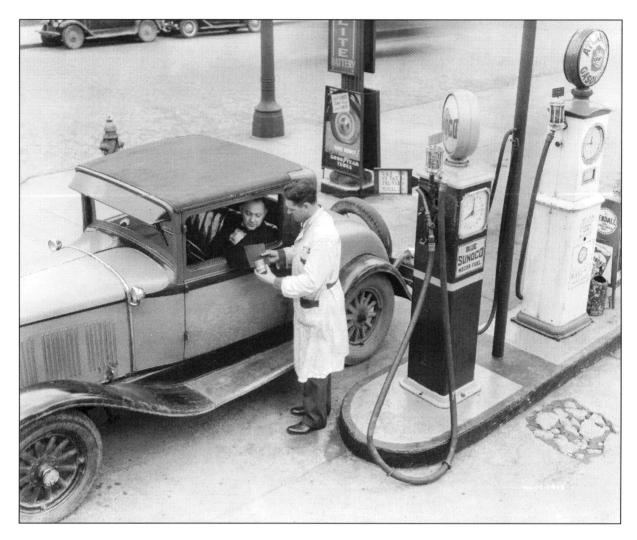

Gas Hose at Service Station, 1934
Service stations throughout the world used Goodyear Gasoline Hose to deliver fuel to their customers' automobiles, including this Sunoco Station in Ohio. By the mid-1930s, the company averaged 14 million feet of garden hose annually and made over 680,000 feet of gasoline hose, nearly 770,000 feet of fire hose, and 90,000 feet of spray hose.[29]

Mount Rushmore under Construction, 1937
Drillers use jackhammers outfitted with Goodyear Pneumatic Tool Hose to carve the face of Abraham Lincoln on Mount Rushmore. By the time of this photograph, Goodyear developed a scientific method of hose construction for braided and wrapped hose that became universally accepted by other companies. Further development occurred in 1937 when the firm created flanged ends on high pressure hose which provided full flow through the product and eliminated the inherent weakness of clamp type couplings.[30]

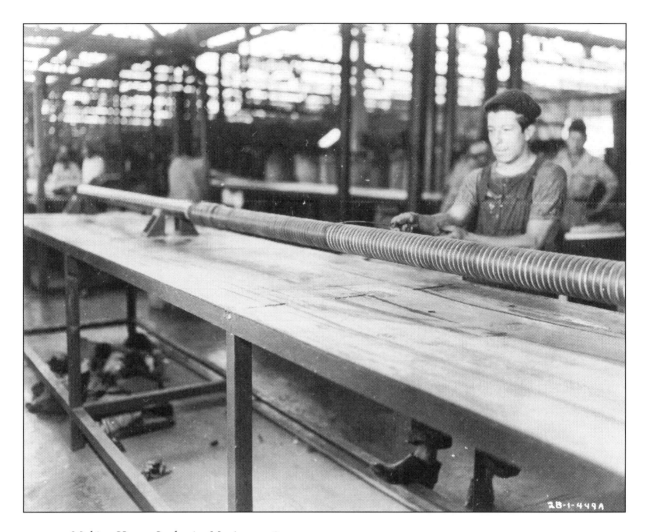

Making Hose—Lecheria, Mexico, 1948
Workers in Goodyear's factory in Lecheria, Mexico, make Goodyear rubber hoses. By the time of this photograph, Goodyear made over eight hundred types of hose. Those hoses were used during World War II to extinguish blazes in London caused by Nazi bombs and rockets and to reconnect water lines broken by explosions. The company also developed an all-synthetic bullet-sealing hose during the war, and the aeronautical branches of the United States Army and Navy used it extensively.[31]

Step on It

Goodyear Soles and Heels for Everyone

In the early twentieth century, rubber manufacturers developed materials to replace leather for shoe soles. There was a leather shortage, and leather lacked resiliency and resistance to moisture. Goodyear manufactured rubber soles and heels on a small scale starting around 1901, but they made them with low quality materials and did not brand or market them. Then, in 1913, the company manufactured and advertised high-quality heels and soles under the trade name "Wingfoot." In order to meet the demand for rubber heels, Goodyear constantly enlarged its factory capacity and continuously developed innovations in the production of rubber soles and heels that helped change the industry. One of these innovations included developing standardized shapes and accurate molds, so rubber heels could be applied by machinery instead of by hand. Also, since rubber had a tendency to crack, stretch, and tear at the stitches, Goodyear created a new synthetic material called Neolin (from the Greek word "neo," or new, and the Latin suffix "lin," or material) that was "waterproof, slip-resistant, crack proof, comfortable, and long-wearing." By 1925, the company had the ability to make over 100 shapes and styles of heels.[32]

Goodyear constantly strived to improve their products and manufacturing methods. In 1937, technicians in the Goodyear Research Laboratory developed a new and improved shoe sole that would be lighter, more comfortable, damp resistant, neat, stylish, and wear longer. Seven years later, an "entirely new material" finally emerged from their test tubes. "Not leather, rubber, or plastic," Neolite, as they called it, was a manmade elastomer resin blend that was unique to Goodyear. Called "test tube triumphs" and "the miracle material for soles and heels," Neolite reportedly did not crack, curl, squeak, or mark floors.[33] Production centered at the Windsor, Vermont, and Gadsden, Alabama plants. Advertising for Neolite began in 1945 with the catchy slogan "Step On It," which quickly became a household phrase. By the end of the 1940s, the company claimed that 25 million people walked on Goodyear soles and heels, including Allied soldiers during the Second World War.[34]

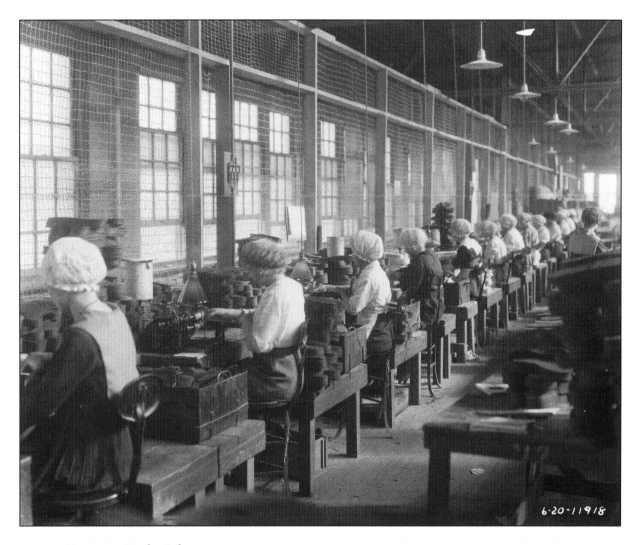

Trimming Neolin Soles, 1918

A row of workers trim Neolin soles at the Akron Plant before final inspection and packaging. Goodyear started manufacturing rubber heels in 1901, and by the time of this photograph, the company was producing 100,000 pairs of soles per day, mainly for the doughboys fighting on the Western Front. In 1917 the company built a new factory for the production of Neolin soles and heels that had a capacity of 100,000 pairs daily. By 1919, Goodyear sold over 12 million pairs, including six million in one year.[35]

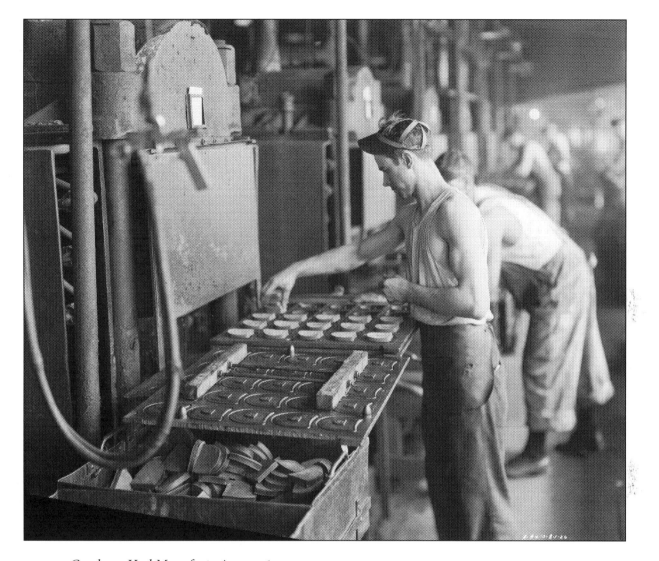

Goodyear Heel Manufacturing, 1926
Rubber workers create Goodyear heels by placing Neolin in molds, so they could be applied by machinery instead of by hand. At the time of this photograph Goodyear stocked 12 million pairs of Wingfoot heels in over 100 shapes, sizes, and styles. This included New Era and Marathon brand rubber heels. By 1937, Goodyear had produced an astonishing one billion pairs of rubber heels, and by the end of the decade, Goodyear was one of the largest producers of rubber heels in the country.[36]

Congressional Medal of Honor Winners in Goodyear Soles and Heels, 1944
Congressional Medal of Honor winners Sgt. Charles E. "Commando" Kelly (left) and Lt. Ernest Childers (right), one of only a handful of decorated Native Americans, show off their Goodyear-manufactured soles and heels on their visit to the Akron Plant during World War II. Throughout the war, the government restricted heels of natural rubber to the armed forces, so Goodyear developed a heel made entirely of regenerated rubber for the American public. The year this photo was taken, Goodyear released a new material for shoe soles that was lighter, more comfortable, damp resistant, and extra resilient. Neolite, as they called it, was a manmade elastomer resin blend that was unique to Goodyear.[37]

Sit on It

Goodyear Foam Rubber for Home, Office, and Vehicle

In the 1930s, Goodyear launched a revolutionary new material made from the milk of the rubber tree that possessed extraordinary cushioning properties and long life. Like many other company products, it began on a trip to England. In 1934, Paul Litchfield and several Goodyear chemists witnessed an unfamiliar substance being "whipped up" at Dunlop Rubber. Realizing its potential, Litchfield sent Paul Shoaff, head of Goodyear's chemical plant, to Sumatra to develop a process of extracting rubber in latex form. Shortly thereafter, the company brought the milky substance to the United States, first on a small scale and eventually in huge tanker cars. In 1936, the company started a department to manufacture foam rubber under license from Dunlop. Soon, Goodyear chemists were beating air into liquid latex in massive mixers until it acquired a foamy consistency. They then molded and water cured the foam into desired shapes. Goodyear called the resultant product "Airfoam" because the cured latex was honeycombed with minute interconnected air cells, completely porous, and self-ventilating. According to Hugh Allen, by the end of the decade "the manufacture of rubber products from latex...grew into substantial proportions."[38]

Goodyear originally introduced this product to the transportation industry where manufacturers found it ideally suited for seats on buses, trains, and steamships. Its many advantages included comfort, cleanliness, and long wear, which made it superior to steel springs as a cushioning agent. Shortly thereafter, Detroit began using Airfoam as padding for automobile seats. In addition, Airfoam soon gained rapid acceptance as filling for furniture and bedding. While Goodyear discontinued manufacturing Airfoam for furniture and automobile seating during World War II, they found new uses for the product in the war effort. Goodyear also manufactured a new plastic insulation material during the war called Resinfoam, which served as a wartime replacement for Airfoam for many military purposes. Immediately following the war, Goodyear once again manufactured Airfoam for the transportation and furniture industries. They also greatly expanded their facilities for the production of this product and developed an improved version called Super Cushion.[39]

Testing Treated Resinfoam, 1943
A chemist at the Goodyear Research Laboratory in Akron tests Resinfoam as members of
the press observe the process. Resinfoam was a nonflammable, waterproof, soundproof,
synthetic plastic insulation developed by Goodyear during World War II. The government
employed it as a wing filler and to insulate cabins on military airplanes. Goodyear also manu-
factured Airfoam during the war. The military packed bombs in Airfoam to prevent them
from exploding during shipment and mounted airplane cameras in it to prevent vibration
and produce quality reconnaissance photographs.[40]

Schwab Latex Company, Inc., 1950

Female workers coat mattresses made with Goodyear Airfoam at the Schwab Latex Company, a Goodyear distributor in New York. These mattresses were probably made in Goodyear's Plant C in Akron, which became one the world's largest continuous production lines for foamed rubber after World War II. When the war ended, Goodyear improved the product and launched the new Super Cushion and opened a new $5 million Airfoam manufacturing plant in Akron, a creaming plant in Malaya, and a modern plant in Canada with a capacity of 100,000 pounds a year. By the end of the decade, automobile manufacturers featured Airfoam in cars of every price class, and it gained rapid acceptance as cushioning for furniture and bedding as it was odorless, dustless, lint-free, and washable.[41]

Tapping Coolies Delivering Latex, 1935
Tapping coolies deliver raw liquid latex gathered from rubber trees to a collection station at Goodyear's Wingfoot Plantation in Sumatra, where they sampled and weighed the rubber "sap" and dumped it into a large holding tank. A fleet of trucks then transported the material to a processing plant where ammonia and a creaming agent were added. The processed latex was then pumped into huge tank cars and sent to a shipping center where the material was piped aboard ships for transfer to the United States for use in Airfoam products. As its name implies, Goodyear made Airfoam by whipping air into the compounded latex until the liquid came to a frothy consistency. Workers then poured it into molds and cured it with hot water and steam, and the resultant cured rubber had millions of tiny interconnected air cells.[42]

Walk All Over It

Goodyear Flooring and Matting for Every Surface

Rubber flooring first appeared in public buildings in 1870. Thirty years later, Goodyear entered the rubber flooring business and released their first successful rubber flooring in 1905, an interlocking molded rubber tile that saw extensive use in private residences and public buildings. The company discontinued their rubber flooring during World War I, but in 1921, Paul Litchfield witnessed the manufacturing of block rubber flooring at several British rubber companies. Upon his return to Akron, he instructed Goodyear's Development Department to start investigating compounds and manufacturing methods for a satisfactory sheet rubber floor covering cut in blocks and laid in decorative patterns. Production began in 1923 when Goodyear entered the field of decorative rubber flooring as a competitor to the Stedman Rubber Company, predecessor of Armstrong-Cork. By 1931, Goodyear rubber flooring appeared in office buildings, banks, stores, hospitals, churches, schools, colleges, hotels, steamships, yachts, railroad cars, buses, airplanes, and private residences across the nation. By this time, they also made the material for desks, counters, and table tops. Later, during World War II, Goodyear developed a nonslip flooring for navy ships and special flooring resistant to sparks and the accumulation of static electricity that was ideal for arsenals and munitions plants throughout the country. After the war, Goodyear found a new market in providing synthetic rubber tile and vinyl flooring in the post-war building boom.[43]

In addition to flooring, Goodyear manufactured rubber mats in the early twentieth century in various sizes and colors for installation where a soft, resilient, protective floor covering was desired, including aisles, corridors, stairs, lobbies, vestibules, and elevators. By 1916, the company made mats in both perforated and plain and matting in corrugated and pebbled. In 1927, the company asserted that Goodyear Rubber Matting could be seen everywhere including hotels, public buildings, schools, hospitals, factories, theaters, stores, ships, offices, and homes. The company also made runner stock, switchboard matting, jardinière mats, and cuspidor mats. Additionally, Goodyear manufactured floor mats of high quality, nonblooming rubber compound and wool in standard sizes for cars and trucks. They also made mat covers for boxing and wrestling rings and huge waterproof blankets that protected athletic fields from the elements.[44]

Rolls of Rubber Flooring in Factory, 1950
Goodyear produced rubber flooring in tiles and rolls, including those displayed by this executive in the Akron Plant. Goodyear rubber flooring graced the interiors of churches, banks, hospitals, hotels, theatres, offices, schools, private residences, and yachts and steamships. It could be seen in businesses like O'Neil's department store and Acme grocery in Akron and in famous buildings across the country, including the US Capitol and Government Printing Office in Washington, DC, the Chrysler Building in New York City, and City Hall and Metro-Goldwyn-Mayer in Los Angeles. Photo by Don Klotz.[45]

Rubber Mats, 1934

A rubber worker exhibits Goodyear Corrugated Floor Mats shortly after they came off the production line at the Akron Plant. Goodyear manufactured rubber mats from an early date in a variety of patterns, widths, thicknesses, and colors for applications in private residences and public buildings. By the time of this photograph corrugated rubber matting existed as one of the company's largest selling flooring specialties.

Mat Press, 1927

A rubber worker operates a mat press at Goodyear's Akron Plant. Goodyear made their mats out of sturdy, bulky corrugation and high-grade hose fabric backing. This construction gave them more resiliency, longer wear, greater strength, increased resistance to abrasion, and improved tensile strength that prevented cracking. By the time of this photograph, Goodyear matting included Wyoga and Monterey brands as well as All-Weather Complete Floor Mats, Wingfoot Universal Mats, and No-Draft Mats that added greater comfort in automobiles, blocked heat and cold, and provided protection from dust, dirt, and engine fumes.[46]

Giant Waterproof Blanket at OSU Stadium, 1937

In September 1937 a giant waterproof blanket made by Goodyear was installed at Ohio Stadium at The Ohio State University to keep the field dry until game time. The huge blanket contained 3,960 yards of 56-inch-wide fabric—a total of two and a quarter miles—and weighed nearly five tons. Soon, the company would produce mat covers for boxing and wrestling rings of a unique construction of extra strength cotton fabric rubber coated on each side, which made it cleaner, more sanitary, and resistant to slipping, wear, dirt, and moisture.

Wrap It Up

Goodyear Film for the Home, the Market, and the Military

While plastic wraps such as cellophane had been introduced to the United States from Britain in 1912, it had limitations, especially since it was not homogenous in composition and therefore failed when folded, wrinkled, or creased. In the 1930s, Goodyear chemists set out to develop a product that would supply industry's call for a lightweight, transparent, durable, pliable, inexpensive sheeting for wrapping and packing that would be inherently impervious to water, moisture, alkali, oil, and grease. Goodyear answered the call by creating a new chemical substance produced from high grade natural rubber reacted with hydrochloric acid called rubber hydrochloride. Placed into a solution and cast into sheet form, the result was a highly versatile transparent rubber film that was thermoplastic and highly moisture-vapor-waterproof with the physical and chemical characteristics to meet many packaging requirements. They named this material Pliofilm. The superior qualities of Pliofilm included strength and durability, moisture retention, flavor retention, transparency, controlled gas diffusion, and ease of fabrication. It also was puncture resistant, pliable, wearable, sanitary, odorless, tasteless, nonexplosive, noninflammable, and easily printable. In addition, Pliofilm was inherently impervious to air, alkali, grease, heat and cold, moisture, mold, oil, vermin, and water.[47]

These characteristics made Pliofilm desirable and economical for countless applications in industry, the home, and the military. In order to serve a variety of purposes, Goodyear furnished it in either cut-to-size sheets or rolls in five standard thicknesses and in 20 different transparent, opaque, and metallic colors. For many years, Goodyear primarily used the plasticized type commercially in the fabrication of household goods and apparel, mostly raincoats, shower curtains, and umbrellas. By the end of the 1930s, the company provided Pliofilm in large quantities for the packaging industry for packing countless items such as fresh and processed meats, seafood, cheese, fruits, vegetables, and cereals. However, the advent of World War II brought a halt to the civilian use of Pliofilm and ushered in a second chapter in the history of this "wonder wrap" as all of the film manufactured during the war went to the armed forces. Because of its combination of superior characteristics, Pliofilm proved the most satisfactory method of packaging metal items for shipment to the theaters of war. When the government lifted restrictions on natural rubber in the post-war years, Goodyear brought Pliofilm back into civilian production. The largest post-war use of Pliofilm was in the food packaging field, marketing it to homemakers and supermarkets.[48]

Pliofilm Bag on New Aircraft Engine, 1943

 The armed forces employed Pliofilm during World War II for packaging and delivering metal items such as instruments, spare parts, and airplane engines to the theaters of war, protecting them from corrosion in atmospheric conditions. In this photograph, workers remove a Pliofilm bag from a new airplane engine before placing it into the aircraft. This new shipping technique proved superior to the conventional packing in grease method. Out of these military applications emerged the packaging formula called Method II (also known as vacuum, vapor, or barrier bag packing), later adapted for shipment of many commercial items.[49]

Shrimp Pliofilm Wrapped, 1951
A worker in a Texas food plant wraps frozen shrimp in Goodyear Pliofilm. After World War II, Goodyear created a new plant in Akron to produce Pliofilm and other new chemical products to meet the growing demand for plastics, especially for protective packaging in the food, tobacco, and pharmaceutical industries. Developments during the war led to 12 compositions and eight gauges for a total of 25 types of film that broadened its scope to scores of diverse products and applications such as electric wire insulation, oxygen tents, wrapping for surgical dressings, decoration and display materials, theatrical costumes, and transparent adhesive tape.[50]

Making Raincoats, 1949

For many years, Goodyear used the plasticized type of Pliofilm commercially in the fab-
rication of household goods and apparel including raincoats, shower curtains, umbrellas,
garment bags, aprons, bibs, book covers, and a number of other items. By the end of 1934,
approximately 408,000 yards of Pliofilm had been sold. Goodyear had made Pliofilm available
for sale in export markets by the time this photograph was taken. As a result, their annual
volume exploded to roughly 25.5 million yards.[51]

Home is Where You Make It

Goodyear Portable Houses for the Masses

During World War II, the federal government established a government program to battle the nation's housing shortage caused by the Great Depression and the unprecedented demand for housing thousands of war workers. Seemingly overnight, prefabricated homes appeared around the country to address the situation. This did not completely remedy the problem, so companies, including Goodyear, stepped in to help. Although houses did not include any rubber and manufacturing them was not in Goodyear's wheelhouse, Paul Litchfield felt that the company had a moral obligation to support the war effort and help address the housing shortage by developing what Goodyear called "an entirely new, complete, low-priced American home." Litchfield, however, did not attempt to build a better house cheaper than companies already in the industry. Instead, he took an entirely new approach than his competitors, who prefabricated sections at the factory and assembled them on the owners' property, by constructing a completely assembled and equipped home in the shop and delivering it to the purchaser in ready to move in condition. After the war, Litchfield viewed the housing business as a purely economic opportunity and built several factories to construct prefabricated homes dubbed the "Wingfoot Home" for low-income families.[52]

In addition to prefabricated homes, Goodyear cooperated in balloon housing projects throughout the country during World War II. By that time, reinforced concrete structures were well-known for their durability and resistance to fire and other elements. Unfortunately, they were also the most costly type of construction. Nevertheless, Goodyear's development of the pneumatic form, popularly referred to as "Airform" or "Balloon Form," transformed this situation. This unique and simple construction technique included laying the foundation, placing and tying an inflated half-balloon or hemisphere with helium and pneumatically spraying it with cement, insulation, and waterproofing with air pressure from a gunite machine. After the concrete set, construction workers deflated and removed the balloons to reveal the completed concrete shell of the building. Goodyear dubbed them "balloon houses" because the balloon building experts of the company's Aviation Products Division manufactured the hemispherical, inflatable forms used in their construction.[53] However, Goodyear did not own the patents to this process—their only contribution being the manufacturer of the balloons—and the patent holder demanded such high royalties on the process that contractors stopped constructing them, causing the balloon houses to fade into memory.[54]

"Igloos" at Litchfield Park, Arizona, 1942
Goodyear "Balloon" or "Airform" houses at Litchfield Park, Arizona aided in the emergency housing situation during World War II. Goodyear announced the balloon-molded homes, also referred to as "Igloos," in 1942 as a new defense service. Balloon homes consisted of two hemispherical sections erected several feet apart and connected with a covered areaway. Airform construction had many advantages as the buildings were permanent class "A" structures; fire, earthquake, and bomb resistant, as well as vermin and termite proof.[55]

Goodyear Portable House, 1943

A woman poses on the steps of the Goodyear "House of the Future," shown for the first time in Akron when Goodyear dedicated its new Research Laboratory. First developed in 1942, the 250-square-foot homes were produced on a small scale in a pilot assembly plant in Litchfield Park, Arizona and limited to authorized construction for war workers. Since the completed home had to be transported over highways on trailers, Goodyear engineers designed the structures eight feet high by eight feet wide and 26 feet long to meet highway height restrictions and federal road regulations, including recessed telescoping sides pushed inward for transportation.[56]

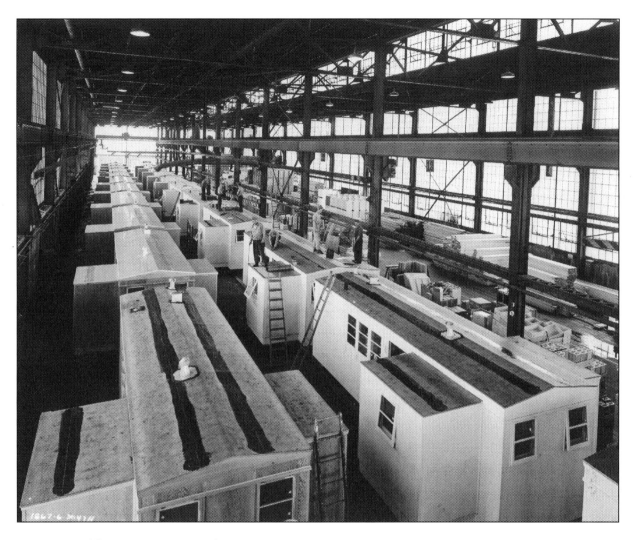

World's Longest Home Production Line, 1947
This photograph shows the end of the quarter-mile long production line in the Wingfoot Homes, Inc. plant in Washington Park, Illinois. The Goodyear subsidiary could produce 30 homes per day, close to 50,000 annually. Delivered homes, dubbed "Model T Houses," could be erected in four hours ready for immediate occupancy. Costing around $2,000, the company targeted first-time home buyers and low income families, mostly in the Western US. In 1948, the Atomic Energy Commission housed scientists developing the hydrogen bomb in more than 2,000 of the dwellings at the Los Alamos Laboratory. This modern mass production assembly line was claimed to be the world's longest for the fabrication and assembly of houses.[57]

Notes

1. C. C. Slusser, "Upholding Our Good Name," *WC*, February 8, 1933.

2. See "Mechanical Goods Were Manufactured Here in Small Way Thirty Years Ago," *WC*, February 8, 1933; "'Four Horseman' Honored at Dinner," *WC*, February 2, 1938; and H. E. Morse, "History of Development of Mechanical Rubber Goods," 1943, MS, Goodyear Records (hereafter GR).

3. See "Mechanical Rubber Goods and Miscellaneous Rubber Goods Manufactured by The Goodyear Tire & Rubber Company," 1918, MS, GR; Goodyear, *Book of Products and Prices* (Akron, OH: Goodyear, 1919); Goodyear, *Encyclopedia of Goodyear Mechanical Goods: General Information* (Akron, OH: Goodyear, 1916); Slusser, "Upholding Our Good Name;" and Goodyear, "Mechanical Goods Sales to Major Corporations," 1934, MS, GR.

4. Goodyear, *Encyclopedia of Goodyear Rubber Goods for the Agricultural Field* (Akron, OH: Goodyear, 1920).

5. See the following Goodyear sales brochures from GR: "Power Transmission by Belting," 1925; "The Yardstick Is a Poor Measure of Belt Values," 1929; and "Glide Belts," "Klingtite Transmission Belts," "Blue Streak Belts," and "Compass Belts," n.d. See also Goodyear, *Encyclopedia of Goodyear Mechanical Rubber Goods for Hardware Dealers* (Akron, OH: Goodyear, 1918); and "Will You Meet a Man That Wants to Save You Money?," March 14, 1932, advertisement in *Time Magazine* (hereafter *TM*).

6. See Goodyear, "Goodyear V-Belts," 1949, sales brochure, GR; and Goodyear, "Standards for Light Duty or Fractional Horsepower V-Belts," 1952, sales brochure, GR.

7. Goodyear, *Goodyear Mechanical Rubber Goods: Descriptive and Illustrative Catalogue.*

8. See "Your 1923 Story on Klingtite Endless Farm Belts," *Goodyear Triangle Supplement*, December 6, 1922; Goodyear, *Handbook of Goodyear Rubber Goods for the Farm* (Akron, OH: Goodyear, 1922); and Goodyear, "Goodyear Farm Belts," 1931, sales brochure, GR.

9. See Goodyear, *Encyclopedia of Goodyear Mechanical Rubber Goods for Hardware Dealers*; and Goodyear, *Encyclopedia of Goodyear Rubber Goods: For the Agricultural Field.*

10. Goodyear, *Encyclopedia of Goodyear Mechanical Rubber Goods: Belt Conveyors and Bucket Elevators.*

11. See Frederic V. Hetzel, *Belt Conveyors and Belt Elevators* (London: Chapman & Hall, 1922), 25; and "Given Most Staggering Conveying Job Ever Devised by Man Goodyear Conveyor Belts Make Good in Big Way," *WC*, February 8, 1933.

12. See "Goodyear Belt 12,000 Miles Long Since Start of Belt Production," *WC*, February 1, 1928; and "Fine Production Record Shown in Belting Section," *WC*, June 17, 1942.

13. See Goodyear, "A Cost Analysis of Transportation by Belt Conveyor," 1945, MS, GR; "The World's Longest Belt Conveyor System," *WC*, February 1, 1928; "Over 3½ Miles More of Goodyear Belts in One Plant," *WC*, December 15, 1932; and "Call in the GTM Today," December 15, 1932, advertisement in *TM*.

14. See H. A. Bruno & Associates, to Goodyear Tire & Rubber Company, n.d., GR; Goodyear, "Brief History of Conveyor Mining," ca. 1945, MS, GR; and "Know Your Products," *WC*, October 12 and 19, 1949.

15. Goodyear, *Annual Report*, 1952, GR.

16. Jill Harkins, "Atom Smasher in Forest Hills Torn Down; Restoration Promised," *Pittsburgh Post-Gazette*, January 21, 2015.

17. See "Postwar Conveyor Plans Are Seen Sending Akron to A New Fame," *ABJ*, February 25, 1945; and J. L. Thornton, "Talk at AIME Meeting," February 17, 1954, GR.

18. See "World Largest Conveyor System Will Bring Gravel to Shasta Dam," *Pacific Purchaser* (April 1940): 38; "Longest Belt Conveyor Built by Goodyear," *Daily Journal of Commerce*, April 29, 1940; E. W. Stephens to the Public Relations Department, December 10, 1946, MS, GR; and "What Becomes of a Ten-Mile Conveyor Belt," *Rock Products* (October 1946): 80. See also the following *WC* articles: "Huge Shasta Dam Belt Goes to New Job," September 13, 1944; "Goodyear Gets Contract for 20-Mile Rubber Belt," November 29, 1939; and "Milestone!," May 22, 1940.

19. M. W. Sledge, "Development of Conveyor Belting to a Major Transportation Factor," ca. 1951, MS, GR; Goodyear, *Rubber Railroads: The Story of Goodyear Conveyor Belts* (Akron, OH: Goodyear, n.d.); and "The Neatest Strip Act in History," advertisement, 1948, GR.

20. "History of Conveyor Belts," ca. 1952, MS, GR.

21. See Paul W. Freitag, "Belt Conveyor Systems for Passenger and Industrial Transportation," (lecture, University of Michigan, Ann Arbor, MI, May 26, 1954), GR; and "Conveyor Mining: Operation and Installation of Conveyors," 1945, MS, GR.

22. Robert E. Mercer to *Journal of Commerce*, September 25, 1958, GR.

23. See the following MSS in GR: H. E. Morse, "Hose Condition Report on Design Problems,"1931; D. E. Harpfer, "Annual Report on Hose Design," 1936; Harpfer, "Hose Progress Report on Development," July 27, 1931.

24. See "Goodyear Belting, Hose, Packing," 1929, MS, GR; and Goodyear, *Goodyear Mechanical Rubber Goods: Descriptive and Illustrative Catalogue.*

25. See "Product and Policy Book of Goodyear Mechanical Rubber Goods," 1930, MS, GR; and Goodyear, *Handbook of Hose* (Akron, OH: Goodyear, 1934).

26. "Goodyear Hose Put to Many Varied Uses in Almost Every Industry," *WC*, February 8, 1933.

27. See *Selling Helps for Goodyear Akron Lawn Hose Dealers* (Akron, OH: Goodyear, 1914?); and "The Noisiest Place at Goodyear," *WC*, August 18, 1926.

28. Goodyear, "Call in the G.T.M. Today."

29. Goodyear, "Do You Know Your Goodyear Products: Gasoline Hose," n.d., MS, GR.

30. Robert E. Mercer to *New York Journal of Commerce*, September 14, 1956 and September 25, 1958, GR.

31. See "Know Your Products," *WC*, September 9, 1949; and "Pete's Note Got Past Submarines," *WC*, April 9, 1941.

32. See "Goodyear Sales Promotion Material for Sole and Heel Dealers," n.d., GR; "Goodyear Wingfoot Heels," July 1926, advertisement in *SEP*; and "Goodyear Wingfoot Half Soles," July 1924, advertisement in *Shoe Repair Service*.

33. Goodyear, *The Story of Neolite* (Akron, OH: Goodyear, ca. 1950).

34. See "Goodyear Neolite Soles," September 1948, advertisement in *Shoe Service*; "Don't Get Fighting Mad Any Longer," *WC*, May 3, 1950. See also the following MSS in GR: "Neolite: The Miracle Material," ca. 1951; "Neolin—What It Is," n.d.; and "Neolite Goes to Town," 1951.

35. See "Goodyear Neolin Soles," September 1922, advertisement in *Shoe Repair Service*. See also the following MSS in GR: "What Neolin Has Done for the Retailer and The Consumer," n.d.; "The Application of Neolin Soles to Shoes of Various Constructions," 1917; and "Neolin Questions and Answers," n.d.

36. See the following *WC* articles: "Shoe Laboratory Anticipates Needs of Manufacturers," November 18, 1925; "Millions More Wingfoot Heels Sold Than Any Other Kind," April 29, 1931; "Did You Know?," March 3, 1937; "Be Sure to Insist on Wingfoot Heels," January 20, 1932; Goodyear, "Neolite: The Miracle Material." See also "Neolin—What It Is."

37. See "How Neolite Became a Brand," *Luggage & Leather Goods* (June 1954); Goodyear, "Neolite," news release, 1942, GR; and Goodyear, *The Story of Neolite*.

38. Hugh Allen, *The House of Goodyear*, (Cleveland, OH: Corday & Gross Company, 1949), 144, 261.

39. For information on Goodyear's foam products see Goodyear, *Goodyear Airfoam* (Akron, OH: Goodyear, n.d.); and "Goodyear Airfoam," August 2, 1948, advertisement in *Retailing Daily*.

40. "Army and Navy Air Forces Use Plastic Foam, New Goodyear Product," n.d., MS, GR.

41. See "Know Your Products," *WC*, January 18, 1950; and "Largest Continuous Production Line," *WC*, August 18, 1948.

42. Goodyear, *Goodyear Airfoam*.

43. See the following MSS in GR: "Rubber Flooring History," 1925; J. S. Bruskin, "Goodyear Rubber Flooring" (lecture, National Design Center, New York, NY, ca. 1962); F. L. Lamb, "Goodyear Static Conductive and Spark Resistant Rubber Floor for Munitions Plants," January 1945; *Goodyear Rubber Tile Floors*, 1929; *Manual of Information on Goodyear Rubber Floors*, 1931; "History of Goodyear Flooring," 1929; H. E. Morse, "History of Flooring," 1934. See also "Long Wear Makes Rubber Tile the Most Economical Flooring," *WC*, February 16, 1917.

44. See "Employees' Sale of Special Mats," *WC*, June 21, 1933; Goodyear, *Encyclopedia of Goodyear Mechanical Rubber Goods: For Hardware Dealers* (Akron, OH: Goodyear, n.d.); Goodyear, "Rubber Floor Coverings" and "Goodyear No-Draft Floor Mats," 1925, sales brochures, GR.

45. See the following MSS in GR: "Specifications for the Installation of Goodyear Rubber Floors," n.d.; *Manual of Information on Goodyear Rubber Floors*, 1931; "History of Goodyear Flooring," 1929; H. E. Morse, "History of Flooring," 1934; and O. C. Pahline to All Equipment Manufacturers, January 19, 1934.

46. Goodyear, *Goodyear Mechanical Rubber Goods: Descriptive and Illustrative Catalogue*.

47. E. C. Randall, "Pliofilm," ca. 1955, MS, GR.

48. See the following MSS in GR: "Goodyear Pliofilm," 1934, "Pliofilm," n.d., news release; and "Pliofilm—Background, properties, uses," n.d.

49. See "Pliofilm Product and Sales Manual," 1938, GR; and "Special Pliofilm Data," 1940, MS, GR.

50. See Goodyear, "Pliofilm for Packaging," in *Modern Packaging Magazine* (July 1950); and "Frozen Foods—A Volume Post-War Market for Pliofilm," 1945, MS, GR.

51. See "Goodyear Pliofilm," 1934, MS, GR; and Goodyear, *Pliofilm Instruction Manual* (Akron, OH: Goodyear, 1944).

52. Boyden Sparkes, "Hey Ma! Our House Is Here," *SEP* (October 21, 1944): 1–7.

53. "Airform Construction: General Information," n.d., MS, GR.

54. See the following MSS in GR: "Storage Made Easy," n.d., news release; "Balloon Homes," n.d., news release; and Clyde E. Scheeter to C. Pines, January 3, 1966.

55. "Airform Construction: General Information," n.d., MS, GR.

56. Goodyear, *Goodyear Portable Homes* (Akron, OH: Goodyear, 1943).

57. Ibid.

Chapter 6
The Arsenal of Democracy
Goodyear War Products for the Allies

"It is the established policy of Goodyear to give priority in management, personnel, and facilities to the defense of our country."[1]
—*Paul W. Litchfield, Goodyear CEO*

The Goodyear Tire & Rubber Company first created war materials in 1916, when they supplied tires for General John J. "Black Jack" Pershing and his army for their fight against Mexican revolutionary Francisco "Pancho" Villa on the Mexican border. The company later called this a "dress rehearsal" for the country's involvement in the First World War. Chief war materials built by Goodyear during World War I included solid tires for army trucks, gas masks, observation balloons, and airships. After the armistice, the company continued to manufacture some rubber products for the US military on a limited basis during the interwar period. Goodyear Chairman Paul Litchfield's world travels and connections with international business leaders led him to the conclusion that another world war was inevitable and put the company on a war footing long before the Nazis invaded Poland in 1939.

Even before Pearl Harbor, Goodyear produced war products for the Allies, and after the war began, the company's war production activities greatly expanded. This included tires, blimps, barrage balloons, belting, hose, and shoe soles, to name a few. In addition to these items, Goodyear made products outside of their normal lines of production. This included rubber articles such as flotation bags, pontoons, rubber attack boats, life rafts, life preservers, and dummy ships. Additionally, the company made nonrubber materials such as gun barrels, gun clips, and powder bags in addition to a variety of airplane parts including bullet-sealing fuel tanks, wings, brakes, and ailerons. With over 90 percent of the country's natural rubber supply cut off by the Japanese conquest of the Dutch East Indies, the company also contributed to the development and production of synthetic rubber. To accomplish this feat, they converted most of their plants around the world to wartime production and built other factories to meet the needs of the Allied forces. As a result, Goodyear grew rapidly during the war—in personnel, facilities, and production. By the end of the war, the govern-

ment awarded the Army-Navy "E" Award, the nation's highest tribute to industry, to ten of Goodyear's plants and subsidiaries for the production of war equipment.[2]

Images from the Goodyear Photograph Collection featured in this chapter illuminate the contributions the company made to the Second World War. This includes hundreds of rare historic photographs depicting an assortment of fighter planes and bombers in different stages of construction. The seldom-seen-before images also show the manufacture and uses of rubber products, including an array of inflatables that helped save the lives of countless downed airmen and sailors who had to abandon ship. The manufacture of synthetic rubber and the facilities created to produce this essential war material are also featured in the photographs. Many of the images in this chapter depict military and civilian personnel, as well as the diverse workforce in Akron, Arizona, and other plants—especially the thousands of "Rosies" that left their traditional homemaker roles to build these indispensable products that helped defeat the Axis Powers and bring peace and stability to the world. The government designated many of the photographs seen in this chapter top secret during the war, and many of the original folders still bear the "Top Secret" stamp, attesting to the crucial role these products played in the Allied war effort.

Slaying the Axis and Saving the Allies

Goodyear Rubber Products for Soldier and Civilian

In 1941, the Rubber Manufacturers Association (RMA) declared that "one of the most important war jobs taken on by the rubber industry has been to make the millions of gas masks needed for both the armed forces and civilians." Goodyear first made gas masks in mass quantities during World War I, but production discontinued after the armistice. However, since the company followed the precarious situation in Europe and Asia in the 1930s, the firm developed them again for the army as early as 1937. The federal government first placed orders for gas masks for the Second World War in 1940, and the rubber industry mass-produced them the following year. Rubber manufacturers including Goodyear designed special machinery and developed new methods of manufacture that improved gas masks, increased production, and decreased costs. "You can't smoke with them on, but they're not bad to wear," one soldier noted.[3] The company also manufactured gas masks for civilian use during the war in case of a gas attack on mainland America. The masks differed from those for soldiers because the company made them lighter and used reclaimed rubber.[4]

In 1941, Goodyear Chairman Paul Litchfield called World War II "a war of production and a war of mobility." As the company noted, "it will be won by the side which has... the strongest and most mobile fighting machine." To assist the country in this endeavor, Goodyear's "soldiers of production" built rubber products outside of their normal lines of production.[5] The company manufactured tank tracks on a limited basis a few years prior to World War II. However, when war broke out in Europe, the government called for rubber blocks to replace the steel ones used on Allied tanks, and Goodyear increased production. Even-

tually, the company became a major supplier, producing half of the Army's requirements for these products. Goodyear also made bogie wheels and treads for half-tracks, which the Allies used during the war for mortar carriers, scout cars, troop transports, armored fighting vehicles, and self-propelled anti-aircraft and antitank guns, and Goodyear products helped move them across the battlefield.[6]

Goodyear also manufactured rubber products to help the United States Navy during World War II. In fact, scientists from the Goodyear Research Laboratory helped solve one of the most troublesome problems facing the navy—slippery decks, which can cause seamen to slip and get hurt, or even wash overboard. Their development of a nonskid covering called Dektred for decks and gun emplacements provided sure footing to the gunners on battleships and cruisers. The navy applied thousands of gallons of Dektred to the weather decks, walkways, and gun emplacements of Allied warships and below deck in officers' and crews' quarters, passageways, landings, and stairways. In addition, Goodyear manufactured gun bucklers to protect the barrels of huge guns on Allied war ships from salty sea water, which splashed into the opening and corroded the guns when they were fired and recoiled into the turret. James Cooper of the Goodyear Balloon Room studied the problem, experimented with numerous products, and then decided to use synthetic rubber because it resisted the grease and oil of big guns.[7]

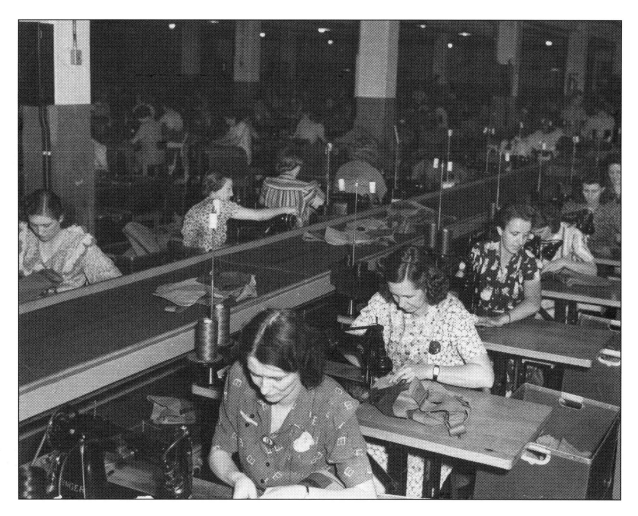

Gas Mask Production, ca. 1942

Scores of factory workers produced large orders of gas masks for the United States armed forces during World War II. These women working on the assembly line in Goodyear's Gas Mask Department sew the masks as they come off the conveyor belt. Women not only made the canisters or air-purifying units, but also the rubber face pieces. They assembled them at Goodyear's plants in Akron; Gadsden, Alabama; and New Bedford, Massachusetts. During 1944, the Gas Mask Department in Akron's Plant 3 occupied an entire floor and employed over 1,700 women.[8]

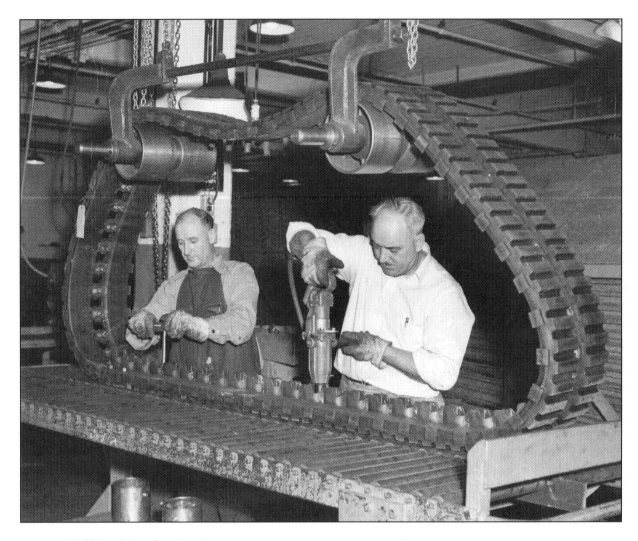

Half-Track Production, ca. 1944
In order to help make the US military the most mobile fighting force the world had ever seen, Goodyear's "soldiers of production" built half-tracks and tank tracks by the thousands. By the end of the war, the Akron Plant alone produced nearly 30,000 of these essential war products, or roughly half of those needed by the army. Goodyear also produced them in their plants in St. Marys, Ohio, and Muncie, Indiana.[9]

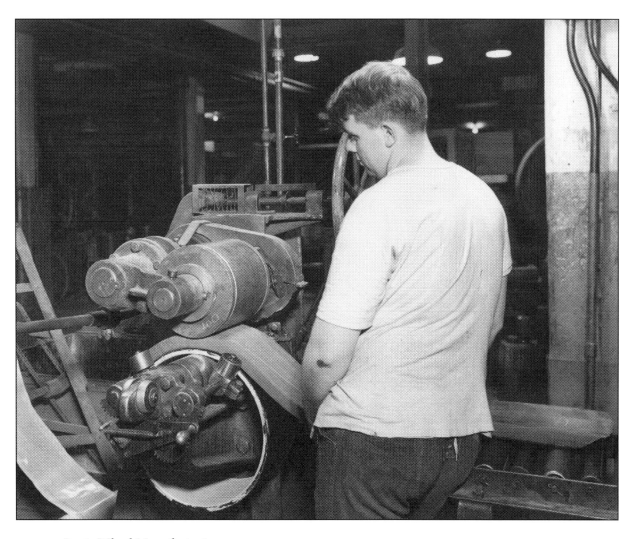

Bogie Wheel Manufacturing, ca. 1945
A Goodyear rubber worker makes bogie wheels for tank tracks and half-tracks during World War II. These rubber wheels kept the treads in line with the drive sprockets and took up the pressure as the vehicle hurtled over rugged terrain. Goodyear made bogie wheels of solid rubber at a rate of 1,000 a day. By the end of the conflict, Goodyear's factories in Akron, Ohio, and Bowmanville, Canada, turned out nearly 120,000 of these essential war materials.[10]

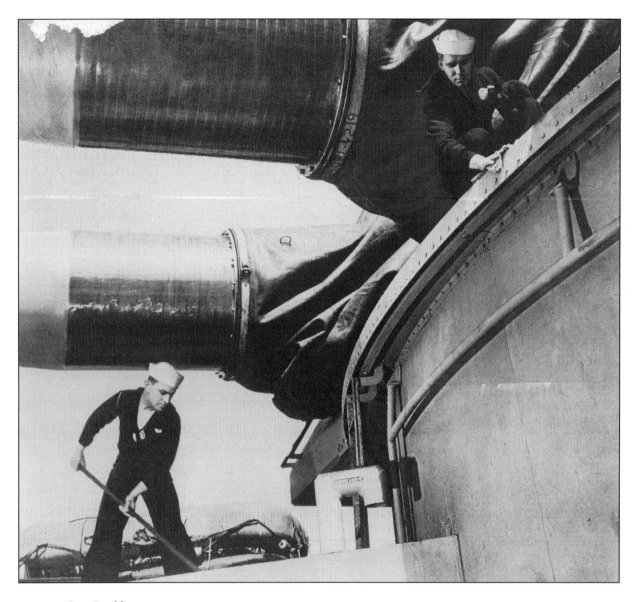

Gun Buckler, ca. 1943
Two seamen clean a section of a US Navy battleship during World War II that contains gun
bucklers manufactured by Goodyear. These huge rubber coverings shielded the massive guns
of Allied warships, thus protecting them from exposure to damaging saltwater. Goodyear
built approximately 600 gun bucklers during the war.[11]

Pump It Up

Goodyear Inflatables for Lifesaving and Deception

"Rubber life boats are the great lifesavers of this war," wrote the Rubber Manufacturers Association in the 1940s. The Goodyear Tire & Rubber Company played a role in their design, manufacture, and development.[12] Goodyear made its first life raft in 1917, when Balloon Room Foreman James F. Cooper designed one for Ward T. Van Orman after he crashed his balloon in Lake Milton near Youngstown, Ohio, and almost drowned. Soon, sportsmen wanted similar rafts for fishing and hunting expeditions. To meet this new demand, Cooper and his team made life rafts in the shape of a boat, and the company eventually built facilities for their manufacture. As aviation continued to develop, pneumatic life rafts became desirable for airplanes operating over water, and Goodyear manufactured them in Akron and tested them at Wingfoot Lake. By World War II, most army and navy sea-going planes and ships carried one or more rafts as standard equipment for temporary emergencies. Goodyear made thousands of these rafts each week in a variety of shapes and sizes for specialized purposes, from one-man life rafts for pilots who bailed out over water to larger ones that could carry dozens of soldiers. Goodyear continued to develop and improve their rafts over the course of the war, making them stronger and safer.[13]

Utilizing its experience in impregnating and coating fabric with rubber, Goodyear also manufactured and improved rubberized inflatable life preservers, or "Mae West" vests, during the Second World War. These items helped save the lives of countless downed airmen and sailors who had to abandon ship. Besides life rafts and vests, Goodyear also manufactured pneumatic rubber assault boats that carried marines into battle and flotation bags that kept combat planes from sinking when forced to land on water. The Allies used Goodyear's rubber pontoons to carry men and materials across lakes and rivers in pursuit of the enemy. While rubber pontoons helped carry the mechanized army across Europe, they also served as assault boats as they inflated with carbon dioxide and could be propelled with an outboard motor.[14]

During the conflict, Goodyear participated in what General Omar Bradley called "the biggest hoax of the war."[15] Operation Fortitude consisted of a scheme to deceive Germany about the date and location of the Allied invasion of German-occupied Europe in 1944. One portion of the deception incorporated a fake army that included dummy landing craft, boats, airplanes, military vehicles, and anti-aircraft guns manufactured by several rubber companies, including Goodyear. Under top secret conditions, the company made these dummy crafts with wood or steel frames covered with heavy-duty canvas or inflatable rubber. As fast as Goodyear could turn out the dummies, they handed them over to the army and navy for shipment to Europe. As Nazi reconnaissance planes prowled the skies looking for clues regarding the Allied invasion, they would spot concentrations of Allied military vehicles and equipment along the English coast, not knowing they were phony, as the dummy ships created the illusion from the air of actual mobile armament.[16] According to Dr. H. Wentworth Eldredge, Captain in the US Air Forces during World War II, the project was highly successful and made "an immense contribution to the success of the landings."[17]

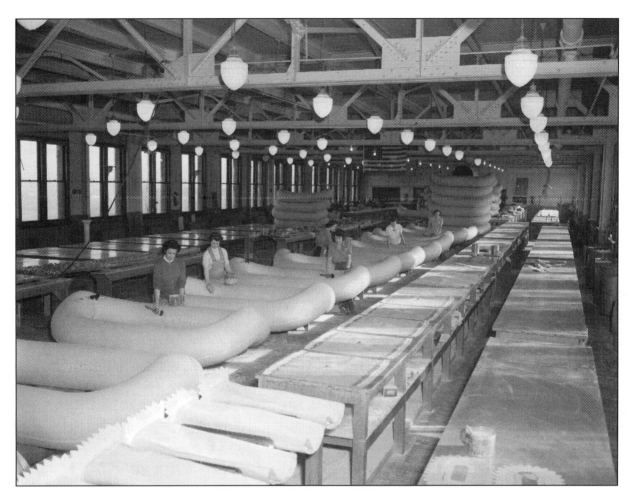

Life Raft Building, 1943
Goodyear made life rafts in record numbers in Akron and its other plants during World War II. The boats became standard equipment on almost all army and navy airplanes that operated over water and were used to rescue downed airmen. Like many rubber products Goodyear manufactured during the conflict, life rafts were constructed from wooden forms and fabric coated with rubber that made them water resistant and airtight. By the close of the war, Goodyear manufactured approximately 200,000 rafts for the war effort.[18]

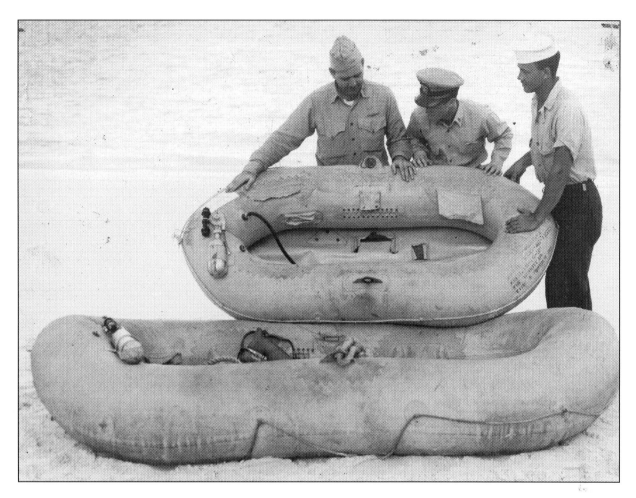

Rickenbacker Raft, 1942

Navy personnel examine the Goodyear-built pneumatic life raft that saved the lives of World War I fighter ace and Medal of Honor recipient Captain Eddie Rickenbacker and crew during three weeks in the middle of the Pacific Ocean in 1942 after their B-17 crashed.[19] The company published letters from airmen saved by Goodyear rafts during the war, including one from three navy fliers who survived afloat for 34 days after being shot down over the Pacific. Similarly, a downed crew of 16 airmen survived 15 hours in a four-man Goodyear raft, prompting one to write, "thank God for Goodyear."[20]

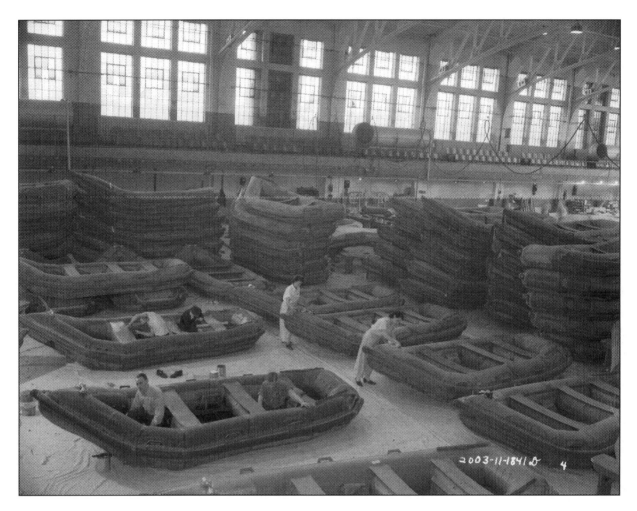

Making Assault Boats, 1941
Employees construct assault boats in the Goodyear Gymnasium in Akron during World War II. Called a "surprise weapon in the new war," they came fully equipped with inflating gas, oars, mounted machine guns, and outboard motors. Allied infantry could carry these pneumatic "attack boats" into battle, use them to cross rivers to pursue the enemy, then deflate to carry them on or discard them. The marines used Goodyear-made assault boats in landing operations in the Pacific, and the navy utilized them during the invasion of German-occupied Europe on D-Day.[21]

Army Tour of Aircraft, 1941

An employee fits a member of the US Army with a rubberized, inflatable life preserver during a tour of Goodyear Aircraft. During World War II, the company made approximately 125,000 of these lifesaving products known as "Mae West" vests because, when inflated, the person wearing them appeared to be as physically well-endowed as the popular Hollywood actress. While not a Goodyear invention, the company redesigned the vests to provide greater buoyancy and hold the wearer upright when afloat. Mostly made at the Windsor, Canada, plant, the vests saved the lives of countless downed airmen and sailors who abandoned ship.[22]

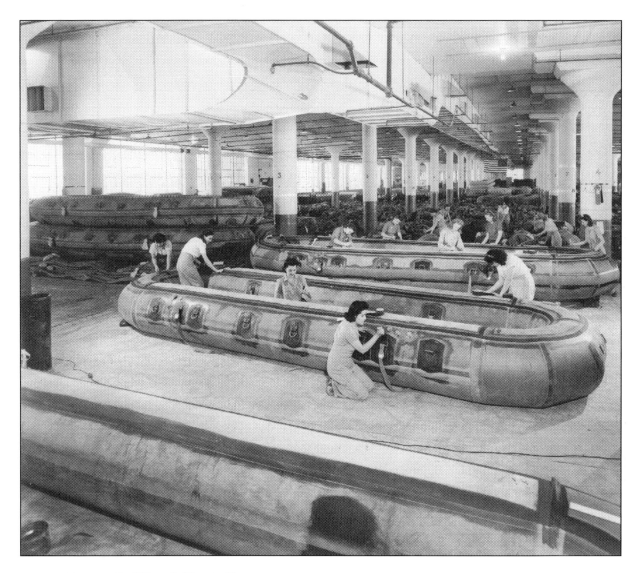

Pontoon Building California Plant, 1943

Teams of workers at the Goodyear California Plant make pontoons of rubberized fabric for the military during World War II. The Allies inflated the pontoons with air-compressor trucks, floated them into place, lashed them together, and covered them with treadways to make bridges for tanks, trucks, and other military vehicles to cross rivers during the invasion of Europe. They also served as assault boats when propelled by an outboard motor. After an operation, the lightweight pontoons could be deflated, folded, and moved by truck.[23]

Flotation Bags in Balloon Room, 1941

Workers in Goodyear's Balloon Room in Akron sit atop pneumatic flotation bags they recently manufactured. Goodyear made thousands of flotation bags of rubber-coated fabric during World War II, which kept Allied planes from sinking when forced down on water.[24] The devices folded into small packages that fit into recesses in the wings and inflated almost instantaneously by pulling some levers. The company described the flotation bags as "one more Goodyear product that contributes to safety in the air and on the sea."[25]

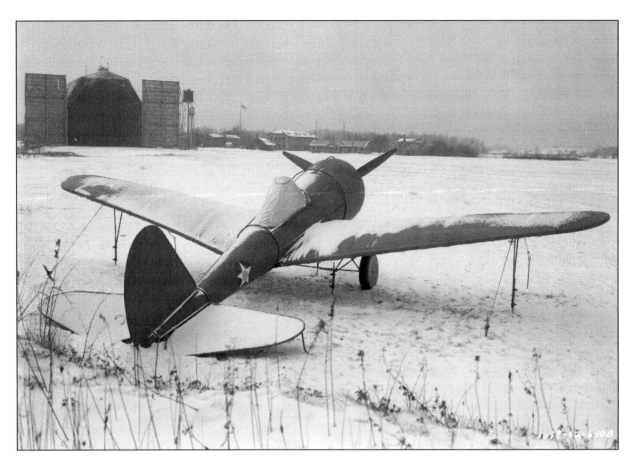

Dummy Plane, 1940

Allied commanders used dummy aircraft made of wood and collapsible canvas, such as this one made by Goodyear, for deceiving the enemy. Some were used in Operation Fortitude, a covert scheme to deceive Germany about the date and location of the Allied invasion of Europe. Teams constructed these fake planes in aircraft hangers during the day and transported them to airfields in the evenings to complete the deception in the days leading up to D-Day. Under top secret conditions, hundreds of men and women tackled the job of cutting, trimming, joining, and painting the fabric in Akron until Goodyear opened a new factory to manufacture these decoys in Woonsocket, Rhode Island.[26]

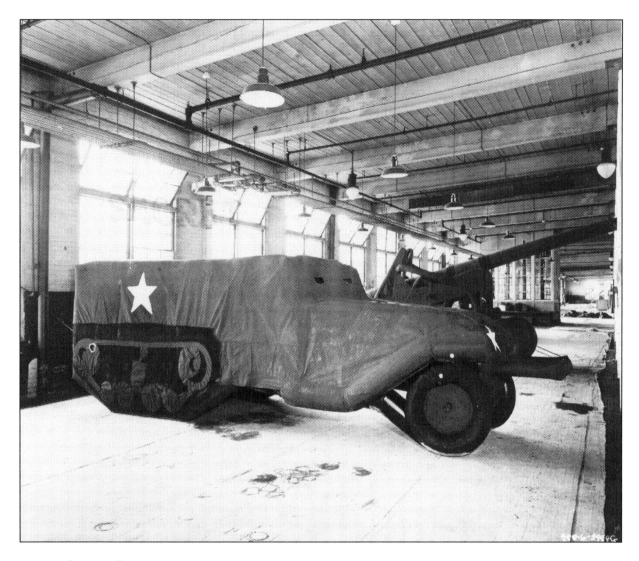

Dummy Equipment, 1944

Under the cloak of secrecy, Goodyear produced thousands of dummy military vehicles and equipment to deceive the Nazis in the weeks before the D-Day invasion, including these pneumatic trucks and anti-aircraft guns. The "phantom" or "ghost" army included dummy landing craft, PT boats, barges, airplanes, half-tracks, tanks, artillery, and other combat equipment used to trick Nazi reconnaissance planes. James F. Cooper and his crew in Akron's Balloon Room manufactured most of them from inflatable rubber with the same know-how used to produce their gigantic parade balloons during peacetime.[27]

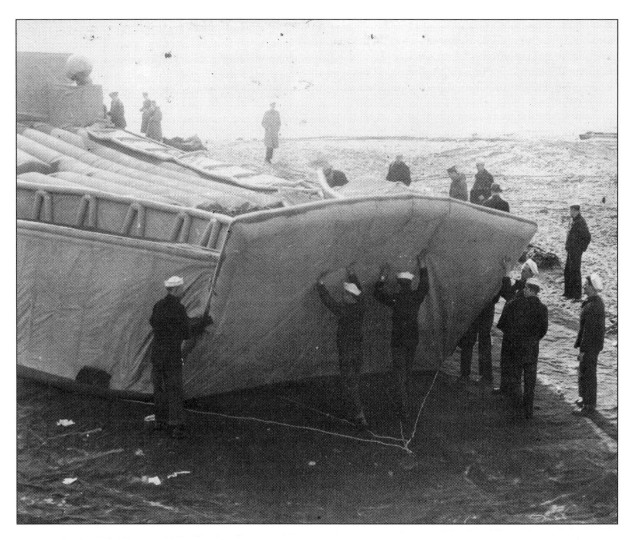

Inflating Decoy Landing Craft, 1944
Navy personnel inflate a decoy landing craft prior to the Allied invasion of Europe. The Goodyear-built dummy vehicles—known by their code names Big Bobs and Wet Bobs—led the Nazis to believe that the real invasion would come at Pas-de-Calais. Since Goodyear made most of the dummy ships pneumatic, the Allies could deflate and easily transport them to a false base at another location to confuse the enemy and influence their defense preparations. Approximately 550 of the dummy craft were made by Goodyear and used in Europe from mid-May to mid-June 1944.[28]

A Herculean Program

Goodyear Synthetic Rubber for Uncle Sam

When over 90 percent of the country's natural rubber supply was cut off by the Japanese conquest of the Dutch East Indies during World War II, Goodyear contributed to the development and production of synthetic rubber. The Germans first manufactured synthetic rubber during World War I, but it was far inferior to natural rubber because it lacked toughness and resistance to wear. This, coupled with the uncertainties of the natural rubber market with its widely fluctuating process, spurred Goodyear and other American manufacturers to pursue the development of a more superior synthetic rubber. In the mid-1920s the company searched for a synthetic rubber that would equal or improve upon natural rubber. Goodyear chemists led by Dr. Ray P. Dinsmore perfected processes for co-polymerizing hydrocarbons to make a durable synthetic rubber. Goodyear called this new synthetic rubber Chemigum, derived from the words "chemical" and "gum." In 1937, the company built its first tires with synthetic rubber treads, and its first tires made completely of Chemigum the following year. However, Goodyear did not mass-produce Chemigum tires at this time because they were difficult to manufacture and cost more than twice those constructed of natural rubber.

When the United States entered World War II, Goodyear turned over many of its patents to the government and shared their experience and know-how in synthetic rubber with other companies in the industry, which pooled their knowledge, processes, and equipment toward manufacturing a standardized product to assist the war effort.[29] During the war, Goodyear opened and operated several government-owned synthetic rubber plants, in addition to the Goodyear Research Laboratory, which achieved important results in many areas of synthetic rubber, or what Goodyear President E. J. Thomas called "a Herculean program." The company used Chemigum to manufacture a number of products during the war, especially bullet-sealing fuel cells and other airplane parts. Its resistance to solvents also made it especially useful for articles such as gasoline hoses, hydraulic brake sealing rings, and similar items, where it came into contact with gas and oil.[30]

Army Officials Inspecting Chemigum, 1942

Paul Litchfield and army officials inspect Chemigum, Goodyear-produced synthetic rubber, in the summer of 1942. Chemigum possessed characteristics that made it superior to natural rubber and some other synthetics at the time, including increased tensile strength, impermeability to the disintegrating action of oil and gas, and resistance to aging, abrasion, and oxidation. Chemigum could also be processed more easily than some other synthetics and possessed the possibilities for blending with natural rubber. Its resistance to solvents led to its uses in gasoline hose, hydraulic brake sealing rings, and other items that came into contact with gas and oil.[31]

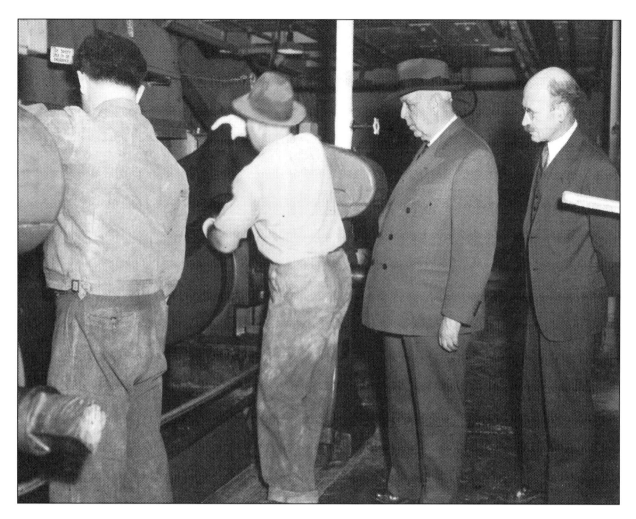

First Synthetic Rubber, 1943
Deaf worker Charles Ewing of Akron's Plant 2 removes the company's first batch of synthetic rubber produced entirely with government materials, as Paul Litchfield and R. W. Moorhouse—superintendent of the Akron Rubber Reserve Company synthetic plant—look on. By the end of 1943, Goodyear had three synthetic rubber plants in operation in Akron, Los Angeles, and Houston. The plants were built by the rubber companies with government funds and under the direction of the Defense Plant Corporation.[32]

Into the Wild Blue Yonder

Goodyear Aircraft for the World War

Even before the Japanese attack on Pearl Harbor, The Goodyear Tire & Rubber Company prepared for all-out war. Since the company already possessed skills in aerodynamics and the fabrication of light metal alloys, manufacturers of military planes turned to the company to help manufacture these war machines. In December 1939, the company reorganized Goodyear-Zeppelin into the Goodyear Aircraft Corporation. That same month, the subsidiary received its first and largest war contract to build complete tail surfaces and wings for Martin B-26 Marauders, and converted its airship dock in Akron into a plant for the manufacture of these parts. At that time, the subsidiary only had 40 employees, but, in a remarkably short time, it grew into one of the country's largest manufacturers of airplanes and airplane parts and one of the largest employers in Akron, with 35,000 on the payroll. The company also grew its facilities, purchasing 147 acres of city property south of the Goodyear Airdock in Akron to build a 400,000 square foot plant to expand production of airplane parts, which grew to five million by the end of the conflict. During the war, the company also built an airplane-manufacturing facility in Litchfield Park, Arizona, with 7,500 workers and approximately 500,000 square feet of working space at its peak. Before long, Goodyear handled some 20 separate contracts for major portions and assemblies for military planes and served as subcontractor to the primary manufactures of combat aircraft. These included the Glenn L. Martin Company, Consolidated Aircraft Corporation, Grumman Aircraft Engineering Corporation, and Curtiss-Wright Corporation.[33]

With the call from President Franklin D. Roosevelt to produce one plane every eight minutes, Goodyear Aircraft employees went to work. One of their greatest accomplishments included the FG-1 Corsair, the first fighter plane built by Goodyear Aircraft and the only plane the company produced entirely. In addition to making over 4,000 Corsairs, the Goodyear Aircraft Corporation manufactured thousands of vital parts for planes including wing tips and armament sections for Grumman F6F Hellcats, empennages for TBF Avengers and Lockheed P-38 Lightnings, outer wings and tail assemblies for P-61 Black Widows, and stabilizers for the famous Curtiss P-40 Warhawks. Goodyear also manufactured parts for the B-25 Mitchell, a twin-engine, medium bomber used by the Allied air forces in every theater of World War II, including the bombing of Tokyo during the Doolittle Raid in April 1942. Additionally, the Arizona Plant manufactured outer panels for the wings of the famous B-24 Liberator and later built wings and empennage sections for the Lockheed PV-1 Ventura and PV-2 Harpoons, the navy's twin-engine medium-range bombers. The plant served as a modification center for the Consolidated PB4Y-1 and PB4Y-2, the navy versions of the army's B-24. Goodyear Aircraft, rated as one of America's ten largest aircraft companies, also produced the fuselage center section and complete empennage for the nation's largest super-bomber, the Boeing B-29 Superfortress. By the end of the war, Goodyear made components for twelve planes, a total of 56 parts.[34]

Airplane Sub-Assembly at Airdock, 1941
Employees of the newly formed Goodyear Aircraft Corporation manufacture components of aircraft wings, empennages, and ailerons in the Goodyear Airdock. Before the large aircraft plant was built in Akron, the company used the Airdock to build airplane sub-assemblies. In the spring of 1941, the subsidiary recruited thousands of mechanics and sheet metal workers. The Goodyear Aircraft Corporation expanded in less than three years from 300 to 35,000 employees for production of airships and fighter planes for the Allied war effort, becoming one of the largest employers in Akron.[35]

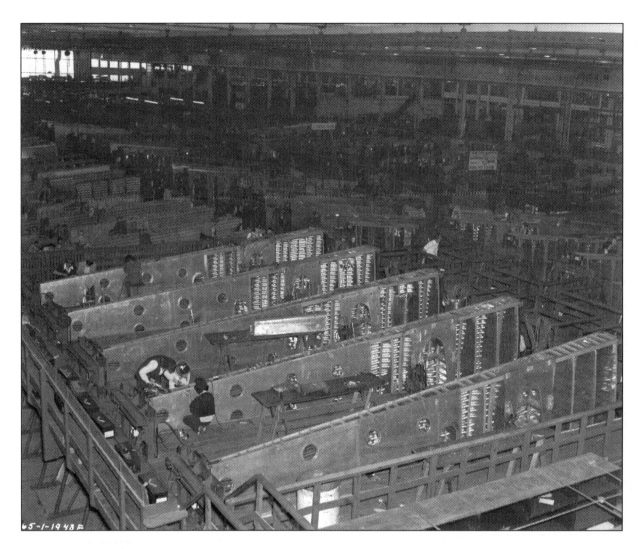

B-26 Production, 1943
Goodyear Aircraft employees in Akron build parts for Martin B-26 Marauders, twin-engine medium bombers used in the Pacific, Mediterranean, African, and European theaters of operation that ended the war with the lowest loss rate of any American bomber. The Goodyear subsidiary fabricated many important surfaces and sub-assemblies in large quantities during the war, including nearly $700 million worth of airframes, airships, airplanes, and other components from October 1940 through V-J Day.[36]

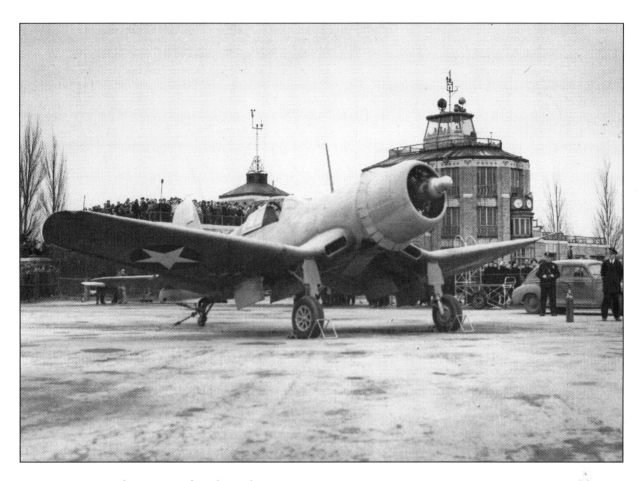

First Goodyear Aircraft Fighter Plane, 1943
Goodyear Aircraft's first fighter plane, the FG-1 Corsair, sits on display at the administration building at the Akron Municipal Airport. The single-seat aircraft was the only fighter plane Goodyear produced entirely. The first one rolled off the production line in February 1943, exactly one year after the company broke ground on the plant. Aircraft delivered its first Corsair to the navy in May after test flights at the Akron Municipal Airport. During the war, the Goodyear subsidiary mass-produced 4,006 of these carrier-based aircraft in Akron's Plant D. The subsidiary delivered its last Corsair to the navy in October 1945, but work continued on a limited number of F2Gs.[37]

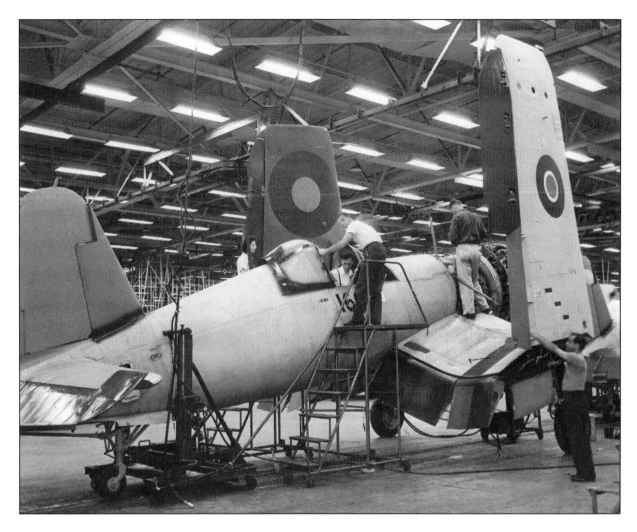

First FG-1 Goodyear Corsair for the British Navy, 1944
In addition to the US Navy and Marine Corps, Goodyear Aircraft built Corsair fighter planes for the country's allies, including this one for the British Navy. This image shows assembly of the plane's famous gull-wings, an ingenious feature that allowed the wings to fold, thus saving space and permitting more planes to be conveyed on Allied aircraft carriers. Other advantages included its retractable wheels and relatively low landing speed, enabling it to land on the decks of carriers or hastily constructed airfields in the battle zone.[38]

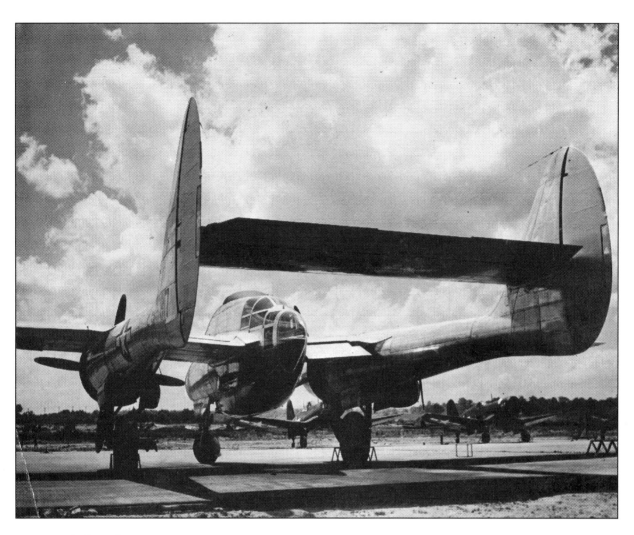

Black Widow, ca. 1944

A Northrop P-61 Black Widow sits outside the Goodyear Aircraft Plant in Akron. The Good-year subsidiary made parts for these twin-engine, twin-boom night fighters that saw extensive use in almost every theater of the war. Goodyear Aircraft manufactured thousands of vital parts for war planes, including stabilizers for Curtiss P-40 Warhawks flown by the famous 1st American Volunteer Group or "Flying Tigers." Goodyear also made parts for the B-25 Mitchell, including the 16 that bombed Tokyo as part of the Doolittle Raid in 1942.[39]

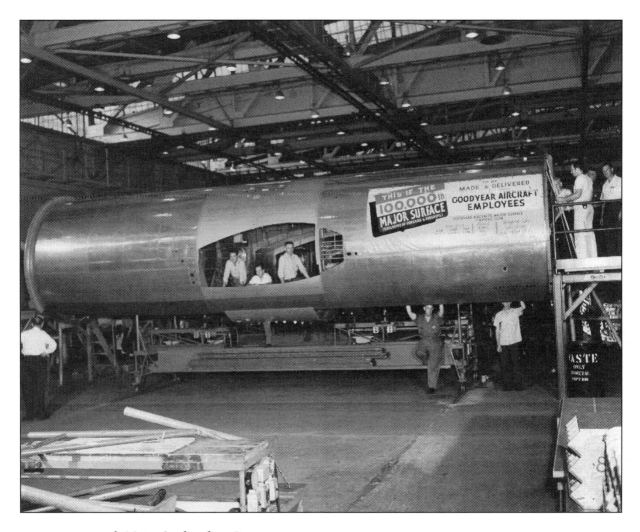

100,000th Major Surface for a B-29, 1945
Goodyear Aircraft employees turn out the 100,000th major surface for a Boeing B-29 Super-fortress toward the end of World War II. The four-engine, propeller-driven heavy bomber designed by Boeing existed as one of the largest aircraft operational during the war and the single most expensive weapons project undertaken by the United States at that time. Designed for high-altitude strategic bombing, this aircraft carried out many significant bombing missions throughout the conflict. Goodyear Aircraft also produced the fuselage center section and complete empennage for the nation's largest super-bomber. In June 1944, American forces bombed mainland Japan with B-29s that contained Goodyear-built components.[40]

Sealing Tanks and Saving Lives

Bullet-Sealing Fuel Cells for the Army and Navy

Goodyear's first development in what became known as bullet-sealing fuel cells started during World War I. Since 75 percent of planes lost in action during that conflict were shot down in flames, the company utilized rubber lining to manufacture leakproof and fireproof gasoline tanks for the military, which self-sealed and plugged any holes created by enemy fire.[41] After the armistice, Goodyear also developed a fuel cell for the army, during which time American planes had relatively little protection against fire hazard from hostile bullets. By the time the national defense program started in 1940, Goodyear had developed a gasoline-resistant type of synthetic rubber called Chemigum, which the company's research laboratory applied to the interiors of bullet-sealing fuel tanks. James A. Merrill, research chemist at Goodyear, developed an effective barrier that resisted aromatic fuels, thereby discovering a true bullet-sealing fuel tank. Shortly thereafter, both the army and the navy's air forces officially adopted Merrill's fuel cells, which soon became an industry standard.[42] During World War II, Goodyear created fuel tanks for Allied bombers and fighter planes including B-17 and B-24 bombers and B-29 Superfortresses. The company also made bullet-sealing fuel and oil cells for tanks and a number of other combat vehicles including scout cars and PT boats. According to the RMA, bullet-sealing fuel cells were "probably the industry's greatest single contribution to the war."[43]

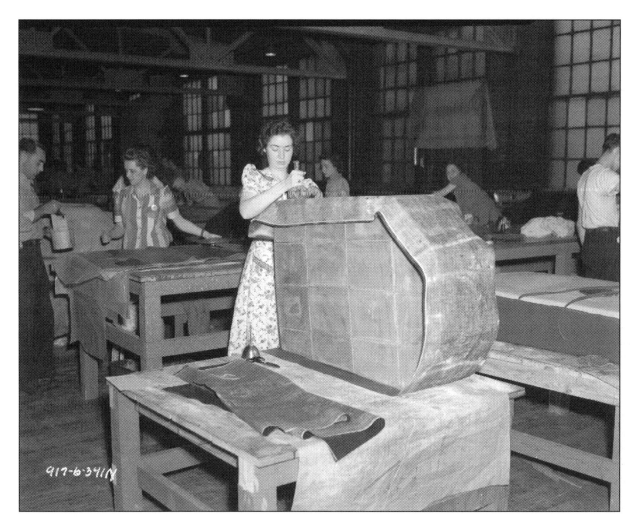

Gas Tank Department, 1941

Employees make bullet-sealing fuel cells in Goodyear's Gas Tank Department in Akron during World War II. By the start of the war, Goodyear had developed a gasoline-resistant synthetic rubber, which it used as an important component in its fuel cells during the conflict. When a bullet or shell fragment pierced the tank, the slight amount of gasoline that escaped caused the inner layer of synthetic rubber to swell and seal the hole, thereby preventing it from exploding. Goodyear produced their first bullet-sealing fuel tank of this type in March 1941 in Akron's Plant 1. Scores of factory workers also made them in Akron's Plant 3; the New Bedford, Massachusetts factory; and the Lincoln, Nebraska plant.[44]

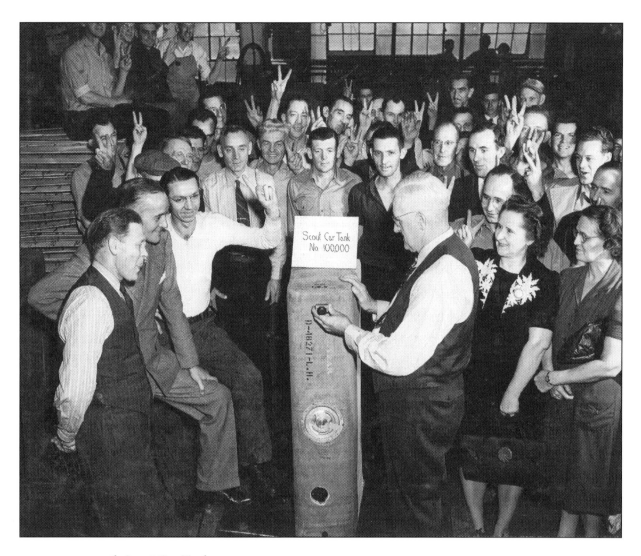

100,000th Scout Car Tank, 1943

Goodyear also made bullet-sealing fuel and oil cells for tanks, scout cars, PT boats, and bomb bay tanks for Allied bombers. Here, employees of the Gas Tank Department at Plant 2 in Akron celebrate the completion of the 100,000th scout car tank in 1943. Two years later, Goodyear produced its one millionth bullet-sealing fuel cell for the war effort. At the height of the war, the company had 400 employees mass-producing these lifesaving devices. They also manufactured bullet-sealing fuel cells for planes used by other Allied countries, including Russia and England, saving countless lives.[45]

Pass the Ammunition

Goodyear Guns for the Allies

During World War II, the RMA wrote that "one of the major 'nonrubber' contributions of the rubber industry to victory has been the mass production of guns for the armed services."[46] This included anti-aircraft guns, cannons, cartridges, bombs, bullets, fuses, and the like. In a very short time, rubber companies across the nation converted from manufacturing tires to munitions. Goodyear was no exception. In January 1941, The Goodyear Tire & Rubber Company formed a subsidiary for national defense activities called the Goodyear Engineering Corporation. Around this time, Goodyear received a contract for the management and operation of a huge powder bagging plant for the Ordnance Department of the United States Army. This new government-owned plant, named the Hoosier Ordnance Works, sat on a 3,000-acre tract fronting the Ohio River at Charlestown, Indiana. The government supplied the material for the bags, which were both fabricated and loaded by the Goodyear subsidiary as the propelling charge for big guns of the national defense program. In addition to the Charlestown Plant, the company also converted their factory at Jackson, Michigan, for the manufacture of three-inch antitank guns. During the conflict, the Goodyear plant in Bowmanville, Canada, produced clips for the Bren gun, a light machine gun made in Britain and used extensively by the British and Commonwealth forces during the Second World War. [47]

Hoosier Ordnance Works, ca. 1944

The Hoosier Ordnance Works—managed and operated by Goodyear from 1940 to 1945—was one of the largest of its kind in the world. The entire plant was devoted to bagging powder that was used as the igniter and propellant charges for America's big guns during World War II. The government-owned facility was located in Charlestown, Indiana, in close proximity to the government powder plant in Louisville, Kentucky, that provided the powder for the loading plant. During this period, the plant had a peak employment of 10,000 people who made artillery and explosive charges for the war.[48]

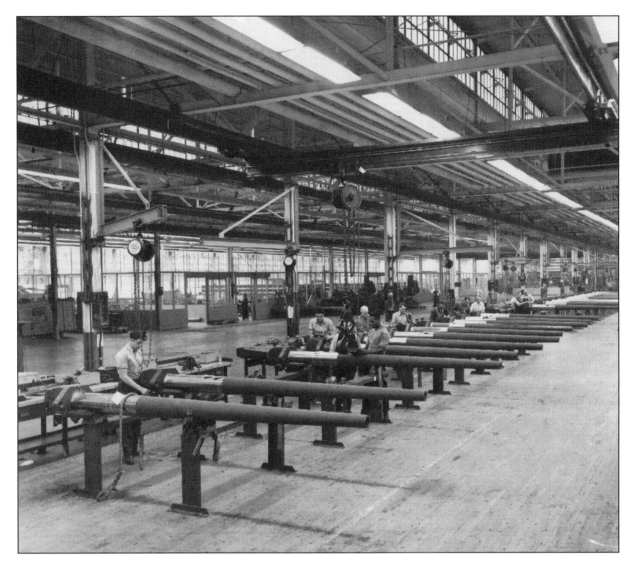

Gun Production, 1942

Employees on the assembly line at Goodyear's Jackson, Michigan, plant turn out 14-foot-long antitank guns during World War II. Built in 1937 for tire production, Goodyear converted the plant from "big tires to big guns" in the record time of six months. The Jackson Plant produced 300 guns per month—and 2,200 total—under a US Army defense contract, before returning to tire production at the end of the war. During the conflict, the Jackson Plant also produced Army truck tires and more than 12,000 bullet-sealing fuel cells for Allied aircraft.[49]

Notes

1. "What Goodyear Is Doing for National Defense," *WC*, January 29, 1941 (hereafter cited as "National Defense").

2. See "Army-Navy 'E' Award to Goodyear Aircraft," *WC*, September 5, 1945; "'E' Award Presented to Aircraft's Arizona Plant," *WC*, June 9, 1943; "Army-Navy E Award," War Department circular, 1942; and "Army-Navy E Award Termination," 1945, news release, Naval History and Heritage Command Archives, Washington, DC.

3. "Air-Purifying Units for Gas Masks 'March' Down Line," *WC*, January 13, 1943.

4. See "Katie Makes Gas Masks," *WC*, May 31, 1944; "Gas Masks for Civilians to Be Produced Soon," *WC*, October 7, 1942; "Gas Masks," n.d., news release, GR; "Goodyear's Contribution to the War Effort," n.d., GR; and "P. W. Litchfield Talk to Organization," Baldwin Papers.

5. Goodyear, "A Report to Goodyear Employees," 1941, GR.

6. See "Great Tanks Now Ride on Rubber," *WC*, November 6, 1940; and Rubber Manufacturers Association (hereafter RMA), *The Rubber Industry and the War* (New York: Rubber Manufacturers Association, ca. 1944), 16.

7. See David Dietz, *The Second Anniversary of the Goodyear Research Laboratory* (Akron, OH: Goodyear Tire & Rubber Company, 1945); and Hugh Allen, *The House of Goodyear*, (Cleveland, OH: Corday & Gross Company, 1949), 466.

8. See "Katie Makes Gas Masks."

9. See the following *WC* articles: "The Real Miss Americas," August 15, 1945; "Right Up Front at Goodyear," March 3, 1943; "Great Tanks Now Ride on Rubber," November 6, 1940; and "National Defense." See also Goodyear, "Tank Track," n.d., news release, GR.

10. Allen, *House of Goodyear*, 424, 591.

11. See David Dietz, *The Goodyear Research Laboratory* (Akron, OH: Goodyear, 1943); and Allen, *House of Goodyear*, 466.

12. RMA, 24–26.

13. See the following *WC* articles: "J. Frank Cooper Called by Death," October 6, 1943; "Admiral Praises Workers on Boats for Job 'Well and Smartly Done,'" June 7, 1944; and "National Defense."

14. See "The Mae West: Giving Credit Where Credit Is Due," *NYT*, May 16, 2006; and "National Defense."

15. James R. Koch, "Operation Fortitude: The Backbone of Deception," *Military Reviewer* 72, no. 3 (March 1992): 74.

16. "Huge Deception Prepared by Goodyear Confused Nazis," *WC*, December 12, 1945.

17. H. Wentworth Eldredge, "Biggest Hoax of the War: Operation Fortitude: The Allied Deception Plan that Fooled the Germans about Normandy," *Air Power History* 37, no. 3 (1990): 15–22.

18. See the following *WC* articles: "Lives Saved by Goodyear Rubber Boat," 1943; "Saved with Two Others by Goodyear Life Raft," October 13, 1943; "Famous Goodyear Raft on Display," June, 24, 1942; and "Out of the Night They Give Their Thanks to Goodyear," March 25, 1942. See also Alvin Townley, "Stranded at Sea," *Air & Space Magazine* (April 25, 2011); and Robert Trumbull, *The Raft* (New York: H. Holt and Company, 1942).

19. See the following *WC* articles: "Thrilled Because They Built Boat Rickenbacker Had," December 9, 1942; "Sure! Goodyear Rafts Saved Life of Rickenbacker," February 3, 1943; "Goodyear Boat Saves Eddie Rickenbacker," December 9, 1942; and "Rickenbacker Meets Builders of Raft Which Saved His Life on Wild Pacific," April 2, 1947. For an account of Rickenbacker's experience see Eddie Rickenbacker, *Seven Came Through* (Garden City, NY: Doubleday, 1956).

20. "Thank God for Goodyear Rubber Company," *WC*, January 3, 1945.

21. See the following *WC* articles: "Woodworking Operation on Every Goodyear Product," August 12, 1942; "Admiral Praises Workers on Boats for Job," June 7, 1944; and "National Defense."

22. See "The Mae West: Giving Credit Where Credit Is Due," and "National Defense."

23. For information on Goodyear pontoons see RMA, 30–31; Goodyear, "Lightning War, US Style," advertisement, ca. 1943, GR; "Rubber Bridge," *Goodyear News* (April 1942); and Allen, *House of Goodyear*, 473.

24. See "Goodyear Bags Save Fighter Plane in San Diego Bay," *WC*, August 13, 1941; and "Presto! Flotation Bags Are Inflated," *WC*, April 21, 1937.

25. See "National Defense."

26. For information on Operation Fortitude see Koch and Eldredge. See also Mary Kathryn Barbier, *D-Day Deception: Operation Fortitude and the Normandy Invasion* (Westport, CT: Praeger, 2007), 27–28; and Roger Hesketh, *Fortitude: The D-Day Deception Campaign* (Woodstock, NY: Overlook Press, 2000), 382.

27. Allen, *House of Goodyear*, 463–464. For information on Cooper see the following *WC* articles: "J. Frank Cooper Called by Death," October 6, 1943; "Woodworking Operation on Every Goodyear Product," August 12, 1942; and "Eleven Won't Sink Fabric Boat," June 23, 1937.

28. See "Rubber Plants Decoy Invasion Confused Nazis," *New York Herald Tribune*, December 6, 1945; and "Huge Deception Prepared by Goodyear Confused Nazis," *WC*, December 12, 1945.

29. See Goodyear, *The Story of Synthetic Rubber* (Akron, OH: Goodyear, ca. 1943); Goodyear, *Chemigum Synthetic Rubber* (Akron, OH: Goodyear, ca. 1943); Goodyear, *From Test Tubes to Tires: The Story of Chemigum* (Akron, OH: Goodyear, ca. 1941); Ray P. Dinsmore, "Synthetic Rubber Status" (address, January 5, 1949, Akron, OH), GR; Dinsmore, "International Aspects of the Rubber Situation" (presentation, Société de Chimie Industrielle, 1957, Athens, Greece), GR; and R. L. Miller to L. E. Judd, March 17, 1949, GR.

30. E. J. Thomas, "The Synthetic Rubber Picture" (address, Detroit Engineering Society, Detroit, MI, September 22, 1943), GR.

31. See Goodyear, "Synthetic Rubber," 1944, news release, GR; Goodyear, *From Test Tubes to Tires*; Goodyear, *Story of Synthetic Rubber*; and Paul W. Litchfield, "Synthetic: A Great New Factor in Our Economic Life," n.d., MS, Baldwin Papers.

32. See "Goodyear Scored Many Firsts in Synthetic Rubber Industry," *Goodyear Triangle Supplement*, March 16, 1943; "Goodyear Rubber Plant Has Big Output," *WC*, February 23, 1945; Goodyear, "Synthetic Plants," May 29, 1941, news release, GR; and E. J. Thomas, "The Synthetic Rubber Picture," n.d., MS, GR.

33. See the following *WC* articles: "Expand Production on Airplane Parts," March 12, 1941; "Goodyear Rushing Work in Defense," June 18, 1941; "Second Building for Big Aircraft Factory Is Begun," May 21, 1941; "Break Ground for Airplane Parts Plant at Airport," April 23, 1941; and "Fifty Aircraft Engineers on Martin Company Project," (*Aircraft Edition*), February 27, 1946. See also the following MSS from GR: "Goodyear Aircraft," July 28, 1941, news release; "Data on New Buildings under Construction for Airplane Manufacturing by Goodyear Aircraft Corporation," 1942; and "Doing What You Can with What You Have," ca. 1941, news release.

34. See the following *WC* articles: "Goodyear Chosen As Name for New Town in Arizona," June 28, 1944; "Will Build Plane Plant in Arizona," August 6, 1941; "Goodyear in Evidence at Guadalcanal," March 24, 1943; "Goodyear Is Praised for Plane Work," July 15, 1942; and "Fifty Aircraft Engineers on Martin Company Project," (Aircraft Edition), February 27, 1946. See also the following MSS in GR: Francis W. Donnel, "History of the Arizona Division of the Goodyear Aircraft Corporation, 1941–1953;" "Goodyear Aircraft," July 28, 1941, news release; "Data on New Buildings under Construction for Airplane Manufacturing," 1942; "Doing What You Can With What You Have," ca. 1941, news release; "Pertinent Facts About Goodyear Aircraft Corporation," n.d.; and "Goodyear Aircraft Production Background," ca. 1946.

35. See "Tells Group How Aircraft Grew to 35,000 Employees," *WC*, September 29, 1943; "In Swift, Orderly Fashion Released Aircrafters Leave Plants for Homes or New Jobs Elsewhere," *WC*, August 29, 1945.

36. See "Expand Production on Airplane Parts," *WC*, March 12, 1941; and "Goodyear Rushing Work in Defense," *WC*, June 18, 1941.

37. See the following *WC* articles: "First Akron-Built Combat Plane Soon to Take Air," February 17, 1943; "Aircraft-Built Fighter Plane Makes Initial Flight," March 3, 1943; "Goodyear Turns Over First FG-1 Fighter to Navy," May 12, 1943; "Corsair Number 1,000 Is Turned Out at Aircraft," March 29, 1944; and "Final Test Flight of Last of 4,006 Corsairs Is Made," October 3, 1945. See also Goodyear, "The Corsair," ca. 1970, news release, GR.

38. For testimonials on the Corsairs see the following *WC* articles: "Corsair Is Best Fighter Plane in Pacific," June 2, 1943; "Flying Goodyear-Built Corsair, Rescued by Goodyear Navy Blimp After Staying Afloat on Goodyear Life Raft," May 24, 1944; and "Corsairs Really Delivered the Goods," September 19, 1945.

39. See "Goodyear Products Figure Prominently in Daring Feats of Flying Tigers," *WC*, May 27, 1942; and "We Bombed Tokyo with Bombers You Helped Build," *WC*, May 27, 1942.

40. "Goodyear Is Big Factor in Japan Bombing," *WC*, June 21, 1944.

41. Morse, "History of Development of Mechanical Rubber Goods."

42. "Goodyear Chemist to Be Honored by President Roosevelt at White House," *WC*, December 2, 1942.

43. RMA, 20.

44. See the following *WC* articles: "Goodyear Turns Out One Millionth Bullet-Seal Fuel Cell," March 14, 1945; "Bullet-Seal Tanks Made by Goodyear Save Many Bomber Planes," October 11, 1944; "Women Who Built First Bullet-Seal Tank in Plant 1 Also Build Last One Prior to Moving of Operations," November 22, 1944; and "Winner of Distinguished Flying Cross Lauds Our Fuel Tanks As Lifesavers," May 3, 1944.

45. See the following *WC* articles: "100,000 Scout Car Tanks Built without Single Defect," November 3, 1943; "Russian Says Self-Sealing Tanks Great," May 27, 1942; "Praise for Our Tanks by Admiral," August 11, 1943; "National Defense"; and "Women Who Built First Bullet-Seal Tank in Plant 1 Also Build Last One," November 22, 1944.

46. Ibid, 60.

47. See the following MSS from GR: "Goodyear Tire Starts New Steam Generating Plant at Jackson, Michigan," 1949; "Construction of Steam Generating Plant at Jackson, Michigan," February 1949, press release; "Hoosier Ordnance Works," January 6, 1941; and "Charlestown, Indiana Powder Bagging Plant," January 6, 1941, news release. See also Arnold Blumberg, "WW2 Weapons: The Bren Gun," *Military Heritage Magazine*, January 20, 2015.

48. See Goodyear, "Hoosier Ordnance Works," and Goodyear, "Charleston, Indiana Powder Bagging Plant."

49. See Goodyear, *Goodyear-Jackson 25th Anniversary Commemorative Booklet* (Jackson, MI: Goodyear, 1962); "Goodyear Tire Starts New Steam Generating Plant at Jackson, Michigan," and "Construction of Steam Generating Plant at Jackson, Michigan." See also "Goodyear Story... Triumph over Obstacles" and "Goodyear Production Vital to America's Defense Program," *Jackson Citizen Patriot*, June 5, 1962; and "Jackson Has Unique Ten-Year History" and "Chronological Outline of Jackson Activities Since 1937," *WC* (*Jackson Tenth Anniversary Edition*), 1947.

Conclusion

The Goodyear Tire & Rubber Company Records in The University of Akron Archival Services of University Libraries possess tremendous historical and pedagogical value. As exhibited on the preceding pages, the historic images from the Photographic Prints and Negatives Series, also known as the Goodyear Photograph Collection, not only chronicle the rich and fascinating history of the largest and most influential rubber company in the world, but also visually document many important subjects in American and world history. Throughout its past, The Goodyear Tire & Rubber Company has impacted industry, life, and culture in this country and abroad, especially through its products. Many of the company's most interesting and influential goods are shown and described throughout this book, from the founding of the company in 1898 through the early years of the Cold War. Still, many other products, people, and places are captured in stunning detail in the hundreds of thousands of historic images in the rest of the collection that remain to be explored by the public.

From the time production began on November 21, 1898, The Goodyear Tire & Rubber Company strived to improve existing products. They advanced cord and balloon tires that helped to transport people and products quickly and safely from point A to point B. They also improved the design and construction of airships, producing some of the largest and most influential zeppelins in the history of lighter-than-air flight, in addition to blimps and balloons that were instrumental in both world wars and others that became advertising icons. Furthermore, the company advanced mechanical goods such as rubber conveyor belts and hoses, which were used to build some of the largest engineering projects in this country and which brought natural resources out of the earth to fire American industry. Finally, the company manufactured and enhanced war products such as gas masks, rafts, and life vests that saved lives during World War II and munitions and airplane parts that helped the Allies defeat the Axis powers. Many of these innovations are captured in the photographs that appear in this volume, while countless others exist in the collection, waiting to be discovered.

In addition to improving products that already existed on the market when they hung out their shingle, Goodyear invented new products and processes that had an impact on people and industry throughout this country and beyond. To name a few, this included the straight-side tire with braided wire bead in 1901, the tubeless automobile tire two years

later, the detachable rim shortly thereafter, and the quick detachable straight-side tire in 1906. They also pioneered the pneumatic truck tire in addition to the LifeGuard inner tube, and in 1909, they developed the pneumatic rubber airplane tire followed by the Airwheel, which contributed greatly to the safety and development of air travel. Later, in the 1930s, the company produced the Airwheel for tractors, hydraulic disk brakes for airplanes, and by the end of the decade was already experimenting with synthetic rubber. During World War II Goodyear designed and manufactured run-flat tires and bullet-sealing inner tubes and perfected their own brand of synthetic rubber called Chemigum. But their innovations went far beyond tubes and tires, for in 1917 they manufactured the first navy blimp, and two years later the first bulletproof gasoline tank for planes, thereby protecting the country and saving lives.[1] Many of these developments, some of which became the standard in the industry and revolutionized transportation, are documented in the company's extensive photograph collection.

Besides these outstanding contributions, Goodyear also developed and improved manufacturing equipment and processes, which advanced American industry. Many of these innovations can be seen in the photographs. In 1904, the company received the Seiberling-Stevens patent for a tire building machine, followed in 1910 by the development of the first testing machine for airplane tires. In 1922, the firm developed Captax organic accelerator and the first cord sectional airbag for curing tires, both of which helped increase output and reduce manufacturing costs, resulting in greater savings for the customer.[2] They also introduced new methods to test their products and deliver their merchandise, including the first "cross-country" truck line in 1917. Soon, Goodyear had a large fleet of company-owned cars, trucks, buses, and planes to continually test their tires and other rubber products and improve them for the consumer.[3]

Due, in part, to their products, Goodyear established itself as one of the "Big Four" rubber companies in the country by 1912, running neck and neck with their closest competitors. In 1915, building on their innovations and numerous "firsts" in the industry, Goodyear became "the acknowledged leader in the tire business." According to the firm, they have since been the leader in tires and tire sundries; number one in mechanical goods; and "the biggest producer and seller of heels and soles."[4] In 1917, with nearly $111.5 million in total sales, Goodyear was second only to the United States Rubber Company.[5] By the dawn of the Roaring '20s, Goodyear was regarded as "one of the eminently prosperous corporations of this country."[6] The progress of the company is captured in its corporate photograph collection throughout this book.

During the 1920s, in spite of a brief era of stagnation and a major reorganization, Goodyear had not only maintained their leadership in tires, but also became a front runner in the entire rubber industry both in volume of sales and in percentage of crude rubber consumption.[7] At the height of its production output prior to the depression, all factories combined including the Akron, California, and Canadian plants annually produced over 12.3 million pneumatic tires, 266,000 pneumatic truck and bus tires, 15.8 million inner tubes, 337,700

solid tires, and almost one million pairs of heels.[8] In the early years of the Great Depression, overall sales plummeted, but the company rebounded by 1934.[9] Sales continued to increase over the span of the decade, until totals hit over $200 million in 1939. As a result of its expansion into the realm of war materials and its adoption of mass production methods, company profits increased right before and during World War II. By 1944, the height of war production, consolidated net sales topped $786 million, far outpacing rivals Firestone and Goodrich. However, at the end of the war in 1945, sales dropped due to the cancellation of war contracts. Nevertheless, the company made up for this loss with the expansion of new factories, both foreign and domestic. Many of the products that put the company on top of the industry are visually captured on the preceding pages, while many others are available in the collection.

A large portion of the company's success in products throughout the period of this study resulted from export sales, as seen in the photographs. This segment of the business increased over 31 percent after the reorganization of the early 1920s to more than $11.5 million, with the largest increase in the period being in 1925, when the net sales of the export business increased a whopping 65 percent, or slightly over $28 million annually. This increased to nearly $57 million just prior to the 1929 crash. Goodyear's overseas plants also contributed substantially to its net profits, especially during the Great Depression.[10] By this time, the company boasted that "Goodyear products are sold in practically every country in the world," and that "wherever you may go, in any country, in any industry, you will encounter Goodyear products of one kind or another."[11] Other elements that led to the company's success in products was the Research, Development, Sales, and Advertising departments, which helped to improve their merchandise and promote its sale around the world.[12]

More importantly than the company itself, perhaps, the photographs highlighted in this volume and the larger collection capture a cross section of the communities where the company manufactured, sold, and utilized its goods, particularly Akron and northeast Ohio. However, the images also serve as a window into the past of other cities across the country including Cleveland; Boston; Chicago; Los Angeles; New York; Rockmart and Cedartown, Georgia; and Phoenix, Goodyear, and Litchfield Park, Arizona. Additionally, the images serve as a microcosm of industry, labor, transportation, and culture during the period from the end of the nineteenth century to rise of the post-war world. The photographs throughout this book visually capture a number of topics important in American and world history that are useful to a diverse audience including students, educators, scholars, and the general public for a number of projects and purposes. These topics include, but are not limited to, manufacturing, working conditions, gender in the workplace, industrial expansion, transportation, aviation, war-time production, racing, and sports and leisure throughout the first half of the twentieth century. The nearly 200 photographs that graced the pages of this volume offer a rare glimpse into the past, helping us to remember rubber and the impact it has had in this country and around the world.

Notes

1. "Goodyear Historical Milestones," ca. 1989, manuscript, Goodyear Records (hereafter MS and GR).

2. Ibid.

3. "Goodyear Home-Coming 30th Anniversary: Program and General Data," 1928, GR.

4. Ibid.

5. See "November 1, 1916 to May 13, 1921," sales report, GR; and "Annual Report of the B. F. Goodrich Company, 1917, B. F. Goodrich Company Records, UA Archives.

6. J. G. White & Company, "Readjustment of Debt and Capitalization of the Goodyear Tire & Rubber Company," 1920, GR.

7. "Goodyear Home-Coming 30th Anniversary."

8. See "Goodyear President's Annual Report," 1931, GR.

9. Goodyear annual report, 1941, GR.

10. See "Goodyear President's Annual Report," 1931, GR.

11. Goodyear annual report, 1939, GR.

12. "Goodyear History," n.d., MS, GR.

Index

S. Victor Fleischer holds a BA and MA in History and MLIS from Kent State University. He has worked as a professional archivist for over two decades, researching, writing, and preserving local history. He currently serves as University Archivist, Head of Archival Services, and Associate Professor of Bibliography at The University of Akron, and previously held similar positions at Youngstown State University and Stan Hywet Hall & Gardens. Fleischer has published articles in the *Journal of Archival Organization*, *Collections*, and *College & Research Libraries News*, and researched, cowrote, and coproduced the Emmy-nominated documentary *Lost Voices of the Great War*. A Warren, Ohio, native, he lives in Tallmadge with his wife Susan and daughter Elizabeth.

Printed in the United States
By Bookmasters